THE HERE'S HOW
BOOK OF PHOTOGRAPHY

EASTMAN KODAK COMPANY
ROCHESTER, NEW YORK 14650

©Eastman Kodak Company, 1971
Second Printing, 1973
Printed in the United States of America

ISBN 0-87985-001-9
Library of Congress Catalog Number: 73-184546

INTRODUCTION

In 1964 Eastman Kodak Company published its first edition in the popular series of HERE'S HOW books on photography. The first HERE'S HOW was so immediately popular that the next year Kodak produced MORE HERE'S HOW, a year later THE THIRD HERE'S HOW, and so on. Each year another new HERE'S HOW book was a hit in camera stores. The book you are now reading is a compilation of the first six *KODAK* HERE'S HOW books on photography, containing articles on specific photographic topics written by photographers who are experts in their fields.

In this book appear the same 39 HERE'S HOW articles that appeared in those six publications, written by 27 specialists. There are more than 400 color pictures, plus charts and diagrams that help explain the tips in each article. The articles cover a multiplicity of subjects from photographing stars, pets, and wild flowers, to underwater photography. Typical subjects include new approaches to photographing children and nature subjects, the challenge of tabletop photography, and the art of seeing. Two articles give graphic, detailed explanations of camera optics and theories. Yet another gives you some apply-them-now techniques for color-slide manipulation.

Each of the 39 articles in this book will be a new and exciting photographic experience for you and your camera. And many others like you have been bitten by the HERE'S HOW bug—more than one million of the first six books had been printed when Eastman Kodak Company decided to put them into this one inclusive book to enrich your photographic pleasure.

And while you're reading this book and trying out the photo techniques it describes, Kodak is printing more new HERE'S HOW books with articles just as interesting as the ones you read here.

CONTENTS

THE THIRD HERE'S HOW

THE FOURTH HERE'S HOW

THE FIFTH HERE'S HOW

THE SIXTH HERE'S HOW

THE HERE'S HOW
BOOK OF PHOTOGRAPHY

Jack Englert, FPSA, was a photographic specialist in the U.S. Navy during World War II. At Kodak, he has served as a development engineer, a photographic instructor, and a Senior Photographic Specialist in the Photo Information department. Jack is well known for his lecturing and TV appearances throughout the country. He has been made a Fellow of the Photographic Society of America for his exceptional ability as a nature photographer, and as an author, lecturer, and teacher. In recent years he has spent much of his picture-taking time photographing both pets and wildlife.

REMOTE RELEASES IN NATURE PHOTOGRAPHY

by John F. Englert, Jr.

Would you like some pictures of wildlife? Big-as-life portraits of small birds or large, dangerous animals completely filling the picture frame? They are yours with a little ingenuity and a remote release for your camera. Here's how.

Place the camera close to a spot frequented by birds or animals. Because they are seldom frightened by equipment, the subjects will come quickly into picture-taking range. Then, with the aid of a remote release, you can photograph them at some distance from the scene.

The ingenuity of the photographer comes into play when he chooses an appropriate place or creates a likely situation for photographing wildlife. Appropriate places can be nesting sites of birds, game trails, or water holes. Likely situations for larger game can be created by baiting an area with food, putting out a salt lick, or, in dry areas, making available a supply of water.

1

The same approach can be used for birds. Feeding stations can be used to attract them. Seed-eating birds can be brought in by means of cracked corn, millet, or sunflower seeds. The hopeful photographer will have no trouble attracting insect-eating birds by using a suet feeder.

The camera should be on a tripod or some other firm support. You can make an improvised mount for your camera by bolting the camera to a piece of wood or other material. The tripod sockets of American-made cameras, and many foreign ones, accept a $\frac{1}{4}$ - 20 bolt. This allows you to attach the camera to the improvised mount by running the bolt through the mount and into the tripod socket.

The key to success in this type of photography is using a suitable remote release with the camera. Most cameras can be tripped at a distance, and the purpose of this article is to explain, in detail, some of the many different types of remote releases. We hope this discussion will help you decide on the release best suited to your purpose, and that it will provide you with the know-how to get started in this interesting field.

MECHANICAL RELEASES

String Release

Let's start out with the simplest release of all, a piece of string tied to the shutter release so that a pull on the string will trip the shutter. Only cameras with a lever-type shutter release lend themselves to this technique. The direction of the pull can be controlled by running the string (fish line is even better) through screw-eyes, positioned at appropriate places.

The action of most shutter releases of the lever type is in a downward direction. Therefore, it is a good idea to have a screw-eye at the base of the camera. (See figure 1.) If the line goes through this screw-eye, the release will be pulled in the proper direction. A screw-eye can be used whenever it is desirable to change the direction of the pull.

Lever Release

Many cameras are equipped with a plunger-type shutter release. It is not possible to use a string tied directly to the camera's release. However, a lever release can probably be improvised. A string attached to the lever will actuate it; this, in turn, will depress the camera's shutter release.

Most of these plunger-type releases have a downward action; therefore, the end of the lever to which the string is attached should be pulled upward. (See figure 2.) Once again, a screw-eye, positioned properly, can be used to make sure that the pull is in the proper direction.

2

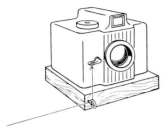

FIGURE 1

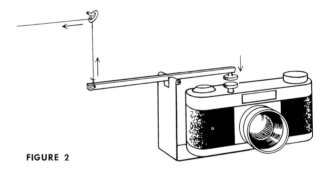

FIGURE 2

Long Cable or Air Release

If your camera has a cable-release socket, you will have a wider choice of remote releases. Long cable releases—up to 12 feet in length—are available from photo-specialty stores in large cities.

Air releases can also be used in cameras equipped for cable releases. A hydraulic type of plunger fits in the cable-release socket. Tubing is attached to the plunger, and a rubber bulb at the end actuates the

3

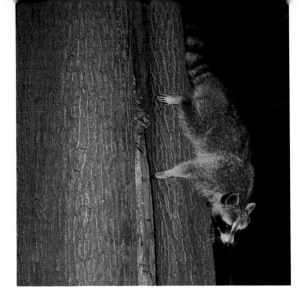

The photographer focused his camera on the tree, then waited behind a bush fifty feet away. When the raccoon appeared, the photographer tripped the shutter and flash by means of an electrical switch connected to a solenoid unit on the camera.

plunger. Manufacturers state that a camera can be operated from any position up to 200 feet. It has been my experience that the distance depends on the type of tubing used. While rubber tubing can be used, it is less efficient than plastic tubing having a relatively small internal diameter. For most subjects, it is not necessary to be more than 30 to 40 feet from the camera, and an air release equipped with plastic tubing should work fine at this distance. Incidentally, air releases are commercially available through most photo stores.

ELECTRICAL RELEASES

A solenoid is a device that exerts a force when an electrical circuit is closed. This force can be used to trip the shutters of most cameras. Generally speaking, the solenoid is mounted on the camera, so that the action of the solenoid can be transmitted to the shutter release. Solenoids which fit cable-release sockets are sold by Karl Heitz, Inc., 979 Third Avenue, New York, New York 10022. Any solenoid can damage a shutter unless the plunger is adjusted to go only .020 to .030 inch into the shutter, just a little farther than is needed to trip the shutter. Any greater throw can be damaging.

With a trip of this sort, it is possible to use a number of methods to photograph the game. Any way of closing an electrical circuit can be used to trigger the solenoid. Let's examine a few of the possibilities.

Switch

Perhaps the easiest way to close an electrical circuit is by throwing a switch. This is my favorite remote release, and it has a number of advantages. It is extremely dependable, and it permits the photog-

4

rapher to choose the proper moment for snapping the picture. Other electrical trips discussed here are good for some situations, but the timing is not controlled by the photographer.

When shooting wildlife pictures, I like to watch the scene of action through a pair of 7 x 50 binoculars from a blind 30 or 40 feet away. (See figure 3.) Holding the switch that controls the picture-taking enables me to shoot at the peak of action or when the pose is just right.

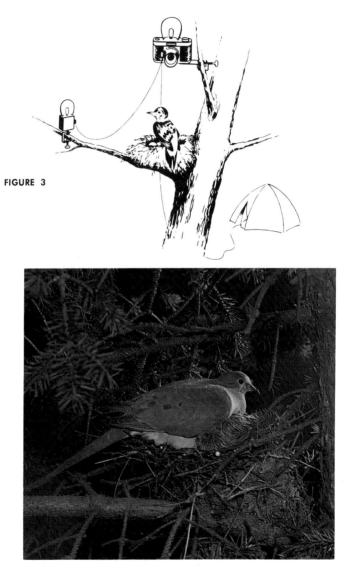

FIGURE 3

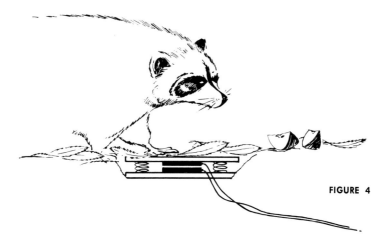

FIGURE 4

There are some disadvantages to this setup. At times, 30 or 40 feet may be too close. This is particularly true when you are photographing large, dangerous animals or shy, timid ones. Then a camera trap may be the answer.

Pressure Mat

A camera trap can be very much like a conventional game trap. (See figure 4.) A pressure mat covered with a few leaves can be placed in a baited area. When there is sufficient weight on the mat, an electrical circuit is closed, and the animal takes its own picture automatically. When you are using a trip of this kind, only one picture can be taken at a time, unless the camera is equipped with an automatic film advance. Otherwise, the photographer must advance the film before another picture can be taken.

Mousetrap Trip

No doubt the least expensive of all camera traps was the one improvised on the spot to photograph the Adirondack black bear seen in figure 5. The trip consisted of a mousetrap, a nail, some bits and pieces of wire, and a fish line.

A fish line was strung across a game trail, with one end tied to a mousetrap. Anything striking the line would set off the mousetrap. The nail was attached to the mousetrap so that the metal bar of the trap would hit the nail as the trap was sprung. The two leads from the

solenoid were fastened to this setup—one to the nail, the other to the metal bar. This made the mousetrap a switch; the electrical circuit was closed when the mousetrap was sprung. (See figure 6.)

With this setup, the photographer can be miles away when the picture is taken. And in the case of black bear, this is good! However, the photographer cannot select the proper moment for snapping the shutter, and only one picture can be taken.

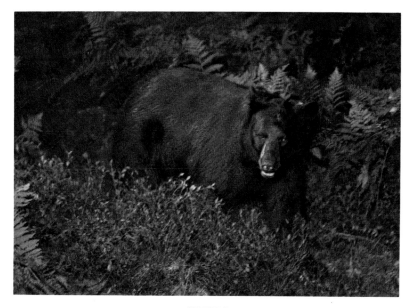

FIGURE 5

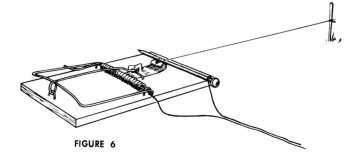

FIGURE 6

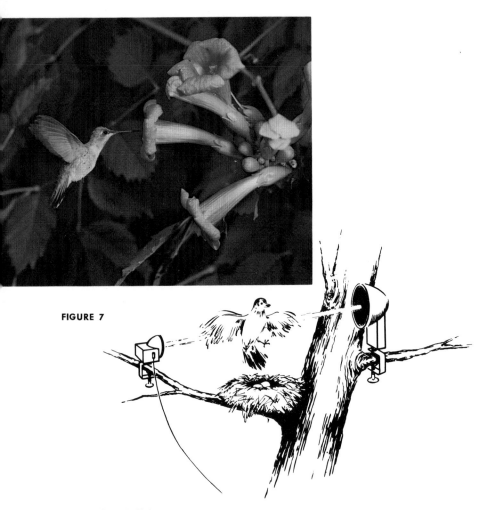

FIGURE 7

Photoelectric Trip

A neat way to set a camera trap is to use a photoelectric trip. A beam of light is directed across a game trail at a photoelectric cell. A change in the light striking the cell will close an electrical circuit and actuate the solenoid on the camera. Therefore, whenever the beam of light is broken, the camera will be tripped. If a camera with an automatic film advance is used, a number of pictures can be taken without your approaching the equipment.

This trip is ideal for photographing birds in flight. (See figure 7.) There is an insignificant time lag in its operation. Tripping the shutter by using a manual switch involves human reaction time, and this may result in a picture with no bird or with *only* the bird's tail.

Figure 8 is a wiring diagram for a photoelectric shutter release. Do not be concerned if you are not electrically inclined. Your local electrical shop should be able to assemble one. The cost of the parts for this release is about $25. A similar photoelectric unit could be made that employs a Silicon Controlled Rectifier (SCR). This unit would have the advantage of considerably lower battery-drain.

The advantage of using this particular circuit is that it incorporates the use of a thyratron rather than a relay; this reduces the time lag considerably. Photoelectric trips using relays may be too slow in their action to photograph fast-moving subjects, such as flying birds.

Remember, the use of remote releases is not the only way to obtain large images of animals and birds. Telephoto lenses have often been used to good advantage. Some nature photographers prefer to work from a blind positioned within picture-taking range, which permits them to be right at the camera. However, it has been my experience that the use of remote releases is the preferred method for some situations. Happy hunting with your camera!

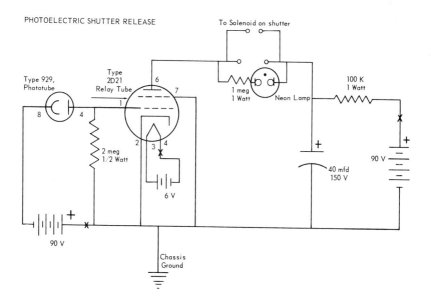

FIGURE 8

The late Charles A. Kinsley, Hon. PSA, FPSA, FACI, taught more than 75 photographic courses in his lifetime. As a widely known photographic lecturer, Chuck photographed all 50 states to illustrate his slide and movie programs. While Director of Kodak's Photo Information department, he managed the staff of specialists who prepare and present public photographic programs, develop services for education and youth groups, and answer thousands of letters every week from people requesting photographic information.

BAD-WEATHER PICTURES

by Charles A. Kinsley

What kind of photographer are you, really? If the fog is heavy at Monterey, do you pray for sunshine or look for a mood shot? If it rains in New York, do you pick out a good show or hurry down to Times Square to hunt for reflections? Does a blizzard mean discomfort or opportunity?

From your reaction to such questions, I'll bet I could make a pretty good guess at how you enjoy your leisure time. Few good photographers have ever had their vacations ruined by bad weather. It's not that they have special sunny-day amulets—it's simply a matter of philosophy.

The fog rolls in. **Ah, such atmosphere!** It rains. **You shoot umbrellas and puddles!** The day is overcast. **What flattering soft light for close-ups of people!** And so it goes—for snow and wind and all the other so-called "bad-weather" elements.

Whether or not you have this bit of Pollyanna in your makeup, you can learn from such happy people. They are the ones who take good pictures no matter what the weather. As a matter of fact, sometimes their pictures seem to be better *because* of the bad weather. Good photographers live in a world of variety, and they live more expectantly. Every change in lighting, atmosphere, or mood demands another shot.

Let's take a look at some of the weather situations that frequently cause people to shelve their cameras.

Does the Haze Faze You?

More pictures are made of people than of any other subject, including landscapes. Fortunately, close-ups of people can be satisfying in practically any type of light. One of the best is hazy-day lighting, just about the time landscapes become disappointing.

When the sky becomes milky instead of clear blue, when shadows appear soft at the edges and more luminous, and when landscapes begin to lose their "punch," this is the time to make the most flattering pictures of people. On clear days, shadows are harsh and a reflector or flash is essential. But on hazy days, the contrast between highlights and shadows is reduced and flesh tones are more pleasing. Notice how much shadow detail there is in the illustrations below.

Many excellent nature shots are also made on hazy days. In the woods or any area where the light is spotty, the nature photographer often has difficulty on clear days in reducing the contrast sufficiently between highlights and shadows to record detail in both. On hazy days, this contrast difference is much less. The illustrations on page 12 are a good example of the value of "soft" lighting.

11

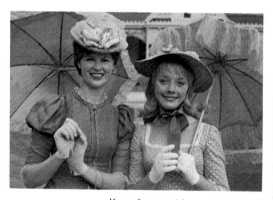

Hazy days provide wonderfully soft, flattering light for photographing people. Lighting contrast is low, so there are no deep, harsh shadows. You may get an occasional good scenic shot in this kind of weather, but it's probably best to concentrate on close-ups.

On overcast days, the sky is a dreary, grayish-white. Keep it out of your pictures by shooting down. A skylight filter will help eliminate the excessive bluishness that comes from cloudy-sky lighting. You need an exposure meter for best results.

The Day Is Gray

On a completely overcast day, the sunlight and skylight are effectively combined into one large diffuse source. The absence of shadows or sunlit highlights gives a characteristic flat appearance to the pictures, accompanied by low color saturation and a tendency toward bluishness. Skies generally appear overexposed when the foreground is correctly exposed, flesh tones are bluish, and many people underexpose their pictures.

Faced with the possibility of such dire results, it's little wonder many people just give up. Actually, it's quite easy to take excellent pictures under such conditions. Using a skylight filter to correct for excessive bluishness and concentrating on close-ups are two of the biggest steps in the right direction.

The skylight filter requires no increase in exposure. It will not penetrate atmospheric haze, as often believed, but because it does produce a more neutral tone, there is an appearance of greater visibility. It also helps eliminate bluish flesh tones, particularly evident in close-ups.

Because of the lack of contrasting highlights and shadows, distant landscapes are particularly dreary. You'll be happier on such days if you forget such scenes and look for objects close at hand.

Be careful about underexposing. There are many degrees of overcast days, and the exposure level may vary by several stops. On a com-

pletely overcast day (not just when a cloud temporarily obscures the sun), you'll need at least 3 stops more exposure than you would use on a sunny day. You may need another 3 when it's just about ready to rain. Your meter will be invaluable in such situations.

To add sparkle, try using flash. You may want to use a reflector in addition to the flash. Two types of lighting are shown in the diagrams below. Flash not only adds contrast; you can also use it when photographing people to put desirable catchlights in the eyes.

Skies reproduce poorly on overcast days. You will improve general landscapes by choosing an angle to eliminate as much sky as possible. Use foreground objects, such as tree branches, to break up large sky areas.

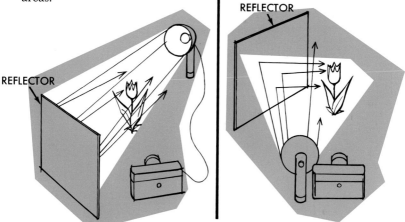

Advanced photographers often provide their own "sunlight" when making close-ups on overcast days. You can use flash on camera, although a detachable flash unit positioned high and behind the subject usually provides better modeling.

If you are taking close-up pictures of people against a sky background, you can improve the sky tone by using flash. The lens aperture should be adjusted for the flash. This will mean less overall exposure in the general areas and there will be more detail in the sky. Instead of having a milky, washed-out appearance, the sky will often contain interesting blue-gray areas.

Let It Rain

Rainy-day pictures are quite different from those made on overcast days. There are more reflections, and many objects take on a different color because of the moisture. For example, fall foliage may appear insipid on overcast days but when wet, quite colorful.

Try shooting right after a rainstorm to capture children in colorful slickers, reflections in puddles, and the rich green of grass and foliage.

The illumination level will vary considerably, depending on the cloud cover. Unless it appears extremely bright, with the sun almost ready to break through, it would be safe to assume during a rainstorm that an exposure increase of at least 3 to 4 stops would be needed. Once again, a meter would be helpful.

Protect your camera against the rain. If you can't find an open doorway or other dry spot, an umbrella can be very handy. One drop of rain on the lens can ruin a picture.

During an actual rainstorm, a distant landscape may be pretty dreary. The solution is to concentrate more on medium-distant and close-up subjects. The observant photographer will be intrigued by such subjects as glistening rocks, reflecting puddles, raindrop patterns, wood and foliage textures, and similar rain effects. In addition, he should be looking for colorful umbrellas, kids playing in the rain or mud, wet animals with woebegone expressions, and other human-interest pictures.

When Smoke Gets in Your Eyes (and Fog, and Smog, and Mist, and Dust)
A major factor contributing to the striking beauty of many successful color transparencies is the effective use of atmosphere. Difficult to define but easy to recognize, atmosphere is employed regularly by the skilled pictorialist to create artistic photographs, in many cases from subject matter not at all out of the ordinary.

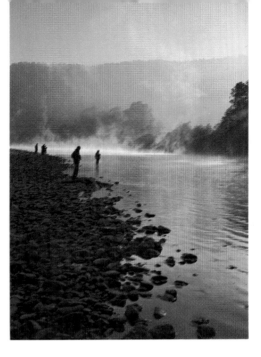

Fog, mist, haze, and other atmospheric effects can provide an artistic quality difficult to get in clear sunlight. Lighting is soft, colors tend to be subtle, and unwanted backgrounds are subdued or eliminated.

Black-and-white photographs made 50 years ago employed fog and mist to establish planes. Such photographs were enhanced by this subdued quality. In color photography, there is the additional quality of color harmony to consider. Fog, haze, mist, and similar conditions create particularly beautiful effects in color. The lighting is soft and the colors tend to be grayed. This gives an artistic quality difficult to obtain in clear sunlight.

Another advantage: Fog and haze limit the depth of view of your camera and so, automatically, unwanted background detail is subdued or eliminated and interest is centered upon the motif.

Exposure tends to be tricky. You may have the feeling you are being somewhat smothered by the fog, and therefore think that much of the light is blocked out. Actually, in many cases, the sunlight is being scattered and bounced around so that very little of it is lost. It's even possible that the diffuse light may so subdue dark areas that you will need to expose even less than for a clear day.

In moderate to heavy fog, a meter reading may not be too helpful. Fog scenes are of a high-key nature and the meter will usually read too high. Experience in judging whether it's a "high" or "low" fog will come with practice. A high fog is actually a rather dense cloud cover near the ground, and the illumination is fairly low, perhaps only ¼ to ⅛ that of a sunny day. An exposure increase of 2 to 3 stops will be required.

In a low fog, the cloud cover is so thin that little of the sun's effect is lost. As a matter of fact, there may be so much scattering of light that the fog acts as a huge reflector and the illumination may easily exceed that of a clear day by a full stop.

There's Snow in the Air

Snow on the ground is no problem, particularly when the sun is shining. You simply adjust exposure for the additional brightness and shoot.

But snow in the air is another matter. For one thing, it has a nasty habit of clinging to the lens. Regardless of whether it's warm enough to melt, the resulting pictures will be considerably less than masterpieces.

If you use flash when it's snowing, be prepared for plenty of white blobs. Flakes near the camera reflect the light and they are always out of focus. The effect is similar to what you'd expect at the peak of a good pillow fight, before the days of foam rubber.

You may like the result; if you don't, about the only alternative is to stand in a protected area with no snow falling between you and the principal subject. An example—if you're out in the street during heavy snow, shooting a face peering out of a house, chances are that if you use flash those white spots will bother you. If you are inside the house, shooting a face peering in, the snow will be behind the subject and you'll have no problem.

Trying to portray a heavy snowstorm is difficult. Too often the day simply looks disappointingly dreary, with little evidence of the falling snow.

You can exaggerate the effect by using a dark background wherever possible. For long slanting lines, try a slow shutter speed, as long as a full second. You'll need a tripod and stationary subjects, of course. You may also need to use a neutral density filter over the lens if you can't stop down far enough.

If you can overlook these minor irritations, you can have fun in the snow. There are mood shots galore—the atmospheric planes of rolling hills, a lone horse with bowed head, brave pedestrians struggling into a gale. Don't forget over-mufflered tots with oversized sleds, or the fragile beauty of branches loaded with wet snow.

The Drama of a Storm

Some of the most spectacular outdoor picture possibilities are of rather commonplace subjects. The lighting is so dramatic that such things as subject matter and composition somehow seem insignificant. This is particularly true just before or after a storm, when golden shafts of sunlight are contrasted with deep grayish-blue storm clouds.

Light of this nature is fleeting and you'll need to work fast. If there's any sun at all (chances are the lighting won't be dramatic if there isn't), exposure will be about the same as on a clear day. Don't let the dark clouds fool you—you *want* them dramatic, and they won't be if you overexpose.

A good rainbow is always impressive—particularly if the "pot-o-gold" happens to be in some significant place such as a field of wheat shocks, the end of a lane, a tiny shack, or a similar thought-provoking area. Rainbows record best when slightly underexposed, so I make it a point to give about a half stop less exposure than my meter demands.

If you're hoping to catch a good lightning flash during a spectacular display, forget it—during the day, that is. The chances of your synchronizing shutter with flash are purely accidental, and mighty slim. At night, it's a different matter. Then you can leave the shutter open long enough to record one or more flashes.

The size of lens opening for night lightning photography will be determined by the general illumination, not by the lightning. A lightning flash will record at practically any opening. See Paul Yarrows' article on "Moons in the Refrigerator" for exposure data for various films. Select the proper lens opening for an exposure of 10 or 15 seconds during heavy displays, longer if the lightning is infrequent. You'll need a tripod or other firm support.

Well, that about does it. I sincerely hope you have the kind of weather you want on your next trip. But if you don't, then I hope these comments have stimulated you just enough to keep trying anyway. You'll have more fun and who knows—it might just be that you'll make better pictures!

It's fairly common to have the sun break through just before or after a storm. This is a wonderful time to shoot the sunlit foreground against the background of dark, bluish storm clouds. Use regular sunny-day exposures to render the foreground properly, and to make the background dark and dramatic.

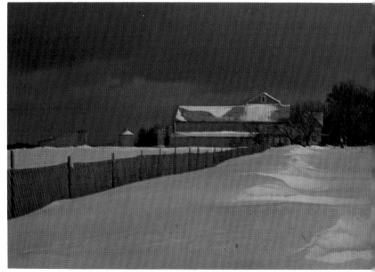

Don D. Nibbelink, FPSA, FRPS, helps create marketing presentations for Kodak. During the past 30 years he has photographed people and places in dozens of countries from the Arctic to the Orient. His pictures have been seen by millions in his books and in photo magazines, print shows, slide lectures, and Kodak Publications.

SUBJECT CONTROL
FOR BETTER PICTURES

by Don D. Nibbelink

If you've ever seen a picture of a coach kissing a football player, it was because some photographer told him to do it!

Which brings up the point that most good pictures are made, not found. You *make* your pictures good by CONTROLLING your subject as much as possible. Casual snapshots made without subject control usually look like—well, like casual snapshots.

Don't misunderstand: You don't have to be a Hollywood director and build your own Sphinx. You don't even have to be an agency photographer and use a walkie-talkie radio to control the position of a red tugboat as it sails beneath the Brooklyn Bridge. What we hope you *will* do is begin to think in terms of ways to improve your pictures by rearranging the things in them.

What do we mean by subject control? Basically we mean making sure you've done all you can to make a good picture before you push

the button. Even such simple directions as, "Smile, please," or, "Don't look at the camera" are elementary bits of subject control. What other types of control are there? The list is as endless as the number of photographic subjects, but we can boil it down to a few that will make better pictures around home or on your next vacation trip.

Landscapes

1. Wait for better clouds, more dramatic lighting, more colorful sunsets. If the light isn't right, wait. The Presidential faces on Mt. Rushmore, for example, are in sun in the morning, but shaded in the afternoon. Is it more trouble to take care in making pictures? Obviously. Are your results better? Much better!

2. Choose your viewpoint carefully to include frames of arches, overhanging tree branches, or a stone fence in the foreground.

3. Use your photographic tools, such as a polarizing screen to darken a blue sky, reduce distant haze, and increase foreground color saturation.

4. Include foreground objects, such as brightly clad people, an automobile, or a boat in a marine scene. Plan to take bright red, yellow, or orange sweaters and jackets when you visit the woods and mountains; use blue and green clothes when you visit the desert. Don't use the same red-shirt-in-the-foreground technique for every picture, or people will think it's part of the scene! Have someone hold some branches in front of the lens—nobody will ever know they weren't

LEFT Everyone who visits Pisa takes a picture of the famous Leaning Tower. But how many people bother to control the scene by waiting until a tourist in a red jacket appears, so they can pay her way into the Tower and tell her where to pose?

RIGHT In Cairo, you can go deep underground to examine the hieroglyphics on the walls of old tombs. Posing the model in this way is subject control; using a strong off-camera flash unit to simulate the light from the oil lamp, and to reveal the texture in the wall, is an important form of lighting control.

19

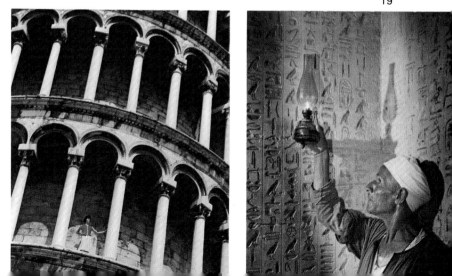

from a growing tree. Clean up the foreground. Remove tin cans, beer bottles, beach towels, yellow boxes, and small boys staring at the camera.

Aerial Pictures
The fact is that you probably won't get a lot of top-notch pictures from commercial airliners because of factors beyond your control, such as haze, or dirty windows. Still, you can increase the odds of getting some interesting and unusual shots by observing these tips:
1. Try to pick a seat on the shady side of the plane, in back of the wing. How do you find out which is the shady side? Ask the ticket agent.
2. If possible, use a medium telephoto lens (such as an 80 or 90mm lens on a 35mm camera), with a high shutter speed.
3. The best time to shoot is coming in for a landing, when ground objects are closer.
4. A skylight filter will reduce bluishness in color slides and movies.

Buildings and Interiors
1. As in the case of landscapes, wait for the best lighting. A building is like a person's face—the front surface should be in the direct rays of the main light.
2. Include people in the foreground for size comparison.
3. Inside, get the room ready to have its portrait taken. Put flowers in vases; use a wad of newspapers for a quick flare of flame in the fireplace; move furniture; in the winter, spray the windowpanes with "snow" from an aerosol container.

Flowers Outdoors
1. Get CLOSE by means of close-up lenses, extension tubes, or bellows.
2. Use sheets of colored paper or cardboard for backgrounds, but don't let shadows cast on them be visible in the picture.
3. Splash a few drops of water on the flowers, or carry an atomizer to make your own "dew."
4. Use reflectors to fill in shadows, or use flash to get good exposure at small lens openings for better depth of field.
5. There are at least three ways to beat the problem of wind movement: Get up early, before the wind does. Tie the stems with string the camera can't see. Make a "wind shield" by fixing a large sheet of clear, flexible plastic to two sticks. The camera "looks through" the plastic as though it weren't there—but the wind can't reach the blossoms.

On hazy or overcast days, the sky photographs as a bald white. So your control is to keep it out of the scene by shooting down. And, of course, that girl didn't just *happen* to be in that spot, holding that umbrella!

6. For super close-ups, add your own bees and insects. Keeping them in the refrigerator for a few hours beforehand makes them sluggish and reluctant to fly—and does no harm.

Pets

There's no doubt about it, pets can be a tough photographic subject. Since you can't make the animals do what *you* want, make them do what *they* want. If you want a cat to lick a goldfish bowl, rub some cod liver oil on the bowl. When you want Rover's attention, use a piece of liver or ground meat.

Cats like closed places, such as baskets, boxes, and (expendable) vases. These things also contain your subject, and keep him in one spot for purposes of focus and lighting. For some animals, you might use a small, high table they'll be afraid to jump from.

Expression is important in animals as well as in people. An unusual sound sometimes produces interesting canine expressions. Since cats are usually harder to control, try using a catnip-filled toy to induce a look of feline ecstasy.

Electronic flash makes a good light source for all pets. It's balanced for use with daylight-type color films, the cost per flash is low, and, above all, it has the action-stopping ability necessary for sharp pictures of moving subjects.

People

You have to be part psychologist, part photographer, and part magician to put people at ease and make them do what you want them to for best picture results. Here are some things that have worked.

Babies

Since it's hard to get children of any age to do anything you want them to, taking pictures of babies is a real exercise in subject control. First of all, there should be no one present except the person taking the pictures and, perhaps, an assistant. It sounds harsh, but the more mothers, aunts, grandparents, and assorted relatives there are in the room shouting orders, the more confused the child will get, and the less chance you'll have of getting any pictures. Try to start with a well-rested child—after a nap, for example. One trick that works well most of the time with small children is to put a piece of cellophane tape around one finger, and record the child's inspection of this funny stuff, and his attempts to get it off. The tape takes his mind off you, produces some interesting expressions, and is invisible to the camera.

Balloons and other simple toys can make good props, and provide a spot of color in your picture. (Try to get clothes and toys of complementary colors for best color harmony.) A hand mirror is another good prop for producing interesting expressions. These tips are mostly for the under-three set. Remember that they have a short attention span and tire easily. If tears come and it's not your day, be smart enough to pack up and read a magazine until another day.

The dyed cloth hanging up to dry in Hong Kong required great depth of field—hence, an exposure of 1/5 second at f/22, with the camera on a tripod. And, as you guessed, the small boy was added for human interest.

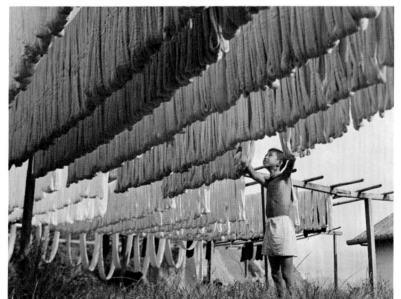

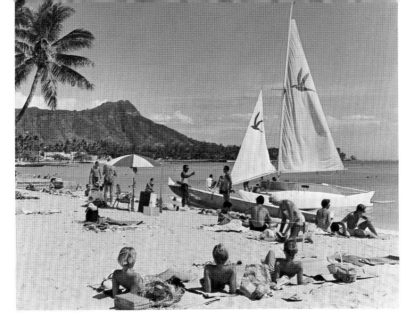

Here are all kinds of controls in one scene. At busy Waikiki Beach, the three girls were positioned to face into the scene. White beach towels and other distracting elements were hidden under hats. Other bathers were kept out of the scene. Finally, a colorful catamaran was positioned to hide the hotel at the foot of Diamond Head. This is making a picture, not taking one!

Other People

1. For close-up portraits (six feet or less), expression is the big thing. You can't suddenly shout, "Hey you, SMILE!" Emote! Be funny. Stand on your head. Keep a store of one-line jokes. Do whatever you have to do to produce a big smile or some other interesting expression.

2. For medium-distant pictures of people—say six feet to fifteen feet— it's usually better if the person *doesn't* look at the camera. Here subject control involves providing natural things for your subject to do while you take pictures. For children, this could mean washing the dog, playing games, dressing up, playing in a sandbox, fishing, fixing a bicycle, or something of that nature.

The same principle applies for adults. If they're not engaged in some interesting activity, invent one. Have them light a pipe, smell a flower, eat a watermelon, hold a golf club, read a book, plant a bush, or do any of a million other things that are at hand. You must direct and control your subject for best results.

3. On trips, you're likely to find many people already doing interesting things: Navajo women weaving a rug; soldiers on guard at colonial Williamsburg, Virginia; cowboys on horseback out West; fishermen in New England; craft workers everywhere. Wherever you go, keep

your eyes open for props that can be worked into a picture-taking situation, even if it's only asking a colonial-costumed model at Sturbridge Village, Massachusetts, to hold an old broom as she stands outside a weathered building.

In foreign countries, take along a piece of paper saying, "Please do not look at the camera," written in the local language. Be pleasant, act like a gracious guest, and most people will be glad to cooperate.

Some photographers go to great lengths. While visiting Hong Kong, one photographer we know found it difficult to keep everyone from staring at his lens, which ruined the spontaneous feeling he was after. So he used a "decoy" in the form of a garishly dressed helper who preceded him through the streets. Everyone looked at the decoy, not the photographer, who was able to shoot unnoticed.

Need More Ideas?

Are you convinced that control will improve your pictures? If these words don't convince you, maybe the illustrations will provide more examples of how easy it is to make better pictures with a little effort. They were taken by the author on a trip around the world. In every case, it was possible to do something to improve an existing scene. You may have to be a little inventive, or a little bold, but try it yourself. Good shooting!

How do you make a better-than-average shot of the Chateau de Chillon in Montreux, Switzerland? You find a natural frame in the form of overhanging leaves, you add a colorfully dressed figure in the foreground, and then wait until the crowd of bathers is out of camera range.

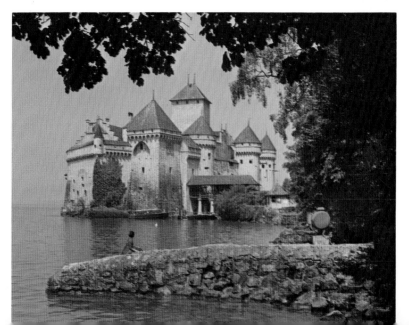

As a correspondent-photographer during World War II, Frank Pallo, APSA, photographed such historic events as the rocket bombings in London and the Nuremburg War Crime Trials. Before joining Kodak in 1947, he operated a portrait and commercial photo studio. Today Frank is a well-known lecturer and teacher, and the Coordinator of Special Events in Kodak's Photo Information department. He has presented idea-inspiring slide shows throughout the United States and Canada, and has served as host for the popular television series "Let's Take Pictures."

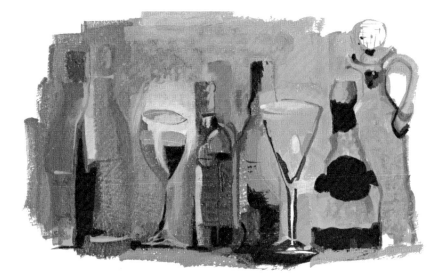

COLORFUL GLASSWARE
by Frank Pallo

As everyone who has tried glassware photography will agree, taking pictures of glass is like photographing an illusion. It presents a tremendous challenge simply because it has form almost without photographic substance. It transmits light, yet reflects it. A goblet or vase cannot simply be placed in front of a background, the lights turned on, and the shutter snapped. The "secret" in photographing any glass is in the lighting and in the complete control of your light sources.

Contrary to what you might imagine after admiring a well-made glassware picture, you don't really need a great deal of equipment for this work. Practically any camera can be adapted for close-ups, but the KODAK INSTAMATIC® Reflex Camera, with its ground-glass focusing and wide array of close-up lenses, is especially suitable. A single-lens reflex camera is desirable not only because it allows exact framing, but

25

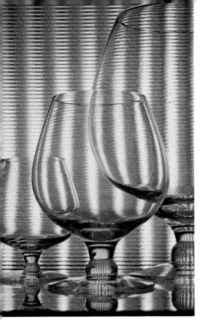

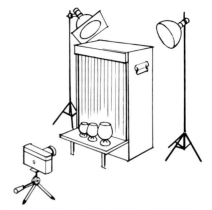

ABOVE A clear spotlight and a red-filtered spotlight behind two sheets of fluted glass and a sheet of opal glass created an interesting peppermint-stripe background. There was no direct light on the glassware.
LEFT Three goblets make an interesting repetition of the same shape in different sizes.

also because it shows you the exact placement of the reflections that are so important in glassware photography.

Lights are no problem either. As a matter of fact, you can make many of the photographs with just one 150-watt reflector spotlight . . . the kind used to illuminate mannequins in store windows. This is a tungsten light that seems to work ideally with KODAK High Speed EKTACHROME Film (Tungsten). The beam of your slide projector makes another useful light source for photographing glassware. Naturally, the commercially made spotlights are easier to use and offer more light-control features, so they should be your ultimate goal in lighting equipment. In addition, most of them work well with KODACHROME II Professional Film (Type A).

Though you may find an occasional use for floodlight illumination, you'll find that spotlights are a lot more effective for most subjects. All good photographs have a strong center of interest, and the spotlight provides an eye-catching circle of light near or behind the dominant subject.

Your own personal preference will determine the kinds and shapes of objects you wish to photograph. Frequent visits to local department, five-and-dime, or gift stores will prove invaluable in selecting the objects having the most appeal. The owners of many shops and stores may even allow you to borrow some of the more expensive goblets and vases in exchange for pictures of them. Department stores often rent expensive crystal for ten percent of the purchase price.

Another visit to a dealer in glass, plastics, or building supplies will enable you to select a wide variety of textured surfaces to be used as backgrounds for your arrangements. Of these, the fluted, ribbed, hammered, pebbled, and dimpled surfaces offer the most variety for unusual glassware pictures.

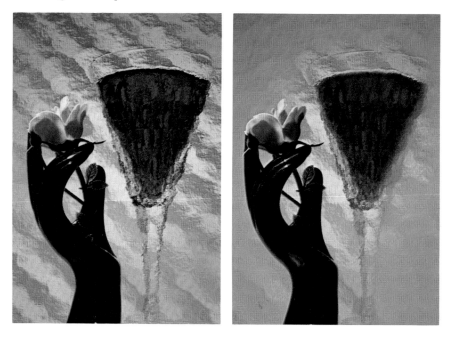

The ceramic hand and the artificial rose came from a dime store. A blue-filtered spotlight behind a sheet of glass provided background color. The background glass was sprayed with matte dulling spray to provide the "frosty" effect for the shot on the right. A small spotlight illuminated the flower petals.

Now that the shopping sprees have been taken care of, let's go to work.

The same lighting techniques apply to color and to black-and-white photography, but since there are more opportunities for applying your ingenuity to color pictures, let's concentrate on color-slide shooting. There are a number of ways to add color to the lighting setup. For example, use glassware that is color-tinted, insert colored cards in the background, place colored cellophane or plastic filters in front of the light, or use colored filters over the camera lens. Of these methods, you'll probably find that using colored filters over the light source will

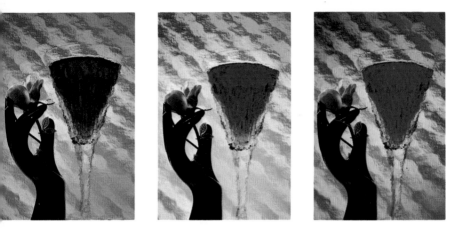

Once you have an arrangement you like, you can make "different" pictures simply by changing the color of the filter over your light source.

prove most versatile. I've mounted several different colors of gelatin in cardboard slide mounts. I put them into an old slide projector, which I use as a colored spotlight. The cardboard mounts with cellophane in them are easy to store and keep clean, and the technique works quite well.

Composing a glassware picture is not much different from composing a conventional pictorial scene. Use big round shapes in your pictures to repeat a circular composition; use long and tall pieces for opposition. Arrange them with the most eye-catching pattern near the center of interest.

Because the pieces of glassware reflect as well as transmit light, it's necessary first to turn off all the room lights. In order to avoid merging the objects with the background, it is most important to arrange them and/or the lights so that a definite outline is created. This is usually accomplished by aiming the main spotlight at the background from a high or low angle. There's no question about it—you do have to experiment until the right effect is obtained.

The worst mistake, with any kind of glassware, is to aim the light directly at the glass objects. Generally speaking, no direct light should be used at all. Rather, the background should be lighted, and the glass arranged in front of it.

If you're using a spotlight with a variable-beam adjustment, try increasing and reducing the size of the beam. Also, raise and lower the light. Notice the effect of these movements in the camera viewfinder. Cameras with ground-glass focusing, like the KODAK INSTAMATIC® Reflex Camera, are best, but not absolutely essential. No matter what equipment you use, you'll find that it pays to shoot a number of different effects at varying exposures and with different colored filters. Then select the one that has the most dramatic balance.

These same suggestions apply whether the arrangement is placed in front of a wall, a piece of cardboard, a seamless paper background, or a textured-glass background. The only difference is in the placement of the main light. In the first three instances, it is aimed at the background from in front of the subject. In the last instance, the textured glass is illuminated from the rear.

If you want to win top prizes with colorful glassware photographs, you can get started by using just one spotlight and a few pieces of glassware. Arrange them on a table about 3 to 6 feet in front of a plain wall —then start shooting.

If you really want to apply your ingenuity, use the textured-glass backgrounds. You can get the various pieces cut to the same size in order to fit them into a wooden rack, like the one shown on page 30. This rack serves as both a background holder and a storage box. Mine is 2 feet square and 8 inches deep.

Make sure you pay particular attention to composition. In glassware photography, composition must be logical as well as pleasing. If a decanter and glasses are to be part of the arrangement, they should be placed together. Logic doesn't stop at mere arrangement either. Suppose a wine bottle and glasses are to be the subject of the picture. If any liquid is shown in the glasses, the bottle or decanter should be emptied by the amount used.

The exposure can be determined by taking a reading from a reflected-light meter at the camera position. However, because the color-saturation effect can vary with different exposures, it's always a good idea to make several exposures at different lens openings or shutter speeds . . . at least for the first few times. In this way, you can use the results as a criterion for future shots.

You'll have a lot of fun creating unusual and colorful effects with glass, for the possibilities are limited only by your own ingenuity. If you're craving for a photographic challenge, this is it. You'll want to try picturing glassware some day anyway, so why not get started right now?

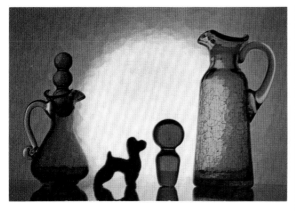

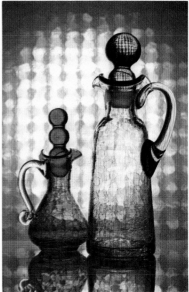

TOP, LEFT AND RIGHT A spotlight provides an eye-catching circle of light behind the subject.

BOTTOM RIGHT Taping small patches of colored cellophane to the back of a sheet of translucent glass created this interesting effect. Only the glass itself was in front of the background. Illumination was from a single clear spotlight directed at the background.

BOTTOM LEFT A wooden box can be made to store your sheets of background glass. It also holds them in place for shooting pictures. A slide projector and a 150-watt floodlight supply the illumination.

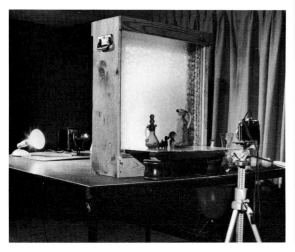

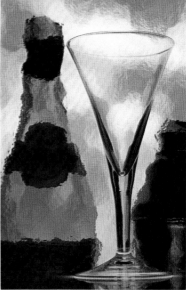

Allie C. Peed is Manager of Advertising, Promotion and Publications in the Professional and Finishing Markets Division. Before joining Kodak, he set up the photographic department of the Kentucky Department of Highways. He is a member of the Society of Photographic Scientists and Engineers, the Society of Photo-Optical Instrumentation Engineers, and the Institute of Electrical and Electronic Engineers. He holds a Photographic Craftman's Degree from the Professional Photographers of America.

PHOTOGRAPHING FLUORESCENT MINERALS

by Allie C. Peed

The photography of fluorescence is an interesting and rather simple photographic pursuit, even though it may sound rather technical. Most of us have seen fluorescent displays in store windows, nightclubs, theaters, or a friend's mineral collection. The colors are fascinating and have an almost supernatural eerie quality. The temptation to record this beauty on color film is great, and it really isn't difficult if you know the ground rules.

The phenomenon of fluorescence involves the "excitation" of certain materials in such a manner that they emit light which is an intrinsic property of the substance. This excitation is effected by the incidence of ultraviolet radiation. In technical terms, ultraviolet radiation is that portion of the radiant-energy spectrum that lies just below the visible blue in the spectrum—hence, the name "ultraviolet," or beyond the

31

violet. Because the human eye is insensitive to this portion of the spectrum, we cannot "see" ultraviolet. However, even though we can't see it, our eyes and skin do react to certain portions (short wavelengths) of ultraviolet by temporarily reddening, tanning, or even burning when subjected to sustained dosages, as is evident in a case of sunburn.

Many substances can be identified by their characteristic fluorescence when examined properly under ultraviolet radiation. In recent years, the fact that many uranium ores are fluorescent has increased the popularity of ultraviolet lamps among prospectors, mineralogists, and "rock hounds." Certain ores are detectable and identifiable very simply by the color of their fluorescence under a brief field examination by ultraviolet radiation.

Ultraviolet radiation is contained in sunlight and, in varying degrees, in the light of many artificial illuminants. We seldom see natural fluorescence in sunlight because the visible-light image is so much brighter than the fluorescence that the faint emission is not noticeable. Only when ultraviolet radiation is divorced from accompanying visible light can fluorescent emissions be seen to good advantage. That's why fluorescent examinations are made in darkened rooms or boxes or at night where there is little visible light. Ultraviolet radiation is then the only illuminant. Under these conditions, the visible light emitted by the fluorescing substance is an induced property. The subject material merely acts as an energy converter in that it "takes in" ultraviolet radiant energy and converts it to a different wavelength in the visible spectrum. According to the law of the conservation of energy, the visible manifestations can never be of greater intensity than the ultraviolet energy which caused them. This is important from a photographic standpoint.

Filters

Remember that silver halides are basically sensitive to only ultraviolet radiation and visible blue energy. The extension of silver halide emulsion sensitivities into the longer-wavelength portions of the spectrum (green, red, infrared) is induced by cyanine sensitizing dyes, but the halides still maintain their ultraviolet and blue sensitivity in most commercial emulsions.

For this reason, the photography of fluorescence must be performed with the aid of a filter that absorbs ultraviolet and keeps it from reaching the film. We have mentioned that fluorescence is induced by ultraviolet radiation of greater intensity than the fluorescence it excites, and that most films are quite sensitive to ultraviolet. If the ultraviolet image reaches the film, its greater intensity will produce a "reflected-ultra-

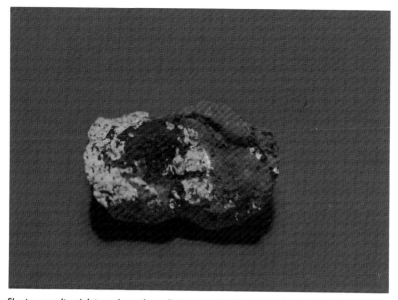

Short-wave ultraviolet produces these distinctive colors in willemite and calcite. Exposure was fifteen minutes at f/16 on KODAK EKTACHROME-X Film, with a quartz-tube mercury vapor arc as the source.

violet" record of greater density than the weaker visible fluorescent-light image. On black-and-white film, a reflected-ultraviolet picture is not greatly different from a reflected-visible-light picture. On color film, however, the ultraviolet image will be recorded principally in the blue-sensitive layer and will result in a bluish reflected-light picture.

Reflected-ultraviolet is another field of technical photography, not to be treated in this article. Its use is in the fields of materials examination where differences in reflecting properties of materials that appear quite similar under visible light make possible the recording of differences which often cannot otherwise be seen. Thus, reflected-ultraviolet photography is used in the study of questioned documents, forensic and legal materials, and paintings and other works of art.

The necessary filter for photographing fluorescence must absorb ultraviolet while transmitting nonselectively all of the visible colors. Such a filter is the KODAK WRATTEN Filter, No. 2A or 2B. Many common color filters meet the requirement for absorbing ultraviolet, but are selective in the visible-light regions. For example, the common No. 8 light-yellow filter absorbs ultraviolet, but it also absorbs some visible

blue; and the usual No. 25 red filter absorbs not only ultraviolet but also visible blue and green light. If you know the colors of the fluorescence you want to photograph, you can refer to filter-absorption data to find one of the common color filters that will work very well. For example, if an ultraviolet-absorbing filter, such as the KODAK WRATTEN, No. 2A or 2B, is not available, a No. 8 light-yellow filter can be used with some sacrifice in recording any blue from the specimen.

In using filters for color selectivity in fluorescent photography, remember that you are photographing the source of light, and that there is little or no reflected image. For example, suppose that you want to photograph a mineral whose fluorescence is generally greenish, and that you want to use a filter to accentuate this color to the exclusion of other colors.* The specimen is displayed on a white card. A rule of thumb in the photography of fluorescence is as follows: For enhancing the reproduction of a particular color of fluorescing light, use a filter which transmits the color of the fluorescence. Thus, a green filter used in the example above would give a green image against a black background on color film, or a white image against a black background on black-and-white film. In either case, you would have the maximum contrast obtainable.

*Note: In accordance with the line of reasoning usually followed in black-and-white visible-light photography, we should select a filter of complementary color (red) to "darken" the specimen against the white background. In the case of fluorescence, though, this would result in no image at all because the "white background" would already be black (unless it were also fluorescent). The ultraviolet reflected from the background would not be transmitted by the filter, nor would the green light of the fluorescence be transmitted by the red filter. Hence, no image would reach the film.

Focusing

In the usual run of fluorescent photography, you'll be working with a small specimen and a small, rather low-intensity, ultraviolet source. You'll have to work close to the subject in order to form an image of adequate size on the film, and it is advisable to have the ultraviolet lamp fairly close to the subject in order to get enough intensity at the subject plane.

The usual close-up tools, including focal frames, close-up lenses, extension tubes, bellows extension, etc, are useful. Remember to correct for the change in effective aperture if you use extension tubes or bellows.

34

While most camera lenses do not focus an ultraviolet image in exactly the same plane as a visible image, this doesn't matter, because the desired fluorescence image is formed by visible light. The ultraviolet is stopped by the filter. (Even in reflected-ultraviolet photography, the difference in the planes of the image is slight and can be ignored if the diaphragm is closed down.) In close-up photography, the depth of field is so shallow that small apertures should be used anyhow, and this will clear up any focus differential.

Exposure

Exposure determination for the photography of fluorescence is something of a problem. Measurement with a photoelectric exposure meter is usually impractical. Most meters respond to ultraviolet, which must not be allowed to influence the exposure determination since it does not reach the film and therefore does not contribute to the formation of the image. Anyway, the intensity of the fluorescent emission itself is usually too low to give a meter reading even if it could be taken through an ultraviolet-absorbing filter.

The best approach to exposure is to make a standard setup with the lamp, camera, film, and a specimen of the material you plan to photograph. Then make a trial exposure series at a fixed aperture. A typical series with small mineral specimens and a small ultraviolet lamp, KODAK EKTACHROME-X or KODACHROME II Film, and an effective aperture of $f/16$ might be 30 seconds, 60 seconds, 2 minutes, 4 minutes, 8 minutes, and 16 minutes. From the results obtained with this exposure series, it will be easy to select the proper exposure level for the rest of the pictures.

One thing must be watched in grouping specimens. The brilliance of fluorescence varies widely, depending on the individual material. If a faintly fluorescing specimen is grouped with a bright one, the film scale cannot handle both in one camera exposure. Either the brilliant or the dim specimen will be properly exposed, but not both. If more than one specimen is to be photographed in any exposure, select specimens of comparable brightness if they are all to be recorded properly.

Film Type

For black-and-white photography of fluorescence, any continuous-tone panchromatic film is suitable. The relatively high-speed emulsions naturally make for shorter exposure times.

For shooting fluorescence in color, which gives by far the more rewarding results, either daylight-type or artificial-light color films

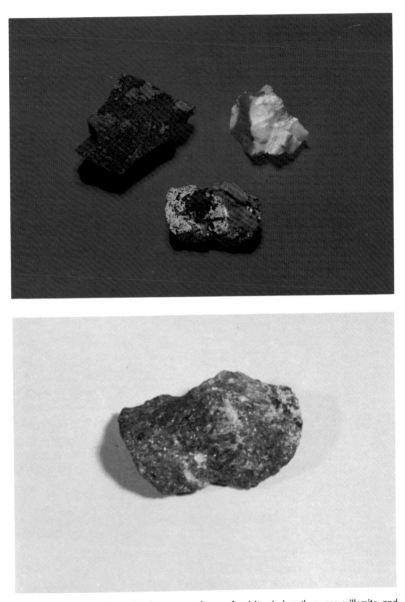

TOP At the upper left and right are two forms of calcite; below them are willemite and calcite in one sample, photographed on KODAK EKTACHROME-X Film by short-wave ultraviolet.

BOTTOM Photographed in black-and-white by normal visible light, the willemite specimen looks much like any other piece of gravel you might find in a parking lot.

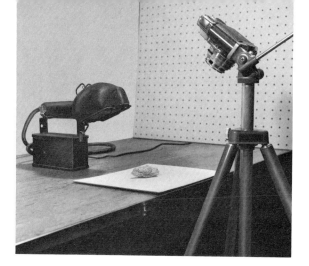

This is the simple setup used to photograph small fluorescent minerals.

can be used. There will be slight variations in color balance with different films, but this will generally be of little consequence. The daylight-type emulsions tend to accent reds, whereas the artificial-light types accent blues slightly.

Light Sources

As we said before, many artificial illuminants radiate some ultraviolet energy. You can use any of these as a source of ultraviolet if you place it in a lighttight housing behind a filter that absorbs visible light but transmits ultraviolet radiation. A No. 18A ultraviolet filter will do the job. So will one of the ultraviolet filter glasses sold by the Corning Glass Works, Corning, New York. You can use photolamps in this manner, too, although they get so hot in a closed housing that they can be on for only about one minute. Normal incandescent filament lamps emit so little ultraviolet energy that they are not useful sources.

There are two types of commercially available ultraviolet lamps. The simplest and least expensive is the "Blackout Fluorescent," such as the General Electric Company's BLB type. While these lamps are physically and electrically much like the fluorescent tubes used in regular lighting fixtures, they do have a special phosphor which emits principally in the long-wavelength ultraviolet region, and the glass envelope is of filter glass which transmits ultraviolet and absorbs visible light. They are inexpensive and available in a number of sizes and intensities. Due to their size and shape, they are particularly valuable for illuminating large subject areas evenly.

For the serious photographer of fluorescence, the more intense

quartz-tube, mercury-vapor arc lamps are best since they are of high efficiency in the production of ultraviolet. They are capable of producing high intensities which make for short exposure times or facilitate the illumination of larger areas.

There are two generally useful ranges of ultraviolet radiation. The most common is the "long-wavelength" 3100 to 4000 Angstrom band. The less common is the "short-wavelength" 2537 Angstrom mercury line, which must be used with some caution because its rays cause sunburn and severe, painful injuries to eyes not protected by ultraviolet-absorbing goggles. Some materials exhibit fluorescence to one type of ultraviolet radiation and not to the other, so that complete coverage of the field requires the availability of both types of sources.

A complete line of ultraviolet lamps of all types is available from Ultra-Violet Products, Inc., 5114 Walnut Grove, San Gabriel, California 91776. Many laboratory-supply houses also handle ultraviolet lamps.

Special Considerations

The absorption of short-wavelength ultraviolet radiation by the glass of most lenses prevents photography of reflected-ultraviolet images. But this does not interfere with the photography of fluorescence, since the image is made up of visible light.

Both types of ultraviolet also excite some fluorescence in such materials as certain optical glasses, the cement used to assemble lens elements, and the dyes used in some filters. This is easily detected by holding the lens or filter close to the ultraviolet lamp and looking for fluorescence. If the lens is found to be strongly fluorescent, you can't use it for reflected-ultraviolet photography, but you can use it for fluorescent photography with an ultraviolet filter in front of it. If the filter is found to be fluorescent, it generally cannot be used in either type of photography. However, the effects of a mildly fluorescent filter or lens can be reduced to an acceptable level by preventing direct rays from the ultraviolet lamp from striking it. Proper orientation of the lamp and the use of a lens shade on the camera will help keep ultraviolet off your lens and filter. Increasing the distance between camera and subject also decreases the intensity of the ultraviolet reflected onto the lens by the subject.

Fluorescence of either the lens or filter appears in the finished negative as a general veiling or fog; and, in color transparencies, it is a colored fog of the same hue as the fluorescence of the lens or filter. In severe cases, the fog completely obscures the image.

Allen Stimson, FPSA, FRPS, FSMPTE, FSPSE, supervises the design of Kodak exposure controls. A recognized authority on photographic exposure-control devices, he holds 65 United States Patents on motor control, lighting, instruments, and exposure controls, and has published more than 35 technical papers. He supervised the design of most of General Electric's exposure meters during his 25 years as an engineer there.

THE EFFECTIVE USE
OF EXPOSURE METERS
by Allen Stimson

People use exposure meters, of course, to get correct exposure. But what is correct exposure? It can be judged from the appearance of a color slide, but—and this is important—it may be evaluated differently by different people. Each observer thinks the correct exposure is the one he prefers. If different exposures of the same scene are judged by several observers, the one preferred by the majority is called the preferred-picture exposure. The exposure that will be preferred can't be exactly predetermined. It can only be evaluated by human judgement, and different observers may not agree closer than ± one stop.

On the other hand, exposure within ± ½ stop of the preferred-picture exposure can usually be predetermined by photometric measurements of a scene with a meter. This is quite satisfactory for most purposes. These comments apply to color-slide films, which require more careful exposure than negative films. If you "zero in" your equipment using

color-slide film, you can be sure of proper exposure when you use negative films. The reverse isn't true. It's important to recognize the fundamental difference between photometric measurement of exposure and preferred-picture judgement of exposure. One is foresight while the other is hindsight. One can be precisely measured and expressed in numbers, while the other can be found only by judging finished pictures. Fortunately, the two are equal for the statistically average scene.

Incident Light

In photography, the illumination on an object is called the *incident light*. You can't see it, just as you can't see the wind. You perceive illumination by the *brightness* of illuminated objects.

Reflected Light

Brightness is the perceived lightness or darkness of an illuminated or self-luminous object. The brightness may not be the same when viewed from different directions. Exposure meters measure average brightness, which correlates well with exposure. Exposure meters which measure brightness are said to measure reflected light. Meters which measure illumination measure incident light. Both incident-light meters and reflected-light meters have advantages and faults as well as emotional advocates. The better method and the best meter are usually the ones with which the photographer is familiar.

Reflected-light meters are usually held at the camera position and aimed at the subject. Incident-light meters are held at the subject position and aimed towards the camera or the light source, depending on the manufacturer's instructions.

Characteristics of Reflected-Light Meters

The usefulness of a reflected-light meter depends upon its calibration accuracy, the freedom from flare and reflections in the light receiver, and the skill of the operator. When the meter's lens and louvers are illuminated by direct sunlight (as when you're reading a backlighted scene), the flare light and that reflected in the louvers may be as great as eight times the light coming from the field at which the meter is aimed, resulting in three stops underexposure! Moderate underexposure can also be caused by a broad expanse of sky in the meter's field. This cause of underexposure is found in most meters and some automatic cameras. The built-in meters on some cameras are designed so that the sky does not influence exposure unduly.

Since individual meters and shutters vary somewhat, and since your personal exposure preference is a factor, you may want to use film speed numbers different from those published by the film manufacturer.

For example, if your shutter is a little slow, or your meter reads a little low, or you prefer fairly dense slides for greater color saturation, you may prefer to set your meter for ASA 80 or even 100 when shooting a film with a published speed of ASA 64. There's nothing sacred about published film speeds. If using a number different from the published one gives results that please you, with your equipment, of course you should use it.

Techniques for Reflected-Light Meters

A reflected-light meter will indicate a good exposure for a scene containing a person and background both in the sun or both in the shade. But if one is shaded and the other sunlighted, a close-up reading on the important subject is sometimes necessary.

A few general conclusions can be drawn:

1. Reflected-light meters can be read when simply aimed at the subject from the camera position if—

 a. the scene contains scattered light and dark areas about equal in importance, or

 b. the scene is uniformly illuminated, or

 c. the sun illuminates the principal subject (faces, for example), and the background is average, or

 d. the background and foreground are not widely different in brightness.

When more than one-fourth of the scene is sky, you can make a valid reading if you tip the meter downward to exclude the sky (except when the sun illuminates the subject).

You can simply aim a reflected-light meter at the scene from camera position and get good results if the scene has about equal areas of dark and light (the gondolier), if the scene is uniformly illuminated (the antique car), or if the background and foreground are of about the same brightness (the barn).

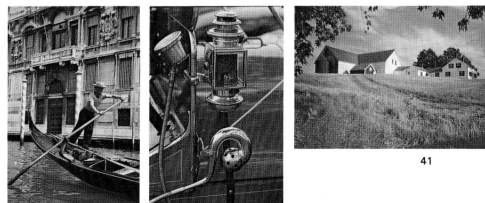

41

2. You should make a close-up reading on the principal subject matter when—

 a. subject brightness is widely different from background brightness, or

 b. the subject is small compared with the background, or

 c. the illumination on the background is different from that on the subject, or

 d. the background is contrasty, for example, when patches of sky are showing through foliage.

3. When the principal subject reading differs by more than double or half from that of green grass, exposure judgement is required. Fair skin has about twice the reflectance of grass, while deciduous foliage has about half. Your meter can't recognize the difference and will tend to expose each so all record at the same density on the film.

When the subject and background are both shaded—or both in the sun—the meter indicates a good exposure. But if part of the scene is in shade and part in sun, as shown on the facing page, top illustration, make a close-up reading on the important subject.

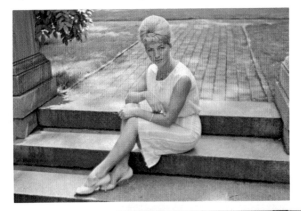

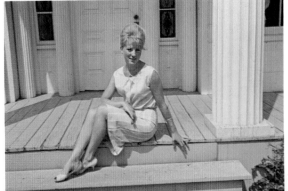

For example:

a. A reflected-light reading from a white wedding cake will usually indicate less exposure than desired. The exposure should be increased from one to two stops more than the meter indicates.

b. A reflected-light reading on black velvet would indicate a good exposure for a monochrome negative. When you use color-slide film, though, this exposure would render the velvet an unnaturally light gray. An exposure halfway between that read from the black velvet and that read from a neutral-gray card is usually preferred.

c. An excessive daylight reading on snow or elsewhere (anything higher than 650 on the Weston meter or higher than 4, high range, on a General Electric PR-1) should be ignored when people are in the picture, because the meter is being deceived by *specular reflected light*. When human faces are in the picture,

43

BOTTOM If more than a fourth of the scene is sky, tip the meter downward to exclude it when making your light reading. This is *not* necessary when sun illuminates the subject.

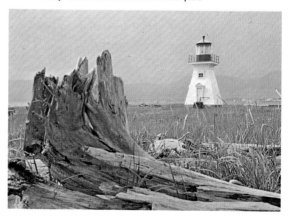

the minimum exposure for KODACHROME II Film (Daylight)—ASA 25—is 1/125 second at *f*/11. For KODACHROME-X or KODAK EKTACHROME-X Film (ASA 64), the minimum exposure is 1/125 at *f*/16. Less exposure than this may sometimes be required on extremely brilliant subjects such as Fountain Paint Pots in Yellowstone National Park, or White Sands National Monument in New Mexico, *if the scene does not include faces of people.*

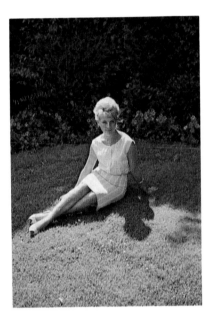

When the subject is much brighter or darker than the background, make a close-up reading on the subject—in this case, the girl. If the meter reading had been made from camera position for this picture, the meter would have read a large expanse of dark background, and indicated an exposure far too great for the girl.

Techniques for Incident-Light Meters

Incident-light meters are less convenient for outdoor use than reflected-light meters, and have not gained wide popularity with amateurs. They are most useful for photographing specific objects, such as flowers, portraits, or studio sets, where the operator can easily hold the meter at the subject position and read it while aimed towards the camera or light source, depending on the meter manufacturer's instructions. Outdoors, the incident-light meter is also held at the subject position and aimed at the camera or light source. Incident light may also be measured from camera position when the lighting is the same as at the subject.

With subjects of average reflectance, the incident-light meter reading should give the same exposure as a gray-card reading using a reflected-light meter. If the illumination is different on different parts of the subject or scene, the *f*-number halfway between the two exposure measurements can be used.

The use of an integrating sphere on some exposure meters makes the meter nondirectional throughout a wide field. This lets the operator aim the meter casually and get the same reading from different directions. This is an advantage in studio work where skilled operators can properly balance the light on a subject, and use the meter only for determining the exposure level. You can use a meter with a flat cell to balance the lighting ratio on a scene by reading the meter directed first toward one light then toward the other.

Reflected- vs Incident-Light Readings

For outdoor use, a reflected-light meter will probably give the higher percentage of well-exposed pictures. When the meter is used with the precautions mentioned above, practically all exposures should be satisfactory. For indoor, studio, or specific-object photography, the incident-light meter seems to have the advantage. The highest percentage of good exposures can be obtained by using the *f*-number halfway between the two exposures determined by both incident- and reflected-light readings.

Substitute-Subject Technique

Sometimes you can't approach a subject to get a close-up reading. For example, you may want a candid picture of a person in the shade on the far side of a sunlit street. In such a case, you can measure exposure on a substitute object, such as the palm of the hand held in a shaded area. As an alternative, you could measure the incident light in a substitute location. A reading from the hand is satisfactory for light-complexioned people. Darker skin and most average subjects may require twice the exposure measured from the hand.

A KODAK Neutral Test Card is a good substitute object to use with reflected-light meters. A piece of felt cloth is easier to carry than a card and just as good. Use a darker piece of felt for dark subjects and a lighter color for light objects. You can choose the felt by reading the brightness with the meter in comparison with a KODAK Test Card.

Snow Scenes

A reflected-light meter usually reads abnormally high on fresh, sunlit snow. This results in underexposure of about one stop. Glare ice and snow may cause an indication of two stops underexposure. You may arbitrarily open your lens the judged amount, or you can use the

A reflected-light meter usually reads too high on sunlit snow or ice, resulting in underexposure. For a scene like this, give one or two stops more exposure than the meter indicates, or use a reading made on the clear north sky.

On overcast days, the sky is the brightest part of the scene. To avoid underexposure on such days, tip the meter down enough to completely exclude the sky, or double the exposure obtained from a close-up reading on the face or hand.

reading you get by pointing the reflected-light meter at the clear north sky. With an incident-light meter, you may use the reading you get by aiming the meter horizontally. If a person appears in the scene, make a close-up reflected-light reading on his face or on your own hand.

Overcast Skies

Pictures made by conventional techniques on overcast days usually look a little dark and gloomy like the weather. The overcast sky is the only light source, and it's brighter than the foreground subject matter. To get a brighter picture, tip the meter downward to exclude all sky effects, or double the exposure obtained from a close-up reading on the face or hand. Since skylight (as opposed to direct sun) is bluish in color, a slight warming filter, such as a skylight filter, often improves the color of your slides and movies.

Desert Scenes

When the weather is very hot, two things happen that can lead to overexposure. First, selenium-cell meters usually read a little low in bright light. Second, films get a little more sensitive at higher temperatures. Both of these tend to cause overexposure in brilliant desert scenes and in warm climates where buildings are white. Arbitrarily reducing the exposure by one-half to one stop usually improves pictures in such cases. Using a polarizing filter reduces the brightness range of the scene and improves color rendition.

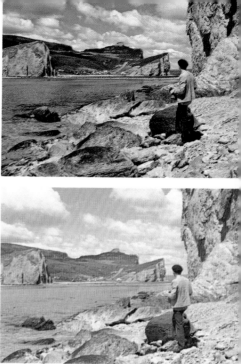

ABOVE Overexposure is fairly common in hot desert areas, because selenium-cell meters read a little low in bright light, and films get a little faster under conditions of great heat. You can arbitrarily reduce the exposure indicated by the meter by one-half to one stop.

RIGHT, TOP AND BOTTOM A polarizing filter reduces the brightness range of the scene at the top by eliminating polarized skylight and reflections. It also darkens blue skies and increases color saturation. In marine scenes like this, it also tends to make the water look "flat" by removing the highlights.

Marine Pictures

Water frequently mirrors the sky or the scene, and gives unduly high meter readings that lead to underexposure. If the reading is excessive (over 650 on a Weston meter, for example), use this limit to compute the exposure unless you're deliberately trying for silhouette effects. If the subject is specific, make a close-up reading from it, or from a substitute subject in similar light. Polarizing filters will increase the color saturation and darken the skies in marine scenes, but they also remove the highlights in the water, making it look dull and flat.

Low-Contrast Scenes

Low-contrast scenes can be successfully photographed with a wider range of exposures than high-contrast scenes. Usually, the minimum exposure that will produce a picture of acceptable brightness is preferred. If the black objects in the scene don't look black in the photograph, the picture may be judged overexposed even though the highlights aren't overexposed. For scenes of moderately low contrast, exposure of one stop less than the meter indicates is usually enough to "set the blacks." On the other hand, if the scene is best rendered in pastels, use one stop *more* than the exposure indicated on the meter.

Low-contrast scenes can be photographed successfully with a wider range of exposures than high-contrast scenes. Usually the minimum exposure that will produce an acceptably bright picture is preferred.

Use of Automatic Cameras

The meters in automatic cameras are similar to hand-held meters. Most automatic cameras are subject to the same influences as hand-held meters and the same precautions should be observed in using them.

Unfortunately, automatic cameras are held in low esteem by a few advanced photographers. The fact is that an automatic camera ordinarily produces a higher percentage of satisfactory exposures than a separate meter and camera, because the meter, shutter, and diaphragm are adjusted in combination to give the correct overall performance. Subject failure rarely causes automatic cameras to differ by more than one f-stop from the preferred exposure. Manual readjustment exceeding this amount should be done with caution.

Cameras with an exposure-control lock can be used as hand-held meters. When you want to exclude the sky, tip the camera downward and lock the exposure controls before aiming at the scene for filming. You can make close-up readings of subjects in the same way.

With automatic cameras that have no manual diaphragm controls, you can alter the exposure in these ways:

1. Exposure can be *decreased* by setting the film speed adjustment for an ASA speed *higher* than that of the film.

2. Exposure can be *increased* by setting the film speed adjustment for an ASA speed *lower* than that of the film.

3. Some cameras have an adjustment for changing the overall exposure level of the camera towards either more or less exposure.

4. With any automatic camera which has a large cell, covering half the cell window with your finger increases the exposure one f-stop. Covering three-fourths of the window increases the exposure two f-stops.

Jack M. Streb, APSA, is Director of Consumer Markets Product Planning for still photography. Formerly, he was Director of Kodak's Photo Information department, which receives thousands of letters each week from people requesting photographic information. Jack has presented his slide and movie programs to audiences all over the United States and Canada. As former Director of Consumer Markets Publications, he supervised the publishing of numerous KODAK Photo Books and KODAK Customer Service Pamphlets.

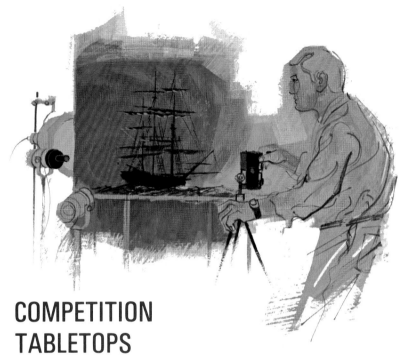

COMPETITION TABLETOPS

by Jack M. Streb

The sun had set long ago, leaving the town chill and dark. A cold north wind howled around the house, tugging at shingles and bending the trees. Icy rain lashed against the windows. Inside, a man was busily preparing to make more pictures to submit to photographic salons!

If this hardly seems like the time or place for picture-taking, a quick glance through the catalogs of a few international photographic salons should convince you that a great many of the pictures that win acceptances are created in the small arena of a tabletop.

One especially popular tabletop subject is glassware—glamorous crystal photographed against various backgrounds, often illuminated by colored lights. We thought glassware was so important—and so interesting—that there's a whole article on it, beginning on page 25 of this booklet.

49

As for other tabletop subjects—well, the sky's the limit. It's photography's fantasyland, where anything goes. People have photographed model ships, trains, planes, and boats; stuffed animals; pipestem figures; fruits and vegetables; flower arrangements; tools; machine parts; toys —and practically anything else you can imagine.

We'd like to show you some of the pictures we've been involved with—and tell you how they were made. Some of the photographic techniques are challenging, and some of the subjects might give you ideas to explore.

How About Equipment?

Before we discuss the pictures themselves, you might be interested to know what kind of equipment is necessary for tabletoppery. Most of the pictures illustrating this article were made with a 35mm camera back, modified to accept a piece of ground glass in the focal plane, and a bellows to permit extreme close-up focusing. Since tabletop pictures are almost always close-ups, the usual close-up techniques apply. We feel that a single-lens reflex camera is most convenient because it frees you from parallax errors in viewing, and makes close-up focusing easy on its ground-glass viewfinder. Both close-up lenses and extension tubes or bellows make it possible to move in closer than the nearest distance marked on the camera's focusing scale.

If you are shooting a scene a foot wide or less, and focusing with a bellows, you need to correct for lens extension.

This table shows an easy way to compute exposures from settings indicated by exposure meters when extension tubes or bellows are used on a 35mm camera:

Long dimension of subject area	12	6	3½	2½	2	1½	1¼	1 inches
Open lens by	⅓	⅔	1	1⅓	1½	1⅔	2	2½ stops
Or multiply time by	1.3	1.6	2	2.5	2.8	3.2	4	5.6 times

When making full-frame close-ups with a 35mm camera—

1. measure the long dimension of the included subject area, and

2. increase the lens opening by the amount shown, *or*,

3. if you want to keep the lens opening constant, increase the exposure time by the amount shown.

Lighting can be fairly simple or quite complicated, depending on the effect you're trying to create. Minimum lighting equipment would probably include at least two or three photolamps in fixtures that

you can aim where you want them. A small spotlight with a snoot or diaphragm is helpful for casting circles of light. For more ambitious efforts, a rheostat is useful for controlling the brightness of your lights.

We prefer an incident-light meter for tabletop shooting, because reflected-light meters are often "fooled" by the large areas of dark background that usually fall behind your tiny subjects. If you don't have a meter that will read incident light, using your reflected-light meter with the gray side of a KODAK Neutral Test Card is a good substitute.

We used KODACHROME II Professional Film (Type A). Without filters, it matches the color quality of light from photolamps (3400K), has ample speed (ASA 40), and offers excellent sharpness and color reproductions.

Leave the Dishes in the Sink

Some interesting tabletop pictures require a bare minimum of lighting, equipment, and props. About a dollar's worth of dime-store plastic dishes and a squirt of pink liquid detergent provided the makings for the picture reproduced in *Figure 1*. Illumination came from three photolamps, one on each side of the camera, and a third behind the dishes. That third light was kept low and close to provide some translucence and interesting shadows in the dishes.

Instead of a sink we used a large darkroom tray set on a low table. Strangely enough, it took some fairly careful arranging to create the appearance of a haphazard tumble of dishes. The suds kept "going flat" as we arranged the dishes, and the final solution was to put an air hose under one of the cups, and let go a blast of air before each picture was taken. Exposure was ½ second at f/22.

51

FIGURE 1

FIGURE 3

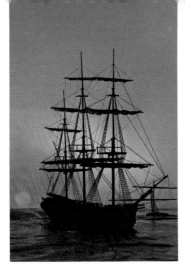

FIGURE 2

Down to the Sea in Ships

"Salty" scenics like the one shown in *Figure 2* can be taken by people no closer to the ocean than the residents of Omaha, Nebraska. The ship is a model only a foot long, with its hull made flat at waterline so it would appear to be sitting in the water, not on it. The water itself is a sheet of crumpled cellophane. A "sky" was created by hanging a sheet of translucent plastic behind the table on which the model was located, and lighting it from behind with a blue-filtered photolamp. This was kept low to simulate the brightness of the sky at the horizon. The "sun" was a small spotlight, filtered red, with a snoot focused to throw a circle of light on the back of the plastic sky. A weak, pink-filtered light was directed up toward the sails to create rim lighting. That was the only light on the ship; everything else was behind the background.

This kind of thing can get very complicated from a lighting stand-point, and we ended up putting a rheostat on each light to get a proper balance of brightness between sun and sky. The best exposure turned out to be four seconds at $f/16$.

Where the Elite Meet to Eat

Food, in many forms, is proper fare for tabletop pictures. The ribbon candy shown in *Figure 3* was left over from a Christmas party. We tried various arrangements, but they all looked "flat" and lustreless. Then we reasoned that since the subject is translucent, light should come through the candy. So we arranged it on a glass-topped light box, then added two photolamps shining down from above to create interesting highlights. Moving in close and arranging the candy di-agonally helped improve the composition.

"Breakfast Smile," the happy arrangement in *Figure 4*, is a high-key effort illuminated entirely by flat, diffused frontlighting. The round frypan didn't compose well anywhere inside the long rectangle of a 35mm frame, so we added the spatula at one side to improve balance, and to add a different texture. Foodstuffs tend to dry out very quickly in the heat of the lights. Either shoot fast or be prepared to retain the shine by doping the subjects up with a few drops of liquid cooking oil.

Eggplant, carrots, beets, and peppers sounds like the start of a good stew recipe. It's also a good recipe for making "Elephant Walk," *Figure 5*. Like all these pictures, this one is simply the suggestion of things you can do with simple props and some imagination. Four lights were used to create shadows and highlights, and ivory-colored paper provided a contrasting background for the vegetables. If you're in doubt about where to use a light, put it where you think it should go, and then stand at the camera position and snap the light on and off to see what its effect on the picture will be. Being the complete master of shadows, contrast, and highlights is half the fun of tabletoppery.

53

FIGURE 4

FIGURE 5

A good idea can almost always be improved, as we think you'll see in *Figures 6* and *7*. The idea seemed appealing, but the first picture was a disappointment. The second time around, we increased separation of the broken eggshell from the egg in the cup, moved in closer, used a colored light to increase the impression of roundness on the shell, changed the color of the background, and painted the ladder yellow. Each of these steps helped improve the first version.

Eggs are often used in tabletop pictures, and you can beat problems of weight and spoilage by working with empty shells, rather than fresh eggs. Make a small pinhole at each end of the shell, and either blow out or suck out the contents. If you think this sounds a little repulsive, we're on your side!

She Sells Sea Shells

The world of nature is full of forms and designs that make good pictures. Close-ups of fossils, for example, with crosslighting to reveal the texture, are often interesting. So is the many-chambered Nautilus, whose delicate spiral pattern is reproduced in *Figure 8*. First we tried glancing rim lighting, but it left deep, dark shadows in the base of the shell. Since the shell is translucent, we ended up shooting it on the same glass-topped light box used for the ribbon-candy picture. The shell is almost completely without color, but the delicate hues that are present have been faithfully captured on KODACHROME II Professional Film (Type A). This picture is good when shown either vertically or horizontally, and one very similar to this has been accepted in a number of salons, both as a pictorial and as a nature slide.

54

FIGURE 6 **FIGURE 7** **FIGURE 8**

FIGURE 9

FIGURE 10

Props on a Budget

If you find your imagination lagging, try a visit to a five-and-ten-cent store. If you don't find an idea-jogging prop or two there, we'll be surprised. The dignified performer in *Figure 9* is an inexpensive brush with a nose and arms made of child's modeling clay. The piano is a 98-cent child's toy. Here's where your imagination comes in. A short length of discarded cloth becomes a curtain for the backdrop. A "hot" spotlight kicked in from the left brightens the red bristles of the brush. And a spotlight with a snoot makes a circle of light, simulating the spotlight of a real stage.

A variation on the same theme is "Concerto," *Figure 10*, using dollhouse furniture and a figure made of pipe cleaners and a ping-pong ball. Including a light source within the picture adds interest to a table-top scene, as the burning candles do in this case. You can usually ignore such light sources in figuring the exposure you'll use. It does help to have the overall light level low enough so that the flames stand out and are visible as flames.

Another picture with a self-contained light source, *Figure 11*, has been successful in many competitions. Again, a ping-pong ball was used as the figure's head, with a pipe-cleaner arm. Lighting was very simple, since no dramatic effects were being sought.

Why Don't You Try?

This short article barely scratches the surface of a subject on which books have been written. But maybe you start to see the fun of table-toppery, for competition, or just for kicks. Look at the advantages: You don't have to live in a scenic spot, because your studio is the top of a table, your subjects the product of your own imagination. You can work the night shift, sleep all day, live in a tiny apartment in a snowbound city, and still make prizewinning pictures.

From a technical viewpoint, problems are relatively few. Use slow shutter speeds and small lens openings if you need depth of field, because subject movement is no problem. There's no need to work in haste, because there's no model fidgeting, no need to "beat the weather" before the light goes bad. If you need more lights or different lights, put them where you want them. And if the pictures don't come out the way you like them, you can do the whole thing over, better, any time you feel like it. We think you'll like shooting tabletops. Give it a try!

FIGURE 11

Paul D. Yarrows, FPSA, FRPS, is a Program Specialist in Kodak's Consumer Markets Division. For several years, Paul has ranked among the top amateur photographers in the world, with more than 3,000 acceptances in international exhibitions. Paul is the first person to hold three 5-star ratings in the Photographic Society of America in color, black-and-white, and nature photography. His imaginative photographic lectures have been enjoyed throughout the United States and Canada.

MOONS IN THE REFRIGERATOR

(and other techniques for night photography) *by Paul D. Yarrows*

Most people's refrigerators are full of milk, butter, meat, cheese, and vegetables. Mine has all those things, but it has something else, too. Moons! Nice, round, full moons. They're all on unprocessed film, waiting for me to add appropriate pictures to the foreground. Let's go back a little bit to see how all this started.

Night photography has always been one of my special interests. Several years ago I was shooting a beautiful night scene of Chattanooga, Tennessee, from the side of Lookout Mountain. The city's lights were twinkling, there was a little afterglow in the sky—everything was beautiful—but the large area at the top of the scene looked empty. If only the moon were hanging on that horizon! But the moon was behind me, over my shoulder. Well, it was easy enough to shoot the city first, then put on a 135mm lens, aim toward the moon, and make a second exposure on the same frame of film, putting the moon into the picture

57

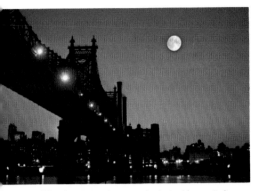

TOP A moon photographed in Vermont hangs over the Queensboro Bridge—an easy bit of photographic magic performed using the technique described in this article.

BOTTOM Another Vermont moon improves a sunset shot of San Francisco's Oakland-Bay Bridge.

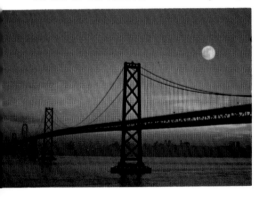

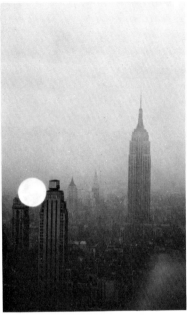

TOP Remember where the moons are—or you may get embarassing results!

right where I wanted it. In fact, it was so easy I decided to shoot a whole roll of full moons to use whenever I needed them to add interest to a nocturnal scene.

Here's how easy it is: Take a roll of unexposed film and load your camera, the way you normally do. Before you close the camera back, wind the film to a frame stop and make a mark with a grease pencil on the back of the film and the inside back of the camera. This orients the film so you can get it back into the camera the same way at a later date. Now shoot a whole roll of full moons, preferably using a long lens,

such as 135mm or 200mm, to get a big image size. An exposure of 1/125 second at f/8 gives a nice bright moon on KODACHROME II Film (Daylight). As a starter, locate all your moons near the upper right-hand corner of the picture, with the camera held horizontally. This has two advantages: It makes it easy for you to remember where they are, and it lets you make either vertical or horizontal pictures later on—like this.

When you tip the camera for a vertical, of course, the moon appears at the top left of the frame. When you've finished a roll, rewind it, but don't wind the leader into the magazine. Leave enough sticking out so that you can reload the camera. Now put the unprocessed film into a 35mm film can, and then into the refrigerator—it helps keep the latent images until you need them.

Now, the next time you want to take pictures at night, reload your camera with the "moon" roll, being careful to line up the grease pencil marks on the camera and the film. Then shoot any kind of night scene you want, remembering to leave some sky area where the moon will appear. When you finally have the film processed, there will be your night scenes as you took them—with a big, full moon in the background! If you want to take only a few pictures at one time, make a careful note of how many exposures you've taken, and rewind the "moon roll" again. When you reload it for a later session, cover the lens and wind off the film until you reach some fresh moons.

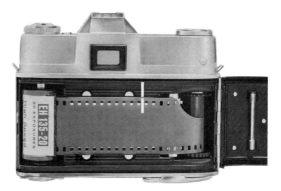

When loading your camera to shoot a roll of moons, make a mark on the film and on the inside of the camera back, as shown here. This lets you orient the film properly when you put the roll through a second time.

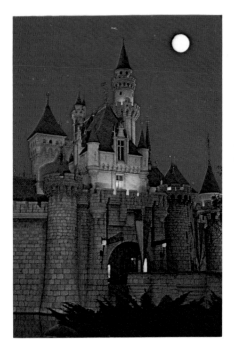

You can put moons in any of your night pictures—with a round paper punch.

There's another way to put "moons" into processed pictures you already have. Simply get a round paper punch and make a hole in the film wherever you want a moon image. This area projects a bright circle of white light that looks quite convincing on the screen. By using holes of different sizes, you can simulate the effect of different focal-length lenses. I have a 50mm moon punch and a 300mm moon punch! A hole about ⅛ inch in diameter is a good size for most moon scenes.

Telephoto Moon Pictures

If the moon is already where you want it in your night scene, try using a telephoto lens of about 125mm or 300mm. The telephoto lens condenses space and magnifies distant objects, thus making the moon appear larger than it actually is when seen normally. With a very powerful telephoto lens in the 500mm to 1000mm range, you can make the moon look extremely large for special effects. When using such powerful telephoto lenses, it is quite important that your camera support be rock-steady. The effects of even the slightest camera movement will be magnified tremendously in your picture because of the long focal length of the lens.

Other Tricks of the Trade

So much has been written about the basics of taking pictures at night that there's no need to treat them exhaustively here. You'll find the KODAK Photo Books *Adventures in Existing Light Photography* (AC-44), 95¢, and *Advanced Camera Techniques* (AC-56), 95¢ helpful sources of information. Many night pictures are basically time-exposure-with-camera-on-tripod situations. But it's also true that you can make hand-held snapshots of big-city streets and bright store windows. The kinds of subjects we're talking about—city skylines, bridges, illuminated fountains—are almost all subjects for time exposure. Here's a table of suggested exposures for some common subjects.

SUGGESTED NIGHT EXPOSURES FOR *KODAK* FILMS*

PICTURE SUBJECTS	KODACHROME II	KODACOLOR-X KODACHROME-X EKTACHROME-X	High Speed EKTACHROME**
Home Interiors at Night Areas with bright light Areas with average light	1/4 sec f/2.8 1 sec f/2.8	1/15 sec f/2 1/4 sec f/2🔺f/2.8	1/30 sec f/2 1/8 sec f/2🔺f/2.8
Interiors with Bright Fluorescent Light†	1/15 sec f/2🔺f/2.8	1/30 sec f/2🔺f/2.8	1/30 sec f/2.8🔺f/4
Christmas Lighting	4 sec f/5.6	1 sec f/4	1 sec f/5.6
Ice Shows, Circuses, Stage Shows—for spotlighted acts only	1/30 sec f/2.8	1/60 sec f/2.8	1/60 sec f/4
Basketball, Hockey, Bowling	—	1/30 sec f/2	1/60 sec f/2
Night Football, Baseball Racetracks, Boxing	1/30 sec f/2	1/30 sec f/2.8	1/60 sec f/2.8
Brightly Lighted Nightclub or Theater Districts (Las Vegas or Times Square)	1/30 sec f/2	1/30 sec f/2.8	1/30 sec f/4
Store Windows	1/30 sec f/2	1/30 sec f/2.8	1/30 sec f/4
Floodlighted Buildings, Fountains, Monuments	8 sec f/5.6	4 sec f/5.6	1 sec f/4
Fairs, Amusement Parks	1/4 sec f/2.8	1/15 sec f/2	1/30 sec f/2
Skyline—10 minutes after sunset	1/30 sec f/2.8	1/30 sec f/4	1/60 sec f/4
Burning Buildings, Bonfires, Campfires	1/30 sec f/2	1/30 sec f/2.8	1/30 sec f/4
Aerial Fireworks Displays— keep camera shutter open on "BULB" or "TIME" for several bursts	f/5.6	f/8	f/11
Niagara Falls—white light Light-colored lights Dark-colored lights	30 sec f/5.6 30 sec f/4 1 min f/4	15 sec f/5.6 30 sec f/5.6 30 sec f/4	8 sec f/5.6 15 sec f/5.6 30 sec f/5.6

*These suggested exposures apply to both daylight-type film and artificial-light film. When you take pictures under tungsten illumination, they will look more natural when you use artificial-light film, while daylight-type film will produce pictures more yellow-red or "warm" in color.

**These suggested exposure recommendations are for High Speed EKTACHROME Film exposed at its normal film speed. You can increase the speed of this film (sizes 120 and 135 only) 2½ times (from ASA 160 to ASA 400 for Daylight type and from ASA 125 to 320 for Tungsten) by using a KODAK Special Processing Envelope, ESP-1, sold by photo retailers. The cost of the envelope is in addition to the normal cost of processing by Kodak. After you've exposed the film at the increased speed, put it into the Special Processing Envelope and give it to your photo retailer or send it directly to Kodak in the appropriate KODAK Prepaid Processing Mailer.

†Tungsten film is not recommended for use with fluorescent light.

NOTE: The symbol 🔺 indicates the lens opening halfway between the two f-numbers shown.

61

➤ **Use a tripod or other firm support when using shutter speeds slower than 1/25-1/30 second.**

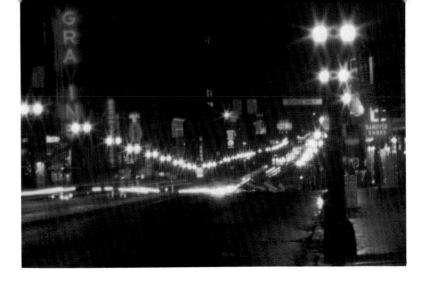

TOP For a different kind of night-picture result, cut a piece of window screen to fit your adapter ring.

LEFT One piece of window screen makes four-pointed stars around all the lights. Two pieces of screen create eight-pointed stars around the lights.

Some of the new super-sensitive cadmium-cell exposure meters practically eliminate the need for exposure bracketing. If you don't have such a meter, it's smart to take one picture at the suggested exposure, plus others at two and four stops more and less than the suggested exposure. You'll probably find several of them useful.

My night pictures are almost all on daylight-type film, because I prefer the warm, ruddy colors. Artificial-light films produce results more like those that the eye actually sees at the scene. The type you use is a personal preference.

One interesting technique is to use a piece of window screen over your lens when you're shooting bright light sources, such as streetlights. It's easy to cut out a round piece of screen that will fit your adapter ring, just like a filter. One piece of screen will put four-pointed stars around the lights. Two pieces placed out of register with each other make eight-pointed stars. The result is something a little more dramatic than usual.

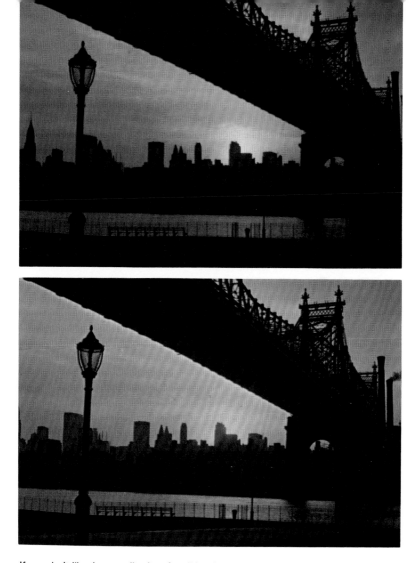

If you don't like the overall color of a slide, change it! We didn't like the weak orange of this Queensboro Bridge sunset—so we bound a sheet of magenta filter material with the slide to get a more dramatic rendition.

Another simple technique is simply to change the overall color balance of the scene by binding a sheet of filter material in with the slide. This works best with sunsets, or when you're shooting at dusk. One of the illustrations shows my original shot of the Queensboro Bridge at sunset. I didn't like the pale orange, so I bound a small piece of magenta filter material with the slide—and you can see the more dramatic

result. The .10, .20, and .30 densities seem to work best. Less density doesn't create much change, and more density makes the projected image too dark.

There's one other technique you might be interested in. Amusement parks are a rich, colorful source of after-dark picture material. Probably every serious photographer has tried at least a couple shots of a whirling Ferris wheel to record solid streaks of color against the black night sky. But how would you like to get results that show the giant wheel apparently cut into slices of color, like some huge pie? Here's how to do it: Set your camera on a tripod and frame the wheel the way you want it. When the wheel stops to discharge passengers, cover your lens with a hat or your hand. As soon as it starts to move again, open your lens. When it stops again, in a different position, cover the lens once more. Do this about eight times, and you'll get results like those in the accompanying illustration.

If you haven't tried pictures at night, you're missing a lot of fun— and a lot of competition pictures for salons, if you're interested in that sort of thing. Exposure isn't critical, things are inherently more interesting at night, and you can have fun around the clock with your hobby.

Now look at the weather page of your newspaper to find the date when the moon will next be full. Then make a date with yourself to go out at moonrise and shoot a roll of film. You can have moons in *your* refrigerator, too!

You can make a "color pie" out of a Ferris wheel by shooting it as described in the story.

Bob Beeler is a Director of Product Planning for Kodak's Motion Picture and Education Markets Division, which is responsible for providing assistance to professional users of motion-picture film, audiovisual materials, and audio-visual equipment. He's a member of the Professional Photographers of America and the American Association of Agricultural College Editors.

Titling Techniques
by Robert Beeler

Why Titles?

A slide show without titles is like a cake without frosting. Titles provide a finishing touch, answer questions, and help bridge gaps. In family and travel slide shows, they help introduce new subjects or locations. In business or education, titles provide graphic explanations of the points you're trying to make. Good titles, like any successful pictures, require planning to carry a message well.

Let's assume that you're familiar with the usual techniques of photographing road and street signs, highway markers, billboards, and other ready-made titles. These ideas are still good ones, by the way. No need to make a title if someone has done it for you.

Whether you're showing personal pictures, travel slides, or preparing a show for educational or industrial use, slide titles add a finishing touch of professionalism.

Where to Start

Jotting down a sentence is a good start. This is the raw material of the title. To make good frosting, boil it down. The fewer words, the better. Use partial sentences. Eliminate "the's." Use nouns and action verbs. Avoid long, involved charts and sentences to be read by the lecturer. Simplify. Round off big numbers. Telegraphic language works, but don't sacrifice clarity. A simple, straightforward statement is better than too much cleverness.

Make Them Easy to Read

As a rule of thumb, if you can read a 2 x 2-inch slide without a magnifier, people in the rear seats can probably read it on the screen.

Bold lettering in white or light colors makes good slides. So do pastel or bright colors against a dark, saturated background. Use cool or neutral colors for most titles—blues, greens, grays, and rich blacks. Reserve bright reds, yellows, and oranges for accents and important words. Dark saturated backgrounds not only add richness to titles, but have a photographic advantage. No matter how careful you are, slides pick up specks of dust. These stand out like a cymbal crash in a lullaby if you use light-colored backgrounds. Dust specks are almost invisible against a deep color.

Backgrounds should *stay* backgrounds, not compete with the title's

One of the most common titling methods is to use ceramic titling letters sold in most camera stores. Use a straightedge to line them up before you take the picture.

66

Bold, light-colored letters against a darker-colored background make legible titles. Ceramic letters placed directly on a sheet of blue paper were illuminated by a single spotlight with a focusing snoot.

A variation on using ceramic letters is to illuminate them from the edges with colored lights. A diffused white light faintly illuminates the bottoms of the letters. These were placed on a sheet of plate glass suspended several inches above a piece of black velvet.

message. A color photograph can make an excellent background—unless it contains more contrast and interest than the copy itself. You can control the results in various ways. Suppose you're using white, three-dimensional letters on a color print, for example. A single, low light source makes the letters stand out brightly against the background. Hardly any photograph can offer as much punch as letters illuminated in this way.

A photograph intended for use as a title background can be darkened in printing. Or, a gray transparent sheet can be placed over the background to reduce contrast and brightness. (Sources for this type of sheeting and all the other items mentioned in this article are listed on page 74.)

Framing

Don't frame titles with straight lines. Keep straight horizontal or vertical lines away from the top, bottom, and ends of your titles. The projection screen and slide mask provide a frame; you don't have to draw a line around the title. And if the transparency isn't mounted perfectly, such lines may not parallel the edge of the slide mask.

Lines or margins obviously meant to be angled or uneven are better. Informal balance is easier to achieve and more successful than precise balance that slips just a little.

Keep the words or charts away from the edges of the background. Allow plenty of spare border. This is especially important with non-reflex cameras with which you have to correct for parallax. Even with a single-lens reflex, framing may not be precise. Also, the area recorded on the film is reduced slightly when the transparency is mounted. You can check what you actually get on the film by opening the camera back and putting a piece of matte acetate or tissue paper in the film plane; hold the shutter open so that you can see the same image the film will see. Another way to check coverage on close-ups is to photograph a newspaper on which you've carefully marked off the area that appears in the viewfinder. Compare the newspaper with the result actually appearing on a mounted slide. You may be surprised to see how much difference there is.

Put the print, paper, or other background material on the floor. Put a sheet of plate glass on some blocks above it. Now you can create a variety of results.

For example, ceramic letters were placed on the glass above a background of embossed paneling. Blue and red gelatin filters over spotlights provided the colored lighting on the background. A white light was directed at the letters, but kept off the background.

In this case, a pile of flashbulbs was placed beneath the glass. Ceramic letters were placed on the glass. A color print, a sheet of colored paper, or almost anything else can be used as background material with this kind of setup.

PREPARATION OF THE TITLE

Picture Multiplane Titles Vertically

Place your print or other background material on the floor. Block a sheet of plate glass several inches above it, as shown in the diagram. Assemble ceramic titling letters on the glass. This technique has several advantages. First of all, it lets you control the background brightness because the background is lighted separately from the title letters themselves. It also lets you control focus. You can make the letters sharp and throw the background slightly out of focus with a large lens aperture. Or, you can make both letters and background sharp.

Shield the camera, tripod, and photographer's arm from light to avoid reflections in the glass. A black card, with a hole for the camera lens to peek through, works well.

This multiplane technique lets you create other interesting effects. You can light the background with colored lights, the letters with white light. You can put actual things—like rock specimens, stamps, coins, jewelry, or any other small articles—under the glass behind your titles.

Acetate-Sheet Cels

A cel is a transparent sheet of acetate, placed over a background. The cel carries the word message. Rub-on transfer letters, such as Letraset,

adhere easily to acetate and create a neat, professional "printing" job. The cel, letters in place, is placed over a color print or any other kind of background for photographing. Since the letters are on the cel rather than on the background itself, you can use the same background with different words if you want to, by making different cels. You can take a picture through a cel to a three-dimensional background scene. Sharp letters against an out-of-focus background are often effective. You can also place the cel in front of an image projected on a piece of white paper. Sidelighting the cel will give you white letters against the projected background.

Acetate cels can make anyone an artist. Suppose you have a map, chart, floor plan, cartoon, or picture which is too "busy" to be good for slides. Put a cel over the original. Trace the outline on the acetate with a broad-nib pen and acetate ink. When the ink is dry, turn the cel over and color the other side. You can use colored felt marking pens or special colors made for use on acetate. You can add colors, wash them off, or change the whole thing, all without disturbing the crisp black lines on the opposite side. When you're satisfied, place the acetate on a colored background of paper, cloth, or what-have-you, and photograph it. This technique produces unusual, effective titles, graphs, and charts.

A cel is a sheet of transparent acetate placed over a background. Rub-on letters transfer easily to cels. Using cels lets you put different words over the same piece of background art.

Rub-on transfer letters, available from art and drafting supply stores, are easy to use and produce extremely neat, legible results.

Here's another use for cels. Trace whatever picture you want on a cel with black opaque acetate ink. Then turn the cel over and fill in the colors with a felt dye marker. This cel was placed over a sheet of blue-green construction paper.

69

FLOW OF ACCOUNTS RECEIVABLE INFORMATION ORIGINATES IN DECENTRALIZED SALES DIVISIONS

| MASD | MWSD | NESD | SESD | SWSD | PNSD | PSSD | HSD |

ORDER AND SHIPPING INFORMATION

COMPUTER CENTER

ORIGINAL INVOICE

CUSTOMER

SALES ANALYSIS COPY OF INVOICE

K. O. FILE DEPARTMENT

SCROLL LISTING INVOICES ISSUED (3)
ACCOUNTS RECEIVABLE TAPE

TABULATING DEPARTMENT

Typewriters, especially electric ones with carbon ribbons, produce neat, black letters. You can type on colored paper, then cut the typed lines into strips and glue them on a dark-colored paper background for title results like this. The connecting lines are strips of pressure-sensitive tape.

Attractive
Force

$+1$ → ← $+7$

Ag^+ Br^-

IONS

The drawing and lettering for this title were done with a lettering set, simply using white ink on blue paper.

Lettering

A commercial artist or sign painter spends years learning to make good letters. A nonspecialist simply can't duplicate the professional's skill. But there are ways to make a neat-looking job. The ceramic titling letters and the rub-on transfer letters we've already mentioned are two examples. Nearly anyone can master a lettering guide and produce neat, legible letters (see illustration).

Another answer to making neat, precise letters is *not* to make them! Deliberately make bold, carefree letters with a brush or broad pen. Don't go back and labor over letters and lines. Make single strokes. The results can look casual and informal on the screen. Colored chalk on black paper lends itself especially well to this casual treatment.

There are many ways to produce effective title artwork, even if you're not an artist. But too much variety in a single show can be confusing. Usually one style is enough for titles in one program. Don't mix ceramic

Nearly anyone can master a lettering guide, and produce neat, legible letters.

THIS IS LEROY
ABCDEFGHIJKLMN

METHODS OF SAMPLING

A. Diary (ARB)

B. Personal Interview

C. Phone Interview (Trendex)

METHODS OF SAMPLING

A. Diary (ARB)

B. Personal Interview

C. Phone Interview (Trendex)

You can type words on white paper, then photograph them with a high-contrast black-and-white film, such as KODAK High Contrast Copy Film 5069. Process the film for maximum contrast and simply project the negative as a slide. To add color to the negative, daub transparent watercolor over the whole negative. You don't have to color each letter individually, because the color doesn't show where the film is black.

letters, typed letters, and rub-on transfer letters all in one show or you'll have hash.

Don't overlook the typewriter. Black letters on light-colored paper look well, especially if you cut the typed lines into strips and paste them on a dark background. Or just place the strips on the background so that they'll curl a little and cast shadows. Make slashing straight cuts with scissors or knife; for variety, tear the paper instead of cutting it.

An electric typewriter with a carbon ribbon makes the sharpest, most even impressions. You can make *white* typed words, too. Set the typewriter to stencil. Use black or dark-colored paper, and type on it with the white paper used for correcting typing errors. You'll end up with white letters on a dark background.

Typing looks better and more legible on a small-size card—a 2⅜ x 3¼-inch area is a good size.

Chalk or crayon on black paper makes an extremely casual type of title that's suitable for a wide range of subject matter. It's fast, inexpensive, and easy to photograph.

CARTOONS

CHARTS

GRAPHS

DIAGRAMS

MATERIALS USED:

1. Black Construction Paper

2. Chalk, Pastel Sticks or Pencils
(such as Eagle Prismapastel)

3. Kodachrome or
Kodak Ektachrome film

71

PHOTOGRAPHIC TECHNIQUES
Title Sizes and Close-Up Lenses
No matter what kind of camera you use, there are definite advantages to keeping your titles a single, uniform size. It can save reframing and refocusing when several titles are being made.

A 10 x 12-inch card with title material mounted on it makes a good size. Here's why. A 35mm camera with a 50mm lens focused at 20 feet will copy an area about 6 x 9 inches when used with a 3+ close-up lens at 12½ inches from the subject. An extra margin of about a half inch on all sides provides a "safe" area, so the background should be 7 x 10 inches. An 8 x 10-inch print or KODACOLOR Enlargement can make an excellent title background. If you'll mount your print or other background material on a 10 x 12-inch card, you'll have room for tape to hold the background material in place, a border for notations, and a handling margin where fingerprints or dirt won't matter.

Most colored papers, pigments, and dyes photograph about the way they look—but once in a while they may not. If precise color is important, you'd better make a test with the same colors, film, camera, and lights you plan to use.

Suitable Films
What kind of film should you use? If you're copying by sunlight, or using electronic flash, daylight-type film is best. When you use photolamps (3400 K), try KODACHROME II Professional Film (Type A). It also gives

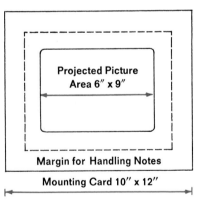

Projected Picture Area 6" x 9"

Margin for Handling Notes

Mounting Card 10" x 12"

A typical copying setup uses two lights at 45 degrees to the copy. It avoids changes of focus and lighting if you make all your titles the same size. For greater control of reflections, you can use polarizing screens over both lights and the camera lens.

A standardized size for titles makes them easier to store and photograph. The format shown in this sketch is a good size for use with 35mm cameras.

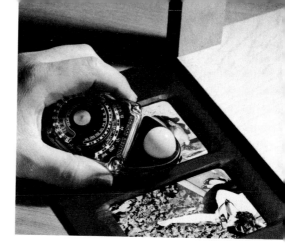

An incident-light meter gives best results when you're photographing flat copy. As an alternative, you can use a reflected-light meter to read the gray side of a KODAK Neutral Test Card placed in the copy position.

good results when you are copying projected images. Usually, no filtration is needed, but make a test with your projector if color is critical. KODAK High Speed EKTACHROME Film (Tungsten) gives good results with tungsten (3200 K).

Using Your Exposure Meter

A good incident-light meter is usually best for determining exposure of titles. Or, you can make a reflected-light reading from the gray side of a KODAK Neutral Test Card placed in the copy position. Use the meter close to the card so that it reads only the light reflected by the card. Avoid casting shadows on the card. If you don't have a test card, you can put a piece of non-shiny white paper in the copy position and give five times the exposure indicated by the reflected-light reading.

A reflected-light reading from the copy itself is usually not satisfactory. A reflected-light reading assumes a normal subject but most titles are low-reflectance subjects. Usually, the best exposure is the one that just barely makes the whites as clear as possible in the final transparency and lets the other densities fall where they may.

Placing the Lights

Photographers who have done much copy work realize the importance of light placement in avoiding uneven lighting, reflections, and flare. The normal lighting setup uses two lights, one at each side of the copy at a 45-degree angle. The lights should give even illumination over the whole copy area. (A pair of reflector floodlights makes a good, high-intensity light source.) Even lighting is less critical for title slides than it is for copy subjects—such as paintings, photographs, or pages from a book.

For dramatic effects, you might want to use a single light at the upper left of the copy to produce long shadows from three-dimensional letters or multiplane copy.

Bright, shiny specular highlights are obvious; we try to avoid them by keeping the room illumination low and by using a lens hood. Diffuse reflections are less obvious. These are scattered, surface reflections that don't have much effect on medium or light colors, but which reduce the

richness of dark or highly saturated colors. One way of getting richer, more saturated colors is to use small light sources when photographing smooth, shiny, saturated colors. This makes it easy to control specular reflections from the camera position. The best method of controlling reflections and getting higher saturation is to use polarizing screens over the light sources and the camera lens, as described in the KODAK Data Book *Copying*, Publication No. M-1.

Modern color films are so fast that reciprocity is not usually a problem. You should remember, though, that effective film speed is usually reduced by extra-long exposures. There may also be changes in color balance when very long exposure times are used.

For simplified title making, you may be interested in the KODAK EKTAGRAPHIC Visualmaker. It eliminates a lot of the fuss of focusing, aiming, and exposure. For more information, write to Eastman Kodak Company, Dept. 641, 343 State St., Rochester, N.Y. 14650.

Sources of Art Materials and Equipment

Most of the materials mentioned in this article are available from camera shops or stationery stores. For your further information, here is a short list of the suppliers of several specific items.

Lettering Guides

Varigraph	Varigraph, Inc. 1480 Martin Street Madison, Wisconsin 53701
Leroy Lettering Set	Keuffel & Esser Co. 15 Park Row New York, New York 10038

Dimensional Letters

Mitten Display Letters	Mitten's Designer Letters 39 West 60th Street New York, New York 10023
Hernard Letters	Hernard Mfg. Company, Inc. 375 Executive Blvd. New York, New York 10523

Colored Paper or Colored Overlays

Papers	Color-Aid, Color-Vu, True-Tone: Lewis Artists' Materials, Inc. 18 East 53rd St. New York, New York 10022
Overlays	Day-Glo: Switzer Bros., Inc. 4732 St. Clair Ave. Cleveland, Ohio 44103

This is the second appearance in a "Here's How" book for Jack Englert, FPSA. In *Here's How,* the first of the series, Jack published an article on remote releases in nature photography. His latest "Here's How" article, on photographing cats and dogs, appears in *The Fifth Here's How.* During World War II, Jack was a photographic specialist in the Navy. At Kodak, he has been a development engineer, a photographic instructor, and Senior Photographic Specialist in the Photo Information department.

Building a Photographic Blind for Nature Pictures

by John F. Englert, Jr., FPSA

For certain types of nature photography, a photographic blind is a necessary piece of equipment. There are times when no blind means no pictures. The main purpose of a blind is to change the form of the human figure to "fool" the birds or other creatures you'd like to photograph. Tents, cars, buildings, as well as even a piece of drab cloth thrown over the photographer, have been used successfully as blinds. But there's nothing quite so good as a blind made specifically for the purpose and incorporating such desirable features as portability, good ventilation, and light weight. A good blind should also be drab in color, tight fitting, and large enough so that the photographer can be comfortable if he finds it necessary to stay inside for four or five hours.

A blind is especially useful for photographing birds, either with the photographer and his camera inside, or used to hide the photographer while he trips remote equipment.

BUILDING YOUR OWN

Here are simple plans for building just such a blind. It's basically an aluminum frame covered with burlap. The only tools needed are a screwdriver, hacksaw, and electric drill.

Burlap is used to cover the frame because it passes air fairly freely and provides ventilation in warm weather. It also lets you look out, since it's possible to see through one thickness of burlap.

Burlap is available from suppliers of upholstery goods. It is usually sold by the yard in 40-inch widths. Preshrink the material before fitting it to the frame, or it might be useless after the first rain. We shrunk ours simply by hanging it on the clothesline and spraying it with a garden hose.

The easiest way to cover the frame is to take two 15-foot lengths of burlap and cross them at right angles to each other (see Figure F). To prevent fraying and eliminate the need for hemming, don't cut the burlap even though it will be slightly wider than three feet even after shrinking. Arranging the material as shown in the diagram makes a square of double thickness approximately three feet in size that forms the top of the blind. After this is sewn, sew three of the four sides together, and install a six-foot zipper in the fourth side corner.

Install portholes in one or more sides. A neat way to do this is to cover 8-inch square holes with two-way stretch cloth having a 6-inch slit for each porthole. The slit makes an opening big enough for viewing and for most camera lenses. It's convenient to have portholes at various heights. For example, openings at heights of 2 feet, $3\frac{1}{2}$ feet, and 5 feet are suitable for photographing ground-nesting birds and those that nest up to about four feet.

MATERIALS

Our total cost for materials, including aluminum, nuts and bolts, burlap, stretch cloth, and the zipper was less than $30, although this may vary slightly (depending on where you live). Here is a list of the materials you need:

ten yards burlap, 40 inches wide
one 6-foot-long, medium-weight zipper
sixteen ¼" x ½" bolts
sixteen ¼" wing nuts
eight 1/16" x 3'4" pieces of angle aluminum
eight 1/16" x 3' pieces of angle aluminum

A *The frame of the blind is made of 1/16-inch angle aluminum. You can easily saw it to length with a hacksaw.*

B *Using a clamp while you're drilling makes it easier to get tight-fitting joints.*

C *Assemble the frame with ½ x ¼-inch bolts. Using wing nuts makes it easy to assemble and disassemble the frame with only a screwdriver.*

D *Your blind will go together quickly and easily if you code the joints with a felt marking pen.*

USING THE BLIND

When you finish, you'll have a sturdy, lightweight, and easily assembled blind that rolls into a bundle 3 feet 4 inches long and about 18 inches in diameter. It weighs about 15 pounds. You can use your blind in two ways: (1) Put the blind close to the subject and make pictures through the portholes. (2) Position the camera close to the picture-taking area and trip the camera by remote control from the blind at some distance from the camera setup. (See *Here's How*, KODAK Publication No. AE-81, for an article on remote camera releases.) Whichever method you use, the result should be more nature pictures of higher quality than you've enjoyed making before.

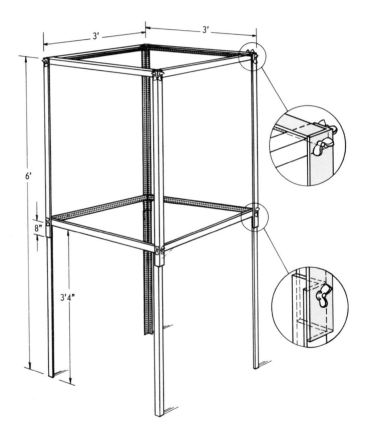

E *Saw the aluminum to length. Assemble the frame using ½ x ¼-inch bolts and wing nuts as shown in this drawing.*

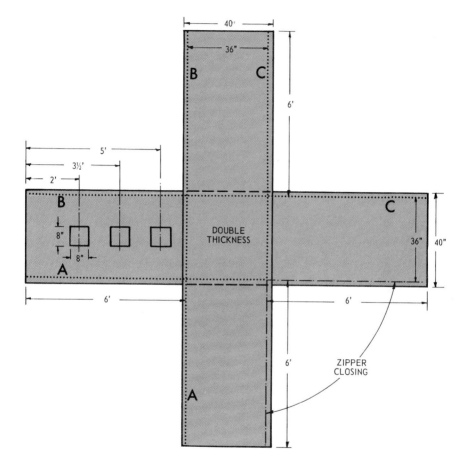

F *The covering of the blind is made from two 15-foot lengths of burlap crossed and sewn together as shown. Wet the burlap to preshrink it before sewing.*

Top—Most hummingbirds will visit an established feeding station even with a blind only two feet away. If you can frame properly before you take any pictures, you can make many exposures without disturbing the bird. Electronic flash helps freeze the rapid movement of wings.

Bottom—With shy birds such as the cardinal, move the blind slowly toward the nest over a period of two or three days. Start at 12 feet; next day move to 8 feet, and finally to the picture-taking distance of 3 or 4 feet.

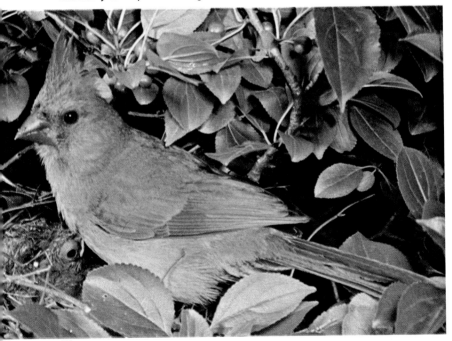

Top—Two people entered the blind set up next to this nesting Killdeer. The bird flew away. A few minutes later, one person left the blind, leaving the photographer inside. The bird thought the blind was empty and returned to the nest. This technique reduces waiting time.

Bottom—Orioles are hard to photograph because they usually nest high in trees. Put the camera near the nest and trip it remotely from a blind on the ground. Watch the nest through binoculars for the best time to take your pictures.

81

John Fish, FPSA, is the Director of Kodak Consumer Markets Publications, as well as a photographic judge, lecturer, author, and editor. He has ranked among the world's top ten monochrome print exhibitors, with more than 500 salon acceptances. During World War II, John served with the AAF 38th Photo Reconnaissance Squadron in the South Pacific. Later he worked as a development engineer in Kodak's Paper Manufacturing Division. John brings a wealth of practical photographic experience to his writings.

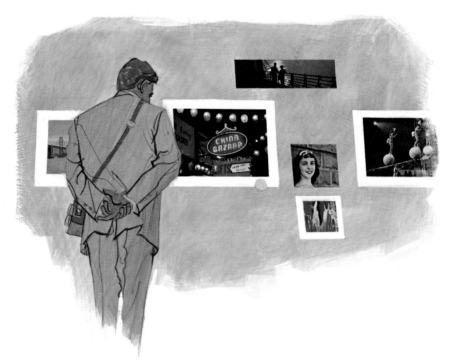

The Anatomy of an Exhibition Photograph
by John Fish, FPSA

Good pictures aren't the results of accidents! Exhibition photographs that may look like chance shots are most often the results of careful planning, patient waiting, or a quick sensing of the "psychological moment."

By itself, the finest camera ever made is incapable of producing a single prize-winning photograph. Every camera requires operation by human intelligence. The way the photographer sees the world around him, indeed his very temperament, determines his capability as a camera artist. Even the simplest box camera, when used by a perceptive photographer, may produce salon material.

82

The sphere of exhibition photography is so wide that everyone has the opportunity to express himself as he desires. The traditionalist concentrates on making photographs exhibiting a high degree of technical excellence, superbly balanced composition, and pleasing tone harmony. In the best examples of traditional photography, the true sincerity of treatment reflects the personality and creative power of the camera artist. On the other hand, some contemporary photographers shun the obvious. Photography, as a visual language, offers the modern photographer unlimited opportunities of expressing his own special way of seeing, as influenced by his environment, experiences, and attitudes.

RULES FOR GOOD PICTURES

While there can never be any fixed and unalterable "rules" for the anatomy of an exhibition photograph, certain compositional aids will prevent the making of serious mistakes in subject arrangement and presentation. There are many geometrical forms around which the composition of a picture can be built. Chief among them are the triangle, circle, radii, and line of beauty (frequently referred to as the "S" curve). These forms of subject arrangement might be likened to the steelwork of a modern skyscraper; they determine the shape or design and add strength.

It is usually best to have one main point of interest because a picture can tell only one story successfully. The principal subject may be one object or several; but, whatever it is, always give it sufficient prominence in the photo to make all other elements subordinate to it.

Excellent picture arrangements can sometimes be made by merely placing figures or objects in certain positions governed by the "rule of thirds." If you divide a scene into thirds both vertically and horizontally, the dividing lines intersect in four places. Any of these intersections provides a pleasing position for your center of interest.

After you've followed the rules of composition awhile, you'll no longer need to spend much time trying to determine the best geometric arrangement of the picture you're taking. Fortunately, we all have something of the artist in us, and soon the recognition of pleasing arrangement will become almost automatic. You'll realize that it is important to place figures or objects in certain positions; that figures should look into, not out of, a picture; and that fast-moving objects should have plenty of space left in front of them to give them the appearance of somewhere to go.

Good pictures usually depend on selecting the proper point of view. You may need only to move your camera a few inches, or a few feet, to change the composition decidedly. Watch out for backgrounds that are more compelling than the subject, and avoid unwanted merging lines that will upset the smooth travel of the eye scanning your photograph.

Peek-a-boo!

Even everyday subject matter can be pic-
torial, such as a child in her crib. Make sure
that all elements of the picture contribute to
the story you wish to convey.

In this instance the all-important eyes of
the child are located in the dynamic position
dictated by the rule of thirds. The photo-
graph's impact is due largely to the tremen-
dous contrast of tone between the face and
the background, the strong human-interest
element, and its simplicity. Simple harmony is
always most effective.

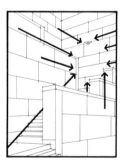

Study in angles

Some picture arrangements are a complex
combination of several basic compositional
forms and principles. For example, the sharp
angles in this scene are more striking and
sensational than graceful curves.

The bright light bulb compels attention and
becomes the center of interest. For best bal-
ance it has been located according to the
principle of the rule of thirds. The repetition
of angles and lines has produced an effec-
tive pattern, and several lead to the bulb in
a modern variation of the old wagon-wheel
composition, the radii.

The end of summer

The leaves for this photograph were deliberately grouped in an oval composition to suggest movement. The oval is not complete within the borders of the picture, but where it passes out of the scene on the right it becomes a lost-and-found line and readily returns the eye to the picture area.

The photograph was created from two negatives to illustrate the mood of autumn. The man's clothing was lightened by local reduction on the final print to provide more separation from the background and to give him more prominence as the center of interest.

Messenger of Zeus

The line of beauty, or "S" curve, can be found almost everywhere in nature. In this study of an iris, the "S" arrangement of the stem and flower suggests grace and beauty and provides easy travel for the eye.

The plain background serves to show the flower to best advantage and the very simplicity of the photograph increases its effectiveness. Because the flower represents a very dominant center of interest, it successfully commands the dead-center positioning.

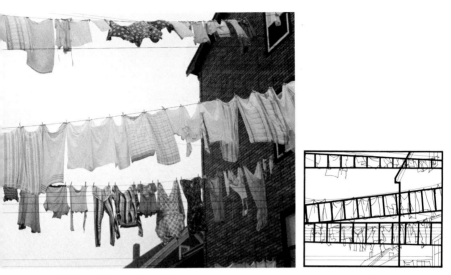

"Cleanliness is..."

Here the dominant form of composition is repetition. It is the basis for most successful pictures in which pattern or design predominate; consequently, it is a favorite form used by modern and abstract artists.

The repeating forms of clothing on the lines create a harmonious rhythm, while the repeating clotheslines provide interest as they invite the eye to swing back and forth through the scene. The mass of the building on the right-hand side tends to provide opposition to the left-to-right eye travel along the clotheslines, thus keeping the viewer's interest well contained within the boundaries of the photograph.

Encore

Circular or oval compositions have the same psychological effect as gun targets. The eye easily travels around the subject, led by the graceful lines formed by the extended leg, the gently-curved back, and the arms and hands. The skirt, which is the lightest tone in the photograph, is appropriately placed according to the rule of thirds.

Remember that bright tones also attract the attention of the eye, and thus the most important elements of the picture should be the lightest or brightest.

APPLYING THE RULES

Start your way to good pictures by planning and sketching each photo; include only important details. Then, in each sketch, look for the leading line that guides the eye into the picture; like a building, a good picture should have an entrance that invites the viewer to focus his attention on the center of interest or rhythm of the scene. If a picture can be diagramed so that, in itself, it has agreeable balance, it is quite likely that it follows one of the many geometrical forms of good composition.

In brief, if a picture has unity, the composition is good, but if it does not hang together, the composition is bad. Composition, then, is nothing more than effective arrangement of your subject matter.

With practice, you will eventually become so familiar with these concepts of composition that application of the rules becomes automatic instead of labored. From your local library, obtain and study several books on composition. View the great photographic works of others and analyze the composition that has made each successful. Just as artists visit art shows, you, as a creative photographer, should make it a special point to visit as many photographic exhibitions as you possibly can. Then try to be in the gallery sometime while a photographic salon is being judged and you'll find that you are voting "in" and "out" right along with the jury.

BREAKING THE RULES

As wider experience is acquired, you will learn that some of the basic rules may have to be broken in order to accomplish a desired result. The photographer who is venturesome about his medium, as well as curious about the world around us, and who dares to break the rules in his search for a fresh, spontaneous expression, may from time to time be subject to censure. But if he has an inventive mind, a basic understanding of the elements of composition, and good technique at his command, his experiments in photographic art will most likely produce occasionally glorious and wonderful results!

Sunburst over Pemaquid

The "L" composition illustrated by the light-house and buildings constitutes a restful balance. The tall lighthouse close to the left edge of the photograph is effectively balanced by the "weight" of the smaller buildings extending all the way to the right edge.

The sunburst was added by printing from a second negative and its proper placement was determined by dividing the scene into thirds, both horizontally and vertically. It was then printed in the area of the upper-right intersection to produce a dynamic photograph in accordance with the mathematical science of art proportion developed by the Greeks in the Fifth Century, B.C.

Spring song

The triangle or pyramid was a favorite compositional form of the old masters, and it works equally well for the serious photographer. Three tulips were used in this arrangement because odd numbers of objects are generally less static than even numbers. Try to visualize a grouping as pleasing using either two or four tulips.

As shown in the diagram, it is important to keep the interest centered within the triangle. If objects outside the triangle attract too much attention, the composition will lose its stability and strength. For this reason the leaves of the tulips were darkened during printing.

F. E. "Gene" Johnson was a well-known photographic exhibitor before he left high school. He earned a chemical engineering degree from Oklahoma University, and joined Eastman Kodak Company in 1944. Gene is a Senior Photographic Specialist in color film and technology in Kodak's Photo Information department. He's a member of the Society of Motion Picture and Television Engineers, the Society of Photographic Scientists and Engineers, and the Photographic Society of America. He has lectured nationally for many years, and has judged numerous color-print and color-slide competitions and exhibits.

KODACOLOR-X Film for the Craftsman
by F. E. Johnson

When KODACOLOR Film was introduced almost thirty years ago, serious photographers viewed it as an interesting novelty for amateur snapshots. But to the idealist it was good news—the first practical move toward a color negative-positive system.

Today that system is complete. KODACOLOR-X Film and KODAK EKTACOLOR Professional Film offer unmatched versatility and rank among the world's finest color films. They yield negatives that provide the basis for the finest of color prints, color transparencies of "original" quality, and excellent black-and-white prints.

The purpose of this article is to help you make the best possible color negatives for whatever use you plan to make of them. To simplify things, I'm going to stick with KODACOLOR-X Film as the reference.

89

Those Orange Negatives

Have you ever wondered why negatives made on Kodak color films have an overall orange cast? It's the result of two built-in masks for color correction. Because all available magenta and cyan dyes absorb some parts of the spectrum they shouldn't, these masks are simply additional images to correct for these unwanted absorptions. They improve color fidelity, and color prints and transparencies made from negatives on KODACOLOR-X (or KODAK EKTACOLOR Professional) Film have "first-generation" color quality. If you'd like to know more about dye characteristics and the details of colored-coupler masking, you'll find both topics covered in the KODAK Color Data Book, *Color as Seen and Photographed,* No. E-74, sold by photo dealers.

A Positive Look at Negative Exposure

Poor pun, but it makes the point. A lot of people think they can expose KODACOLOR-X Film any old way and still get a good picture. And they're almost right. Because of this film's wide exposure latitude, you can turn it just about every way but loose and it'll still come through for you, from something like two stops under to about five stops over. But that's the *negative* way to look at exposure. Why plan on making mistakes?

In spite of its remarkable exposure tolerance, the film produces the best negatives when the exposure is as correct as you can make it. If you take the same care in exposing KODACOLOR-X Film that you do in exposing color-slide films, you'll be really pleased at the picture quality. If you make a mistake once in a while, as we all do, the film's exposure tolerance will serve as a cushion for you—but always try for "on-the-button" exposure. A meter setting of 80 is recommended for ASA-calibrated meters, but don't be afraid to use a different number if your equipment requires it. The same is true of flash guide numbers. They are just that—guides. Modify them if you need to for best negative quality.

The three pictures on page 91 show what happens with two stops underexposure, normal exposure, and four stops of overexposure. Such great overexposure results in a harsh print, but it's usable. You should never make on error that great anyway. With negative color films, follow the old black-and-white rule: when in doubt, overexpose.

Before going on to other things, I want to discuss briefly one aspect of exposure that is not too well known. Color films are complex. They incorporate three separate emulsions to record the red, green, and blue portions of the spectrum. These have to be balanced for both speed and contrast if colors are to be properly reproduced. Over the exposure range of from 1/50,000 second to 1/10 second, the three emulsions of KODACOLOR-X Film work together just fine. At exposure times longer

These prints were made from negatives that received (reading clockwise) two stops underexposure, normal exposure, and 4 stops overexposure. Such great overexposure results in a harsh but usable print.

than 1/10 second, however, they start to argue among themselves a bit. All lose speed and contrast, but not to the same extent. This is called the "reciprocity effect." Reasonably satisfactory exposure corrections can be made for progressive speed losses in exposure of up to 100 seconds or so, but there's no way to compensate for the increased contrast differences among the three emulsion layers beyond this time. KODACOLOR-X negatives exposed for longer than 100 seconds get harder to print correctly as exposure times are lengthened, and beyond this, let's say, two minutes—the negatives are practically impossible to print with anything like quality results. Those relative speed losses and contrast differences in the three film layers add up to color distortions which can be so severe that no printing filtrations will handle them.

Therefore, if you must use exposures longer than a 1/10 second, by all means introduce the necessary corrections. General suggestions appear in many of our pertinent publications, but for your immediate convenience here's the data (for critical work the particular film emulsions

91

should be checked by practical tests, of course): A 1-second exposure requires a lens-opening increase of ½ stop; a 10-second exposure requires a lens-opening increase of one stop; a 100-second exposure, a lens-opening increase of 1½ stops. Color corrections can be introduced during printing. Please let me hasten to add, however, that the appropriate filter for the illumination should be used.

Fill Those Shadows!

Critical slide-makers soon learn that black, harsh shadows don't make attractive pictures. They use fill-in flash or reflectors to put light into shadow areas. But when they switch to color-negative film, they think their contrast worries are over. They know KODACOLOR-X Film has wide camera-exposure latitude. So they may not bother to fill in shadows, thinking that if they expose for the shadows, the scale of the film will automatically cover the brightness range from brilliant highlights to dark shadows. And it will—KODACOLOR-X Film holds highlight and shadow detail to an extent unknown in slide film.

The catch is that negatives have to be printed on either paper or film. A print or transparency made from a contrasty color negative will be just as contrasty as an original color slide exposed under the same circumstances. Sure, you can dodge and burn in when making your own prints —that's a beauty of the system. But why not take care of the situation to begin with? For top-quality side-, top-, or backlighted close-ups, illuminate the shadows in color-negative work just as you would in taking slides. The pair of illustrations on page 93 shows what a difference it makes. By the way, there are some very useful fill-in flash tables in the KODAK Master Photoguide, No. AR-21, sold by photo dealers.

About "Failure"

"Failure" is a word we photographers don't normally like to use. But if you're going to understand color negatives and their printing characteristics, there's a type of failure you should know about. It's called "subject failure," for want of a better term.

When production-line prints and enlargements are made from color negatives, the overall color balance of the negatives must be estimated electronically to produce the highest percentage of excellent prints as economically as possible. The equipment used to do this is designed for "average" distribution of colors. If a negative shows a cyan overall balance, for instance, it's corrected to avoid excess red in the print.

This is a logical approach, but it doesn't quite hold true when a predominant area of one color appears in a negative. It affects the equipment in the same way an overall cast of one color would. As a good example, if you make a close-up of a person in a red sweater, the large proportion of red in the negative fools the color-balance integrators

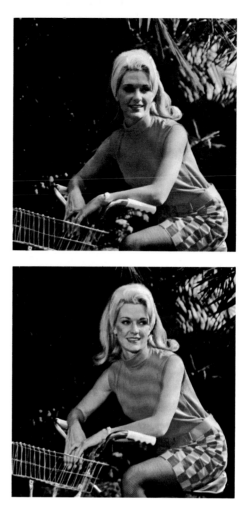

KODACOLOR-X Film holds highlight and shadow detail better than color-slide films. Nevertheless, prints or slides made from contrasty negatives (top) will be just as contrasty as a slide made under the same conditions. Moral: Use fill-in flash or reflectors (bottom).

into making a cyan correction where none is required. The result is a print with too much cyan in all areas.

This is what subject failure means: the distribution of colors in a negative doesn't indicate the true color corrections necessary to get a good first print. Negatives of this type can be printed successfully, usually by reprinting them with manual corrections, to get acceptable prints. This of course, defeats the economy of production operations. Complete correction is rarely feasible without full custom treatment.

So, please, whenever you have inexpensive production prints made from your negatives, give your finisher a break and evaluate the prints not only in terms of negative exposure but also from the viewpoint of subject treatment. Some very fine negatives just don't lend themselves to production printing; to get the most out of them will require custom

handling, either by yourself or by a custom lab.

As an expert craftsman, you should learn to anticipate subject failure, and allow for it when you order inexpensive prints. The shot of a pretty model in a yellow dress against a gray background may come back with a noticeably blue background and bluish flesh. The people who made the print didn't cheat you; they did the best they could for the price. The way you handled your subject matter fooled the printers, that's all. Just as you don't expect salon-quality black-and-white prints from a production photofinisher, don't expect to realize the full potential of every color negative from production printing.

If you anticipate subject failure, your production prints can be top-notch. (Try photographing the gal in the yellow dress against an equal expanse of blue sky!) Before you take a picture, check the viewfinder critically for a large proportion of one color or similar colors. If you see a lot of one color but know the picture will still be a good one, take it. Just remember that it's very possible that only custom printing will do it full justice. Perhaps I should mention here that Kodak does no custom work of any kind. If you want us to process and print your exposed film, just take it to your dealer. If you want to send it directly to us, use KODAK Prepaid Processing Mailers.

Let There Be Light

No light, no picture. That's one of the simplest rules in photography. In color photography, however, the color of the light is also important. Since KODACOLOR-X is a color negative film, it *can* be exposed by almost any kind of light because color corrections can be made during printing. There are some situations, though, that no amount of manipulating can correct. One is mixing colors of light. If you photograph a room illuminated with photolamps, for example, with daylight streaming in the

The large expanse of orange jacket in the negative "fooled" the automatic printer into making a cyan correction in the print. That's why the fence behind the girl looks cyan instead of brown-gray. This effect is called "subject failure."

94

windows, the daylight areas will print bluish if you balance for photo-lamps, and the floodlit areas will look yellowish if you balance for day-light. So, if practical, use blue flashbulbs instead of photolamps.

Speaking of photolamps (3400 K) or tungsten lamps (3200 K), there's no reason why you shouldn't use them with KODACOLOR-X Film, a great film for portraits and the like. Just use the filter and effective film speed setting that the instructions suggest. Keep in mind that you should use enough light to hold your exposures to one second or shorter. That should be no problem at all. In fact, for the sake of picture sharpness, you've got to use exposures shorter than 1/10 second for anything but still lifes.

Electronic flash is, in a sense, a light source that stands apart. Most units now in use approximate daylight quality very closely. This makes it ideal for fill-in flash pictures outdoors. Incidentally, the *KODAK Master Photoguide* is a gold mine of technical information, including a very valuable electronic flash exposure computer. If you don't already have a *Master Photoguide* in your gadget bag, I suggest you get one from your photo dealer.

A word of warning: Be sure to allow ample recycling time to avoid underexposure. Watch that "ready light"!

One toughie is fluorescent lighting. Since it's deficient in red and has a discontinuous spectrum, all colors are not represented. On-camera filtration helps considerably (see the *KODAK Color DATAGUIDE,* No. R-19), but some negatives still fall into a never-never land that defies correction for proper colors throughout.

Finale

To wrap things up, let me summarize the main things you need to remem-ber to get the best results from KODACOLOR-X Film.

1. *Expose* your negatives as correctly as possible. Aim dead center on the recommended exposure and let the film's latitude cover any errors. Don't use the latitude as a cover-up for sloppy technique.

2. *Control contrast* in lighting with fill-in flash or reflectors. It will give your prints the luminous quality you admire.

3. *Be conscious* of the possible effects of large areas of one color or similar colors. You needn't avoid them—they often help make striking pictures. Just remember that your negatives may present problems for production printing, and only custom printing may do them justice.

4. *Simplify* the job of printing your negatives by sticking to standard photographic light sources and avoiding mixtures of different colors of light. Follow the filtration instructions on the film instruction sheet. If you do use unusual lighting and order custom prints, provide the lab with all necessary special instructions, such as the type of lighting used.

5. *Read* the film instruction sheet. From time to time we do make changes.

Kenneth T. Lassiter is Director of Publications in Kodak's Professional and Finishing Markets Division. He has edited many of Kodak's publications on scientific and engineering photography. He is a member of the Professional Photographers of America, the American Society of Photogrammetry, and the Society of Photo-optical Instrumentation Engineers, and is publications vice-president for the Society of Photographic Scientists and Engineers.

Multiple Flash for Picture Pep
by Kenneth T. Lassiter

I like pictures with pep—pictures that have a three-dimensional "snap" and natural-appearing shadows. That's why I use multiple flash.

Properly made multiple-flash pictures have a property called "modeling." Look around you. There are probably shadows under or beside nearby objects. Chances are these shadows are caused by light coming from overhead, the side, or somewhere in between. This is modeling.

Now imagine yourself to be a flashlight. Better still, hold a flashlight to your nose in a darkened room and study those same objects. They have no shadows, no modeling. This is the way your subjects look when you make pictures with a single flash unit attached to the camera. Flash-on-camera pictures are convenient to make, and many of them are darn good. But for the ultimate in flash-picture quality, you can't beat multiple flash.

Multiple flash lets you take your studio with you. With one or two extension or "slave" flash units, you can have a two- or three-light "studio" anywhere—on the back porch, in the back yard, or in the back woods.

TWO TECHNIQUES FOR MULTIPLE FLASH

There are two ways you can make multiple-flash pictures. One is to use one or more extension flash units wired to your camera. The other is to use a "slave" extension flash. A slave unit has a small photocell which triggers its own flash when it "sees" the light from the flash on your camera. You can use any combination of conventional flashbulbs or electronic flash, as long as you follow the table of shutter-speed and camera-synchronization settings on page 104.

Wired Extensions

Many conventional flash units—the kind that use bulbs—have a place where you can plug in an extension flashgun. Most extension flash units have their own battery power supply, so you have to maintain battery polarity when you plug in the extension.

Some electronic flash units allow additional flash heads to be fired from one power pack. If all your flash heads are identical, this arrangement simply divides the light equally among all flash heads attached to the power pack. Since it doesn't give more total light than one flash head attached to the power pack, you don't gain light, but you do gain flexibility and control over where you put the light.

In any wired extension flash system, all lamps are flashed by the synchronization contacts in the camera shutter. This means synchronization is no problem if the same type of bulb is used in all units.

Slave Extensions

Slave systems don't need wires. This one fact makes them worthwhile. The main concern with slave units is getting all the bulbs to flash while the shutter is open. The type of photocell used with electronic flash units has a delay of 1 millisecond or less—so short it poses no synchronization problems. But the type of photocell circuit usually used with conventional flashbulbs has a delay of 5 to 12 milliseconds between the flash peak at the camera and the flash peak at the slave unit, depending on the distance from the camera. This can be tricky.

Most flashbulbs fire about 12 to 20 milliseconds after current is applied. (This includes flashcubes, magicubes, AG-1B, M2B, M3B, 5B, 25B, and most other commonly used bulbs.) You have to allow for this delay, plus the delay of the triggering circuit itself. Paste the table from page 104 inside your hat, and you'll have all the answers for how to make everything synchronize properly.

Which Type for You?

Wired systems are easy to synchronize, but their wires are easy to trip over. You can't use them in some places, such as on a busy sidewalk. Slave systems are convenient to use, but other photographers may trigger your unit if you're not careful. They're not as reliable to use in sunlight as wired systems, and most can't be used at great distances. Fifty feet from camera to slave unit is about tops.

One beauty of slave units is that *any* kind of on-camera flash can be used to trigger them. You can use even a simple box camera with a flash unit to trigger slaves.

If your flashgun accepts plug-in extensions, you may want to buy extra lamp heads to use with it. If your electronic flash unit accepts more than one flash head, you have another way to get into multiple flash. And if you're a do-it-yourself type, you can buy photocells to trigger electronic flashguns. Circuits for building both slave and triggering devices are published in electronics-hobby magazines.

LET'S MAKE PICTURES

Here are some lighting arrangements that produce good pictures. Some require a flash unit on the camera. This is easy. Others call for *no* flash at the camera. So you need an extension cord to connect one flash unit to the camera's flash socket. You can get flash extension cords at most photo supply stores.

Main and Fill Light

The most basic two-light arrangement uses an extension flash as the main light source, with the flash on the camera used to fill in the shadows. This arrangement is good for informal portraits and is easy to use for candid shots. Have someone play "Statue of Liberty" and hold the extension flash. Or simply clamp it to a door, the back of a chair, or whatever is handy. A C-clamp or similar clamping device will do a good job of holding the extension light.

Variations of the main-and-fill-light arrangement are fun to experiment with. Try placing the main light in one of the alternate positions shown in the diagram on page 100. Or, use bounce flash or bare-bulb flash for the fill light.

You've heard talk of lighting ratio—the ratio of illumination in the highlights to that in the shadows. In the two-flash pictures on pages 99 and 100, highlights are created by both main and fill light. Shadows are illuminated by fill light only. When the same flashbulb size and reflector type are used for both main and fill light, the table on page 100 provides an easy way to figure lighting ratio.

The basic main-and-fill-light arrangement is good for close-ups, informal portraits, and groups of people. A black background card eliminates shadows behind the rose.

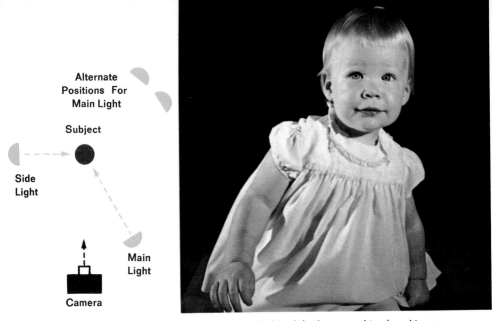

One flash at the camera serves as a main light, while the second is placed to one side to provide accent highlights. Again, a black background eliminates shadow problems.

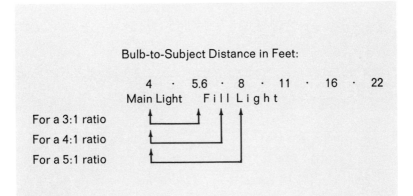

Bulb-to-Subject Distance in Feet:

4 · 5.6 · 8 · 11 · 16 · 22
Main Light F i l l L i g h t

For a 3:1 ratio
For a 4:1 ratio
For a 5:1 ratio

The bracket for each ratio can "slide" along the footage scale. For example, if you want a 3:1 ratio, you can put the main light at 4 feet and the fill light at 5.6 (or 5½) feet, or you can put the main light at 5.6 feet and the fill at 8 feet, and so on down the line. We've made the footage scale the same as the f-numbers on your camera so that it'll be easy to remember. I prefer ratios of 4:1 or 5:1 for black-and-white, and 3:1 or 4:1 for color.

A couple of tips: For portraits, put the main light on the side the subject is facing. Keep your subject away from the background.

Sidelighting

Two sidelights produce interesting crosslighting effects. This arrangement is especially good with dark backgrounds, profile portraits, and edge-lighted glassware. Usually each sidelight is placed the same distance from the subject.

The "Y" Light

My favorite flash setup takes three flash units. It's especially good for children. It combines the best of the main-and-fill and sidelight arrangements. Put a light on each side of the subject, with the main light at the side of the camera and about a foot and a half above the subject's eye level. The diagram below shows what I mean.

Base exposure on the main light. Use the flash guide number to find the right lens opening. Then divide the *aperture* into the guide numbers of the sidelights. The result is the distance in feet that each sidelight should be from the subject. This assumes the use of flash units of different brightnesses. If the units are of the same brightness, base your exposure on the main light, and place the sidelights at the same distance from the subject as the main light. Notice that no fill light is used. So much light is bouncing around now that you don't need it.

Side Lights Equidistant From Subject

Subject

Camera

With three flashes, you can improve modeling still more. Two side flashes are placed fairly high, and equidistant from the subject. A main fill light at the camera produces modeling. I call this "Y" lighting.

101

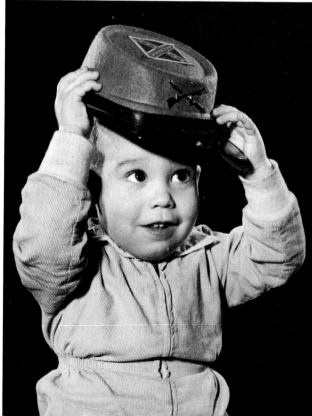

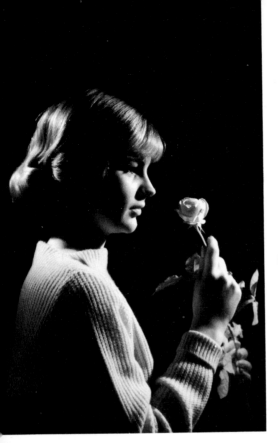

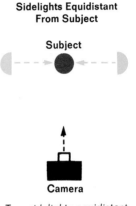

**Sidelights Equidistant
From Subject**

Subject

Camera

*Two sidelights equidistant
from the subject are good
for profile shots like this.*

Large Subjects

Some subjects are too big to light properly with one bulb. You can solve this by using several bulbs and letting each one light a different part of the subject.

To make the lighting even, position the bulbs this way: Put the first flashbulb where you want it. Figure the lens opening you'll need from the flash guide number for that bulb. For each remaining light, divide the guide number for that bulb by the *aperture* you just computed. That's how far each bulb should be from the subject it's lighting. Watch out for unwanted reflections.

Everything is simpler if all flash units have the same light output. When you plug identical electronic flash heads into the same power pack, each head puts out the same light. With conventional flashbulbs, try to use the same type of bulb and reflector. If you have to mix units for some reason, try to get the same guide number in all units by varying the combination of bulb and reflector. For example, an M2B bulb in a

polished bowl-shaped reflector has the same light output as a 5B bulb in an intermediate-shaped reflector.

You don't *have* to have the same light output from each flashbulb, but it keeps the arithmetic of figuring light placement from getting messy.

Always base exposure on the distance from the *main light* to the subject. Since each flashbulb is illuminating a different part of the subject, exposure is the same as with a single bulb.

Longish rooms are difficult to photograph well with one flash, so I used three as shown in the diagram. A short time exposure after the flash lets the room lights "burn in" to create a natural appearance.

103

Fill-in flash outdoors is an old, dependable technique. Using two flashes makes it better yet. This girl was photographed with the classic two-flash arrangement, with the fill light on camera and the main light high and to one side.

SYNCHRONIZATION

If you're not careful, you may find one or more of your flash units going off when the camera shutter is closed. This, of course, defeats the whole purpose of multiple flash. The chart below lists some multiple-flash systems I have found to work. With the slave system, I assume you'll use a photocell with about a 1-millisecond delay with electronic-flash slaves or a 5- to 12-millisecond delay with flashbulbs. In any case, check your camera and flash-unit instructions before starting. Pick a system that suits your equipment, and stick to it until you have mastered the technique. One final warning: Keep the off-camera flash out of the picture and use a lens hood.

Multiple-Flash System	Type of Flash Lamp at Camera	Type of Flash Lamp at Extension	Synchro-nization	Shutter Speed (second)	
				Leaf Shutter	Focal-Plane Shutter
WIRED	Electronic	Electronic	X	Any	Up to 1/50 or 1/60*
	Flashcube, AG-1B, M3B, 5B, 25B	Flashcube, AG-1B, M3B, 5B, 25B	M	Any	—
	Flashcube, AG-1B, M3B	Flashcube, AG-1B, M3B	FP	—	Up to 1/30*
	6B, 26B	6B, 26B	FP	—	Any
	Flashcube, AG-1B, M2B, M3B, 5B, 25B	Flashcube, AG-1B, M2B, M3B, 5B, 25B	X	Up to 1/30	—
SLAVE	Electronic	Electronic	X	Up to 1/250	Up to 1/50 or 1/60*
	Electronic	Flashcube, AG-1B, M2B, M3B, 5B, 25B	X	Up to 1/30	—
	Flashcube, Magicube, AG-1B, M2B, M3B, 5B, 25B	Electronic	X	Up to 1/30	—
	Flashcube, AG-1B, M3B, 5B, 25B	Flashcube, AG-1B, M3B, 5B, 25B	M	Up to 1/30	—
	Flashcube, Magicube, AG-1B, M2B	Flashcube, AG-1B, M2B	X	Up to 1/30	—

*See your camera instruction manual for shutter speeds that can be used with your camera.

John W. McFarlane, FPSA, holds a degree in Physics from the University of Toronto. He joined the Kodak Research Laboratory in 1928, later transferred to the Sales Department, and in 1939 directed the writing of the first KODAK Data Books. He recently retired as Manager of Kodak's Consumer Markets Publications. McFarlane served several years as Honors Committee Chairman of the Photographic Society of America, of which he is a Cornerstone Member. He was also a founder and Chairman of the PSA Technical Section.

Some Chit-Chat About Lenses
by John W. McFarlane, FPSA

Lenses interest you or you wouldn't be reading this. We assume that you don't keep your camera lens around merely as a collector's item or object of art, (not as funny as it sounds!) but that you use it to take pictures. So you are concerned with definition. We won't attempt a definition of definition—you know what it is anyway, or do you?

Many factors affect definition in your negatives or slides. Some of these are:

1. Camera shake and subject motion
2. Depth of field
3. Your focusing technique
4. Precision of the focusing arrangement
5. Excellence of the lens itself
6. Diffraction of light

These factors are listed in the order of your control over them. No. 1 is the "big spoiler" of most pictures. No. 6 is beyond you, unless you can repeal a rather important law of physics. Let's consider them in the order given.

The six possible camera motions.

Camera Shake—a real definition devil

A camera, or anything else, can be moved linearly in three ways and turned in three more ways. Moving it straight along (A) the lens axis has hardly any effect on definition. Motion sideways (B) or vertically (C) has a bit more effect. The real villains are the three rotations. Motion around the lens axis (D) doesn't affect definition centrally but does spoil it peripherally. Turning the camera around (E) or up and down (F) really degrades definition.

Actually, any camera shake is usually made up of all six motions, but E and F are most serious. These rotations are smaller with increasing "angular inertia," or resistance to a sudden turning force. The greater the camera's weight and/or dimensions, the greater its angular inertia. Small, light cameras need more careful handling and higher shutter speeds than do big, heavy ones. Its size and weight was one reason why a certain much-loved camera, sometimes called the "candid cobblestone," made such sharp pictures.

You can increase a camera's angular inertia by attaching something to it to increase its weight and size. If you attach a folded tripod to your camera and hold it by hand, you can even get sharp pictures or smooth

Mirror test for camera steadiness.

movies while bobbling around on skis. Or perhaps you'd like to try this trick used by some expert ski movie-makers: Attach the camera to a long bar of wood and then rest one end of the bar on your shoulder.

Check your usual shutter-releasing technique this way: Tape a small mirror to the front of your camera and roughly at a 45-degree angle to its lens axis. Direct a beam of light from a flashlight or projector to the mirror. Watch the reflected spot of light on a wall 10 to 20 feet away. Release the shutter. If the spot jumps, improve your technique! You can develop the ability to hold the camera still for fairly long exposures this way. But use a 1/125-second or faster shutter-speed setting for outdoor picture-taking.

Subject Motion

Subject motion does not spoil nearly as many pictures as camera shake does. If the subject is moving steadily, as in a race, pan to follow it. If the motion is erratic, as in a tennis game, use the highest practical shutter speed. When you use high-speed films for action pictures, keep this in mind: High shutter speeds are calibrated at full aperture. It follows that at small apertures a between-the-lens shutter at 1/500 second gives more exposure than indicated, as much as half a stop more.

107

DEPTH OF FIELD

Fierce arguments lose enthusiasts deep in depth of field. So, let's settle some and maybe start some others. You can take as gospel these comparisons.

Comparison picture

Made with a 4 by 5-inch camera, an 8½-inch lens at f/8, a subject at 8 feet.

Greater depth at smaller aperture. Same conditions as for comparison picture, but lens stopped down to f/16. Note the much greater depth along the fence.

Greater depth at greater distance. Same conditions as for comparison picture, but subject at 16 feet. Depth decreases rapidly with decreasing subject distance. Therefore, estimating distance for close-ups must be quite accurate.

Equal depth for equal lens diameters. Same subject distance as comparison picture, and same diameter of aperture (not same f-number). This picture was made with a 35mm camera with a 50mm lens at f/2.0, which is practically equal in diameter to the 8½-inch lens at f/8. The print was enlarged to the same image size.

Greater depth at shorter focal length. Same distance and f-number as comparison print, but taken with a 35mm camera with a 50mm lens, and the print enlarged to same image size as comparison print.

Swings can increase depth. If the lens or camera back can be swung, as on a view camera, depth can be increased greatly if the plane of the film, the plane of the lens, and the average plane of the subject all meet in a common line. In this picture the only difference from the comparison picture is that the lens mount was swung. Depth in the fence is increased, but at the expense of the model.

Equal depth for equal image size and f-number, regardless of focal length

These pictures, from 2¼ by 2¼-inch negatives were both taken at f/11, with the subject distance adjusted to give the same size image of 126-size film box (center). Focus was at the arrow on this box. The picture at the top was made with an 80mm lens, the other one with a 150mm lens. Note that the depth is the same, as shown by the number of film boxes in sharp focus.

Depth of Field

These generalities assume that you will view the picture from the correct center of perspective (which you *sometimes* do). When you view slides or movies taken with interchangeable lenses, not only do the previous generalities apply but this one, too:

Depth for relatively near subjects is proportional to the square of the subject distance, inversely proportional to focal length, and inversely proportional to the diameter of the lens aperture. Since this means that long-focus lenses have very shallow depth, they demand great care in focusing.

Depth in extreme close-ups is very shallow. We have heard of the "photographer" whose first picture with a 3+ supplementary lens was a real fuzzygraph. Of course, that lens "must have" ruined definition. But he focused by guess and missed by 2 inches, while the depth of field was only one inch. When you use a 2+ or stronger supplementary lens, you *must* measure distance unless you have a reflex camera. You can tie a string around the supplementary lens and knot the string at the working distance. Or you can make a focal board as shown below.

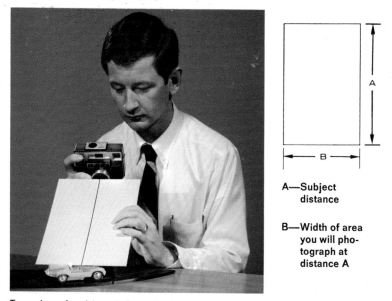

A—Subject
distance

B—Width of area
you will pho-
tograph at
distance A

To make a focal board, first check the instruction sheet for your close-up lens to determine the correct subject distance and field width. Then cut the cardboard as shown above and draw line A down the center. Hold the focal board perpendicular to the lens with one end of the line against the center of the lens and the other end of the line against the subject. Then remove the cardboard to take the picture.

Depth of field with close-up lenses

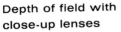

These pictures were all made at f/11 with a 35mm camera having a 50mm lens at its INF setting. A 2+ close-up lens was added for the upper picture, a 3+ for the middle one, and a 1+ and 3+ for the lower one. The 15-inch ruler was included to show depth. Because of its angle to the lens axis, the apparent depth shown on the ruler is greater than the true depth. In each case, the point focused on was the 7½-inch mark.

Note that the depth for the 1+ and 3+ (at a 10-inch distance) is only one-fourth that for the 2+ (at a 20-inch distance).

One depth argument about close-ups concerns the use of lens extension versus the use of supplementary lenses. Comparing the two approaches for the same subject distance and the same indicated f-number is not valid. Take a subject at 10 inches or, more precisely, 250mm, for which a camera lens set for infinity will be focused when a 3+ and a 1+ lens are added. The combined focal length of a 50mm camera lens with these supplementary lenses on it is 41.7mm, so the indicated f-number should be *divided* by 1.2 to get its true value. In practice, though, the use of close-up lenses doesn't require any change in exposure settings, because the change in effective f-number exactly compensates for the ex-

posure change caused by increased image size. (More about "effective f-number" later.) To get the same image size by lens extension alone, the subject must be at 300mm. At the required lens extension, f-numbers must be *multiplied* by 1.2. This gets a bit involved, but when the two approaches are adjusted for the same image size and same effective f-number, the depth is the same.

Another debated (but not really debatable) question is depth of field for very close, ultra extremely close close-ups. This applies to lenses of different focal lengths focused by extension. Should you use a 35mm or a 90mm lens for insect portraiture? At the same f-number and image size, depth is the same. Perspective is better with the longer focal length, and lighting is easier.

Let's debunk a few things about depth of field—its calculation is founded partly on a fallacy. Depth is mathematically derived by assuming that a small enough disk of light, known as "circle of confusion," on the film will look like a point. Therefore, a small amount of blur will not be detectable, while more blur will begin to look fuzzy. Reasonable enough. The size of disk chosen for computing depth is usually 1/1,000 of the focal length. A correctly viewed print presents this disk size as 1/1,000 of the viewing distance, or like a dime at 60 feet, which *does* look like a point.

But depth is shallower than expected if the subject has much fine detail—like a long shot of a garden showing dozens of individual blooms. Photograph along a fence and you'll find less far depth and more near depth than depth tables say. The far detail is finer, the near detail is coarser. Most ultra-close-up subjects do not have fine detail, which helps increase the appearance of depth. Distant shots usually (but not always) have a lot of fine detail. A ship's anchor has less fine detail than an exploded view of a wrist watch. So don't take any depth table or indicator as exact; temper it with experience.

Above all, depth depends on viewing distance. We mentioned that it assumes viewing the picture for correct perspective—a more reasonable assumption than any other. But we look at small prints from too far away, and large ones from too close up. If you enlarge part of a picture, you naturally view it much more closely than correct perspective dictates, and it therefore has less depth than expected. So, when you look at 16 by 20-inch salon prints, keep your distance. Works of art should be seen, not smelled.

Your Focusing Technique

Focusing is not extremely critical except in the close-up range, or with poor light when you use wide apertures. Combine the two, and focusing does get a bit tricky. On the other hand, outdoor subjects beyond 12 feet can all be shot with a 25-foot setting. Some tourists take all travel pictures this way—very monotonous!

If you focus by rangefinder or ground glass, develop ability to focus with no more than two motions—one on either side. Extended wiggling back and forth doesn't gain sharpness but does waste time that may be vital. If you can focus with just one motion, so much the better.

You may encounter the baffling problem of focusing at 1:1 with extended bellows. You can't focus by moving the lens alone; the image just changes size but doesn't get any sharper. You must move either the subject, the camera back, or the whole camera.

Precision of the Focusing Arrangement

Accuracy of rangefinder, flatness of the film, and other mechanical arrangements are things you can take for granted in a good, but not an abused, camera. However, if your results are often unsharp, particularly if sharpest focus is consistently either nearer or farther than you intended, you'd better check your camera. At a series of focusing settings, make a series of negatives of a subject at ten feet. A wide aperture, say $f/4$, will give decisive results. Use a tripod, and keep notes of the focusing-scale settings and rangefinder or ground-glass appearance. The results will tell if your technique needs mending, or if the camera does.

Excellence of the Lens Itself

Modern lenses of reputable manufacture don't have aberrations—at least you won't see them. The lens designers have done a creditable job in minimizing these, always with the purpose of the lens in mind. It is true that central definition of a lens meant for a 4 x 5 camera is not as good as a lens of equal focal length meant for a movie camera, but the 4 by 5-inch negatives can be critically sharp when judged for their intended purpose.

If you want to release the Pandora's box of aberrations, use about 10+ worth of supplementary lenses on a 50mm lens at $f/2$—that will do it. But usual supplementaries used at the small apertures needed for depth won't affect definition.

If you want to "test" a lens by photographing a spread-out newspaper or a blank brick wall precisely at right angles, put your camera on a very solid tripod and make a series of pictures through a focusing range at correct exposure. This test will tell you if you can confidently photograph spread-out newspapers and blank brick walls. You might also photograph the subjects you usually do—and be critical about results. If the results are excellent, so are the lens and the camera.

Incidentally, you just can't test a lens alone while it's mounted in its camera. A true lens-test camera is built of precisely machined heavy castings, has micrometer adjustments, and holds the film absolutely flat by means of a vacuum back. The whole thing is mounted on a very heavy bed plate.

DIFFRACTION OF LIGHT

One of the author's early optical exploits was the making and use of a high-power telephoto camera. It used a 135mm $f/4.5$ lens plus a "tele-negative" lens* adjustably spaced some distance behind the $f/4.5$ lens. With about two yards of bellows, it could give about a 200-inch focal length. Focused at indicated $f/5.6$, it gave a fair ground-glass image; but used at $f/22$, definition was terrible. This was a mystery till the author learned that light travels in straight lines *except* when it goes through a very small aperture. Due to its wave nature, light is spread, or *diffracted*, at a small aperture. In the above case, indicated $f/22$ meant effectively $f/800$!

Even a "perfect" lens does not image a point of light as an infinitely small point. The image at the lens axis of a distant point of light looks like a very small spot with faint rings around it. The effective size of the spot, in mm, is about $\dfrac{\text{effective } f\text{-number}}{1000}$. So at $f/800$, the telephoto camera gave a blur 8/10mm wide—very bad!

Let's examine a typically good 50mm $f/2$ lens on a lens bench. We look through a microscope at the image of a distant point of light formed by the lens. Here's what we see on the lens axis (center of the picture): At $f/22$, there is a small spot surrounded by faint rings. As the aperture is opened up, the spot gets smaller. At full aperture, the spot is very small but surrounded by haze, which in practice would slightly lower contrast. Now we turn the lens 21° off axis, which corresponds to the corner of a 35mm frame. Again at $f/22$ we see a similar small spot that decreases in size with wider aperture until around $f/5.6$ it starts to sprout aberrations and then goes through a series of fantastic shapes. At a smaller angle off axis, the performance is similar or perhaps not quite as good, depending on the type of lens correction chosen by its designer.

The best balance between diffraction and aberrations for this type of lens is therefore around $f/8$-$f/5.6$. However, no precisely detailed statement can be made about the definition of all lenses, or even all $f/2$ lenses. The general rule, "best definition two stops from wide open," is not always safe.

In general, definition on the axis is better than elsewhere, because only two aberrations, spherical and chromatic, plague the axis. The rest of the area is affected by these, plus coma, astigmatism, field curvature, lateral color, and distortion. (Distortion affects image shape but not definition.) Their simultaneous correction to a high degree is a severe problem. The definition loss over the field by aberrations at large aperture is usually greater than the loss by diffraction at small aperture. However, we must emphasize that definition loss by either diffraction or aberrations is extremely small compared to "mechanical aberrations" of the camera and its operator.

*A special negative lens designed for the purpose

Effects of Diffraction and Residual Aberrations

Prints from enlarged positives of lens-test negatives. These negatives were made by a good 50mm f/2 lens on KODAK High Contrast Copy Film 5069, reproduced here at 50X. These negatives were made in a high-precision lens-test camera at, or very close to, best axial focus. The negatives were chosen from a series of test negatives made at focusing increments of 0.001 inch. Differences in definition are most noticeable in the J and K sets of lines.

In each test chart has been added a picture of a distant point of light, enlarged here 200X. Each picture corresponds in aperture and axial position to the chart on which it appears. The pattern at f/22 is a true diffraction pattern, known as an Airy disk, named after the mathematician who explained its structure. The rays in the f/5.6 patterns are diffracted from the edges of the diaphragm leaves.

It is true that the wider the aperture, the better the definition on the axis of a lens corrected only for the axis. There is a famous camera that can work at f/30, yet gives excellent definition—the 200-inch reflector at Mt. Palomar. Why the apparent contradiction? The basic fact is this: The size of object which will be resolved in the image as a separate object depends on the angle subtended by the lens aperture at the object. In other words, it is the *linear* diameter that is important if diffraction alone is concerned.

What can we conclude about diffraction? For usual picture-taking, forget it. At 1/250 second, which is desirable to avoid camera shake, average outdoor subjects fall in the f/8 to f/5.6 aperture range with currently popular films. Definition in this range can be *slightly* better than at either extreme. But use f/22 for depth in close-ups. We have just examined a lot of gorgeous, tack-sharp 16 x 20-inch color prints from 2¼-inch square negatives shot by electronic flash at f/22. Likewise, don't hesitate to use f/2 when it's needed for a shutter speed high enough to avoid camera shake.

There are a few unusual places where diffraction may trouble you:

1. High-power telephotography.
2. 1:1 copying with ordinary cameras at apertures smaller than f/16.
3. Process-camera work at apertures smaller than f/22.
4. Enlarging to large size. A safe rule is to use the lens at a linear diameter (not f-number) not less than 1/100 of the lens-to-paper distance.

On lens axis at f/2
Definition limited by aberrations

Corner of field at f/2
Definition limited by aberrations

On lens axis at f/5.6
Definition limited by diffraction

Corner of field at f/5.6
Definition limited by aberrations

On lens axis at f/22
Definition limited by diffraction

Corner of field at f/22
Definition limited by diffraction

117

WHAT IS "EFFECTIVE *f*-NUMBER?"

As you probably know, the *f*-number indicated on your lens is the focal length divided by the working diameter of the lens. It's not well known, but the working diameter is not the actual diameter of the iris, but is the diameter which the iris appears to have when seen through the front of the lens.

The *f*-number system was chosen because the brightness of an image of a given distant subject is essentially the same for a given *f*-number, regardless of camera size or focal length. This simplifies exposure; cameras of all sizes can use the same settings.

Image brightness on the film decreases as the lens is moved out from its infinity setting to focus on a close-up subject. The exposure change isn't significant in the normal focusing range of most lenses. But when you use extension tubes or bellows to get closer to your subject than 8 times the focal length of the lens, indicated *f*-numbers aren't valid. You have to make a correction. The brightness is then governed by lens-to-film distance rather than focal length. Fortunately, the exposure correction is a simple one, depending only on the relation of image-to-object size, or magnification. So, the exposure correction can be applied di-

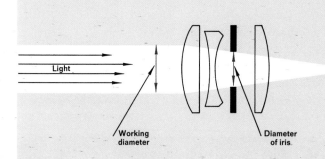

The working diameter of a lens is greater than its iris diameter.

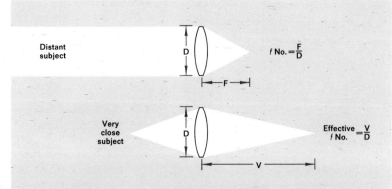

$$f\,No. = \frac{F}{D}$$

$$\text{Effective } f\,No. = \frac{V}{D}$$

Effective *f*-number with the lens extended for extreme close-ups is greater than the indicated *f*-number.

rectly for 35mm cameras by using the table below, or by other means given in the KODAK *Master Photoguide*. Or, if the lens-to-film distance is known, the effective f-number can be found by multiplying the indicated f-number by $\dfrac{\text{lens-to-film distance}}{\text{focal length}}$

Exposure Increase for Extended Lens—35mm Cameras, any focal length

Long Dimension of Subject Area	12	6	3½	2½	2	1½	1¼	1 inches
Open Lens by	⅓	⅔	1	1⅓	1½	1⅔	2	2½ stops
Or Multiply Time by	1.3	1.6	2	2.5	2.8	3.2	4	5.6 times

SOME PERSPECTIVE ON PERSPECTIVE

Another fruitful (or fruitless) lens argument is about perspective, telephoto effects, etc. The word "telephoto" applies strictly to that type of long-focus lens which has a positive front combination and a negative rear combination widely spaced from the front one. This can result in a physical length shorter than the focal length. However, the perspective in the picture is exactly the same as that from a simpler type of long-focus lens of equal focal length. The term "telephoto effect" is widely, if incorrectly, used to mean the kind of perspective rendering that comes from using a lens longer in focal length than the normal camera lens. But let's use the term "long focus" here. The optical antonym ($2 term for opposite) is "wide angle."

You get, naturally, a long-focus effect if you use an 80-, 90-, or 100mm lens on a 35mm camera. You get the same effect if you enlarge a 35mm "frame" masked down from a 2¼ by 3¼-inch negative taken with a 100mm lens, usual for that camera. What's the difference? Likewise, you get a long-focus effect by enlarging part of a negative exposed in a 35mm camera, even though it was made with the usual 50mm lens. Actually, the fundamental is a ratio of focal length to picture diagonal.

Incidentally, long-focus pictures are rarely viewed for correct perspective because this would require them to be held too far away. So you look at them from too close a viewpoint. As a result, longitudinal dimensions are compressed—increasingly with increasing ratio of focal length to picture diagonal. For example, you may have seen long-focus baseball movies made along the third to home-base line. It looks about 20 feet long and the runner seems to be making about 3 miles per hour.

If you want a really authoritative book on lenses, see *Lenses in Photography* by Rudolf Kingslake, published by Barnes & Co., 1963.* It must be a good book—it agrees with this article.

*Out of print.

Donald C. Ryon is the Curator of Kodak's Patent Museum in Rochester, New York. Don began his Kodak career as an industrial photographer in the Camera Works Division. He spent nine years as a correspondent in the Sales Service Division, answering questions about advanced still cameras and the applications of optics. He also wrote Kodak technical manuals for more than eleven years. His after-work hobbies include constructing and flying gliders, and photographing the stars.

Photographing the Stars
by Donald C. Ryon

We photographers pride ourselves on seeing the world with a keener eye than most people. But maybe there's a big part of the landscape we've missed. The stars are as much of our landscape as the hills, lakes, and trees. Given a map of the earth, most of us can recognize the more prominent features even though we may never have seen them. But how many stars can we identify on a sky chart, even though we have seen the stars all of our lives?

Have you ever tried to explain the stars to a child? It was my seven-year-old son who shamed me into finding answers to his questions. In helping him, I discovered a whole new world for my camera. I photographed the constellations with a 35mm camera, and then used a small needle to prick a hole through the stars that made up each constellation. When the film was projected, the constellation stood out dramatically among the hundreds of stars photographed. I also made 8 by 10-inch prints to take outdoors at night for reference, but these proved an anti-

climax compared to the projected slides.

Did you know that the stars are as colorful as land subjects? Probably not, because dark-adapted eyes have low sensitivity to color. KODACOLOR-X Film and an $f/3.5$ lens will record the red star Betelgeuse in the constellation Orion, the yellow star Capella in the constellation Auriga, and the gold star Albireo in the constellation Cygnus. The constellation Cassiopeia, the familiar W which we all know so well, contains two blue, one white, one golden, and one green star. Why not let your camera, loaded with color film, show this to you?

With the advent of man-made satellites and man's race for the moon, our interest has turned skyward with great excitement. It is fun to record the path of a satellite, but the greatest thrill comes when you photograph a satellite cutting across a constellation which is readily recognized by your friends. However, such photography is not foolproof; for example, in the shot on page 126, I failed to record the first star in the handle of the Big Dipper and barely got the second star in the illustration.

All this fun can be yours with no knowledge of astronomy (that will come automatically). A good camera that can make time exposures, a RIGID tripod, and fast film are all you need to enjoy this most fascinating and rewarding hobby. One of its virtues is the fact that it is always practiced in good weather. A simple star chart will be a help. Your local public library will have books on amateur astronomy which contain such charts. However, the most helpful gimmick I have found is a *Star and Satellite Path Finder,* distributed by the Edmund Scientific Company, 103 East Gloucester Pike, Barrington, New Jersey 08007. It is a dial indicator that shows all the constellations overhead when the dial is set for the month, day, and hour.

Before going into details about photographing star trails, constellations, and satellites, I feel a few words on technique are in order. My first roll of star pictures taught me more than did my previous 20 years of photography. For example, you cannot hand-hold your camera, regardless of the exposure. Ninety-nine percent of all camera shutters jar the camera slightly during operation. The most rigid tripod is no assurance of rigidity. These revelations are caused by the fact that a star is a true point source of light and NO MOVEMENT can be tolerated unless you want pigtails for star images. All this can be overcome if you mount your camera on a rigid tripod, cover the lens with a cardboard, use a long cable release to open the shutter on TIME or BULB, wait three seconds or so for the camera to stop moving, and then remove the cardboard from in front of the lens. At the end of the exposure duration, again cover the lens with a cardboard before closing the shutter.

NOTE: Commercial processing laboratories may not recognize star images for what they are, and unless you instruct them otherwise, might return your negatives unprinted.

STAR TRAILS

The earth rotates 15 degrees per hour, or one degree every four minutes. To us humble humans anchored on this earth, it is easier to appreciate this movement by assuming that the stars move. Furthermore, the stars appear to rotate around Polaris, the North Star. Each star near Polaris traces a tight circle in its movement, and as the distance from Polaris increases, the radius of curvature increases until the stars above the equator appear to travel in straight lines. This star movement is most fortunate for us because we can use it not only to produce pictorial results of great beauty but also to learn much about our camera and its lens. To help us in making better star trails later on, let us first learn something about the camera.

Load your camera with KODAK TRI-X Pan Film, mount it on a rigid tripod, focus the lens for infinity, and point it straight overhead. Set the lens diaphragm at its largest opening. Open the shutter as already described and remove the card from in front of the lens for exactly four minutes. Replace the card for exactly one minute—do not close the shutter or advance the film—and, during this minute, close your lens down one stop. Remove the card from in front of the lens at the end of the one minute and expose for exactly four more minutes. Repeat this operation for each successive lens opening, all the way down to $f/16$ or $f/22$.

If you have your own processing facilities, it will be very helpful if you can remove and process this piece of film before going on. Process it in your favorite developer for about 50 percent longer than you normally would. The final results should look like the illustration. Note that all stars are represented by streaks, one for each lens opening, of decreas-

FOCUS and EXPOSURE TEST. With the camera firmly supported on a tripod, four-minute exposures were made at f/2.8, f/4, f/5.6, f/8, f/11, and f/16 on TRI-X Pan Film. The lens was covered for one minute between exposures.

ing density and width. You will also note that faint stars have very narrow streaks and may appear in fewer segments than others. Bright stars have wider, denser trails. Pick one bright star trail and examine it closely. If each segment is exactly the same length, your exposure times were identical. Since each exposure was four minutes in duration, the length of each segment represents one degree of travel in that part of the sky. If all segments are in a straight line, not steps, your tripod and camera combination is rigid; otherwise, the camera moved while you adjusted the diaphragm. If all the traces of one star are needle-sharp, you have an excellent lens correctly focused for infinity. However, don't feel badly if the best traces result from an aperture one or two lens openings from wide open. A star is an extremely demanding subject, far more so than terrestrial subjects. For best printing, there should be good contrast between the star trace and the sky. You'll soon learn that black skies with no moonlight are best. The farther away from the glow of cities you are, the longer you can expose without overexposing the background.

Now try a star trace for pictorial purposes. The region of the North Star is most dramatic, and if you can include a nearby tree or church spire, the final result will be well worth it. With the lens opening which gave you the best trace before, make a series of single-trace exposures, each on a separate frame of the film, and of 30, 60, 90, 120, and perhaps 180 minutes' duration, respectively. Plan your shooting so that you are not interrupted by the rising moon or sun. For really dramatic results on a moonless, clear, black night, try KODACOLOR-X Film with a lens opening around $f/3.5$. Also, if you adjust your lens so that it is slightly out of focus, you tend to get an enlarged but diffused trace which adds to the color rendition.

CONSTELLATIONS

Photographs of constellations add an aesthetic purpose to photographing star trails. The results make beautiful prints and slides in both black-and-white and color, and they prove to be a very effective teaching medium.

There are many techniques for photographing constellations, but my favorite is as follows: To select a particular constellation, set up my camera, and trace for 30 minutes with KODAK TRI-X Pan Film and a lens opening of $f/11$; then to cover the lens for two minutes, open it to $f/4$, throw it slightly out of focus; and finally to uncover the lens for three more minutes. A diffusion screen over the lens for the final exposure works just as well as throwing the lens slightly out of focus. The resulting picture shows a constellation that appears to be plunging through space with a tail following each star.

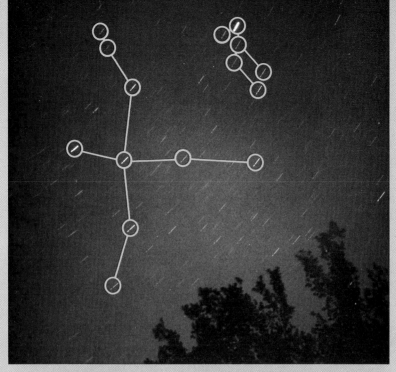

Top—Photographs are valuable for identifying constellations. Lyra is at the upper right, and Cygnus (the Swan) at the left. A 28mm wide-angle lens was used at f/4. Exposure on KODAK TRI-X Pan Film was one minute open, 30 seconds with the lens covered, then four minutes open. Bottom—Nearby trees frame Cassiopeia. KODAK TRI-X Pan Film was exposed for five minutes at f/4 through a 28mm wide-angle lens.

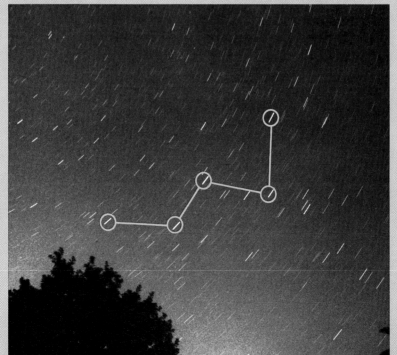

The greatest problem in constellation photography is locating the correct stars in the finished photograph, unless you are photographing a very bright constellation like Orion. In my own case, I solved this difficulty by selecting a lens with sufficient coverage to include an old friend I had photographed before and adjacent to my new target. For example, the first photograph combined Polaris and Cepheus. The second photograph combined Cepheus, Cygnus, and Lyra.

SATELLITES

Satellites are a joy to photograph. Use the same camera technique as for star trails. KODAK TRI-X Pan Film is an excellent choice. I use KODAK HC-110 Developer, Dilution A, at 75 F for four minutes. The main problem

Bottom—With proper timing, you can photograph a man-made satellite crossing a familiar group of stars. Here Echo II passes through Ursa Major. KODAK TRI-X Pan Film, 50mm lens at f/2.8.

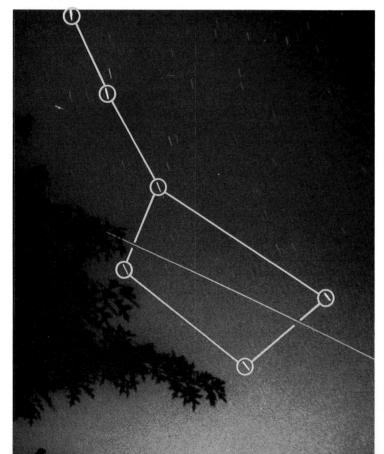

is to know ahead of time where to aim your camera. Local astronomical observatories, amateur astronomical clubs, and planetariums may be able to furnish you with the times, the degrees above the western or eastern horizon, and the direction of travel for all visible satellites. Satellite photography is particularly rewarding when the satellite path crosses a well-known constellation, or if you are extremely lucky, perhaps two satellites will cross within your photograph. It is this unknown factor that continues to attract the amateur, as well as the professional, astronomical photographer.

The Big Dipper (Ursa Major) photographed with KODACHROME II Film and a 50mm lens at f/1.9. The camera was mounted on a rigid tripod, the shutter opened for 15 minutes, then the lens was covered with cardboard for one minute. The final exposure was made by uncovering the lens for 20 seconds. Photograph by Ralph K. Dakin.

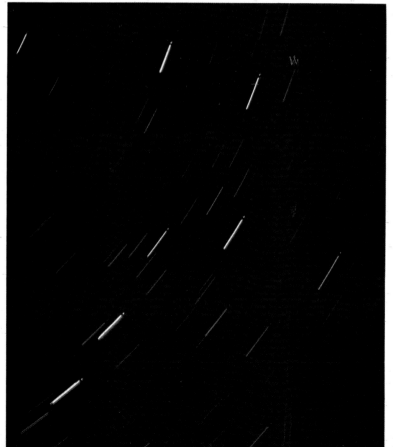

STAR TRAILS AROUND POLARIS.
KODACOLOR-X Film, exposure 90 minutes at f/4.

Dr. Grant Haist, FPSA, FRPS, is a Research Associate in the Kodak Research Laboratories, where he deals with unconventional photographic systems. Grant devotes his spare time to making exhibition photographs, lecturing, and writing about photography. He is a 5-star exhibitor and has had more than 1,500 prints exhibited in international salons. His pictures have appeared in national magazines and have won prizes in many contests, including 13 consecutive annual awards from the Freedoms Foundation.

PHOTOGRAPHING CHILDREN NATURALLY

by Grant Haist

Babies and children are the most photographed of all picture subjects. Only photography provides an enduring record of the continuing growth and the varied activities of the very young. Because intimate picture records of babies and children become more precious, indeed, priceless, as time passes, you should take each new photograph with the utmost care to insure the very best portrayal of childhood. Surprisingly, you can take an outstanding child photograph almost as easily as you can a casual snapshot. But you must combine a knowledge of child psychology with a definite camera-handling approach to achieve this goal.

The child's unawareness of the photographer in this backlighted scene produced a candid and striking picture. You can get pictures like this in your own backyard by sitting on a lawn chair near where the child is playing, and grabbing your camera for an eventful moment like this one.

Give a gift to a very young child, then photograph action that results. Be sure to have all photographic preparations made before the gift is presented so that you can get a complete picture series from the moment that the child first sees the gift.

Capturing Natural Expressions

Successful child photography involves nothing more than capturing on film the spirit of childhood. Almost all pictures of infants have this natural quality. Babies are unaware of the camera as they are pictured during the normal course of their daily routine. But as children reach about four or five years of age, they become acutely conscious of the presence of the camera. Stereotyped poses and expressions usually replace the normal youthful interests. Too often, the photograph shows this induced artificiality. Only after the shutter has been released and the camera put away does the child's naturalness return.

Most children are hopeless in responding to posing directions. Asking a child to pose in a specified way invariably results in a loss of naturalness. The young and eager often overact in their effort to please. Some may respond with a lackadaisical, let's-get-it-over-with-quickly attitude. Attempting to correct these attitudes generally produces an even less satisfactory response. So, unless a gifted child model is avail-

able, you should refrain from specific posing directions, as the results are usually less than desirable.

But if a child is enjoying an activity of his own choosing, the natural enthusiasm that he shows will be recorded on the film without the need for any posing instructions. The normal progression of the activity will insure many opportunities for picture-taking that will be superior to those situations that might have been contrived. The unplanned and the unexpected provide chances for capturing an exceptional photograph. Your objective should be catching the fleeting expression or the momentary situation rather than attempting to direct the action.

Your children are usually not aware of the camera when they're busy doing something. The photographer took this natural-looking picture while the girl was working on her "masterpiece."

In taking a picture series of a child making paintings, be sure to show the result of the activity. This may require you to set up a final picture, as was done here.

The Picture-Series Method

The method that I use to photograph a child of camera-conscious age involves selecting an activity that the child is known to enjoy, such as listening to a bedtime story or playing in a pool of water. Then I plan a number of photographs to tell the complete picture story of the event. But the picture-series method can also be used if only a single photograph near the end of the activity is wanted. The child should be allowed to enjoy himself from the beginning rather than be instructed to start with a preconceived pose that might be part of the later action. Film exposures are made from the beginning also, so that picture-taking becomes part of the activity. If you follow the picture-series approach, you will have a storytelling set of photographs, the most striking of which can be used as an outstanding single photo.

The picture series should show a complete story; the first photograph sets the scene, followed by several others of the continuing action, and with a final picture that satisfactorily concludes the activity. The opening photograph should show the child or children and all essential props in detail. This establishes the location of the activity, but be careful to see that the backgrounds are simple and compatible with the story to be pictured. The following photographs of the series may be close-ups, especially of facial expressions. Catch any action at its peak intensity. The final photograph should complete the story by showing the logical result of the previous activity. Sometimes, a logical ending may not be suggested, so an illogical one, especially if humorous, may do just as well.

Finding Picture Opportunities

Episodes suitable for making a picture series are truly infinite in number. Everything that a child does during the wakeful hours is a new adventure in the continuing story of childhood. You should observe this great variety of daily activities for situations that might be suitable for a picture series. And be sure to write down immediately any picture possibility, because chance observations are often difficult to remember at a later time.

Most children will repeat an enjoyable activity, so pictures may be taken at that time. But you need not limit your picture opportunities to situations that can be repeated. You can create new diversions by using gifts to provide the interest that brings out the most animation in a child. For example, giving an artistically inclined girl a set of finger paints would provide the situation for picturing the modern artist at

There are many picture-series possibilities outdoors. High-angle views make common scenes more interesting.

Try to select activities that involve lots of action for a picture series. Use the sun as the main light, with fill-in flash to light the shadow areas.

work. Or presenting a pumpkin to a boy could result in a how-to-do-it series on decorating the Halloween jack-o'-lantern.

You should make all photographic preparations before the presentation of the gift. The first time the child sees the gift will be the time of maximum enthusiasm. This is the time to get a complete set of pictures. The child's interest will be diminished the second or third time the gift is used, although such repeat sessions can be photographically productive. However, the child may exhibit much less animation than occurred the first time.

Unfortunately, some situations pass by so quickly that all the desired film exposures cannot be made. One year, my very young daughter had a new birthday cake presented to her on three different days. This allowed me to use a different type of film on each occasion so that I might have color transparencies, color negatives, and black-and-white negatives available. Surprisingly, cake frosting did not lose its appeal, even on the third occasion.

Select activities in which the child can show off her abilities, such as bouncing on the bed. Here, bounce-flash lighting was used in a dimly lighted room. A weak fill-in light was near the camera.

135

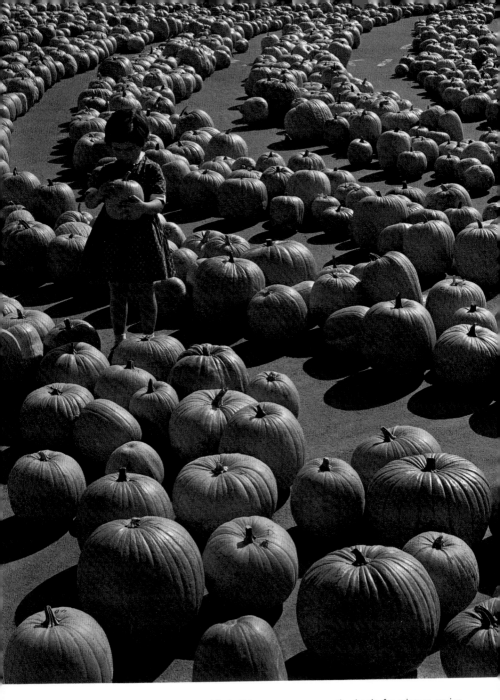

Many events connected with holidays can serve as the basis for picture series.
Such a series is valuable as a record of the child as well as having the added
appeal of a holiday occasion.

The picture series should begin with a photograph that sets the scene for the activity, followed by a number of pictures showing the ensuing action, and ending with a picture that concludes the story in a satisfactory manner.

Planning the Picture Series

Getting a complete set of pictures at one time will require some planning. You should visualize how the activity might begin and then form a fairly definite conception of the content of the first picture of the series. By arranging the conditions at the very start of an activity, you can cause the desired situation to occur without asking the child to pose. You do not need to plan for the pictures that follow the first one, only be ready to capture the unexpected. The concluding picture of the series may be the one that requires some direction from you if a desired ending has been visualized, but the child may spontaneously provide a logical conclusion without any interference.

The picture-series method of showing the high points of a normal and unrestricted activity allows you to plan and to record a number of pictures to tell a story. This is better than waiting and straining to catch a decisive moment that may never occur. However, your picture series will also contain the supreme peak of activity that did happen. This can be used as a single picture. But you will find that the entire set

of pictures is more effective, since each picture contributes to the completeness of the story. And, given a choice, most persons will find the series more enjoyable than the single photograph.

Photography and fun will become associated in the mind of a child who is allowed to enjoy himself while the camera is present. Future photographic sessions will be welcomed by the youngster. But you should carry the psychology of securing child cooperation at least one step further. Photographic modeling is a paid profession, regardless of the age of the model, and you should reward your young models as a regular practice. A small reward, such as a favorite candy bar, a small toy, or a picture book, should be given immediately after the last shutter click. If the reward is always given immediately, without fail, the taking of photographs becomes associated with a most pleasant experience, thus ensuring the child's favorable attitude the next picture-making time.

Working with an Assistant

A happy, animated child is the first requirement for outstanding child photography. But there are still many discordant details that may mar the finished photograph. An assistant is invaluable for detecting and correcting many of these deficiencies, thus freeing the photographer's attention for the selection of the best possible picture composition or for catching a fleeting highlight of action. The child's mother can often provide such help by keeping stray wisps of hair in place, smoothing wrinkles from clothing, or, in the case of an infant, providing other necessary services. A regular assistant, who has become familiar with your own particular working methods, is the most efficient.

During the actual time of film exposure, your assistant should be near, or even slightly behind, you. Two moving persons, widely separated, provide a divided source of attraction for the child's attention. Sometimes happy expressions can be coaxed from a tired or self-conscious child by having your assistant engage in a pantomime behind your back, such as a clown-like attempt to hit you on the head with any available object. Crazy antics should be used sparingly and only as a desperation measure for totally unresponsive children.

Securing Adequate Lighting

Photography of children under conditions of only slight control makes more difficult the problem of obtaining sufficient lighting. Outdoors, use a reflector or fill-in flash near the camera, with the sun behind the picture subject, to secure good facial rendition. The sun provides the

backlight to help separate the subject from the background. This is especially important for pictures of children with dark hair that might blend into a shaded or tree-filled background.

Rapid-recycling electronic flash is also an excellent source of fill-in lighting for outdoor use. Regular or improvised reflectors permit you to observe just how much light is being directed into the shadows. Reflectors are especially useful with cameras having focal-plane shutters. The high shutter speeds needed to stop action of children at play won't synchronize with electronic flash in a focal-plane camera, so reflectors may be used to supply the necessary lighting.

Indoors, use bounce flash to give a soft, even illumination that is both natural-appearing and effective over a wide area. To give a sparkling highlight to the eyes, use a weak fill-in flash at or near the camera. But you will have to determine by test the correct exposure for the bounce lighting under the actual conditions of use. Starting at about twice the normal exposure for direct flash, take a series of exposures that includes pictures with both greater and lesser exposure than the estimated exposure. Using a color-slide film, such as KODACHROME II Film (Daylight), for the test exposures will aid you in selecting the correct exposure and also determine whether bounce lighting in that room will give color casts on the film. Be sure to record the exact placement of the lights, the camera and subject location, the lens settings, and all other important information. Even better, write the details down before making the exposures. I often sketch a map of the floor arrangement with the distances marked and the height of the lights noted. It's amazing how much you can forget by the time the processed film is available for study.

The diffused lighting given by bounced flash produces a feeling of softness that is characteristic of childhood. However, you may wish to have pictures that show maximum detail and texture. Direct flash gives this type of rendition. For best results, use at least two lighting units: one for the off-camera main light, the other for the fill-in light on or near the camera. The two-light triangle lighting arrangement avoids the overly dark shadows and the flat lighting given by a single source of light near the camera. Cameras with a permanently attached flash unit may be used to trigger a slave lighting unit at some distance away. A non-wired slave unit can supply the main source of off-camera light, with the on-camera flash being used as the fill light. An electronic flash with two flash heads can be used for the same lighting arrangement.

(See "Have Flash, Will Travel," page 159) Place the stronger off-camera light so that the illumination will come from the direction in which the child is facing. But shadow areas should be well illuminated, too, just in case the child does not look in the anticipated direction.

Some Helpful Techniques

Photograph the Child's Possessions—Tell the child that you want to take a photograph of her doll or favorite stuffed toy, or of his block house or sand castle, but do not mention taking the child's picture at the same time. Children are much less self-conscious if you are photographing their possessions, even though they are in the picture, too. You can stage a birthday party for a child's favorite doll, and then invite the child to attend. Dolls have birthdays too, you know!

Use a Flash Decoy—Some of the younger children will smile wondrously at the light from a flashbulb after the picture has been taken. If you observe any amazement on the part of the child to a flash, have an extra hand-triggered flashgun available. Flash this gun first, and then when the child reacts, take the picture with the regular lights. Surprisingly, the flash decoy can be used to relax over-tensed adults but usually it is good for only one picture with the grown-ups.

Photograph from the Child's Level—Lower the level of your camera so that it is even with the child's eyes or lower. Children, especially those just beginning to walk, live in a world of huge furniture and giant adults. By photographing from a low level you can show some of the child's perspective in your photographs. You can also picture some of the difficulties of the small child as he attempts to cope with his gigantic surroundings, such as the problem of climbing into a chair.

Children are best photographed in the security of their own home or in the familiar surroundings where they are the most relaxed. The illustrations show my daughter Lynne Ann under such conditions. But providing a child with an interesting diversion will permit you to photograph anywhere. When children have fun, they forget the immediate surroundings, even though these may be strange. Some professional photographers have adopted a walkaround technique of child portraiture in which the film exposures are made as the unrestricted child is allowed to investigate a number of play areas in the same bounce-lighted studio. By photographing children naturally, at home or away, you can capture the spirit of youth with a series of film exposures. The picture-series method will give not just one picture but the entire story for all to enjoy.

Bob Harris, a Program Specialist in Kodak's Photo Information department, is an experienced professional photographer, lecturer, teacher, judge, and author on the subject of photography. He was awarded the degree of Master of Photography by the Professional Photographers of America. In 1967 he was listed by PSA as the world's top color-slide exhibitor, and he also exhibits black-and-white and color prints. Bob has a Bachelor of Fine Arts degree in photographic illustration from Rochester Institute of Technology.

"PUSHING" <u>KODAK</u> HIGH SPEED <u>EKTACHROME</u> FILM *by Robert S. Harris*

Introduction

For decades photographers have attempted to increase the effective speed of color films by "push" processing. This has always led to sacrifices in quality that in the past have been fairly severe. Now the speed of KODAK High Speed EKTACHROME Film can be increased at least 2½ times. To increase the film speed, see page 149. This increased speed allows you to use faster shutter speeds, smaller lens openings, or a combination of both. This, in turn, permits you to take color photographs in very dim light or to stop action in fast-moving sporting events.

Close-up pictures require small lens openings for greater depth of field. Pushing the film speed lets you use smaller lens openings. **EH, ASA 400, 1/125 second at f/16.**

Available light from the lamps was used to photograph this girl. **EHB, ASA 320, 1/30 second at f/2.8.**

Your flash pictures can be taken at greater distances, or with smaller flashbulbs without a change in your guide number.

Let's discuss some situations where this extra speed will be useful. Then we will discuss the processing modifications that more than double the speed of High Speed EKTACHROME Film.

Depth of Field

Small maximum apertures are characteristic of some telephoto lenses and lens converters. Smaller apertures can also be very desirable with your regular lenses for obtaining maximum depth of field. Depth of field becomes shallower as the degree of magnification becomes larger.

Let's say you want to photograph a small bug so that it is nearly life-size on your film. You can accomplish this with a long-focal-length lens, or you can move in closer with your regular lens. In either case, your depth of field will be very limited and a fast film will allow you to use smaller apertures and obtain better depth of field.

Existing Light

High-speed films and "fast" lenses make it easy to take pictures in existing daylight or artificial light indoors. Existing light produces natural-looking pictures and is often more pleasing than other types of lighting. Since you are usually shooting at wide apertures, it is important to focus critically. Pay special attention to holding your camera steady, and for shutter speeds longer than 1/30 second, use a camera support. The Existing-Light Exposure Dial in the *KODAK Master Photoguide* will give you a starting point for your exposure. See your photo retailer for a copy of the *KODAK Master Photoguide*, KODAK Publication No. AR-21.

142

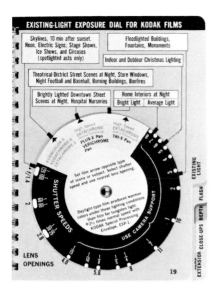

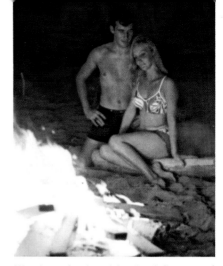

Watch out for the misleading influences of glaring lights, like this fire, or dark surroundings when using an exposure meter.
EHB, ASA 320, 1/30 second at f/2.

Existing-Light Pictures

There are two types of High Speed EKTACHROME Film—Daylight type for use in daylight, and Tungsten for use with artificial illumination. When you plan to make natural- or existing-light photographs under tungsten-type lights, use the Tungsten film.

Let's go to a wedding. This is a wonderful opportunity to practice your natural-light photography. Bring your meter instead of your flashgun, and you will find your subjects far more willing to be photographed. Most clergy have restrictions on flash photography in the church, but there are few objections to existing-light photographs. Most folks won't even realize that you are taking pictures, especially if you can muffle the click of the shutter with church music, singing, or oratory. If you would like to get a close-up of the actual ring ceremony, be sure to get clerical approval before the ceremony to take pictures through a side door to the altar. Maintain your unobtrusive photographic manner by keeping out of the audience's sight and by using an 80mm to 135mm lens through the door to "get in close" to the ceremony.

High Speed EKTACHROME Film (Tungsten) pushed to a speed of ASA 320 is adequate for most weddings. An $f/2$ aperture on your 35mm camera might be adequate in a dimly lighted church, but rely on your meter for precise exposures. After the church service, when everyone steps outside, it's time to slip on an 85B filter to continue your wedding coverage in daylight. Remember, the speed of the pushed Tungsten film drops from 320 to 200 when the 85B filter is used over the lens for daylight shots. Events are pretty fast-moving once outside the church, and you may want to rely on a basic bright-sunlight exposure of 1/250

143

second at between $f/11$ and $f/16$. Now you're set for the bride and groom dashing through the rice shower to their car. If you want to photograph the happy couple in the car, jump into the front, open your aperture about 4 f-stops, and take a shot of the bride and groom close together in the back seat. Whoops! Don't forget to allow for parallax for those close distances of about three feet.

There are many other indoor situations that require the speed of pushed High Speed EKTACHROME Film (Tungsten). They include basketball, bowling, swimming, hockey, stage productions, the circus, ice shows, boxing, political events, pageants, and a variety of ceremonies. Your meter and a good knowledge of its use are important in this sort of photography.

If you can get a close-up reading of the actual subjects you're shooting, fine. But if your meter "sees" large areas of surrounding darkness, your pictures will be overexposed by the readings the meter gives. Bright floodlights shining into the meter will bias your readings in the other direction. Assuming a film speed of 320, a typical night exposure at a big-city ball park will be about 1/125 second at $f/2.8$. If your meter suggests an exposure much different from that, it's probably being "fooled" by extraneous factors.

Action Pictures

Let's go to the races—any races—people, dogs, horses, boats, cars and cycles. They all have one thing in common—speed. Some photographers prefer to represent speed by using slow shutter speeds and controlled panning to produce blurred images on the film. This is fairly difficult and requires considerable experience to perfect.

The surest way to succeed in handling speed photography is with speed—a speedy film, a fast shutter speed, speedy reflexes, and panning. Panning is the technique of following the motion of the subject with the camera. This is similar to the way a hunter follows the flight of a duck with his shotgun. Panning will result in the sharp reproduction of the subject you are following while blurring the background. If you don't pan, remember that action travelling at right angles to the camera is hardest to "stop." Diagonal movement and movement toward or away from the camera are easier to stop. Also, the farther the action is from you, the easier it is to stop, because the relative image movement on the film is less. The best way to stop any action is to use the fastest shutter speed you can under the prevailing lighting conditions.

In some action shots, you can pick the peak of the motion as the

Watkins Glen, New York—a Formula 1 racing car was shot through a 135mm lens panned with the movement. **EH, ASA 400, 1/250 second at f/8.**

instant of exposure. In such sports as springboard diving and pole vaulting, there is a split second of stopped motion as the athlete reaches the apex of his dive or vault. This should be the moment of exposure. You can't start to shoot at the peak of action, though—you have to anticipate it. Your own reaction time, plus the time it takes for the shutter to open after you start pushing the release, can cause you to miss the peak of action.

By using fast shutter speeds, panning accurately, and anticipating peak action, you will increase your yield of sharp action photographs.

Travel Pictures

Let's go anywhere—by car, plane, train, horseback, canoe, or foot. The function of the camera is to record the events as they appear. The camera work shouldn't get too involved because the trip should be enjoyed first and photographed second. Equipment for this documentary-type photography should be light and compact. Ideally, your 35mm camera should have an $f/2$ lens, a good built-in meter, and a flash unit that uses the tiny AG-type flashbulbs or flashcubes. A pushed

145

film speed of 400 for High Speed EKTACHROME Film (Daylight) is practical because it will allow you to take pictures in bright sunlight and also in the deepest shade or at dusk. Almost any camera and film will record the events that happen in bright sunlight, but lots of interesting things happen at dusk or in places where there is little light. A trail through a heavy forest, for instance, can require four or five f-stops more exposure than you need in direct sunlight. A flash picture would

There was an early-morning fog when this picture was made from a campsite in the Adirondack Mountains. **EH, ASA 400, 1/125 second at f/13.**

A silhouette by moonlight, taken from a mountaintop in the Adirondack Mountains of New York. **EH, ASA 400, 1/30 second at f/3.5.**

The sun had just settled below the horizon, and the lights were being turned on as this sailboat returned to port. **EH, ASA 400, 1/25 second at f/3.5.**

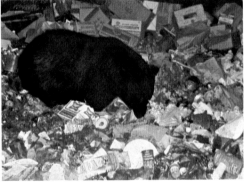

You don't want to get too close to this bear— so pushing your film speed lets you use flash from a greater-than-normal distance. **EH, ASA 400, 1/30 second at f/4 with an 80mm lens and an M5B flashbulb.**

Extra film speed is helpful in places where the sun rarely shines—such as in this deep ravine at Stony Brook State Park, New York. **EH, ASA 400, 1/60 second at f/8.**

not reproduce this woodland trail as it really appeared. The foreground would be brightly lighted by the flash, but the background forest would vanish into darkness. Most twilight scenes of city skylines require the natural-light technique to record them as they actually appeared. Natural-light photographs, then, are needed whenever scenes are to be reproduced just as they appeared. Flash pictures are needed when there just isn't enough natural light for pictures, or when you want control over lighting.

This pushed High Speed EKTACHROME Film (Daylight) has advantages with flash photography as well. First of all, you can use tiny AG-type flashbulbs or flashcubes. When you push the film speed to ASA 400 you multiply your flash guide number by 1.6. If you push the film speed to 640, you double your guide number. Flash pictures can be made at greater distances when the film speed has been pushed. Let's say you wanted to photograph a bear while you're on vacation in the Adirondack Mountains. The bear would usually appear at night, so you would have to use flash. It is always good advice to maintain a substantial distance between you and the bear. Since most folks would prefer a close-up, a telephoto lens used in combination with the fast film and flash will bring the bear closer on the film, but no closer to you. Don't forget to increase the exposure by one *f*-stop for flash pictures outdoors at night because there are no walls or ceilings to reflect the light. The bear himself will need ½ to 1 *f*-stop additional exposure because he is a very dark subject. Only the speed of a pushed film will satisfy all these requirements.

Underwater Pictures

The adventure of skin diving is a challenging sport that is gaining popularity very fast. If you become serious about this sport, you may want to start photographing some underwater sights. Underwater photography is covered in detail in "Underwater Photography," page 292. Push-processing of High Speed EKTACHROME Film for underwater photography can be a great help, because there is a substantial reduction in the quantity of daylight as you go deeper underwater.

Light falls off very rapidly underwater. A wide-angle lens aimed toward the surface was used for this shot. ***EH, ASA 400, 1/250 second at f/6.7.***

Push-Processing of KODAK High Speed EKTACHROME Films

You can increase the effective speed of High Speed EKTACHROME Film and maintain good quality by using the KODAK Special Processing Envelope, ESP-1, or push-processing the film yourself with KODAK EKTACHROME Film Chemicals, Process E-4.

KODAK Special Processing Envelope, ESP-1—Kodak will push-process your High Speed EKTACHROME Film, sizes 135 and 120 only, to $2\frac{1}{2}$ times the normal ASA rating—from ASA 160 to ASA 400 for Daylight type, and from ASA 125 to ASA 320 for Tungsten. To get this service, purchase a KODAK Special Processing Envelope, ESP-1, from your photo retailer. (The purchase price for the envelope is in addition to the regular charge for KODAK EKTACHROME Film processing.) Return the exposed film in the Special Processing Envelope to your photo retailer or place the film and envelope in the appropriate KODAK Prepaid Processing Mailer and send it to the nearest Kodak Processing Laboratory. When using the KODAK Special Processing Envelope, be sure to expose the Daylight film at 400 and Tungsten at 320.

Processing the Film Yourself—By using EKTACHROME Film Chemicals, Process E-4, you can increase the speed of the Daylight film to 400 and Tungsten to 320 by multiplying the processing time in the first developer by 1.5. If you don't mind some loss in color quality, you can push the Daylight film to 640 and Tungsten to 500 by multiplying the processing time in the first developer by 1.75.

Jeannette Klute is a Research Photographer in Kodak's Photographic Technology Division. Her hobby is making superb nature pictures with large-format cameras. She has had over 200 one-"man" print shows in this country and abroad, circulated by such organizations as the Royal Photographic Society of London and the Smithsonian Institution. Her book, *Woodland Portraits*, published by Little, Brown & Co. in 1954 is a collector's item.

Editor's Note: While Miss Klute uses a large reflex camera, small single-lens reflex cameras are also well suited to flower photography. The desired shallow depth of field can be attained by using wide apertures. A 2-inch lens used at $f/2$ has about the same depth as an 8-inch lens at $f/8$ on a 4 x 5 camera. Such wide apertures also have the advantage of short exposure times.

HOW TO PHOTOGRAPH WILD FLOWERS

by Jeannette Klute

The photography of wild flowers can be very exciting, particularly if you just plunge in and make pictures that please you. Getting started is often the problem. Don't be afraid. Forget any of the formal rules of composition that you may know and start making pictures.

I want to suggest an approach to the subject which may be new to you, but which I have found useful in getting ideas for pictures. Take your camera into the woods or fields and then look through your viewer or at your ground glass and let the flower images in the camera suggest picture possibilities. When you see something exciting or interesting— perhaps a gorgeous color combination, a dramatic line that three blossoms make, or an interesting shape—you have your idea. Now get down to work and make a picture of it. Put your camera (I use an old 4 x 5 Graflex) on a tripod and keep looking at the ground glass,

not at the subject. You cannot help being affected by what you know the plant looks like, but try to be as objective as you can. Watch what it looks like in the viewer—that is your picture, not what you are thinking. Your feelings don't show in the picture unless you make them—if you feel tender, try to make the picture look that way; if you are impressed by the subject's dramatic qualities, try to make the picture dramatic; if your reaction to the subject is "How lovely," try to make a picture to which you would have the same reaction. Look over every square inch as imaged on the ground glass and try to create a picture, still keeping your original impression.

What is a picture? What are you trying to make? In making a picture you are taking a particular viewpoint of a flower and removing it completely from its environment. When it is viewed in totally different surroundings, it must continue to be a satisfying unity under the new conditions. It must be a self-contained whole. To create this picture of your idea, just keep looking and trying to make everything express that idea. It is probably even more important to guard against letting anything detract from it.

Here are a few simple practical things to do which help make a satisfying unity or picture. A simple thing helps, such as removing a distracting stick from the background. It is surprising how often something so simple isn't done merely because it is not seen by the photographer. To enhance the original impression of the flower, try darkening the background with a shadow. Perhaps a slightly higher angle of the camera will put the subject against a little darker green and make it look better. At times moving the tripod by inches will correct the balance of a picture. Remember: You are *making* a picture, not taking it. If it is a common flower and there are more than one of them in the picture, perhaps by removing one flower you will direct the attention of the observer to the particular blossom you want him to see.

Probably when you found the subject, your camera aperture was wide open. When you get down to work, don't automatically stop it down to $f/16$ or $f/32$ without first looking carefully to see the effect. You may destroy your original carefree feeling or impression.

Sometimes you may want to repeat the color in the background. One way to do this is to move another blossom into the background but keep it out of focus. This will give you a blur of color which may help your idea. It is surprising how such a minute change can make or break a picture.

You can sometimes spend an hour or two composing your subject

and still have a spontaneous picture which looks like your first quick impression. On the other hand, you can wreck everything in two minutes; your picture can become stiff and overworked, with no freshness remaining. Occasionally you can make a good picture in two minutes, but it is usually because you have photographed the same subject before. On other occasions, a rare set of circumstances will pull everything together, and you have a picture immediately.

It may seem in what follows that I am stressing manipulation of the plant and background to make a picture; this is not the case. I always photograph the plant in its natural environment and with natural light. I do not transplant or cut a flower except when it is a common weedy type. I am also very careful not to tramp down the ground around a rare plant.

I do this for two reasons: First, our wild flowers are in danger of extinction and must be protected; and second, my aim in a picture is to make the flower look natural, and the best way to do this is to photograph it growing naturally. Most of the manipulation lies in seeing and in choosing the light, etc, although a flower may be tied out of the way with string or held back with a cord.

Mayapple

One place where many pictures fail is in the background. Since our topic here is wild flowers, we will assume a flower to be the subject. The background, however, is just as important and is the part of the picture over which the photographer has greatest control. Many changes can be made here which will add to the subject.

Let us consider what has been done and what might have been done in the two pictures of the mayapple. I have included a pair of pictures to show the effect of lens aperture on the background. The pair was taken, one after the other, without moving the camera and with only the aperture and shutter speed changed. Picture A was made at $f/8$ and Picture B at $f/45$.

Out-of-focus backgrounds offer many possibilities. In the first place, they make the plant stand out clearly. The trees in this picture have become long, vertical, dark lines which, in context, suggest a woodland. The blue sky has become a large blur of blue which adds a note of color relief to the otherwise all-green picture. The all-green effect was one that I had found interesting. Objects can be added for their color alone. The area of green to the left of the picture was introduced deliberately by adding the leaf shown in the $f/45$ picture. I wanted this

large area of green to balance the green in the upper right-hand part of the picture. Since the shadow on the trees in the background is out of focus just in back of the blossom, it gives a dark-green surrounding for the white flower. If I had wanted it for my picture, I could have introduced any color—even a piece of red paper if I had needed a spot of red, for instance. An out-of-focus background has to be carefully handled. Of course you can put anything in, or make the background out of focus to any degree, but it must not detract from the theme of your picture. An object which arouses too much curiosity will draw attention to itself. In general this will not happen if the background is completely out of focus or if it is a repetition of the main object. It is interesting to notice that the large aperture also takes out the blade of grass between the flower and the camera.

Returning to the picture, I strongly recommend low tripods for flower photography. However, for this picture I needed such a low angle that I dug a small hole in the ground to get the camera low enough. Other times I have used a flat board on the ground, propped up with wooden wedges.

Because the light coming through the leaves was so green, I used a foil reflector to throw white light on the blossom.

153

Mayapple A Podophyllum peltata
4 x 5 KODAK EKTACHROME Film
6115, Daylight Type (Process E-3),
8½" EKTAR Lens,
f/8, 1/25 sec., 2:30 p.m.

Mayapple B
Same except f/45, 4 sec.

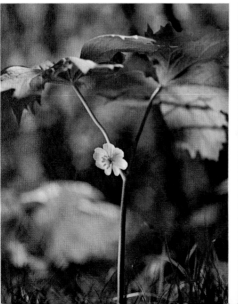
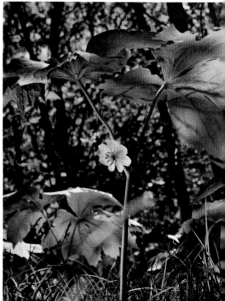

Jewel Weed

For many reasons one of my favorite times to work with flowers is just after a rain. In this case it was the rain that helped make the picture. I had tried many times to photograph the jewel weed and had failed, but it always seemed to me that it had picture possibilities. The plant is fairly large, growing nearly three feet high with many small blossoms about one inch in size spread at random all over the plant. A long shot was poor because it was difficult to see the blossoms and the plant looked like a jumble. When I came in close, the little blossom seemed insignificant. The blossoms did not grow in lovely groups of three or four, as do those of the trillium or jack-in-the-pulpit, which allow the photographer to have an easy composition. So the problem here was to find some way to show the beauty of this plant. In this case the raindrops clinging to the blossom and the leaves formed a pattern in their own right which added interest to the picture. The brightness of the raindrops is caused by the reflection in them of the overcast sky above the horizon in the background. The dull light showed the color of the small blooms and allowed the small pattern of darker colored dots on the flower to be seen. Bright sunlight with strong shadows would have cut up the flower too much.

The background at some distance and in dull light provided a dark backdrop with a slight variation in color, which in this case set off the green leaves and the orange blossoms, and added a subtlety of feeling. A black card would not have given the same effect; I feel it would have been too dark and somber for the picture I was making. Such a card can be too plain and sometimes lacks realism.

The leaves in the back were made slightly out of focus to soften their outline. When they were in focus, they detracted from the plant; and if they had been taken out, the base would have seemed too bare.

Wind is a serious problem for the photographer when working with a fragile flower such as this. Try to work just after a rain when it is often quiet. On windy days try the deep woods, or try plants that grow close to the ground. Use windbreaks: nylon cloth clipped to poles, large white cards, heavy foil (which may be folded for ease in carrying), or a carrying case or knapsack. Any of these placed close to the flower will give added wind protection. Winds are often calm early in the morning.

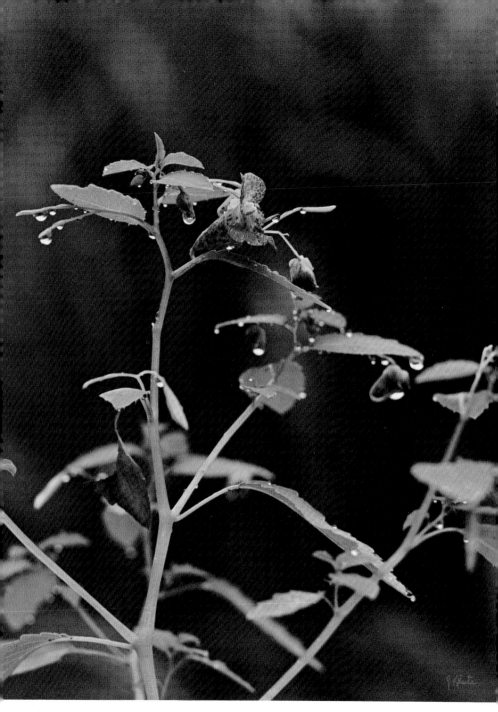

Jewel Weed Impatiens biflora

4 x 5 EKTACHROME Film, 10" EKTAR Lens, f/16, 1/10 sec., 10:40 a.m. 155

Water Flag
Iris Pseudocorus
4 x 5 EKTACHROME Film,
10" EKTAR Lens,
f/8, 1/100 sec., 8:45 a.m.

Water Flag or Iris Pseudocorus

When you have a beautiful large blossom, you can often make a dramatic picture by coming in close to the subject. The problem here was to show the form of the flower and to make it glow the way it did when the sun was shining. Iris are wonderful to work with because there are so many ways to photograph them. This plant could be photographed in soft misty light with a green background, giving it an ethereal quality. Or, you could show two or three blossoms, making a lively picture with two or three bright yellow spots forming the composition. The possibilities are limitless. You could spend an entire day just trying to see how many completely different pictures could be made from a single plant.

Now let us get down to making a dramatic, glowing picture of this iris. The flowers grow in large clumps in wet places. The plant is two or three feet high and the blossoms are three to four inches across. I chose a clump growing at the edge of a pond so I could use the water as a background. Water is one of the best backgrounds for this type of picture. Try looking in your ground glass at water. The range of colors is tremendous. For this picture I wanted a rich dark blue to set off the yellow. I wanted the maximum color contrast possible for the maximum punch.

This picture, too, was taken after a rain as you can see by the few raindrops on the left-hand leaf. The rain seemed to have made the blossoms slightly translucent. The sun came out in full force, lighting the flower from above and slightly from behind it. The petals seemed to be full of sunshine. The light coming through the petals and grazing the surface of the plant sepal provided the glow that I wanted.

Indian Pipe
Monotropa uniflora
4 x 5 EKTACHROME Film,
8½" EKTAR Lens,
f/8-11, ½ sec., 3:30 p.m.

Indian Pipes

It is a standard rule in pictures that contrast in the subject should not exceed the density range of the film. This means having good detail in the highlights and in the shadows. This holds true in most cases; however, this is a rule that can be broken to produce a desired effect. In the case of these Indian pipes, I was trying to achieve a feeling of eeriness and mystery. The underexposed black was intentional, and I was able to get the effect by waiting for the light to shine on the plant from the back, giving more contrast than the film could handle. Backlighting is a very useful tool for the photographer, but the problem of exposure is difficult. I always bracket the exposure, but in the case of backlighting I may make as many as five to seven exposures because it is impossible to tell without seeing the result just which exposure will be right. The time of day was midafternoon, and the sun coming through the openings in the trees acted like a spotlight on the plant. The light came through the whitish leaves and some of them are slightly overexposed. The light on the tree trunk in the background was so dim that it did not register. This gave the effect I was after. It was necessary to use a white card to reflect light onto the plant to get some of the mid-tones. Only a little reflected light was used, because I needed to keep the foreground dark to avoid the distraction of the pine needles and dead leaves at the bottom of the picture. The almost totally out-of-focus fragment of plant in the background makes it hard to see, and gives a merest suggestion of the other plants. The fact that it is hard to see tends to make it mysterious. Of course, this can be easily overdone.

157

Pinkster Flower or Wild Azalea
Rhododendron (Azalea)
nudiflorum
4 x 5 EKTACHROME Film,
10" EKTAR Lens,
f/6.3, 1/100 sec., 2:40 p.m.

Azalea or Pinkster Flower

This azalea was a shrub three to four feet high, with a cluster of blossoms about a foot from the ground. The pale pink and general brightness of the images on the ground glass first caught my attention. When I pointed the camera at the bush, everything was out of focus and I had the effect I wanted, but the picture had no form. To get this form, I found a row of blossoms which gave me a strong line and yet were far enough from the others to give me the background I wanted. To increase the flow of line towards the bottom of the picture, I tied one of the branches up to the other so that its blossom appeared in the lower part of the picture. The conflict here was how much to have in focus and how much to have out of focus.

One of the biggest problems was to find a camera angle in which the branches were not too sharp. I wanted to play down the blackness of the branches. Remember, an out-of-focus object appears much less dark.

Focus is such an important tool that you must be sure to make it work for you.

158

Don D. Nibbelink, FPSA, FRPS, helps create marketing presentations for Eastman Kodak Company. During the past 30 years he has photographed people and places in dozens of countries from the Arctic to the Orient. His pictures have been seen by millions in his books and in photo magazines, print shows, slide lectures, and Kodak publications.

HAVE FLASH, WILL TRAVEL *by Don D. Nibbelink*

The two things that differentiate between the average snapshooter on vacation and the good photographer in a similar travel situation are—
1. the degree of control exercised over the subject.
2. the way in which flash is used.
The various aspects of subject control are discussed in my article, "Subject Control for Better Pictures," page 18. This article deals with the use of flash in taking outstanding travel pictures of people.

The use of flash-on-camera to provide enough light for photographing interiors or people after dark is so obvious and is explained so thoroughly elsewhere that it won't be dealt with here. *Let's look beyond the point where you think of light simply as something there should be enough of to take a picture.* Let me show you why *you should use flash almost every time you photograph anyone outdoors within a 20-foot range.* Why "almost" every time? Here's why: On hazy days, the sun casts very weak shadows. This is ideal portrait lighting. Flash might actually spoil it. On sunny days, with the subject positioned in open shade against a dark background, you don't need flash.

159

Don Nibbelink shot these illustrations during a three-week trip to the Eastern Canadian Arctic, in the Eskimo villages of Cape Dorset, North West Territories, and Povungnituk, Quebec. He used the flash techniques described in his article and feels that they will improve anyone's yield of quality travel pictures.

With these two exceptions, I recommend flash for photographing people outdoors. Why? Here are the flash "bonuses" that will make your pictures better.

1. Flash lightens harsh shadows on your subject's face. Important? You bet. The objective of your picture should be to reproduce the scene as your eye sees it. Your eye is a magic thing that adjusts itself when you look into a shadow area. Film, with its fixed sensitivity, just can't do this. Furthermore, most people—including you?—simply don't recognize deep eye shadows in their subjects even when the shadows are there. Your camera not only sees these shadows, but it reproduces them in a more contrasty way than they appear to your eye. So use flash to "erase" the shadows just enough to result in a normal-appearing subject. *Fill-in flash for faces is especially important if your end result is a print rather than a slide.* A print has a shorter tonal range than a transparency, and shadows "block up" faster.

2. Fill-in flash helps you to get better facial expressions. Your subject looks away from the sun, rather than squinting into it. Use the sun as backlighting and fill in the shadows on the face with flash. (Incidentally, this also adds lively catchlights to the eyes.)

3. Fill-in flash can help to separate a subject from the background. Flash puts the "spotlight" on the main subject, if you want to look at it this way.

4. I'll bet you never thought of it before, but fill-in flash results in more *colorful* pictures. Color pictures are combinations of color*ful* areas, where light is reflected to the camera, and color*less* areas, where there are dark shadows. Light up those shadows with flash, and presto, more color! Just one word of caution—don't overdo the amount of fill light. I'd rather see too little fill than too much. We won't go into the "how's" of fill-in flash; it's covered nicely in the fill-in flash tables in the *KODAK Master Photoguide*, KODAK Publication No. AR-21.

WITHOUT FILL-IN FLASH **WITH FILL-IN FLASH**

My electronic flash unit (rated at 2,000 beam candlepower seconds) added shadow detail on the near side of the subject's face. Always use a sunlight exposure for whatever film you're using with fill-in flash. In this case, it was 1/125 second at f/11 for KODACOLOR-X Film. For shots in the five- to eight-foot range, I cover the flash head with two or three fingers to prevent too much fill-in. For more distant shots, up to about 15 feet, I simply uncover the flash head for more light.

Inside Information

Sometimes people ask me, "What flash equipment should I use to get good interior pictures?" This is like asking what brand of piano you should use to play well. It's not the specific equipment that's important, but how you use it.

Actually, my recommendation for bringing home really super flash shots would be to take along *two* identical electronic flash units. Not one, but TWO, each with its own power supply. To this add one photoelectric cell. When light from the on-camera flash hits the photoelectric cell on the remote (or "slave") unit, both units fire at the same time. (There's a good treatment of two-flash photography beginning on page 97.)

Let's back up a bit to see why I suggest *two* lights. Your goal is a pleasing, *natural* lighting effect—which you can't achieve with ordinary single flash on the camera. Outdoors, on a sunny day, you always see objects illuminated by *two* light sources: strong light from the sun, and weak light reflected from the sky. To recreate this natural lighting indoors, you must also use *two* light sources. These two flash units are traditionally arranged so that the strong source (representing the sun) comes from high and to one side of the subject, while the weaker source (representing the sky light) comes from the camera position.

161

The many advantages of fill-in flash are apparent in this picture of an Eskimo girl playing on her school teeter-totter. She has a pleasant expression because she was looking away from the sun. The flash has illuminated the shadow areas to provide more color. It has given her eyes desirable, lively catchlights.

Here's a hazy-day lighting situation where you should not use fill-in flash, because it might spoil the soft, natural lighting effect.

If your two flash units are identical (so they can be used interchangeably), you make the main light "stronger" simply by placing it closer to the subject. For normal lighting ratios, put the main light about one-third closer than the camera light. For more dramatic sidelighting, use the main light at half the distance of the camera light. If the shooting situation forces you to use both lights equidistant from the subject, cut the output from the camera light by about half. Some electronic flash units have a half-power switch which lets you do this. If yours doesn't, cover the flash head with one thickness of white handkerchief *or* cover up about half the reflector with your fingers. It works!

Always base your exposure on the off-camera light. This two-light system is great. Here are some of its advantages.

1. Subject textures are retained.
2. Subjects have a more three-dimensional appearance.
3. The overlighted foregrounds and underlighted backgrounds that sometimes result from flash-on-camera are eliminated.
4. The main light can be used from either side of the subject to illuminate the frontal planes of the subject's face, regardless of which direction the subject is facing.

Two portable electronic flash units provided this pleasing lighting. The main (stronger) light was at the side in line with the woman's face. The fill-in light at the camera illuminated the shadows. I covered about half the flash reflector of the on-camera light with my fingers to make it weaker than the main light.

The formula for placing the main light, or side light, is in the preceding sentence. It's so vital that I'd like to restate it like this. *The main (stronger) light should illuminate the frontal planes of the subject's face, no matter which direction the subject is facing.* In other words, the subject's nose should aim directly toward the main light.

Let's refine this a bit. The light should be above the subject's head, but not so high that the subject's eyes won't pick up catchlight reflections from it. It goes without saying that the subject does *not* face the camera squarely in "mug-shot" fashion. This makes poor pictures with any kind of lighting (unless the subject is very close to the camera).

Madonna and child, Eskimo style. Notice the delicate sidelighting on the child's face. This effect would have been ruined by using only a single flash at the camera position.

It Takes Teamwork

You need a slave to hold the slave! A wife, husband, or friend makes the best "second-light holder" we know of—and is far more flexible than a tripod. After the first few pictures, your helper will know the job well enough to require only a few instructions.

Exposure Determination

Just as in studio lighting, exposure for this portable, two-light system is based on the stronger light—your off-camera slave unit. Divide the guide number by the *slave*-to-subject distance. The fill-in light at the camera doesn't even enter into the exposure calculation. *If*, however, you use the slave unit as a top, back, or background light, determine exposure by the *camera* light-to-subject distance. You'll find the direct-reading "Do-It-Yourself Flash Stickers" in the *KODAK Master Photoguide* handy. Apply one to each light.

P.S. After proofreading this article, an ex-friend of mine told me: "Yes, but all this flash stuff doesn't apply to me because I use a real fast film with a fast-lens camera." How do you ever get through to a person like that?

A popular Eskimo art form is carving soft soapstone. These imagina-
tive and individualistic artists never make two designs the same.
Again, notice how the main light is coming from the side the Eskimo
is facing.

This woman defleshing a seal hide with an Eskimo knife called an
"ulu" was photographed inside a tent. I used the two identical elec-
tronic flash units I recommend as standard equipment for top-notch
travel pictures. Always keep the main light to one side, and make it
brighter than the on-camera light by positioning it closer to the sub-
ject. If both lights have to be the same distance from the subject for
some reason, cover part of the on-camera light reflector with your
fingers and base exposure on the off-camera light.

165

Jack M. Streb is Director of Consumer Markets Product Planning for still photography. Formerly, he was Director of Kodak's Photo Information department which receives thousands of letters each week from people requesting photographic information. Jack has presented his slide and movie programs to audiences all over the United States and Canada. As former Director of Consumer Markets Publications, he supervised the publishing of numerous KODAK Photo Books and KODAK Customer Service Pamphlets.

BEHIND THE COLORAMA *by Jack M. Streb*

High over the vast interior of New York City's Grand Central Terminal glows the largest transparency in the world. It's called the "Kodak Colorama." The giant, 18 by 60-foot transparency is illuminated from behind by over a mile of cold-cathode tubes, and has a picture area equivalent to more than 10,300 35mm negatives.

A new picture has been displayed every three weeks since May 15, 1950. The story behind the planning and taking of these huge pictures offers a fascinating glimpse of professional photographers at work—and a short course in just about every photographic technique you can imagine.

Most of the pictures are taken by the photographers of Kodak's Photo Illustrations Division—a small group of highly skilled and

166

awesomely resourceful professional lensmen. The men in "PID," as the group is called around the office, are responsible for most of the pictures Kodak uses in magazine ads, dealer displays, and the thousands of pieces of literature Kodak publishes.

Every photographic problem you're ever likely to encounter turns up in spades when you're trying to shoot a Colorama. This results partly from the massive scale of the project. Obviously, conventional-size negatives won't produce sharp enlargements 60 feet long. So a camera, adapted to use 8 by 20-inch sheets of KODAK EKTACOLOR Professional Film 6101, Type S, was created to shoot Colorama negatives. It weighs as much as a loaded three-suiter, has the bulk of a small doghouse, and requires the patience of a Matthew Brady to use it successfully. The shortest lens that will cover its oversize negative has a focal length of 14 inches, or over 350 mm. Depth-of-field problems are often severe, to put it mildly. Scenes that might be photographed with relative ease in smaller, conventional equipment become more difficult with this cumbersome box.

Then there are the usual problems of weather, lighting, subject control, and model availability that affect every photographer. Add to that the problems often encountered in transporting and using this equipment all over the world, in strange countries and climates. A few examples of the difficulties routinely met—and overcome—will show what we mean.

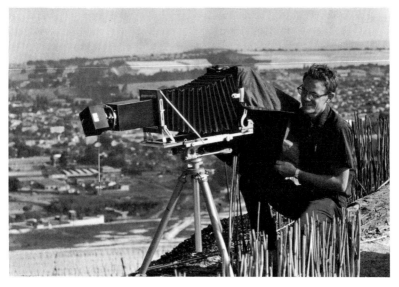

A Kodak photographer on assignment in South Africa focuses a 48-inch lens mounted on the oversize Colorama camera to shoot some distant wildlife. **167**

Shooting the Rockettes

Your assignment: Go to the Radio City Music Hall in Manhattan and shoot a Colorama of the internationally famous precision dance team known as the "Rockettes." Sound simple? Let's see how PID photographer Bob Phillips did the job.

Weeks of careful planning came before the final hectic day when the picture was made. It was obviously impractical to shoot the carefully planned scene during an actual show, so it had to be done early in the morning. When the theater closed at midnight following the last show, the 36 Rockettes who would be in the picture slept in their Radio City dormitory so they would be on hand for an early-morning set call.

Then a careful work plan as closely scheduled as a Rockette dance routine went into action. During the night, three tons of equipment were moved into Radio City, including 88 professional electronic-flash condenser units—the greatest concentration of "strobe" lighting ever assembled for a single picture at that time. Each of the dozens of flash heads had to be carefully positioned, wired to its power supply, and test-fired. Every piece of equipment down to the last connecting cord and piece of tape had to be in the right place at the right time.

While electricians rigged the lighting units, stagehands shifted 55 by 90-foot "drops" into place. A blue-nylon reflector curtain was rigged to bounce the lights. Window mannequins trucked in from 5th Avenue

stores were dressed in Rockette costumes and placed on the stage for test exposures. Brawny stagehands locked arms and "stood in" for the Rockettes for some of the tests. The actual dancers would occupy a 72-foot length of stage. By adjusting swings and tilts, Bob was able to get everything in focus with this 16-inch lens set at $f/20$.

By 4:30 in the morning, the test shots were completed and rushed to a lab for processing, to make sure lighting, model positioning, and exposure were satisfactory.

When the girls appeared next morning, they had to change their usual order. Normally the taller girls stand in the center of the stage to give the audience the appearance of a straight, even line. To produce the desired perspective in the picture, though, the tallest girls had to be placed farthest from the camera.

With girls, lights, camera, and background all in order, Bob was ready to shoot. Then he noticed a distracting light bouncing from the orchestra pit. He tore up a sheet of black paper and suspended a piece of it from tape stuck *inside* the camera bellows. According to the ground-glass image, the problem was solved. But would it change the exposure, or any of the dozens of other variables? Thousands of dollars and dozens of people were involved in the success of this button-push. Bob tripped the shutter.

The result was one of the most spectacular of the Colorama pictures. It was used not only in Grand Central Station but also on the front and back covers of a record album featuring Radio City talent.

Hong Kong Harbor

On the other side of the world from New York City, Kodak photographer Lee Howick met a different set of problems in trying to photograph Hong Kong Harbor at dusk. After much searching, Lee found the right spot for his camera—at the end of a steep, rugged, rocky road that led to a cliff high over Victoria.

It was so windy on the cliff that Lee had to build a makeshift windscreen out of focusing cloths to prevent his big camera from moving during the time exposure that would be necessary for the dusk shot.

One of the best times to take "night" pictures is after the sun has

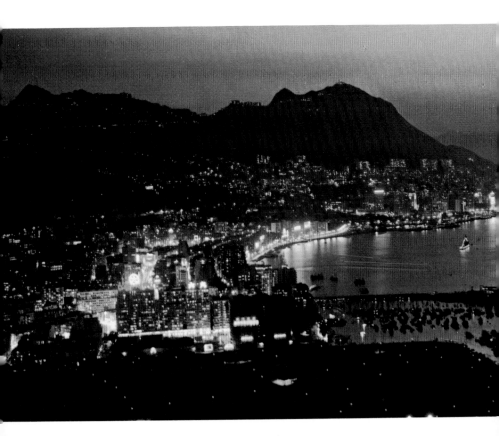

gone down, but before the sky has turned completely black. Lee settled down early in the evening and waited for just the right moment.

When the light level was about the same in the sky and in the lights of the city, it was too dark to even see the numbers on the exposure meter. Lee "guesstimated" the exposure at 60 seconds, with the 14-inch lens set at $f/16$. A few streaks of lights from moving boats show on the water, but the big boats at anchor are tack-sharp. The picture drew admiration in Grand Central Station and was used as the center spread in a Kodak Annual Report.

Action in 8 x 20

For several reasons, an 8 by 20-inch view camera mounted firmly on a heavy tripod isn't the ideal tool for photographing action subjects: It has no viewfinder. There's no chance to change focus during the action. It can't be moved quickly to follow the action. With its long lens, depth of field is pitifully shallow. And, to top everything, the normal top shutter speed of the Colorama camera is only 1/150 second.

Kodak photographers Wes Wooden and Pete Culross had some problems to solve when they were assigned to shoot a college football game for Colorama use.

They tried to capture a football game at Pittsburgh one Saturday. No luck. They tried Penn State another Saturday. It poured through the whole game. Even when the weather was good, the 1/150-second shutter speed wasn't fast enough to stop the action.

After considerable research, Wooden and Culross located a special

high-speed shutter—but it was mounted in a 17-inch lens with a maximum aperture of f/17. They determined that they could shoot at 1/250 second with the lens wide open and get a usable image by "pushing" the film during processing, as long as the sun was shining brightly.

Another Saturday found our photographers at the Syracuse-Kansas game in Syracuse, New York. A heavy cloud cover melted away just before kickoff. The pair set up their ungainly camera only a few feet from the sidelines, then sent helpers onto the field to determine what area would be in the picture and how much would be in sharp focus. Then they sat and waited for the action to come to them. It came, all right—players charging out of bounds crashed close to the camera. Once they actually hit it. The big tripod teetered—then righted itself. They kept on shooting, 19 sheets of film in all. The best negative was chosen, and the first outdoor action Colorama went up in Grand Central.

Alps Adventure

As PID photographers circle the globe for pictures, they often have unexpected adventures. Kodak photographer Neil Montanus chartered the services of a Swiss pilot to help him find a good spot in the Alps for a Colorama assignment. As they flew, they saw on the snow below them a crossed-skis distress signal. They landed, to find that a man had fallen into an icy crevasse hundreds of feet deep. By a lucky chance, his fall had been stopped by a snow shelf only 30 feet down. The pilot radioed for help, then took off to lead a rescue party back to the scene. The accident victim was rescued, everyone involved joined in a party—and no pictures were taken that day. On the following day, Neil tried again and produced the colorful picture shown here.

From the Air

Several Kodak Coloramas have been shot from airplanes or helicopters by PID aerial photo expert Ralph Amdursky. For his aerial Coloramas, Ralph shoots with a modified aerial mapping camera with a 24-inch, $f/5.6$ lens. A roll of film 9½ inches wide and 75 feet long is driven through the camera electrically. Each long roll of KODAK EKTACOLOR Professional Film can produce 40 Colorama-size negatives.

The camera is focused on infinity. When he wants to photograph closer subjects, Ralph inserts shims between the lens and the camera body. The closer the subject, the more shims he uses to increase the lens-to-film distance. Once the camera is airborne, focus is fixed for a specific distance and can't be changed.

One of Ralph's Colorama assignments was to photograph the luxury liner *France* entering New York harbor on her maiden voyage. This was a "news"-type shot, with absolutely no chance to control the subject or wait for good weather.

A gloomy winter day awaited the arrival of the *France*. Ralph and his equipment hovered overhead in a chartered helicopter. He had learned

176

the length of the ship so he'd know how many shims to use behind the lens to produce the right distance and field size. As the ship neared port, everything seemed in order.

Then Ralph noticed his exposure counter. It said the film in the magazine was exhausted—and he hadn't yet made a single picture. A quick check revealed that a short circuit in the electric-drive unit had run the entire roll of unexposed film through the camera. And there was no more film on board the helicopter.

With the *France* coming over the horizon, he quickly had the pilot fly back to LaGuardia Airport. He grabbed a fresh roll of film and performed the ticklish job of reloading the yard-long camera in flight. Hovering at the right distance from the ship for his prefocused lens, Ralph got a beautiful shot of the *France* coming into the harbor, accompanied by tugs and fireboats shooting tons of water skyward in welcome. The negative was rushed through processing, and a 60-foot transparency was made in Rochester, assembled, shipped to New York City, and hung in Grand Central before the *France* left New York. From shooting to display took only 96 hours.

From the Moon

This Colorama of man's first steps on the moon was rushed through to completion so that it could be on display while the Apollo 11 astronauts were in New York City for a ticker-tape parade.

Apollo 11 commander Neil A. Armstrong took these pictures on Kodak Ektachrome Professional Film, Daylight Type (Process E-3), using a Hasselblad Camera fitted with a special lens. The camera was left on the moon to lighten the load for lift-off, and only the film returned to earth with the astronauts. After the film was held in quarantine to make sure that it had brought no "moon germs" to earth, it was released and rushed to the processing lab at the Manned Spacecraft Center in Houston, Texas. The processed Ektachrome Film was flown to the Kodak lab in Rochester, New York, on Thursday. Double crews worked around the clock to create the giant Colorama in just 48 hours —a process that normally takes three weeks! By Sunday, the Colorama had been trucked to New York City and was installed. It was lighted

during a special ceremony on Monday, when Dr. Louis K. Eilers, president of Eastman Kodak Company, presented it to the people of New York "as a tribute to the astronauts of Apollo 11—and to the entire National Aeronautics and Space Administration team."

From left to right, the dramatic pictures show astronaut Edwin E. "Buzz" Aldrin, Jr., descending from the lunar excursion module against the stark surface of the moon and the cold darkness of space. Next he sets up the seismometer, which was left behind to record moonquakes and the impact of meteorites. A space portrait of Aldrin shows the LEM with photographer Armstrong reflected in Aldrin's faceplate. Then we see Aldrin unloading equipment from the LEM in the background, while in the foreground a special stereo camera designed and built by Kodak to record the texture of the moon's surface awaits its turn at picture-taking. The final picture shows Aldrin beside the American flag unfurled on the lunar surface. The crosses on each picture enable geologists to make precise photogrammetric measurements of the objects within the picture.

From the Sea

Taking pictures underwater poses some very special considerations that photographers on land don't encounter. Neil Montanus spent two years planning and testing before he could photograph this underwater Colorama.

First he had to find a way to keep the camera dry. The 8 x 20-inch view camera enclosed in a watertight housing would have been most unwieldy, so Neil had to find a substitute camera—a camera with a smaller body but one that could accept a large negative size. He adapted a K-17 Aerial Camera, which is about half the size of the Colorama camera and produces a 9 x 9-inch negative. With KODAK EKTACOLOR Professional Film, Type S, in aerial rolls, Neil could take 125 pictures during one dive. The camera was enclosed in a Plexiglas watertight housing which was fitted with a wire viewfinder shaped in the Colorama format.

Although the overall negative size was 9 x 9 inches, the part of the negative used for the Colorama was $2\frac{5}{8}$ x 9 inches. This was not only the first underwater Colorama, but also the first time a Colorama had been enlarged from such a small negative.

Underwater photographers usually take along some lighting equipment, because the amount of sunlight filtering through the water gets weaker as they go deeper. Sealed-beam movie lights were used to bounce light into the shadow areas and to put some red light back into the scene. (Water filters out the red light in sunlight, and underwater pictures often look extremely blue.) The lights had to be carefully insulated to avoid any possibility of electric shock, because salt water is a

The K-17 Aerial Camera is enclosed in a Plexiglas watertight housing which has a wire viewfinder shaped in the Colorama format.

very good conductor of electricity. A generator which supplied power to the lights floated in a dinghy over the "underwater studio."

Neil and his crew of divers and models spent months testing the camera and lighting equipment in local swimming pools. Then they made location tests in Florida and the Virgin Islands. The first test pictures were disappointing because the water wasn't clear. Finally, they were ready for the final shooting in the Underwater National Park at Buck Island off St. Croix in the Virgin Islands.

Five people put on their scuba gear and took the equipment to the bottom of the sea. One of the crew acted as a lookout for the sharks and barracuda that often took a keen interest in the underwater studio. Neil and his helper set up the camera and sturdy tripod on the sandy bottom. The two models were in place, but where were all the fish? To attract the fish, the crew tied frozen chicken legs behind the pieces of coral. Even with the chicken to lure them into the camera range, it was several days before the fish trusted this strange setup enough to stay in the area for any length of time. After two years' work, Neil finally got his underwater Colorama.

HOW COLORAMAS ARE MADE

By the end of 1971, more than 360 brilliantly colorful panoramic views from all over the world had gone up over the East Balcony of Grand Central Terminal. Every one has a fascinating story behind it. We wish we had the space to tell them all. There *is* one more interesting story to tell. It concerns what happens to a Colorama negative after it's been shot.

Although most Coloramas are shot on a sheet of film measuring 8 by 20 inches, the Colorama is actually enlarged from an area of the negative measuring only 4⅞ by 16¼ inches. A giant enlarger projects the negative onto KODAK EKTACOLOR Print Film 4109 (ESTAR Thick Base). Since the whole Colorama is too big to make in one piece, it's made up of 40 vertical strips, each 18 feet high and 19 inches wide. Each strip is enlarged from a half-inch-wide section of the negative. The 40 strips of film are carefully registered, spliced together with transparent tape, and rolled onto an 18-foot-long spool. Film, spool, and a special packing box—a half-ton load—are then shipped from Rochester to New York City.

Four specialists in Grand Central Terminal remove the old transparency and hoist the new one on its spool to a platform on the smallest "railway car" in Grand Central. The bottom end of the spool rides a small truck down a tiny railway, unwinding the transparency as it goes. The Colorama transparency itself is held tightly by springs attached to the huge steel supporting frame. The change is made in the small hours of the morning, and the lights go on behind the newly hung transparency in time for the 8 a.m. Monday opening. The whole cycle is repeated every three weeks.

The next time you see the Kodak Colorama in New York City—or one of the miniature versions used as displays by photo retailers all over the world—take another look. We hope you'll be reminded of the story behind the Colorama.

Every three weeks since May, 1950, a new 18 by 60-foot Colorama transparency has been hung in New York's Grand Central Terminal.

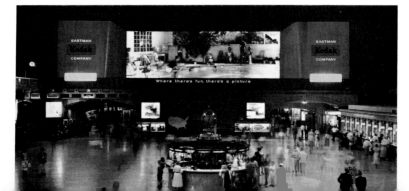

Paul D. Yarrows, FPSA, ARPS, is a Program Specialist in Kodak's Consumer Markets Division. For several years, Paul has ranked among the top amateur photographers in the world, with more than 3,000 acceptances in international exhibitions. Paul is the first person to hold three 5-star ratings in the Photographic Society of America in color, black-and-white, and nature photography. His imaginative photographic lectures have been enjoyed throughout the United States and Canada.

COLOR-SLIDE MANIPULATION *by Paul D. Yarrows*

For years, advanced amateurs have used various techniques to present their slides in a different manner from the casual snapshooter. Whether for camera-club competitions, international exhibitions, or personal use, they have found that some of the greatest rewards in color-slide making lie in using their creative talents to communicate their ideas.

This article describes some of the techniques I've found useful. It's important to mention at this time that whatever gadgetry is used, it is the result that counts. You are free to use your imagination to interpret the world as you see it. The techniques in this article may help you create a mood or achieve a special effect which will allow you to express yourself photographically.

Note: Some of these techniques for slide manipulation require unusual materials. A list of sources of such materials appears on page 192.

The original transparency of the silhouetted tree was intentionally overexposed.

A normally exposed sunset provided the background.

A montage was created by binding both transparencies in a single slide mount.

Here's another montage, made by binding together the overexposed slide of the sun with a misty scenic.

COLOR-SLIDE MONTAGES

Occasionally you may find in your collection of slides several that are overexposed. Save them. They can be used in a "sandwich" with other slides to produce some pleasing results. The expert may even overexpose just for this purpose.

Montage Technique

First, remove the two transparencies from their cardboard mounts. Next, place the two in contact with each other and position them in a mask. Then bind the transparencies and mask between glass.

A bright sun peeking through a hazy sky, or a colorful sunset is easy to sandwich. Other subjects to keep in mind for montages are tree bark, textured cloth, and peeling paint. Remember, the final density of the combined slides should be the same as one normally exposed slide. Bracket your exposures so you have a choice of densities to pick from.

KODAK EKTACHROME Infrared Film can produce strikingly unusual pictures. Shot without a filter, it has an overall reddish or magenta cast (left). A yellow No. 12 filter is recommended for use with EKTACHROME Infrared Film. You can also get acceptable results with a yellow No. 8 or orange No. 15 filter.

KODAK EKTACHROME Infrared Film, Size 135

For way-out photo fans, there's a "way-out" film. KODAK EKTACHROME Infrared Film will launch you into a new world of color photography. An exposure index usually applied to color films for ground photography has not been assigned to this product. As a starting point, try a basic exposure of 1/125 second at $f/16$ in bright sunlight through a No. 12 filter. This exposure should be bracketed by one half stop and one full stop to insure getting one with the correct exposure. Keep records of what exposure and filter you use so that you can repeat the effects when you want to. Try a variety of filters used for black-and-white photography to obtain different "offbeat" colors. Keep the film refrigerated until several hours before use.

Processing—Your photo dealer can send this film to Kodak or another laboratory, or you can mail it directly with the appropriate prepaid processing mailer.

To process the film yourself, use KODAK EKTACHROME Film Chemicals, Process E-4. Total darkness is a must. No safelights of any kind can be used during processing.

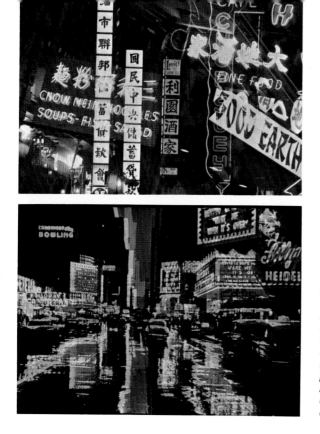

Multiple exposures of illuminated signs on a single frame of film can produce brilliantly colorful results.

This triple exposure was made through green, red, and blue filters. The camera was moved slightly between exposures; each picture was made through one of the three color filters.

If you send your film to a custom-processing laboratory or another commercial processor, be sure to indicate the type of film you are sending. You might attach a conspicuous note reminding the processor of the no-light requirement.

MULTIPLE EXPOSURES

A multiple exposure simply means taking two or more pictures on the same frame of film. This technique involves cocking the shutter of the camera without advancing the film. Check the instruction manual of your camera to see how to do it. When starting out, you'll find that night scenes give the best results. Subjects can be separate or merged together, and shot from various angles.

Try a triple exposure—the first through a red filter, the second through a blue filter, and the third through a green filter, moving the camera ever so slightly between exposures.

Original transparency, made on KODAK EKTACHROME-X Film.

High-contrast negative made by contact-printing original transparency on KODAK Professional Line Copy Film 6573.

DERIVATIONS

One kind of derivation is the result of sandwiching a black-and-white negative made from a color slide with the slide itself, slightly out of register, to form a characteristic outline, or bas-relief effect.

For a dramatic effect, you can make the black-and-white negative on KODAK Professional Line Copy Film 6573*. If you use the 4 x 5-inch sheet film, you can make several negatives at the same time. Remove the slide from the cardboard mount and place it on the Professional Line Copy Film, emulsion to emulsion. Use a printing frame or place a large piece of glass over the slide and the Professional Line Copy Film so that they will be in close contact. With the light from a 25-watt bulb,

*You can also use KODALITH Ortho Film 4556, Type 3 (ESTAR Thick Base), and develop it in KODALITH Super Developer. KODALITH Film is sold through suppliers of graphic arts materials (listed under "Graphic Arts Materials" in the yellow pages of your telephone directory).

make an exposure. Try one or two seconds from a distance of about three feet. Keep a record of your exposures. It may be necessary to make several to arrive at the exposure that suits your purpose best. Once you know the basic exposure, you're set for future attempts. Process the film in KODAK Professional Line Copy Developer.

Wash, fix, and dry the film as suggested on the instruction sheet that comes with the developer. Since the exact degree to which a negative and slide are off register is important, assemble and tape the negative and slide film over a light box or white card. Place them in a KODAK Mask; then bind them between glass.

To make this cross-eyed owl, I cut out the eyes from a color print of an owl. I glued the black part of the eyes onto yellow paper and then put them into place from the back of the print. After copying the picture onto color-slide film, I made a Diazochrome derivation. Making derivations with Diazochrome film is explained on the next page.

Original transparency.

High-contrast negative made on KODAK
Professional Line Copy Film 6573.

DIAZOCHROME FILM

If you're not satisfied with the original color, change it! Here's how.
Make a high-contrast copy negative from a color slide by placing the
slide in contact with KODAK Professional Line Copy Film 6573, as
previously suggested. Then place the high-contrast negative in contact,
emulsion-to-emulsion, with a colored Diazochrome film of your choice.
You can handle the Diazochrome film in normal room light. This film
is available in large sheets and can be cut into 2-inch squares for use
with 35mm slides. At the top of each sheet is a notch. When the notch is
at the top right side, the emulsion is toward you. (The emulsion side
also feels sticky when you touch it with a moist finger.)

Hinge two pieces of slide cover glass with tape at one end to form a
miniature printing frame. The Diazochrome film comes interleaved
with sheets of paper that are silver on one side. Cut a 2-inch-square
piece of this silver paper and place it between the glass. Then place the
high-contrast negative and Diazochrome film in the glass printing frame,
with the Diazochrome film between the negative and silver backing
paper. Tape the two pieces of cover glass together. Expose the film by
placing it in a 500-watt slide projector with the negative toward the
light source for 1 minute. (Again, keep records on your exposure and
development times for future use.) The dark areas of the negative are re-
produced as colored areas on the Diazochrome film, and the clear
areas of the negative should remain clear with no color.

Red Diazochrome made by contact-printing a piece of Diazochrome film with the high-contrast negative.

Derivation produced by binding the Diazochrome with the original transparency.

191

The water lily is another derivation made with the Diazochrome film process. Blue Diazochrome film was used in this case.

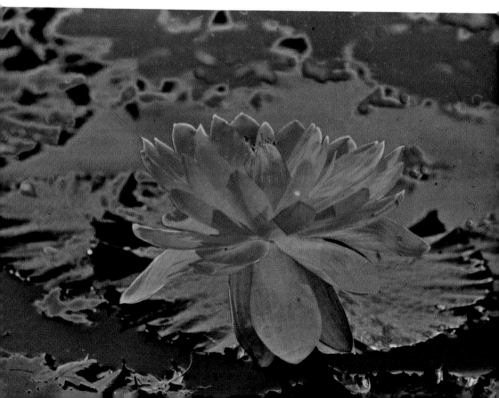

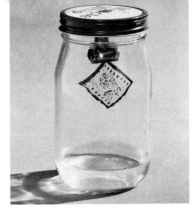

You can use any large jar for developing Diazochrome film. The "developing tank" in this picture is made from a large salad-dressing jar. Remove the cardboard insert from the inside of the lid and poke a small hole in the middle of the cardboard. Thread a string through the hole and tie a knot in the string. Put the cardboard, with the string hanging from it, back into the lid of the jar. Tie a film clip to the string, and you've made your own Diazochrome film developing tank.

Diazochrome film is developed in ammonia fumes. You'll need to use 28% concentrated ammonium hydroxide, which you can buy from your pharmacist. Household ammonia is not strong enough. Since it is the fumes that develop the film, you'll need only a small amount of solution.

You can make a developing tank from a large jar with a screw-on lid. To keep the film from touching the solution, suspend a short piece of string from the top of the jar and tie a film clip to the end of it. The film clip will hold your Diazochrome film above the liquid while it is being developed in the ammonia fumes. Be sure to cover your nose and mouth when opening the jar because ammonia fumes are very irritating when inhaled. Work in a well-ventilated area. If the film accidentally gets wet, wipe it with a soft cloth.

Develop the film for 4 minutes. Actually, some colors of Diazochrome film develop in less time, but I prefer to develop my film for 4 minutes to get the most saturated colors.

To complete the procedure, mount the Diazochrome film with the original slide in a KODAK Mask and glass slide mount. You can arrange the two pieces of film either in or out of register, depending on the effect you're trying to achieve. You can use the high-contrast negative over and over again with other colors of Diazochrome film.

Sources of materials:

Diazochrome Film: Technifax Corporation
　　　　　　　195 Appleton Street
　　　　　　　Holyoke, Massachusetts 01040

KODAK Professional Line Copy Film 6573,
KODAK EKTACHROME Infrared Film, Size 135, and
KODAK Professional Line Copy Developer:
　　　　　　　Photo Retailers

Carl Dumbauld is Director of Photo Information in Kodak's Consumer Markets Division. His department provides photographic information to amateur photographers through slide and movie programs, television programs, youth photo programs, and thousands of letters weekly. Carl has worked in the field of professional photography, and as past Director of Publications, he wrote and edited many Kodak publications on photography. He has a Bachelor of Fine Arts degree in Photographic Illustration from Rochester Institute of Technology.

A Practical Look at Movie Lenses
by *Carl S. Dumbauld*

If a psychiatrist were to read this article, he might suggest calling it "Understanding Your Lens." I must admit that it would be a very descriptive name indeed! But I thought the word "Practical" in the title would attract your attention, and practical this article is!* If you don't really understand some of the whys and wherefores of the lens (or lenses) on your movie camera, I believe you will 15 pages from now. Maybe your camera has interchangeable lenses, and you're not sure what the extra lenses can do for you. Maybe you've been using a zoom lens, and strange things have been happening, and you're not sure why. Perhaps you're in the market for a new lens or a new camera (or both), and you need some help in deciding what will best fill your needs. If any of these situations sounds familiar, read on!

*For a more technical discussion of lenses and some special hints on getting the most out of lenses for still cameras, you may want to read "Some Chit-Chat About Lenses," page 105.

WHAT ABOUT FOCAL LENGTH?

To get the most out of your movie lenses, there are a few basic terms you must understand. "Focal length" is one term that is much talked about but not always understood. Because we're interested in the practical use of lenses, I won't get bogged down in a lot of technical jargon. But it is important to know what focal length really means. It's even more important to know what lenses of different focal lengths can do for you.

First, what does focal length mean? Practically speaking, the light reflected from a point at infinity falls on the front of the camera lens as parallel rays. The lens (focused on infinity) bends the rays of light so that they converge behind the lens to form an image of the point from which they originated. The distance between the image of that point and roughly the center of the lens (actually the rear nodal point, but let's not get into that!) is the focal length of the lens.

Now let's get to the crux of the matter. What can knowledge of focal length do for you? The focal length of the lens determines the size of the subject's image formed on the film. When the distance between the camera and the subject remains unchanged, a change in the focal length of the lens is proportional to the change in the size of the subject's image.

I said I was going to be practical, didn't I? Okay, for an example let's assume you're taking movies with a 6.5mm lens on your camera. There is a red barn in the scene. Now, without changing your distance from the barn you switch to a 13mm lens. The image of the barn will be twice as big. Simple, isn't it? The pictures below show what happens to image size when you change from a lens of one focal length to another, or when you change the focal length of a zoom lens.

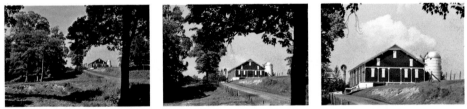

| 6.5mm lens | 13mm lens | 27mm lens |

Measure the barn in the pictures representing the 6.5mm and 13mm lenses. You'll find the barn is twice as big in the picture representing the 13mm lens. Measure the barn in the picture representing the 27mm lens. In this picture the barn is just slightly more than 4 times as large as the barn in the picture representing the 6.5mm lens. The subject distance was the same for each picture. Of course, as the image size of the barn increases, the area included in the picture decreases.

Just for the record, I'll end this section by mentioning the obvious. I said that as focal length increases, image size increases. As image size increases, the area included in the picture must be less (see pictures at bottom of page 194). In other words, as illustrated below, when focal length increases, the angular field covered by the lens decreases.

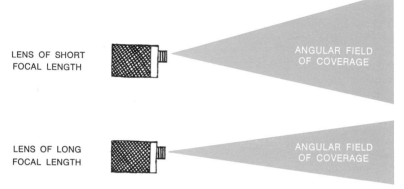

WHAT ABOUT DEPTH OF FIELD?

"Depth of field" means the area which *appears* to be in focus in front of and behind the subject on which the camera is focused.

Theoretically, when you make a movie and you focus on a lamppost 25 feet away, only the lamppost will be in focus. Any point in the scene that is closer or farther away than 25 feet will not be registered as a point on the film. Instead, it will be registered on the film as a small blurred circle. Such circles are called "circles of confusion." This is illustrated in the diagram below. The farther the point in the scene is from the point focused upon, the larger the circle of confusion becomes.

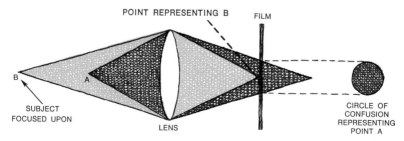

The red point (A) is not the same distance from the camera as the point focused upon (B). Both points cannot come to focus at the same distance behind the lens. Therefore the red point will be registered on the film as a circle rather than as a point.

Considering this example from our practical viewpoint, you and I know that some things in front of and some things behind the lamp-post will look sharp when the movie is projected. What really concerns us is how big the circles of confusion can become before the picture no longer *looks* sharp. When this point is reached, the subject is no longer within the depth of field. In computing the depth of field for Kodak movie lenses, a circle of confusion of .001 inch in diameter is used for 16mm cameras, .0005 inch is used for regular 8mm cameras, and .00065 inch is used for super 8 cameras. Of course, tables based on circles of confusion of other sizes would vary from those we've printed on pages 197 to 204.

When you look at the depth-of-field tables on pages 197 to 204, remember that the picture doesn't suddenly become fuzzy at the depth-of-field extremes. Let's assume you've focused on a subject 10 feet away, and the depth of field is from 7 feet to 15 feet. The circles of confusion will be smallest at 10 feet. They will gradually become larger and pass the sizes of the circles of confusion mentioned above at 7 feet and 15 feet.

Now that you know the basis of depth of field, we'll look at the factors that control depth of field. Depth of field becomes greater as (1) the focal length of lens decreases (subject distance remaining unchanged), (2) the size of the lens opening decreases, and (3) the subject distance increases.

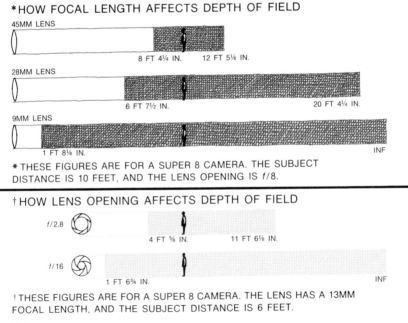

*HOW FOCAL LENGTH AFFECTS DEPTH OF FIELD

45MM LENS
8 FT 4¼ IN. 12 FT 5⅛ IN.

28MM LENS
6 FT 7½ IN. 20 FT 4¼ IN.

9MM LENS
1 FT 8⅛ IN. INF

* THESE FIGURES ARE FOR A SUPER 8 CAMERA. THE SUBJECT DISTANCE IS 10 FEET, AND THE LENS OPENING IS f/8.

†HOW LENS OPENING AFFECTS DEPTH OF FIELD

f/2.8
4 FT ⅝ IN. 11 FT 6⅛ IN.

f/16
1 FT 6¾ IN. INF

† THESE FIGURES ARE FOR A SUPER 8 CAMERA. THE LENS HAS A 13MM FOCAL LENGTH, AND THE SUBJECT DISTANCE IS 6 FEET.

*HOW SUBJECT DISTANCE AFFECTS DEPTH OF FIELD

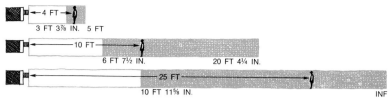

*THESE FIGURES ARE FOR A SUPER 8 CAMERA. THE LENS HAS A
28MM FOCAL LENGTH, AND THE LENS OPENING IS f/8.

From looking over these illustrations, you can see there are times
when focusing is most critical because depth of field is slight.
These times include situations where you use a long focal-length lens
or a large lens opening, or when you are close to your subject.

Of course, a combination of these factors would make accurate
focusing even more important. For example, assume you are using a
45mm lens on a super 8 camera to make movies of a subject only
4 feet away. At a lens opening of f/4, your depth of field would be
from 3 feet 10⅛ inches to 4 feet 1⅞ inches. Critical focusing re-
quired? You said it!

DEPTH-OF-FIELD TABLES*

For Super 8 Cameras

The distances given in these tables are measured from the film plane.
These tables are based on a circle of confusion of .00065 inch.

9mm Lens

Distance Focused On (in feet)		f/2.7		f/4		f/5.6		f/8		f/11		f/16	
		ft.	in.	ft.	in.	ft.	in.	ft.	in.	ft.	in.	ft.	in.
∞ (INF)	NEAR	5	11⅜	4	¼	2	10⅜	2	⅛	1	5½	1	0
	FAR	∞		∞		∞		∞		∞		∞	
25	NEAR	4	9¾	3	5⅝	2	6⅞	1	10¼	1	4½	0	11½
	FAR	∞		∞		∞		∞		∞		∞	
15	NEAR	4	3¼	3	2⅛	2	4⅞	1	9¼	1	4	0	11¼
	FAR	∞		∞		∞		∞		∞		∞	
10	NEAR	3	8⅞	2	10½	2	2¾	1	8⅛	1	3¼	0	10⅞
	FAR	∞		∞		∞		∞		∞		∞	
6	NEAR	2	11⅞	2	4⅞	1	11⅜	1	6⅛	1	2⅛	0	10⅜
	FAR	∞		∞		∞		∞		∞		∞	
4	NEAR	2	4¼	2	⅛	1	8⅛	1	4⅛	1	⅞	0	9⅝
	FAR	11	11⅝	∞		∞		∞		∞		∞	

*These depth-of-field tables are based on circular lens apertures. Since the
apertures in cameras with automatic exposure-control systems are seldom
circular, use these tables only as guides with such cameras.

197

13mm Lens

Distance Focused On (in feet)		f/2.8		f/4		f/5.6		f/8		f/11		f/16	
		ft.	in.	ft.	in.	ft.	in.	ft.	in.	ft.	in.	ft.	in.
∞ (INF)	NEAR	12	5	8	4⅝	5	11⅛	4	2¼	3	⅝	2	1⅛
	FAR	∞		∞		∞		∞		∞		∞	
25	NEAR	8	3¾	6	3½	4	10	3	7⅛	2	8⅝	1	11¼
	FAR	∞		∞		∞		∞		∞		∞	
15	NEAR	6	9⅝	5	4⅝	4	3½	3	3⅜	2	6½	1	10⅛
	FAR	∞		∞		∞		∞		∞		∞	
10	NEAR	5	6⅝	4	6⅞	3	9	2	11½	2	4⅛	1	8⅞
	FAR	50	1½	∞		∞		∞		∞		∞	
6	NEAR	4	⅝	3	6	3	0	2	5¾	2	⅜	1	6¾
	FAR	11	6⅛	20	7⅞	∞		∞		∞		∞	
4	NEAR	3	⅜	2	8½	2	4⅞	2	⅝	1	8⅞	1	4⅝
	FAR	5	10⅜	7	6¾	11	9⅛	69	9½	∞		∞	

28mm Lens

Distance Focused On (in feet)		f/2.7		f/4		f/5.6		f/8		f/11		f/16	
		ft.	in.	ft.	in.	ft.	in.	ft.	in.	ft.	in.	ft.	in.
∞ (INF)	NEAR	57	4⅜	38	9½	27	8⅞	19	5⅛	14	1⅝	9	8⅝
	FAR	∞		∞		∞		∞		∞		∞	
25	NEAR	17	5½	15	2⅞	13	2¼	10	11⅝	9	⅝	7	¼
	FAR	43	11¾	69	4⅛	∞		∞		∞		∞	
15	NEAR	11	11	10	10⅛	9	9⅛	8	5⅞	7	3⅝	5	11
	FAR	20	2⅝	24	3½	32	3¾	63	11⅝	∞		∞	
10	NEAR	8	6⅜	7	11⅝	7	4⅜	6	7½	5	10½	4	11⅜
	FAR	12	⅞	13	4⅞	15	6⅜	20	4¼	33	3⅜	∞	
6	NEAR	5	5¼	5	2½	4	11⅜	4	7⅛	4	2¾	3	8¾
	FAR	6	8⅛	7	¾	7	7⅜	8	7¼	10	3½	15	3
4	NEAR	3	8⅞	3	7½	3	6	3	3⅞	3	1½	2	10¼
	FAR	4	3⅜	4	5¼	4	7¾	5	0	5	6¼	6	8⅛

36mm Lens

Distance Focused On (in feet)		f/2.7		f/4		f/5.6		f/8		f/11		f/16	
		ft.	in.	ft.	in.	ft.	in.	ft.	in.	ft.	in.	ft.	in.
∞ (INF)	NEAR	94	5¾	63	11⅝	45	9¼	32	1	23	4¼	16	¾
	FAR	∞		∞		∞		∞		∞		∞	
25	NEAR	19	9⅞	18	⅜	16	2⅝	14	1⅛	12	1⅜	9	9¾
	FAR	33	9⅞	40	8⅛	54	5⅝	110	1	∞		∞	
15	NEAR	12	11⅝	12	2⅛	11	3⅞	10	3	9	2	7	9½
	FAR	17	9¼	19	6	22	2	27	10⅝	41	2	198	9⅞
10	NEAR	9	⅝	8	8	8	2¾	7	7¾	7	⅜	6	2¼
	FAR	11	1¾	11	9¾	12	8¾	14	5⅛	17	3⅝	25	10¾
6	NEAR	5	7¾	5	5⅛	5	3¾	5	⅞	4	9½	4	4⅝
	FAR	6	4⅝	6	7⅛	6	10½	7	4	8	⅛	9	5⅜
4	NEAR	3	10	3	9¼	3	8¼	3	6¾	3	5⅛	3	2⅝
	FAR	4	2	4	3	4	4⅜	4	6½	4	9½	5	3¼

45mm Lens

Distance Focused On (in feet)		f/2.7		f/4		f/5.6		f/8		f/11		f/16	
		ft.	in.	ft.	in.	ft.	in.	ft.	in.	ft.	in.	ft.	in.
∞ (INF)	NEAR	146	10⅛	99	7⅛	71	4⅛	50	½	36	5⅜	25	1
	FAR	∞		∞		∞		∞		∞		∞	
25	NEAR	21	5	20	½	18	6⅞	16	8¾	14	10⅝	12	6⅞
	FAR	30	0	33	2⅜	38	2½	49	4⅞	77	11½	∞	
15	NEAR	13	7⅝	13	¾	12	5⅛	11	6⅞	10	8	9	5⅛
	FAR	16	7⅞	17	7⅛	18	10⅞	21	3⅜	25	3	36	7½
10	NEAR	9	4½	9	1¼	8	9½	8	4¼	7	10½	7	2⅛
	FAR	10	8⅜	11	1	11	7	12	5⅛	13	8⅛	16	5¼
6	NEAR	5	9¼	5	8	5	6½	5	4⅜	5	2	4	10⅜
	FAR	6	2⅞	6	4⅜	6	6⅜	6	9⅜	7	1⅝	7	9¾
4	NEAR	3	10¾	3	10⅛	3	9½	3	8½	3	7⅜	3	5½
	FAR	4	1¼	4	1⅞	4	2⅝	4	3⅞	4	5⅝	4	8⅝

For Regular 8mm Cameras

The distances given in the following tables are measured from the film plane in the camera. These tables are based on a circle of confusion of .0005 inch.

6.5mm Lens

Distance Focused On (in feet)		f/2.7		f/4		f/5.6		f/8		f/11		f/16	
		ft.	in.	ft.	in.	ft.	in.	ft.	in.	ft.	in.	ft.	in.
∞ (INF)	NEAR	4	⅜	2	8⅝	1	11⅜	1	4¼	0	11⅞	0	8⅛
	FAR	∞		∞		∞		∞		∞		∞	
25	NEAR	3	5¾	2	5½	1	9⅝	1	3½	0	11⅜	0	7⅞
	FAR	∞		∞		∞		∞		∞		∞	
15	NEAR	3	2¼	2	3⅜	1	8⅝	1	3	0	11⅛	0	7¾
	FAR	∞		∞		∞		∞		∞		∞	
10	NEAR	2	10½	2	1¾	1	7½	1	2⅜	0	10¾	0	7⅝
	FAR	∞		∞		∞		∞		∞		∞	
6	NEAR	2	5	1	10½	1	5⅝	1	1⅜	0	10⅛	0	7¼
	FAR	∞		∞		∞		∞		∞		∞	
4	NEAR	2	⅛	1	7½	1	3¾	1	¼	0	9½	0	7
	FAR	253	6⅝	∞		∞		∞		∞		∞	

9mm Lens

Distance Focused On (in feet)		f/2.7		f/4		f/5.6		f/8		f/11		f/16	
		ft.	in.	ft.	in.	ft.	in.	ft.	in.	ft.	in.	ft.	in.
∞ (INF)	NEAR	7	8⅞	5	2⅝	3	8¾	2	7⅜	1	10¾	1	3⅝
	FAR	∞		∞		∞		∞		∞		∞	
25	NEAR	5	11	4	3⅞	3	3	2	4⅜	1	9⅛	1	2⅞
	FAR	∞		∞		∞		∞		∞		∞	
15	NEAR	5	1⅜	3	10½	2	11⅞	2	2¾	1	8¼	1	2⅜
	FAR	∞		∞		∞		∞		∞		∞	
10	NEAR	4	4⅜	3	5¼	2	8⅝	2	⅞	1	7⅛	1	1⅞
	FAR	∞		∞		∞		∞		∞		∞	
6	NEAR	3	4⅝	2	9½	2	3⅜	1	9⅞	1	5⅜	1	⅞
	FAR	26	1½	∞		∞		∞		∞		∞	
4	NEAR	2	7⅝	2	3¼	1	11¼	1	7	1	3½	0	11⅞
	FAR	8	2⅜	16	7⅛	∞		∞		∞		∞	

13mm Lens

Distance Focused On (in feet)		f/2.7		f/4		f/5.6		f/8		f/11		f/16	
		ft.	in.	ft.	in.	ft.	in.	ft.	in.	ft.	in.	ft.	in.
∞ (INF)	NEAR	16	1⅛	10	10¾	7	9⅜	5	5¾	3	11½	2	8⅝
	FAR	∞		∞		∞		∞		∞		∞	
25	NEAR	9	9⅞	7	7¼	5	11⅜	4	5¾	3	5⅛	2	5½
	FAR	∞		∞		∞		∞		∞		∞	
15	NEAR	7	9½	6	3⅜	5	1⅝	4	0	3	1⅝	2	3¾
	FAR	∞		∞		∞		∞		∞		∞	
10	NEAR	6	2¼	5	2¾	4	4⅝	3	6⅜	2	10⅛	2	1¾
	FAR	26	¼	114	⅛	∞		∞		∞		∞	
6	NEAR	4	4½	3	10½	3	4¾	2	10⅜	2	4¾	1	9¼
	FAR	9	6	13	2¼	25	5¼	∞		∞		∞	
4	NEAR	3	2½	2	11⅛	2	7¾	2	3¾	2	0	1	7½
	FAR	5	3½	6	3¼	8	1⅜	14	6⅝	∞		∞	

30mm Lens

Distance Focused On (in feet)		f/2.7 ft.	in.	f/4 ft.	in.	f/5.6 ft.	in.	f/8 ft.	in.	f/11 ft.	in.	f/16 ft.	in.
∞ (INF)	NEAR	85	4½	57	9⅜	41	4⅛	28	11⅝	21	1	14	6
	FAR	∞		∞		∞		∞		∞		∞	
50	NEAR	31	7¾	26	10¾	22	8⅜	18	4¾	14	10½	11	3¼
	FAR	118	10⅞	∞		∞		∞		∞		∞	
25	NEAR	19	4⅝	17	6	15	7½	13	5½	11	5⅝	9	2½
	FAR	35	2	43	8¾	62	5½	174	7¼	∞		∞	
15	NEAR	12	9⅜	11	11¼	11	⅜	9	10⅞	8	9½	7	4¾
	FAR	18	1⅛	20	2	23	4¾	30	9⅜	50	10⅛	∞	
10	NEAR	8	11½	8	6½	8	⅞	7	5⅛	6	9⅝	5	11¼
	FAR	11	3½	12	⅝	13	1½	15	2	18	9¾	31	4⅝
6	NEAR	5	7⅜	5	5¼	5	3	4	11¾	4	8¼	4	3⅛
	FAR	6	5¼	6	8⅛	6	11⅞	7	3¼	8	3⅜	10	1⅛
4	NEAR	3	9⅞	3	8⅞	3	7⅞	3	6¼	3	4½	3	1¾
	FAR	4	2¼	4	3⅜	4	4⅞	4	7⅜	4	10¾	5	5½

For 16mm Cameras

The distances given in the following tables are measured from the film plane in the camera. These tables are based on a circle of confusion of .001 inch.

15mm Lens

Distance Focused On (in feet)		f/2.8 ft.	in.	f/4 ft.	in.	f/5.6 ft.	in.	f/8 ft.	in.	f/11 ft.	in.	f/16 ft.	in.	f/22 ft.	in.
∞ (INF)	NEAR	11	7	8	2	5	10	4	1	3	0	2	1	1	6
	FAR	∞		∞		∞		∞		∞		∞		∞	
12	NEAR	5	11	4	10	3	11	3	1	2	5	1	10	1	4
	FAR	∞		∞		∞		∞		∞		∞		∞	
6	NEAR	4	0	3	6	3	0	2	6	2	0	1	7	1	3
	FAR	12	2	21	0	∞		∞		∞		∞		∞	
4	NEAR	3	¼	2	8½	2	5	2	¾	1	9	1	5	1	2
	FAR	6	0	7	8	12	2	104	6	∞		∞		∞	
2	NEAR	1	8¾	1	7⅝	1	6¼	1	4½	1	3	1	¾	0	10⅞
	FAR	2	4½	2	7⅛	2	11⅜	3	8½	5	6	29	11	∞	

25mm Lens

Distance Focused On (in feet)		f/2.8 ft.	in.	f/4 ft.	in.	f/5.6 ft.	in.	f/8 ft.	in.	f/11 ft.	in.	f/16 ft.	in.	f/22 ft.	in.
∞ (INF)	NEAR	30	0	21	0	15	0	10	6	7	9	5	4	4	0
	FAR	∞		∞		∞		∞		∞		∞		∞	
30	NEAR	15	0	12	0	10	0	7	10	6	2	4	6	3	6
	FAR	∞		∞		∞		∞		∞		∞		∞	
15	NEAR	10	0	9	0	7	6	6	3	5	2	4	0	3	2
	FAR	29	0	50	0	∞		∞		∞		∞		∞	
10	NEAR	7	6	6	10	6	0	5	2	4	5	3	6	2	10
	FAR	14	10	18	9	29	0	155	0	∞		∞		∞	
6	NEAR	5	0	4	8	4	4	3	10	3	5	2	10	2	5
	FAR	7	5	8	3	9	9	13	6	25	0	∞		∞	
4	NEAR	3	7	3	5	3	2¼	2	11	2	8	2	4	2	0
	FAR	4	7	4	10	5	4¼	6	3	8	0	15	0	∞	
2	NEAR	1	10¾	1	10¼	1	9½	1	8⅝	1	7½	1	6	1	4½
	FAR	2	1½	2	2	2	3	2	5	2	7	3	0	3	9½

50mm Lens

Distance Focused On (in feet)		f/2.8 ft.	in.	f/4 ft.	in.	f/5.6 ft.	in.	f/8 ft.	in.	f/11 ft.	in.	f/16 ft.	in.	f/22 ft.	in.
∞ (INF)	NEAR	120	0	80	0	60	0	40	0	30	0	20	0	15	0
	FAR	∞		∞		∞		∞		∞		∞		∞	
50	NEAR	35	0	30	0	25	0	20	0	18	0	14	0	12	0
	FAR	80	0	100	0	300	0	∞		∞		∞		∞	
25	NEAR	21	0	20	0	18	0	16	0	14	0	12	0	10	0
	FAR	32	0	35	0	40	0	60	0	150	0	∞		∞	
15	NEAR	13	3	13	0	12	0	11	0	10	0	9	0	8	0
	FAR	17	0	18	0	20	0	25	0	30	0	40	0	∞	
10	NEAR	9	0	8	9	8	6	8	0	7	6	7	0	6	0
	FAR	10	8	11	0	12	0	13	0	15	0	20	0	30	0
6	NEAR	5	8	5	7	5	6	5	4	5	0	4	3	4	4
	FAR	6	4	6	6	6	9	7	2	7	6	8	6	10	0
4	NEAR	3	10½	3	9½	3	9	3	8	3	7	3	5	3	3
	FAR	4	1½	4	2	4	3	4	4	4	5	4	11	5	6

63mm Lens

Distance Focused On (in feet)		f/2.8		f/4		f/5.6		f/8		f/11		f/16		f/22	
		ft.	in.	ft.	in.	ft.	in.	ft.	in.	ft.	in.	ft.	in.	ft.	in.
∞ (INF)	NEAR	200	0	140	0	90	0	65	0	48	0	33	0	25	0
	FAR	∞		∞		∞		∞		∞		∞		∞	
50	NEAR	40	0	35	0	33	0	30	0	25	0	20	0	16	0
	FAR	68	0	80	0	100	0	200	0	∞		∞		∞	
25	NEAR	22	0	21	0	20	0	18	0	16	0	14	0	12	0
	FAR	28	0	30	0	33	0	40	0	60	0	100	0	∞	
15	NEAR	14	0	13	6	13	0	12	0	11	0	10	0	9	0
	FAR	16	0	17	0	18	0	19	0	21	0	25	0	40	0
10	NEAR	9	6	9	3	9	0	8	6	8	0	7	6	7	0
	FAR	10	6	10	9	11	0	12	0	12	6	13	0	15	0
6	NEAR	5	10	5	9	5	8	5	6	5	3	5	0	4	9
	FAR	6	2	6	3	6	5	6	7	6	9	7	0	7	6
4	NEAR	3	11	3	10½	3	10	3	9½	3	8½	3	7½	3	6
	FAR	4	1	4	1½	4	2	4	3	4	4	4	6	4	8

102mm Lens

Distance Focused On (in feet)		f/2.7		f/4		f/5.6		f/8		f/11		f/16		f/22	
		ft.	in.	ft.	in.	ft.	in.	ft.	in.	ft.	in.	ft.	in.	ft.	in.
∞ (INF)	NEAR	500	0	300	0	200	0	170	0	120	0	85	0	60	0
	FAR	∞		∞		∞		∞		∞		∞		∞	
100	NEAR	85	0	80	0	70	0	65	0	55	0	46	0	40	0
	FAR	125	0	140	0	170	0	250	0	600	0	∞		∞	
50	NEAR	46	0	44	0	42	0	38	0	35	0	31	0	27	0
	FAR	55	0	60	0	65	0	70	0	85	0	125	0	300	0
30	NEAR	28	0	27	6	27	0	25	6	24	0	22	0	20	0
	FAR	32	0	33	0	34	0	36	5	40	0	50	0	60	0
20	NEAR	19	3	18	11	18	6	17	11	17	0	16	3	15	0
	FAR	20	10	21	3	21	9	22	7	23	9	26	0	30	0
15	NEAR	14	7	14	4	14	2	13	10	13	5	12	9	12	0
	FAR	15	5	15	8	16	0	16	5	17	0	18	0	20	0
8	NEAR	7	11	7	10	7	9	7	8	7	6	7	4	7	2
	FAR	8	1½	8	2	8	3	8	4½	8	6	8	9	9	0
6	NEAR	5	11¼	5	11	5	10½	5	10	5	9	5	8	5	6
	FAR	6	¾	6	1	6	1½	6	2	6	3½	6	5	6	7

152mm Lens

Distance Focused On (in feet)		f/4		f/5.6		f/8		f/11		f/16		f/22	
		ft.	in.	ft.	in.	ft.	in.	ft.	in.	ft.	in.	ft.	in.
∞ (INF)	NEAR	800	0	540	0	375	0	275	0	190	0	140	0
	FAR	∞		∞		∞		∞		∞		∞	
200	NEAR	160	0	140	0	130	0	120	0	100	0	80	0
	FAR	270	0	300	0	425	0	700	0	∞		∞	
100	NEAR	90	0	85	0	80	0	74	0	65	0	60	0
	FAR	110	0	120	0	140	0	160	0	200	0	360	0
60	NEAR	56	0	54	0	52	0	50	0	46	0	40	0
	FAR	65	0	67	0	70	0	75	0	90	0	100	0
40	NEAR	38	0	37	4	36	0	35	0	33	0	30	0
	FAR	42	0	43	0	44	0	46	6	50	0	55	0
20	NEAR	19	6½	19	4	19	0	18	9	18	3	18	0
	FAR	20	6	20	8	21	0	21	6	22	0	23	0
12	NEAR	11	10½	11	9	11	8	11	7	11	4	11	2
	FAR	12	1½	12	3	12	4	12	6	12	8	13	0
8	NEAR	7	11¼	7	11	7	10½	7	10	7	9	7	8
	FAR	8	¾	8	1	8	1½	8	2¼	8	3¼	8	4½

"NORMAL" LENSES

Perhaps you have compared the view seen through the viewfinder of a 35mm still camera with the view seen through the viewfinder of a movie camera (both with "normal" lenses). If so, you may have been surprised to notice that the still camera viewfinder included a larger area. Obviously, this is because the angular field covered by the normal lens on a movie camera is smaller than that covered by the normal lens on a still camera. But why this difference?

One reason camera designers chose a lens with a smaller angle of coverage to be the normal lens on a movie camera is so that you can place your movie camera farther from your subject when you're shooting, and still maintain a large image size. This additional space between the camera and the subject leaves the subject more free to move about, as he should in movies. Also, when the subject is at some distance from the camera he can move nearer or farther from the camera without an appreciable change in image size. For example, if the subject is 12 feet away from the camera and moves 3 feet closer, the image size becomes only ¼ larger. If the subject is 6 feet away and moves 3 feet closer, the image size becomes twice as large.

There's another reason why camera designers felt that the normal lens on a movie camera should cover a smaller angular field than is covered by the normal lens on a still camera. In a movie there is action taking place and the scene is changing frequently, so your eyes don't have time to scan as large an area as they do when you look at still pictures. Because of this, camera designers chose normal lenses for movie cameras with an angular field approximately equal to the angle of conscious vision of the human eye. Thus a 25mm lens is normal for 16mm cameras, and a 13mm lens is normal for 8mm cameras. When super 8 cameras were introduced (with the larger super 8 format), a focal length of approximately 12 or 13mm was retained as normal. This was due to the rising interest in normal movie lenses with increased angular field.

LONG FOCAL-LENGTH LENS (Telephoto Lens)

From this point forward, I'm going to join the millions of people who call a long focal-length lens a "telephoto" lens. This terminology isn't quite correct. In the strict sense of the word, a telephoto lens is a specially constructed lens in which the total physical length is less than the focal length. However, for the sake of simplicity, I'll call a long focal-length lens a telephoto lens, too.

A telephoto lens has a focal length greater than the focal length of the normal lens for the camera. While a 25mm lens is a normal lens on a 16mm camera, it would be a telephoto lens on a super 8 or regular 8mm camera.

As I've already illustrated, you would choose a telephoto lens if you wanted to get a larger image size from a fixed camera-to-subject distance. Remember, though—a telephoto lens magnifies camera movement as well as image size. The camera movement is magnified the same amount the image size is increased. The same amount of camera "jiggle" would appear about twice as great with a 25mm lens as with a 13mm lens. The moral of this story is to use a tripod with a telephoto lens.

Also remember that depth of field is less with a telephoto lens than with a normal lens, so focus carefully!

WIDE-ANGLE LENS

The wide-angle lens for your camera is one with a focal length shorter than that of the normal lens. You would choose the wide-angle lens for greater angular coverage or to increase the depth of field (when you aren't concerned about decreasing image size).

ZOOM LENS

A zoom lens is a lens of variable focal length. It's a wide-angle, normal, and telephoto lens all in one. You're not restricted to these three positions, either. You can set the focal length to any position between the wide-angle and telephoto extremes. Add to this the convenience and economy of using one lens instead of three, and you'll understand the popularity of the zoom lens.

The focal length range of a zoom lens is often referred to as a ratio. For example, if the range of a zoom lens is from 9mm to 45mm, it has a 5:1 ratio. This means that zooming from the wide-angle position to the telephoto position increases the image size five times.

For most of your movie-making, you should look through the camera viewfinder and adjust the focal length of the zoom lens to cover the area you want to photograph *before* you take pictures. Of course, you can also zoom the lens from one position to another while you are taking pictures. I'll add my plea to that of viewers everywhere—don't overdo the zooming! Zooming can be very effective, but if you zoom too much, the members of your audience will begin to feel as if they are on a long roller-coaster ride.

You don't always have to zoom *in* on your subject. When your subject is appropriate, set the lens at its telephoto position so that some detail of the subject fills the frame. Then zoom to the wide-angle position to show the complete subject. For example, if you are

The *KODAK INSTAMATIC®* *XL55 Movie Camera has a 9 to 21mm zoom lens. This means the lens has a ratio of 2.3:1. With the lens in the 21mm position, the image size is more than twice as large as when the lens iş in the 9mm position.*

making a fishing movie, make a shot with lens in the telephoto position, showing the fisherman baiting the hook. As he completes baiting the hook, zoom to the wide-angle position to show the entire fisherman as he begins to cast.

The principles of focusing that apply to interchangeable lenses also apply to zoom lenses. The depth-of-field tables on pages 197 to 204 are applicable to zoom lenses set at the focal lengths listed. Because of the large depth of field you get with a wide-angle lens, focusing is not so critical when the zoom lens is in the wide-angle position. When the zoom lens is in the telephoto position, critical focusing becomes very important. This accounts for an effect that baffles some moviemakers just beginning to use a zoom lens. Even though a zoom lens is not focused critically in the wide-angle position, the subject may still be acceptably sharp because of the great depth of field. But if the lens is then zoomed to the telephoto position, the depth of field is decreased and the subject may fall outside the depth of field. The result—a sharp picture that goes out of focus as the lens is zoomed to the telephoto position. The lesson here is simple. Always focus carefully—be particularly critical when using the telephoto position.

VARIETY THROUGH LENSES

You can use interchangeable lenses and zoom lenses to add variety, impact, and interest to your movies. The pace of your movies will begin to drag if the image size is always the same and if all the shots are made from the same angle. One way to change image size is by using lenses of different focal length. Intermix overall or "long" shots with "medium" shots, and don't overlook the impact of detail or "close-up" shots.

When you change image size, change the angle you're shooting from, too. Let's assume you're making a movie of a boy building a sand castle on the beach. Open with a long shot. Include the boy, the castle, and enough of the surrounding area to establish the location. (You can use a wide-angle lens, so you don't have to run way down the beach to make this shot.) Follow this with a medium shot including only the boy and the castle. To change the angle, shoot from a point slightly behind the boy to show him working on his project. (You can use a telephoto lens if you want to make this shot from a distance.) The close-up shot can be made from a high viewpoint, showing the boy's hands doing some detailed work. Follow this with another close-up from a very low viewpoint, looking up at the intent expression on the boy's face. This is the kind of variety that makes a movie dynamic.

Now *YOU* be practical—put your lenses to work!

"Alas, poor Yorick." John W. McFarlane, FPSA, observes a piston from his own antique Rolls-Royce. McFarlane is the retired Managing Editor of Kodak's Consumer Markets Publications. His first article in this series of booklets, "Some Chit-Chat About Lenses," appeared in *More Here's How* (KODAK Publication No. AE-83).

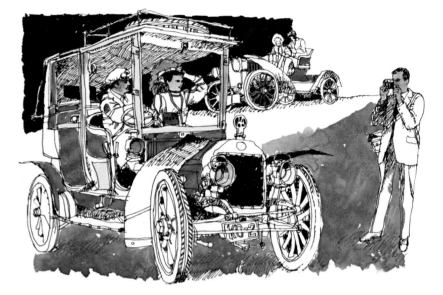

How to Photograph Antique Cars
by *John W. McFarlane*

Most people like cars. Some are as enthusiastic about cars as you and I are about photography. Among the objects of their affection are antique cars, classic cars, sports cars, and special-interest cars. The antique-car hobby is growing tremendously. The largest American club has more than 30,000 members.

No sharp dateline divides antique cars from others. The pre-1914 cars with brass trim are obviously antiques; they are perhaps the most spectacular ones to see and photograph. Some later cars are also considered antiques. Hobbyists are restoring cars of the 30's and 40's. For example, car clubs have a special competition class for Model A Fords. The term "classic" generally means luxury cars of the 20's and perhaps as late as the 40's. Both antiques and classics represent a heavy investment of time and money for the owners. A well-restored, 1910 Model T Ford, for example, may change hands at $6,000. Most owners of antique cars lavish great care on them, take them seriously, and drive them carefully.

PHOTOGRAPHIC OBJECTIVES

Applying your photographic hobby to another hobby is really fun! Antique cars offer a new challenge in colorful subjects. Some pictures of car details are appearing in photographic salons. Who knows, the steering wheel may replace the wagon wheel! Perhaps a related collection of pictures will interest you, such as a collection of photos of different types of acetylene headlamps. Another collection might contain pictures of as many different models and years of a certain-make car as you can find—say, Cadillac. Perhaps you have a friend who is setting out to restore an antique car. He may not take time to photograph his progress as he works. If you can make the necessary photographic history, both of you will value the results highly. There is also acceptance for good photographs of antique cars in magazines, both commercial and club. Slide shows on antique cars are quite popular, even with general audiences.

CAMERA, ACCESSORIES, AND FILM

In my opinion, a single-lens reflex camera is the most useful type of camera for photographing antique cars, partly because of its ability to make extreme close-ups that have been accurately focused and framed. You also need close-up lenses for a really close approach. Flash (either bulb or electronic) is needed for fill-in light outdoors and for indoor shots.

Cars in the Ford Museum photographed by existing light at a small lens opening. A tripod was used.

A tripod is quite important for pictures of exhibits in museums, convention halls, etc. (Always check to make sure that a tripod is permitted.) The colorful nature of the subject demands color film. KODAK EKTACHROME-X, KODACHROME-X, and KODACOLOR-X Films are better to use than slower films whenever subject motion or poor light is involved. On the other hand, film of still higher speed presents a problem in taking close-ups with flash; you "run out of" small aperture! If you are taking existing-light pictures by tungsten light in a museum, use KODAK High Speed EKTACHROME Film (Tungsten)—film speed ASA 125. If the museum is illuminated predominantly by daylight, it's possible that you may be able to take hand-held shots with an f/2.8 or faster lens, using KODAK High Speed EKTACHROME Film (Daylight)—film speed ASA 160.

Kodak will push-process your High Speed EKTACHROME Film, sizes 135 and 120 only, to 2½ times its normal film speed—from ASA 160 to ASA 400 for Daylight type, and from ASA 125 to ASA 320 for Tungsten type. To get this service, purchase a KODAK Special Processing Envelope, ESP-1, from your photo dealer. (The purchase price for the envelope is in addition to the regular charge for KODAK EKTACHROME Processing.) Return the exposed film in the ESP-1 Envelope to your photo dealer, or place the film and envelope in the appropriate KODAK Prepaid Processing Mailer and send it to the nearest Kodak Processing Laboratory. When you use the ESP-1 Envelope, be sure you have exposed the entire roll of film at the higher film speed.

HOW TO FIND ANTIQUE CARS

You have probably seen a parade or auto show which included antique and classic cars. You may have seen a meet held by an antique-car club. Some meets are open to the public. Newspapers often announce these events. Most cities now have local antique-car clubs. You can locate these through local offices of the American Automobile Association. Consider joining a local club. Write to the

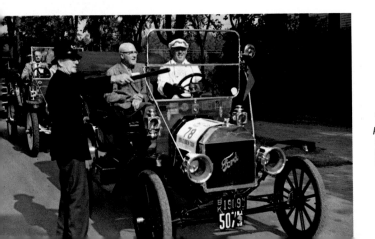

"Antique" policeman poses (at photographer's request) with 1909 Model T Ford, Greenfield Village.

club secretary (enclosing a self-addressed, stamped envelope) to obtain the necessary information.

The national clubs all publish excellent magazines and hold large meets and tours. Local clubs usually have calendars of events of national-club activities. One of the big events every year is the Glidden Tour. About 300 pre-1931 cars tour part of the United States. These cars are usually the best of the antiques. The drivers are usually willing, sometimes glad, to have their cars photographed.

You might seriously consider joining one of the national clubs, to gain some good knowledge of antique cars and events. The largest nationwide club is the Antique Automobile Club of America, with headquarters at 501 W. Governor Road, Hershey, Pennsylvania 17033. Another is the Veteran Motor Car Club of America, Inc., which is most active in the East, with headquarters at 15 Newton Street, Brookline, Massachusetts 02146. The Horseless Carriage Club of America is largely western, with headquarters at 9031 East Florence Avenue, Arrington Square, Downey, California 90240.

There are car museums and large technical museums which include cars. Two of the latter are the Ford Museum in Dearborn, Michigan, and the Science Museum in Chicago. There is an annual "Old Car Festival" at Greenfield Village in Dearborn each September. It draws a lot of excellent antique cars.

COOPERATION FROM THE CAR OWNER

Before you approach a car owner, read up on antique cars either in antique-car magazines or in books available from your library. For example, you could read books on antique cars by Ralph Stein. Then an antique-car owner will know that you are sincerely and intelligently interested.

If the cars are roped off at a meet, don't go inside the ropes. Under no circumstances should you raise the hood or sit in the car. Don't touch any part of the car. Promise to send the owner photographs only if you know that you will carry through. If you are shooting slides, shoot duplicates for the owner. If the car is being judged at a meet, you may not get much cooperation until the judges have finished with the car.

PICTURE SITUATIONS

Let's start with what is sometimes the most trying picture situation: a moving parade. Stand where the sun will be behind you, lighting the oncoming cars. Be early enough to get in front of the crowd. Use a fast shutter speed to stop the motion of the cars.

Another situation is taking shots of cars on tour from a moving car.

If you have a choice, use a convertible with the top down. Stabilize your camera by attaching a tripod to it, but keep the tripod legs collapsed and folded together, and don't let them touch the car. Hold the camera with your right hand, the tripod legs with your left. Use a shutter speed of 1/250 or 1/500 second. Be sure your driver passes the antique cars with care so that you can get three-quarter views from the rear of your car. If you shoot pictures through the windshield, wear a peaked cap to keep sunlight off the top of your camera. Otherwise, sunlight can reflect onto the windshield and bounce back into the camera lens.

A typical picture situation is a large annual meet of 500 or more cars. The cars are parked close together and there are thousands of people. Groups of cars make interesting pictures, and you can get at least the front two-thirds of most of them. The "flea market" (area devoted to sale of car parts, etc.) offers interesting picture possibilities, too.

Antique-car lineup at the Old Car Festival. Backlighting adds sparkle to pictures such as this.

The Concours d'Elegance is a more formal meet, usually of classic cars, at which judging is on appearance alone. The Concours is a spectacular sight, and often the cars are well spaced in beautiful surroundings. Concours cars are usually in magnificent condition.

Earlier, we mentioned museums for interesting cars. Get permission for pictures, of course, and find out if tripods and/or flash pic-

tures are permitted in the museum. Take existing-light pictures, with camera on tripod, of cars or groups of cars. On the other hand, flash works out better for pictures of details, such as engines.

The best picture situation is the local meet in a rural area. Judging is not usual and there is a more relaxed air. You have a much better chance to become acquainted with the car owner. If properly approached, he may be willing to move his car for the best photographic angle.

Modern vehicles and buildings in the background spoil the effect; foliage or sky is better.

FLASH TECHNIQUE

Flash technique for pictures of cars differs from that for pictures of people. For one thing, cars are bigger than people—well, longer anyway. Another difference is that facial shadows are not as deep as shadows on cars. Fenders are deeper than eyebrows! Still another thing: polished people don't present reflection problems like polished cars do.

Flash pictures of cars require a stronger flash because the subject distance is greater. With a 64- or 80-speed film, a flashcube or an AG-1B bulb in a shallow reflector demands a very large lens aperture at the distance needed. A larger bulb in a polished-bowl reflector is more practical. This is true both indoors and outdoors, for fill-in flash. When possible, you can use an extension flash near the rear of the car to supplement the flash on the camera.

213

Gray and Davis acetylene headlights on a 1909 Peerless, with and without fill-in flash.

Shadows on a car need more fill-in light outdoors than do shadows on a face. As a working rule, choose the same lens aperture you would use for an indoor flash shot at the same distance, but use the right shutter time to give proper sunlight exposure. This technique assumes a camera that has full-range synchronization with bulbs, or "X-synch" with electronic flash.

As for reflections, anticipate and avoid them. This usually means shooting at an angle. A straight side-view of a black car, taken by flash, usually gives a glaring reflection. So does a straight front-view of a flat-tanked radiator.

PICTURE-MAKING WITH THE OWNER'S COOPERATION

Let's assume that you have an agreeable working arrangement with the car owner. First of all, get him to move the car to where there is a good background free of modern cars and modern buildings. Foliage is nearly always a good background—after all, 1905 foliage didn't look any different. It's possible to document a car quite well in five shots, plus close-ups of interesting details. The five shots are:

1. Three-quarters front from the driver's side, with the owner sitting in the car.

2. Three-quarters rear from the other side.

3. Instruments and controls taken from back of the front seat. This picture needs fill-in flash unless the car is a very early, open type.

4 and 5. Engine from each side. Both of these pictures will also need fill-in flash. There are always very dark pockets of shadow around the engine.

All of these five shots mean moving the car so that the part photographed will be in the sunlight.

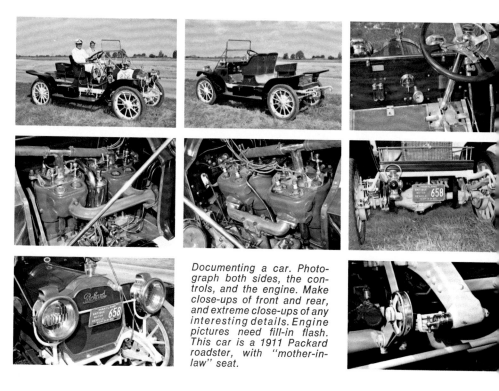

Documenting a car. Photograph both sides, the controls, and the engine. Make close-ups of front and rear, and extreme close-ups of any interesting details. Engine pictures need fill-in flash. This car is a 1911 Packard roadster, with "mother-in-law" seat.

Another type of picture (of more interest with classic cars) is the "coachwork" shot. This is a straight side-on shot made primarily to show the body outline. You should stand so that you are in line with the windshield, holding the camera lens at such a height that just a small part of the far door shows above the edge of the near door.

If an open car has a particularly interesting or beautiful upholstery job, it is shown best from a point about 8 to 10 feet above the ground. If possible, use a stepladder for this type of shot. Don't try standing on your own car—and especially not on the antique car itself.

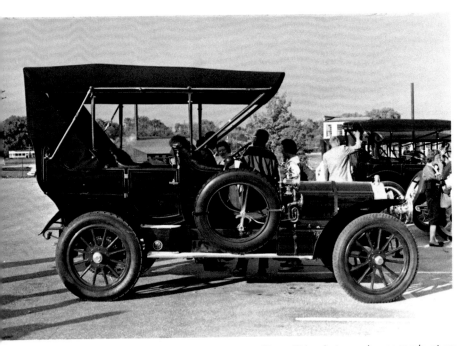

"Coachwork" shot of a 1907 Thomas Flyer. This photograph was made at an old-car festival held at Greenfield Village, Dearborn, Michigan.

Now for some close-ups of details: There are interesting parts— like headlights, sidelights, antique-type speedometers, bulb horns, acetylene generators, and (on many pre-1911 cars) the Selden patent license plate. (Selden had a basic patent for which most car manufacturers paid license fees, until Henry Ford defeated Selden about

1911 after a long patent suit.) These small details mean close-range focusing, in many cases with supplementary lenses. A close-up of an early-type Firestone tire is of interest. The tread says "NON SKID." Firestone still has the old molds and is now supplying these obsolete tire sizes.

Many classic cars are black; for these, you will need about double the exposure you would normally give. When you photograph a white car on slide film, give ½-stop less exposure than for an average subject.

If you are photographing people seated in a touring car with the top up, you will need flash; otherwise, the people's faces will be much too dark.

Speaking of people, at many car meets the owners of the older antiques are encouraged to come in costume; in fact, prizes are offered for the best costumes. People in period costume, seated in their cars, add greatly to the interest of the picture.

Jerry McGarry is an Audiovisual Specialist assigned to the Hollywood, California office of Kodak's Motion Picture and Education Markets Division. He provides information about Kodak audiovisual products and counsels on the planning, production, and presentation of audiovisual media. A native of Philadelphia, Jerry attended Temple University School of Communications, majoring in television production. Prior to joining Kodak, he had been a motion picture director, studio owner, and an industrial audiovisual manager.

Slide-Duplicating Techniques
by Jerome T. McGarry

How many times have you toyed with the idea of making duplicates of some of your favorite slides? True, duplicates are readily available from your favorite photo dealer. But as with so many processes in photography, it's often more rewarding and more fun to do it yourself. Extra slides are useful as gifts, for swapping, or for repeating certain scenes in a show. When you duplicate your own slides, you can enlarge certain areas, improve poor exposure, or use filters to make color changes. You can even combine two or more images into a single new slide by making double exposures.

There are several ways of duplicating slides. I'm going to describe the methods that I think are the simplest and the best.* They are the following:

1. Photographing the image of the original slide from a normal front-projection screen.

2. Photographing the image of the original slide from a rear-projection screen.

3. Photographing the original slide by transillumination using photolamps, electronic flash, or a light box.

Before we get into specific techniques, let's take a look at some details that apply to all of the methods of slide duplicating.

THE CAMERA

A single-lens reflex camera is ideal for slide duplicating because it eliminates the parallax problem. If you must use a camera with a nonreflex viewfinder for close-up work, you may be able to install your own "ground glass." With the camera shutter open, open the camera back and place a piece of waxed paper, matte acetate, or frosted glass over the film plane. The image you see on the paper or glass is the same that will be recorded on the film.

WHICH FILM TO USE

For convenience, when I duplicate slides I choose a film to match the light source I'm using. This table will help you choose a film to match your light source. Of course, you may use other film-and-light-source combinations by following the filter recommendations on the film instruction sheets.

Some Recommended Films for Slide Duplicating

Film	Light Source
KODAK EKTACHROME Slide Duplicating Film 5038 (Process E-4)†	Photolamp (3200 K)
KODACHROME II Professional (Type A)	Photolamp (3400 K)
KODAK High Speed EKTACHROME (Tungsten)	Slide-Projector Lamp Photo-Enlarger Lamp (both approximately 3200 K) Photolamp (3200 K)
KODACHROME II (Daylight) KODACHROME-X KODAK EKTACHROME-X	Electronic Flash Daylight

*You can also use these methods for making negatives from your slides. Unless the contrast of the slide is low, the contrast of the negative will be greater than normal.

†Available only in 100-foot rolls. You can use short lengths in re-usable KODAK SNAP-CAP 135 Magazines (available at photo-supply stores).

EXPOSURE TESTS

No matter which method of slide duplicating you choose, you'll need to make some exposure tests. Use a slide of "average" contrast and brightness for your tests. As I describe each duplicating method, I'll tell you how to determine the *basic* exposure. However, in *every* instance you should bracket your exposures at least 1 stop on either side of the basic exposure. When you see the processed slides, choose the best exposure and use this as the basic exposure for future dupes. If you duplicate other slides that are lighter than average, use a 1-stop smaller lens opening than your test indicated. Use 1-stop more exposure for duplicating slides that are darker than average.

Some people always bracket exposures of each slide, even after they've completed their exposure tests. That way they're always (well, almost always) sure of getting a dupe with an exposure that suits them "just right."

BEGIN WITH A CLEAN ORIGINAL

To help insure a spotless duplicate slide, keep the original as clean and dust-free as possible. Never touch a transparency with your fingers; handle mounted transparencies by their mounts, unmounted transparencies by the edges. Remove dust or lint particles from slides with a clean, dry, camel's-hair brush. You can remove light fingerprints or oily smudges by applying KODAK Film Cleaner sparingly with a plush pad or a wad of cotton.

Keep your original slide clean! Handle mounted slides by their mounts, unmounted transparencies by the edges.

Position the camera as close as possible to the projection beam. If the focal lengths of the camera lens and projector lens are approximately the same, the tripod-mounted camera can straddle the projector.

PHOTOGRAPHING THE IMAGE FROM A NORMAL SCREEN

If possible, project the slide to be copied on a matte white screen. (Masonite or a similar material painted with several coats of flat-white paint is excellent and inexpensive.) Arrange the projector and the camera so that the camera is as close as possible to the axis of the projection beam. This will help avoid distortion in the dupe. If the focal lengths of the camera lens and the projector lens are approximately equal, you can set up the tripod-mounted camera to straddle the projector. (For example, a 3-inch projector lens and an 85mm camera lens work fine in this manner.) If the camera has a shorter-focal-length lens (as is often the case), set it up in front of the projector, just under the projector beam. After you project the slide on the screen, you can move the camera back and forth to crop the picture any way you like. You can also crop the picture by using a longer-focal-length lens on the camera.

Work in a darkened room. Determine the basic exposure by taking a reflected-light reading from the projected image. Take an overall reading—hold the meter so that it doesn't shadow the screen or read the dark border around the image. Make a record of your test exposures and the projector-to-screen distance. For your exposure test to be useful, the projection distance must be the same each time you make a copy. The brightness of the image will change if the projection distance is changed.

221

COPYING FROM A REAR-PROJECTION SCREEN

In this method of duplicating slides, you use a translucent rather than an opaque screen. Place the projector behind the screen and photograph the projected image from the front. The slide must be reversed in the projector so that it will be properly oriented on the screen.

An excellent material to use as a rear-projection screen is a blackish translucent material called Lenscreen. It is available in single sheets from firms such as Polacoat, Inc., 9752 Conklin Road, Cincinnati, Ohio 45242, and Edmund Scientific Co., 380 Edscorp Bldg., Barrington, New Jersey 08007. Also, a 20 x 20-inch KODAK Day-View Screen (Part No. 762355) works well. You can send a price request and an order to Eastman Kodak Company, Central Parts Services, 800 Lee Rd., Rochester, New York 14650. These rear-projection screen materials are rigid and can easily be held in place by blocks of wood.

You can buy rigid rear-projection materials which are easily held in place by wooden blocks.

Another material that you can use for a rear-projection screen is matte acetate tacked or stapled to a wooden frame. Matte acetate is colorless, has a fine grain, transmits light well, and is less expensive than the special materials listed above. It is usually available through art-supply shops. The only disadvantage in using matte acetate is that the projected image appears brighter at the center, causing a "hot spot" in the center of the dupe. You can compensate for this effect by placing a "dodger" a few inches in front of the lens in the center of the projection beam. A half-dollar or similar-sized object glued to a piece of glass makes a good dodger. Adjust the dodger-to-lens distance until the projected image no longer appears brighter at the center.

222

You can make a rear-projection screen by tacking or stapling matte acetate to a wooden frame.

When you use a matte acetate rear-projection screen, the center of the projected image will be brighter than the edges unless you use a "dodger" in the projection beam. An easy-to-make dodger is a half-dollar glued to a piece of glass.

You can also use commercially available, tabletop rear-projection screens for copying your slides. Most of these units include a mirror to orient the image, so it isn't necessary to reverse the slide in the projector.

Determine your basic exposure by taking an overall meter reading from the projected image. Alter the camera-to-screen distance to crop the picture. Always keep the projector-to-screen distance constant so that your exposure tests will be useful. Work in a darkened room to eliminate reflections on the surface of the screen.

Ready-made rear-projection screens such as this one are available for the non-do-it-yourselfer.

PHOTOGRAPHING THE SLIDE BY TRANSILLUMINATION

In this method of duplicating slides, you copy the slide directly, not the projected image. The camera should be equipped with a close-up lens (or lenses), extension tubes, or bellows focusing so that you can locate the camera close enough to the slide to make a one-to-one (same size) copy.

223

When you use extension tubes or bellows, you must allow for the change in effective aperture. If you are making a one-to-one copy, either open the lens 2 stops more or increase the exposure time by a factor of 4. If you use close-up lenses, no exposure compensation is necessary. When you work at these short subject distances, use a lens opening of f/8 or smaller.

When you photograph a slide by transillumination, the light source can be a photoflood lamp, electronic flash, or a light box.

To copy a slide directly (rather than the projected image), you'll need close-up lenses, extension tubes, or bellows focusing.

Using a Photo Lamp (3400 K)

Set your camera on a tripod with an adjustable pan head so that the camera can be aimed straight down. For convenience, place your light near the floor (I prefer using a reflector photo lamp in a clamp-on type socket). Arrange a piece of diffusing glass, such as KODAK Flashed Opal Glass (available from photo dealers), several feet above the light. One simple arrangement is to turn a stool upside down and place two pieces of wood across the leg brace to support the diffusing glass. Another easy setup is to place two chairs back-to-back about a foot apart, and use the chair backs to support the glass.

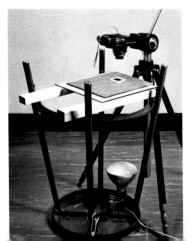

An upside-down stool makes a convenient slide copying setup. The light source can be photo lamp or electronic flash.

Next, cut an opening, slightly larger than the picture area of the slide, in a piece of cardboard. Lay the cardboard on the diffusing glass and position your slide over the opening. Work in a darkened room to avoid reflections on the surface of the slide.

If you place the light less than about 2 feet from the diffusing glass, position a heat-absorbing glass several inches below the diffusing glass. The heat-absorbing glass, usually available from plate-glass shops, will protect the diffusing glass and the slide from the heat of the lamp. Heat-absorbing glass may introduce a slight shift in color balance, which you can correct with filters. More about color correction later.

You can determine your basic exposure with an incident- or reflected-light meter. With a reflected-light meter, place the cell directly against the illuminated slide. The exposure indicated by the meter should be quite accurate if the meter cell is no larger than the slide area. If you use an incident-light meter, hold it so that the cell is in the position that the slide will occupy, but without the slide in place. Face the meter cell toward the light source.

Using Electronic Flash

The setup with electronic flash is basically the same as with photolamps. Place the flash unit behind the slide, pointed directly at the slide and arrange a piece of diffusing glass, such as KODAK Flashed Opal Glass, between the flash and the slide. You will need a cord long enough to connect the flash unit and camera. Since electronic flash closely approximates daylight, use Daylight type color film and work in subdued room light.

I can not suggest specific camera settings for good exposure because of the variety of flash units in use today. Make a test carefully with your equipment—about five or six trial exposures. Use a shutter speed of 1/60 second and aperture settings of f/4 to f/16. Place the flash 18 to 24 inches (for compact units) from the slide. For larger units, 36 to 48 inches.

Record the aperture setting used for each frame number. Measure and note the exact distance from the flash to the slide being copied. Remember, exposure will change as the distance is altered.

If your tests are all overexposed (too light), move your flash farther away or use another thickness of diffusing glass and repeat the tests. Of course, the opposite is true if they are all underexposed.

Using a Light Box

If you plan to duplicate quite a few slides at different times, you may want to build a special light box. Such a box offers the convenience of a standard copying setup. When you want to duplicate some

slides, just plug in the box and set up your camera.

Construct the box as illustrated below. While the dimensions are not critical, the box should measure about 10 inches square. Make the box from wood. The opening in the top should be large enough to illuminate the slides you plan to copy. If you expect to copy slides of different sizes, make the opening large enough to accommodate the largest slide. Then cover the opening with glass, so you can lay smaller slides on the glass. Use a black, opaque mask around the slide on the illuminator to keep stray light from reaching the camera lens.

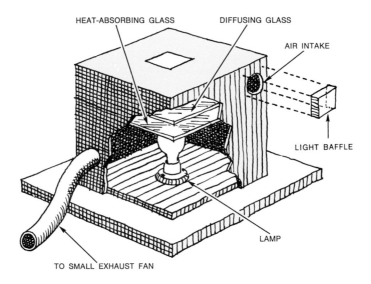

If you make one side of the box a hinged door, it will be much easier to replace the lamps when necessary. Paint the inside of the box with a matte white paint. Install a lamp socket in the center of the bottom of the box. You can use either a photoflood lamp or a photo enlarger lamp, No. 211 or 212. Make provisions for including a heat-absorbing glass and a diffusing glass (such as the KODAK Flashed Opal Glass) between the lamp and the slide. To allow air circulation, there must be some space between the sheets of glass and the sides of the box. You can best achieve this by using sheets of glass about ¾ inch smaller than the inside dimensions of the box. Tack small blocks of wood to the nonmovable sides of the box to support the glass.

226

Drill an air-intake hole above the diffusing glass, and another opening for an exhaust hose near the bottom of the box at the opposite corner. Make a light baffle for around the air intake out of a small box open on two adjoining sides. One open side will fit against the light box, and the other open side will face the base of the box. Attach a small exhaust fan, or even a tank-type vacuum cleaner, to the exhaust opening with a flexible hose. The flexible hose will help prevent vibrations from being transmitted to the light box.

Install a household dimmer switch in the wiring of the box so that you can reduce the brightness and heat while you position the slide and adjust the camera. Be sure to switch to full brightness to take the pictures.

Determine the basic exposure as described in "Using a Photo Lamp (3400K)," page 224. Work in a darkened room to avoid reflections on the slide.

If you plan to duplicate many slides of equal size at one session, position the first slide and the camera, and mark the *exact* position of the slide with tape. This will make positioning successive slides easier, faster, and more precise. It will also allow you to accurately position several slides for making multiple exposures—a technique you can use to make titles or montages.

COLOR CORRECTION

Evaluate your duplicate slide by projecting it on a screen with your projector. If the color balance isn't the way you want it, you can make corrections when you re-shoot the original by placing KODAK Color Compensating Filters (called CC Filters) over the camera lens or between the slide and the light source. Don't use more than two filters over the lens, as the sharpness of the dupe may be impaired. You can use any number of filters between the slide and the light source. In fact, you can use the less expensive KODAK Color Printing Filters (called CP Filters) behind the slide. In this position, filters have no effect on the sharpness of the dupe.

To reduce a certain color, use filters of a complementary color when you re-shoot. (See the table on page 228.) You can judge approximately what effect a filter will have by looking through it at the projected image. The filters come in densities from .025 to .50. The density numbers are followed by letters indicating the color. For example, a CC20Y filter is a Color Compensating Filter with a density of .20, and it's yellow. In general, I think you'll use filters with a density of .10 to .20. The following table will help you choose filters for correcting color balance.

If the color balance is too:	Add these filters:
Cyan	Yellow and Magenta
Magenta	Yellow and Cyan
Yellow	Magenta and Cyan
Red	Cyan
Green	Magenta
Blue	Yellow

For *each* filter you use of either .10 or .20 density, increase the exposure by ⅓ stop.

PREFLASHING TO REDUCE CONTRAST

When you duplicate a slide, the dupe normally has more contrast than the original. Sometimes the added contrast is acceptable. But if you duplicate a contrasty original, the added contrast might be excessive. In this case, you can preflash the film to reduce the contrast of the dupe. In preflashing, the film is given a uniform exposure before the copy exposure is made. The preflashing exposure lowers the maximum density and the contrast of the shadows.

The most convenient method of preflashing is to expose the film to the same light source used for copying your slide, but without the slide in place. This exposure should be approximately 1/100 of the exposure for duplicating the slide. You can easily accomplish this by placing a 2.0 neutral density filter over the camera lens and making an exposure with the same lens opening and shutter speed as you'll use for making the dupe.

For copying slides, I personally enjoy making my own slide-duplicating equipment. However, if you don't have the time or aren't interested in doing this, you can see your photo dealer about the many commercially made slide-copying devices which are available.

Slide duplication requires a little patience and practice. But after you've duplicated some of your slides and have seen the results, I believe you'll agree that slide duplicating can be both useful and creative.

John Paul Murphy, APSA, ARPS, FKCC, is a Photographic Specialist in Kodak's Consumer Markets Division. He is a past president of the Rochester International Salon of Photography, an International Salon judge, a photographic lecturer, a salon exhibitor, a former naval aviation and industrial photographer, and has earned many honors and awards for his photographic accomplishments. He holds a Bachelor of Science degree in Photographic Science and an Associate of Applied Science degree in Photographic Illustration, from the Rochester Institute of Technology.

Imaginative Color Printing
by John Paul Murphy

Most of us began printing and enlarging with black-and-white materials. Black-and-white printing is important, challenging, and a lot of fun. Making color prints is even more rewarding. You're probably already interested in color printing and are making your own color prints, or you wouldn't be reading this article.* Rather than discuss the basics of color printing, I'm going to tell (and show) you how to give your color prints a shot in the arm. You might find that some rather ordinary pictures can become prize winners, and that some of your prize winners can become "best of show."

*If you want to brush up on some of the basics of color printing, you may want to look over KODAK Publication No. E-66, *Printing Color Negatives.* You can get a copy at your photo dealer. Or, if he doesn't have it, send $2 plus your state and local taxes to Eastman Kodak Company, Department 454, 343 State Street, Rochester, New York 14650. Be sure to specify title and code number.

When you make your own color prints, adding a dash of imagination can make your photographs more interesting and pictorial. When the finished print looks special because of some extra touch on your part, the whole process becomes more exciting. Imagine how drab a painting might be if the artist were forced to repeat exactly what he saw without heightening a shade, or rearranging the colors. His paintings might not be too exciting. In photography, too, there are times when you should deliberately emphasize colors for effect. Or, when the occasion arises, you can correct a color fault or blemish to make the scene appear more realistic.

You can do many imaginative things in color printing. Actually, the sky's the limit (not really, because I'm even going to tell you how you can change the color of the sky)!

DODGING AND BURNING IN

As a starter, let's consider this color photograph of a landscape in upstate New York, taken on a cold and wintry January morning. This is a straight print—I didn't use any controls when I made it. Not a bad picture, but what can be done to improve it?

First, the foreground is a little too dark. To lighten large areas such as this, "dodge" them during the basic exposure. Begin by determining the exposure for the overall scene. Then, during part of the basic exposure time, use a piece of dark cardboard to "dodge" the area you want to lighten. Don't hold the cardboard still—move it in and out so that the area you're making lighter will blend smoothly with adjoining areas (see figure 1).

To dodge smaller areas, use a small circle of dark cardboard (about the size of a half dollar) taped to a piece of stiff wire. If the area is just a little too dark, hold it back for about 10 to 20 percent of the basic exposure. Increase the percentage for those areas that need more lightening. In this picture I decided to dodge the foreground for about 20 percent of the basic exposure time.

How about the sun and sky in this picture? In the uncontrolled print, they weren't dark enough to give me the pictorial effect I wanted. I darkened them by burning them in after the basic exposure. To burn in the large sky area, I used the same piece of cardboard I used for dodging the foreground. After the basic exposure, I turned the enlarger on again but held the cardboard so that only the sky got additional exposure. When you burn in an area, the additional exposure is often one or two times the basic exposure. In this picture I burned in the sky for two times the basic exposure.

When the sky was dark enough, the sun was still a little too light. To burn in small areas such as this sun, use a piece of dark cardboard with a hole in it, as in figure 2. In the picture on the next page, I burned in the sun an additional three times the original exposure.

Fig. 1—Use dark cardboard to keep light from an area which is too dark—the same "dodging" technique used in black-and-white enlarging.

Fig. 2—Whenever you burn-in or dodge, keep the cardboard moving slightly so that the controlled area blends with surrounding areas.

231

And there you have it—the finished print, showing the two primary controls—burning-in and dodging.

Right now you may be thinking, "There's nothing new here that I haven't already done in black-and-white printing." You are quite right—all you need to do is start the ball rolling and try these techniques in color printing. Just use your black-and-white talents for color printing, and you'll be more than rewarded by your finished color prints.

SELECTIVE FILTRATION

How can you use the basic dodging and burning-in techniques for more advanced controls in color enlarging? Simply by manipulating filters. Look at the scene of a lonely pasture (page 233). What's this—a blue horse! Who ever heard of a blue horse? I guess you know how it happened. Some of this scene is in sunlight, but the horse is in shade and is illuminated primarily by light reflected from a blue sky. This is the sort of thing you may not notice when you snap the shutter,

but you'll certainly see it in your picture. Let's see what can be done to restore a more natural appearance to the horse.

I used the best filtration for the overall scene and dodged the image of the horse during the *entire* basic exposure. I cut a horse shape out of a piece of dark cardboard and taped it to a stiff wire to do the dodging. After I exposed the paper I changed the filter

pack to correct for the too-blue horse. Since I wanted to add yellow to the horse, I took yellow from the filter pack. In this particular instance I took CC20 yellow filtration out of the pack. Next I used the cardboard with the horse-shaped hole in it to expose the horse. (Remember, I dodged the horse for the entire basic exposure, so there was *no* exposure for the horse on the paper at this point.) My exposure for the horse was the same as the basic exposure. Sometimes the exposure for the controlled area (the horse, in this instance) will be more or less than the basic exposure. In addition to the times when exposure compensation may be required for the different filtration, there will be times when you may want the controlled area lighter or darker than it was in the uncontrolled print.

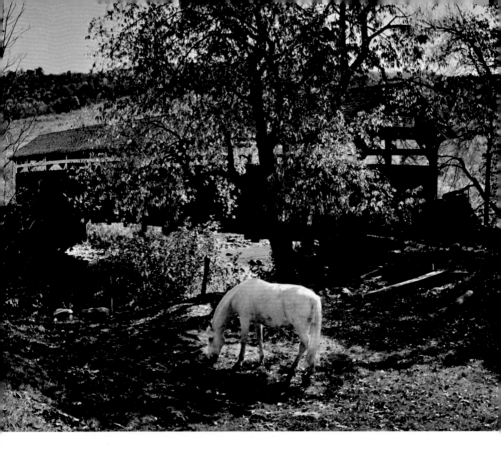

And that's the end of the blue-horse problem. Incidentally, sometimes you will have to make a compromise, just as I did in this print. There is still some blue remaining in the image of the horse. If I had removed all of this blue area, the rest of the horse would have been too yellow.

CHANGING OVERALL COLOR BALANCE

Now let's really let the imagination run wild! Here are five renditions of one scene—an icy winter snowscape. By changing overall filtration, you can make a picture look as though it was taken at different times of day. The yellowish cast of the first picture gives it a sunrise look, doesn't it? All I did was remove yellow from the basic filter pack. (As you know, removing a given color from the filter pack *adds* that color to the print.) The second picture looks more like midmorning on a cold winter day. Then I made the third, reddish rendition because I wanted a sunset print. If you want a moonlight shot, make a cyan or bluish print such as picture 4 or 5. You be the judge—some people

like all five prints—others have a specific preference. The important thing is that you can have your choice because you have complete control over the results.

Incidentally, this picture was really taken in the late afternoon.

1

2

3

4

5

236

USING *KODAK* RETOUCHING COLORS

There are some things that you can do to improve your color prints after the darkroom work is done. Before I began working on the print of fall foliage below, all the leaves on the ground had the same drab, brownish color that you can still see in the leaves on the right-hand side of the print. This is an example of how you can add color to small areas of your color prints by using KODAK Retouching Colors. You can apply the colors with a spotting brush. (I used a No. 2 KODAK DeLuxe Spotting and Coloring Brush.) Use a moist brush, and just apply the dyes until the print looks the way you want it to look. To make the colors permanent, hold the print over steam for a few seconds. (Don't overdo it—the steam from an electric vaporizer is adequate.)

You can add color to small areas of your color prints by applying KODAK Retouching Colors with a brush.

You can use a ball of cotton to apply KODAK Retouching Colors to larger areas of your prints.

You can use retouching colors to improve larger areas, too. In the picture of the lighthouse on the preceding page, the rocks were lacking in color. They were quite pale and drab. You can add color to larger areas such as this by applying retouching colors with a ball of cotton. Apply the color dry, right from the container. You may need to use another ball of cotton to smooth the colors out. If you "bleed" color into an area where you don't want it, simply wipe off the dye before fixing it with steam.

You can increase the intensity of the color by alternately applying steam and more color. The steam will fix the color already on the print and allow you to add more density and color.

These pictures of a small girl reading a book in the wicker chair are good examples of how you can increase color saturation by applying retouching colors. In the picture on the right, I added yellow to the chair and red to some areas of the little girl's pajamas to increase the color saturation.

There is one important point to remember when you apply KODAK Retouching Colors. They are translucent, so they do not completely cover the color underneath. This means that you can't use these colors to change red to blue, for example. But as you've seen, retouching colors are quite useful in putting color where color isn't or in increasing the saturation of a color.

Your own imagination is the key—be sure to use it!

John Schroth is a member of Kodak's Motion Picture and Education Markets Division. In his counseling of business and professional groups on the effective use of audio-visual techniques, John continually works with the techniques about which he teaches. As a former training-staff specialist and evening-college instructor, he has had wide experience in the planning and execution of numerous courses for Kodak and for other organizations.

How to Produce a Slide-Tape Talk
by John F. Schroth

What people see influences them. So does what they hear. Put sight and sound together in a well-planned slide-tape program, and you have a powerful tool for educating, entertaining, and influencing an audience. Our goal here is to tell you how to do this well.

The important first step to take in planning a slide-tape program is to decide what you want the program to do: Entertain friends with the story of your trip? Convince people to support a fund drive for a local hospital? Train people to drive safely? Whatever your goal, you must know your audience and appeal to its personal interests and background.

GATHERING IDEAS

Begin by deciding what you must "say" to reach your goal. At this stage, a "brainstorming" session is good (even if it involves only you), because each idea often generates new ones. During such a session, a teen-age diplomat would think of all the things the folks at home might want to know about the countries he will visit. A civic group promoting urban renewal would jot down every problem of the inner city.

239

A planning board is useful for organizing your idea cards and for planning your entire program. For information concerning ready-made planning boards and printed cards, write to Medro Educational Products, P.O. Box 8463, Rochester, New York 14618.

Write down all of your ideas on small cards; then organize the cards. You can use a planning board, as illustrated above. *Audiovisual Planning Equipment,* KODAK Pamphlet No. S-11, includes instructions for making a planning board. A single free copy is available from Eastman Kodak Company, Department 412L, 343 State Street, Rochester, New York 14650. Of course, if you don't have a planning board, a table will serve the purpose, too.

The next step is to group your cards. Each group will be like a chapter of your story—each card a paragraph within the chapter. Then arrange the cards in the best sequence to tell your story. For example, the teen-age diplomat could have a group of cards for each country—each card might represent something of interest in that country.

Consider program length. Few people can hold the attention of an audience for more than an hour. Try to get your message across effectively in a half hour or less.

You can edit your story at this point by changing the position of some of the cards within a group, or even the position of entire groups. You may decide to throw out some cards because they contain unimportant or irrelevant data. When the editing is done, you'll have a well-organized flow of ideas which leads to your goal. The organized cards are your guides in planning both your pictures and your narration.

PLANNING THE PICTURES

In a slide-tape talk, pictures carry the lion's share of the communication load. For pictures to tell a story, they must be interrelated and the series must have continuity (such as the series on print-mounting shown on pages 251 and 252 of this book). Since pictures are the basis of your story, they must be done first. The words come later and serve to round out your message and tie it together.

The amount of detail you put into planning your pictures is your decision. Some people in the "presentation business" insist on very complete planning of pictures and words before a single picture is made. These people use the planning board approach to decide

Some people like to decide precisely what each slide will show before any pictures are made. Using planning cards is a good way of planning your pictures.

exactly what pictures they want. This approach isn't to restrict the photographer. It's simply to tell him *specifically* what pictures are required and where the emphasis must lie.

A much less detailed approach is called "planning in the camera." The photographer knows the story but works with a written outline—not a detailed treatment. He takes the pictures he thinks will do the job best. When the entire production is a one-man job, the "planning-in-the-camera" approach is the one most frequently used.

TAKING THE PICTURES

Your slides should be simple, understandable, and legible. Using different angles and intermixing long, medium, and close-up shots adds variety. Use different slide formats, too. Masks such as those shown on page 242 are commercially available for cropping or giving a new shape to your slides.

If you want help in picture-taking, see your photo dealer. He has KODAK Publications on all phases of photography. For help in making and using titles effectively, read Titling Techniques in *More Here's How,* KODAK Publication No. AE-83. Or, read *Simple Copying Techniques with a KODAK EKTAGRAPHIC Visualmaker,* KODAK Pamphlet No. S-40. A single free copy is available from Eastman Kodak Company, Dept. 412L, 343 State Street, Rochester, New York 14650.

It's better to shoot too many pictures than too few. This gives you a choice of pictures—but be unmerciful to yourself (and most merciful to your audience) by selecting only the pictures you need to get the point across.

After most of the slides are made, an illuminator is a big help in editing and arranging them. The pamphlet *Audiovisual Planning Equipment,* mentioned earlier, contains instructions for making an illuminator. You can use 2 by 2-inch cards to represent any pictures still to be made. Label the cards to indicate the pictures that they represent.

An illuminator is useful for editing and arranging your slides. You can build your own illuminator, or you can buy one from your photo dealer.

241

a garden of pictures

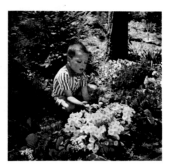

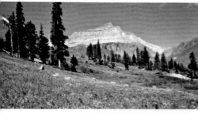

The variety you get by shooting pictures from different angles and distances, and by using masks helps keep your program dynamic.

Commercially available masks allow you to crop your slides. You can eliminate distracting areas, emphasize a part of the picture, and add interest and a change of pace to your program.

THE WORDS

Your narration ties the pictures together, puts emphasis where you want it, and rounds out your story. The best narration won't call attention to itself—it will be simple, brief, and to the point. Your pictures will carry most of the communication load.

Don't explain the obvious. How often have you heard things like, "And here's a picture of little Johnnie washing the dog." We know it's a picture; it has to be Johnnie; and cats just don't look like that. On the other hand, some points can be handled nicely with words. If you want people to know the population of Rocky River, Ohio, just tell them what it is. It isn't necessary to photograph a sign showing the population figures.

Begin preparing your narration by making notes for each picture. Using these notes, talk through the slides to get the feel and pace of your program. Record and play back your run-through. Listening to yourself helps you find spots that need polishing. Run-throughs also test the continuity of your pictures, and help you with any final picture-editing that may be necessary to achieve the pace you want. If your narration seems awkward, confusing, or involved, you may need to change the sequence of some slides, delete a few, or add some new ones to make points you overlooked.

When the words and pictures flow smoothly, write out the working script. Your first script will not contain cue marks, but when completed, your script will be similar to the one illustrated below. It should contain:

1. Slide number and brief description of each slide

2. Narration for each slide

3. Cue marks to show slide changes

4. Cue marks indicating where background music and sound effects will be used

Slide	Subject	Narration	Background Music and Effects
43	Town from church tower	During the summer, the town I lived in celebrated its 800th anniversary. ●	
44	Long shot of parade	The festivities opened✖with a parade of floats. Each one depicted an important era in the town's history—	Fade in march music
45	Float close-up	...from the days when it was inhabited by Teutonic tribesmen...●	
46	Float close-up	...to the war with the French...▮	
47	Float close-up	...to relatively modern times and the founding of the chemical plant.✖	Fade out march music
48	Group shot of me with "family"	Experiences like these ▮ helped me to know and better understand the wonderful people with whom I spent my summer, especially my German "family."	

In this sample script, the cues for slide changes are large dots made with a felt-tip marking pen. The music and sound-effects cues are large asterisks, 243 *with an explanation of the cue in the right-hand column.*

CUING FOR SLIDE CHANGES

A slide flashing on the screen at "just the right moment" can mean the difference between a strong point well made, and just another point. Good timing is important. It helps the program move briskly and keeps the words and pictures in good synchronization. The moral—be sure the cue marks for slide changes are accurately marked on your script.

Run through your program several times to become thoroughly familiar with the script and the sequence of the slides. Then ask someone to follow along with a second script to mark the exact place where you push the change button for the next slide. For split-second timing you must push the advance button slightly ahead of when you want the slide to appear because of the mechanical time lag.

The best time for a slide change may be right in the middle of a sentence. Project each slide only long enough for the information to register—no longer. This means different timing for different slides. Variety such as this helps keep the show interesting and dynamic.

MUSIC AND OTHER EFFECTS

Background music and sound effects add further variety and interest to your show. Background music should support your pictures—almost without being noticed. Match your music to your pictures. Choose music that helps put your audience in the mood you want.

It's a good idea to use music recorded and legally cleared for public use. (Firms from which background-music and sound-effects records are available are listed under "Music Background" in the yellow pages of telephone directories in larger cities.) This avoids problems due to copyright laws and other legal restrictions. Also, music that is familiar to your audience may draw attention from your story.

You may want to use a single musical theme threading throughout your presentation to bind it together. However, to change pace or mood, choose several different musical selections. Repeat a selection if it isn't long enough to cover a complete section of the show. You may also repeat a selection to help tie the mood and content of one section of the show to that of a similar section.

CUING FOR BACKGROUND MUSIC

Decide where you want a musical background and what selections you're going to use. Run through your program and mark the places on the script where music should begin and end. If you have sound effects that you recorded "on location" or that you plan to lift from sound-effects records, mark their locations on the script, too. To be sure that the music or sound effects fit the mood and the space allowed, try them out. If you want to gain impact by having certain bars of music emphasize certain words and pictures, time the music

and the dialogue so that the emphasis comes where you want it. If you need a section of music without narration, you can record the music on a separate tape and splice it into your narration tape. It will take several dry runs before you'll be ready for a smooth recording session.

METHODS OF RECORDING NARRATION PLUS BACKGROUND

The easiest way to record narration and background simultaneously is simply to have the background sounds playing as you narrate—both are recorded at the same time through one microphone. Music and sound effects should originate some distance from the mike, so it's best to have a helper operate your playback equipment (tape recorder or phonograph). If you don't have a helper, keep the playback equipment within reach but use an extension speaker. The quality of the background music depends greatly on the speaker quality.

You can fade music and other effects in and out by adjusting the volume of the playback equipment. If you're using a directional microphone, you can fade the background sound in and out by turning the mike toward and away from the sound source.

Another method of recording voice and background together is to feed both the microphone and playback machine into a mixer that feeds into your tape recorder. Control the volume of each source with the gain controls on the mixer. Use monitoring headphones to get the balance you want. If you don't have headphones, a few trial runs will do the trick.

If you have a stereo tape recorder, you can record the narration and background on separate tracks. The advantage—you can make changes in one track without affecting both. If you want to combine the tracks later, feed the output of both channels into a single channel on a second recorder.

GETTING READY TO RECORD

For the live recording session, then, you need this equipment:

1. Slide projector, with slides ready to show in order
2. A projection screen (or wall)
3. Tape recorder, with mike and enough tape for the entire program
4. The script, cue-marked for slide changes and other effects
5. Playback machine or mixer if you plan background music or special effects
6. Music and sound effects on tape or phonograph records

If your slide projector operates by remote control, place it far enough from the mike so that you don't record the operational sounds

You can make a mike box to help eliminate unavoidable noises, such as those made by car horns and barking dogs. Line the box with a thick felt padding. This box has an adjustable "T-bar" on top to help the narrator maintain the recommended distance from his microphone.

of the projector. Placing the projector beyond an open door in another room is a good idea—just so you can see the projected slides.

The mike should always be on a table by itself so that it won't pick up vibrations from other equipment. You can make a simple box to squelch those sounds you can't avoid, such as blasts from car horns, etc. The box must be open on one side, big enough to hold the mike, and lined with sound-absorbing material (thick felt padding is good). Place the mike in the box and speak into the open side. (Use this box system only if you don't plan on mixing voice with background via one microphone.)

RECORDING

Your script controls the entire operation. It contains the narration and cues for slide changes and background effects. If you record only a section at a time you can listen to your results to be sure all is well. (The break isn't a bad idea for you, either.) When you're using background music, stop at the natural pauses in the music so that your breaks aren't noticeable.

SYNCHRONIZING SOUND AND SLIDES

One simple method of synchronizing sound and slides is for the projectionist to change slides by following the cues on the script while listening to the tape. Another approach is to use audible cues recorded on the tape. No doubt you're familiar with the beep tones sometimes used to indicate a slide change. Unfortunately, the beep tones may detract from the presentation. If you use audible cues, pick the least distracting sound—like the tap of a pencil.

The smoothest, most professional show has inaudible cues on the tape that automatically change the slides. Several tape-recorder-projector synchronizers are available (through stores specializing in audiovisual equipment) which trigger the advance mechanism on slide projectors in response to cue marks you put on the tape. Only projectors with remote-control outlets can be used, because the synchronizing equipment operates the projector via its remote-control

A KODAK CAROUSEL Sound Synchronizer, Model 2, is ideal for synchronizing a stereo tape recorder with KODAK CAROUSEL and EKTAGRAPHIC Projectors with remote-control outlets. During recording, the sound is taped on one track, and each slide change records a signal on the second track. On playback, the signal advances the projector.

outlet. The KODAK CAROUSEL Sound Synchronizer, Model 2, teams up admirably with a stereo tape recorder and KODAK CAROUSEL and EKTAGRAPHIC Projectors with remote-control outlets.

If you produce an automatically synchronized slide-tape program, keep in mind that all potential users may not have a remote-controlled projector and a synchronizer. So always include a script that is cue-marked for slide changes when the program is sent out to other users.

A FEW VARIATIONS

A combination tape-live program sometimes makes an interesting presentation. Live narration can be interspersed with a recording. This is easy if you are giving your own program, but even if someone else presents it, part of it can be given "live" from the script. If you give the show yourself, the live part can be a question-and-answer session at the end. If the program is all on tape, using two people for narration adds variety and a change of pace.

Producing a slide-tape talk is a real challenge. You creatively and effectively combine the power of pictures and sound to tell a meaningful story. The reward comes when your audience reacts in the way you planned. This is communication with a purpose. You can really put your slide presentation into a class by itself if you add motion pictures (super 8 or 16mm) at strategic places. Stills are great for many situations, but sometimes the realism and impact of a short film is the best way to convey your idea.

Audio-Visual Library Distribution of Eastman Kodak Company circulates by mail many free programs on all phases of photography. Many of these programs are slide-tape programs. If you're interested in seeing how such programs are put together (and in picking up some pointers on photography at the same time), you can obtain a complete list and description of the programs by writing to Eastman Kodak Company, Photo Information, Dept. 841, 343 State St., Rochester, New York 14650. Ask for *Your Programs from Kodak,* KODAK Publication No. AT-1.

Paul D. Yarrows, FPSA, ARPS, is a Photographic Specialist in Kodak's Photo Information department. For several years Paul has ranked among the top three people in the world who have had the highest percentage of blackand-white prints accepted in international competitions. With more than 2500 acceptances, he holds a five-star rating in the Photographic Society of America in blackand-white, color-slide, and nature photography. His imaginative photographic lectures have been enjoyed throughout the United States and Canada.

Print-Finishing Techniques
by *Paul D. Yarrows*

After you remove your photographic prints from the wash water, anything that you do to enhance them is a print-finishing technique. When you've made an exciting shot and produced the best possible print, you can add the final touches by practicing good print-finishing techniques. These techniques can mean a blue ribbon in competition or a fine-quality photograph to display in your home or office. Here are the print-finishing techniques I use for KODAK EKTACOLOR Professional Paper and black-and-white prints.

DRYING MATTE-FINISH PRINTS

If you're making matte-finish prints, remove excess moisture (as well as any possible sediment) by wiping the emulsion with a soft moist sponge or a KODAK Photo Chamois. This speeds drying and helps prevent water spots, rippled edges, and uneven drying.

Using a KODAK Photo Blotter Roll is a convenient way of drying matte-finish prints.

An easy way of drying prints to a matte finish is by using a **KODAK** Photo Blotter Roll. Just place the prints, face down, on the blotter and roll it up. The corrugated cardboard permits air circulation to speed drying. Another method of matte-drying prints is to stack the prints between muslin-faced blotters (available from photo dealers).

Sometimes prints may curl when they dry. This is particularly true in the winter when the relative humidity is low. Under these conditions the emulsion dries so completely that it shrinks more than the paper and pulls the print into a face curl. Any of the following procedures will help minimize curl:

1. Pull the print, emulsion side up, across the edge of a table, as illustrated below. Be sure you don't make any sharp bends in the print which could crack the emulsion.

2. Dampen the back of the print very slightly with a moist sponge and put it under weight. The emulsion side must be dry and should be resting on a clean, dry surface.

3. Soak the print in KODAK Print Flattening Solution, then dry it in your usual way.

You can minimize print curl by pulling the print, emulsion side up, across the edge of a table.

FERROTYPING

Ferrotyping is the process of giving a high gloss to your prints by pressing the emulsion against a smooth surface during drying. The high gloss increases the richness of blacks and increases the tonal range of the print. You must make your prints on smooth-surface papers (such as Kodak papers with an F surface) if you plan on ferrotyping them.

You can buy special ferrotype tins. There are two types in general use: black japanned tins and chrome-plated tins. If you use a black japanned tin, treat it periodically with KODAK Ferrotype Plate Polish. This keeps it clean and helps prevent the prints from sticking to the tin.

If you use a chrome-plated ferrotype tin, polish it occasionally with Bon Ami soap cakes (*not* the spray or powder). You can also use glass wax or Nu Steel No. 1 all purpose cleaner and polish. Allow the cleaner to dry; then wipe it off. You should be able to draw your finger across the tin without picking up a trace of the polish. These cleaning agents not only clean chromium plates but also deposit a thin layer of fatty acid that makes it easier to remove the prints when they're dry. (Do not use these cleaners on japanned tins).

When you ferrotype a print, you must have a layer of water without air bells between the print and the tin. So, while the print is still in the water, wipe it with your hand to remove any air bells clinging to the emulsion. Also, rinse the tin and swab it thoroughly with your fingertips.

Lift the print from the water by two adjacent corners. Hold it over the tin and lower it gradually so that the emulsion side of the print "rolls" onto the ferrotyping surface. Remove excess water with some type of squeegee. The straight-edged "window-wiper" type works well. Squeegeeing also pushes the print into firm contact with the tin. Then press a blotter sheet over the back of the print to pick up any water still present. Leave the blotter over the print and roll the print firmly against the tin with a roller, such as the KODAK Master Print Roller. Then remove the blotter and leave the print on the tin until the print dries and pops off by itself.

250

Use a squeegee to press the print against the ferrotype tin and to remove excess water.

Your final step in ferrotyping is placing a blotter over the print and rolling it firmly against the tin.

MOUNTING

A mount disassociates a picture from its surroundings and consequently emphasizes the picture. A well-chosen mount calls attention to the picture, not to itself. Most photographers use a material such as KODAK Dry Mounting Tissue for mounting their prints. This is the way it works:

1. Tack the tissue to the back of the print, using a tacking iron or a household iron (for black-and-white prints, set the iron between silk and wool—for color prints, set it for synthetic fabrics).

2. Trim the print.

Tack mounting tissue to the print with a tacking iron . . .

or with a household iron.

Then trim the print.

251

3. Position the print on the mounting board. Holding the print in place, lift one corner of the print and tack the mounting tissue to the mount. Do this on *three* corners.

4. If you have a dry-mounting press, put the print into the press and protect the print with a double thickness of heavy kraft wrapping paper which has been dried in the hot press. Any moisture in the paper could cause it to stick to the print. Then close the press for about 30 seconds for color prints or 1 minute for black-and-white prints. The temperature of the press should be about 200-220 F for color prints and between 200 and 275 F for black-and-white prints.

5. If you don't have a mounting press, use a household iron to mount your print. Cover the print with kraft paper, as mentioned above, and run the iron back and forth over the print. Keep the iron in motion and work from the center of the print toward the edges. Don't push down too hard, or you may mar the surface of the print. Use the same settings on the iron as suggested in Step 1 for tacking the tissue to the print.

You may also mount your print by using a photographically inert cement, such as KODAK Rapid Mounting Cement. Do not use rubber cement, because it may contain compounds that, in time, could stain the print.

Underlays dress up a print, too. To mount a print with an underlay:

1. Tack the dry-mounting tissue to the print and trim off the excess tissue.

2. Tack the print to a piece of art paper that is slightly larger than the print.

3. Tack dry-mounting tissue to the art paper and trim the excess tissue.

4. Tack the art paper to the board.

5. Mount the print with a mounting press or a household iron.

Gray or black underlays are quite effective with black-and-white or color prints.

When tastefully used, color underlays also dress up color prints.

You can buy *overlay* mounts in art or photo-supply stores. There's no actual mounting involved when you use an overlay. Just lift the overlay and slide the print into place. Then tape or glue the bottom corners of the print to the mounting board. While these mounts are fine for temporary or home use, they usually aren't acceptable for photographic contests or salons.

Overlay mounts are easy to use. They are good for displaying prints at home and for temporary mounting.

To eliminate white spots, apply dyes by using a brush in a stippling motion until the spot disappears.

SPOTTING

Despite all the precautions you take against dust and dirt, most prints seem to end up with at least a few white spots. You can fill in the spots by using dyes and brushes, such as KODAK DeLuxe Spotting and Coloring Brushes. The brushes are available in different sizes. I usually use a No. 0 or 2. KODAK Spotting Colors, for black-and-white prints, are dry dyes supplied in a set of three colors: black, white, and sepia. Another type of spotting dye for black-and-white prints is a liquid called Spotone. You can spot color prints with colored dyes, such as KODAK Retouching Colors.

To spot your prints, dampen the spotting brush slightly and pick up a little spotting dye of the right color on the tip of the brush (you can mix colors if necessary). Rotate the brush to make a fine point. Apply the dye to the spot with a dotting or stippling motion until the dye matches the tone of the surrounding area—and the spot is no longer visible. It's best to begin with dark areas and work on lighter areas as the dye works out of the brush. If the dye bubbles when you apply it, the brush is too wet.

ETCHING

Now and then one of your prints may have a black spot. You can eliminate such spots by etching them with a good-grade surgical steel knife, such as the KODAK Etching Knife.

The first time you do any print etching, start with a scrap print for practice. Scrape the emulsion very lightly with the knife—don't dig it. Unlike spotting, which should be done after ferrotyping, etching should be done *before* ferrotyping because it disturbs the print surface.

PROTECTING THE PRINT SURFACE

By this time, you have quite a bit of time invested in your print. You can protect black-and-white prints from surface scratches and abrasions by waxing them with a paste wax such as Simoniz, or a liquid wax such as Johnson's Glo-Coat. Apply the wax with a smooth cloth and rub it down with a clean, soft piece of flannel.

You can also protect matte prints by spraying the surface with a clear spray, such as Krylon Crystal Clear No. 1303. Practice spraying on an extra print. Hold the spray can about a foot from the print and spray with an even, sweeping motion. Repeat the process if the first coat doesn't cover. If you apply too much spray at one time, the print surface will have an "orange peel" texture.

You can use paste wax to protect black-and-white prints.

You can use clear spray to protect the surface of matte prints.

255

TITLING

Printing the title of your photograph and your name just under the print adds the finished touch. Keep the title short and simple. Ideally, the first letter of the title should start even with the left edge of the print. Print your name in the lower right corner to match the title. The last letter of your name should be flush with the right edge of the print.

When you enter prints in photographic salons or camera-club competitions, print all the required information on the back of the mounting board in the upper left corner. Include your name and address, the title of the print, and the number that corresponds to the number on your entry form.

As you begin trying these print-finishing techniques, I'm sure you'll find them quite rewarding. After a little practice, I believe you'll be so pleased with the results that you'll probably be "hooked"— like I am.

Jack Englert, FPSA, was a photographic specialist in the U. S. Navy during World War II. At Kodak, he has served as a development engineer, a photographic instructor, and a Senior Photographic Specialist in the Photo Information department. Jack is well known for his lecturing and TV appearances throughout the country. He has been made a Fellow of the Photographic Society of America for his exceptional ability as a nature photographer, and as an author, lecturer, and teacher. In recent years he has spent much of his picture-taking time photographing both pets and wildlife.

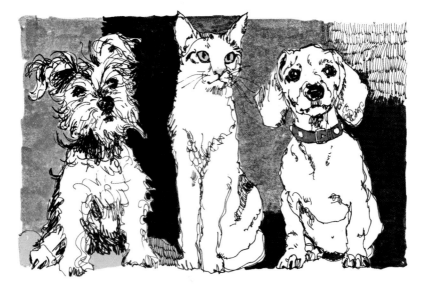

Photography of Cats and Dogs

by John F. Englert, Jr.

Almost everyone likes pictures of cats and dogs. Many people find these animals among the most fascinating of all photographic subjects. Wouldn't you like some top-notch pet pictures—perhaps of your own cat or dog? All that is required is a little ingenuity, planning, patience, and understanding, and the pictures are yours.

You can use any adjustable camera to take pictures like those I've used to illustrate this article. If you decide to use electronic flash, you'll need to use a camera with X synchronization. In selecting a film, just match the film to the light source you're using. Use daylight film in daylight or with electronic flash, tungsten film with Tungsten (3200 K) and Type A film with photolamps (3400 K).

257

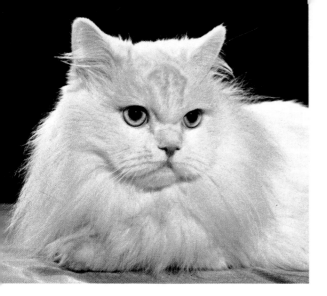

Move in close to capture the detail of your pet and to eliminate distracting surroundings.

CLOSE-UPS

More than anything else, being able to see the detail of markings, the appealing expressions, and the interesting antics of your pets will make your pictures something special. Close-up pictures not only show detail, they are also dramatic.

With a large dog you can shoot a "head and shoulders" type of portrait simply by moving in as close as the camera's minimum focusing distance allows. With a smaller animal you may need a close-up lens or a lens extension (tubes or bellows) to permit picture-taking at closer distances. Your photo dealer or the manufacturer of your camera can give you information concerning the close-up equipment available for your camera.

GROOMING AND BACKGROUNDS

What mother would think of having her child's portrait taken without sprucing him up a bit? Good grooming helps produce a fine portrait. This is also true for pet portraiture. A few moments spent brushing the animal and wiping his eyes will pay off in better pictures.

After you've groomed your subject, check the surrounding area to make sure that it, too, is neat and tidy. Keep foregrounds and backgrounds simple and unobtrusive. They should not draw attention from the main subject in the picture. A large sheet or roll of heavy paper makes an ideal background for a studio-type shot. The color of the background should be harmonious with your subject. Rolls of background paper in various sizes and colors are usually available from art-supply shops and large photo-supply stores. Place the background far enough behind the subject so that the subject will not cast shadows on it.

258

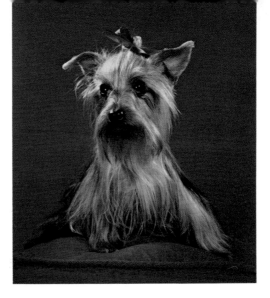

Grooming the pet before you shoot helps produce a high-quality picture.

I use my basement for most of my indoor animal photography. Basements and garages are probably two of the most popular areas for "animal studios" because rolls of background paper can be suspended from pipes or rods on the ceiling, as illustrated below. For variety, I like to have several rolls of background paper in different colors on hand. Then, when I'm ready to take pictures, I unroll the color I want. After the shooting session, I can roll up the paper for safekeeping until next time.

If you shoot your pictures in a room of your home or apartment, you can cut off the amount of paper you need and fasten it to the ceiling or wall with masking tape.

For outdoor shooting, look for an uncluttered background. Green grass or blue sky makes a good background. For a background of green grass, use a high camera angle. Then make sure your subject is looking up. For a blue sky background, use a low camera angle.

259

I shot from a low angle when I photographed my friend Pat jumping the fence (below). Shooting from this position eliminated the unsightly buildings in the background. Incidentally, this picture didn't just happen. I had someone hold Pat outside of the picture area until I was all set to shoot. Then, on my signal, Pat's master called her. Planning and subject control are always important.

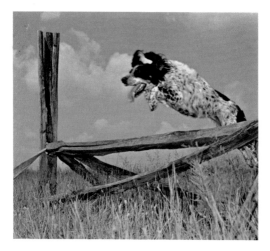

The blue sky always makes a good, uncluttered background.

SUBJECT CONTROL

Animals are just like people (well, almost). Each one has a different personality, and this calls for a variety of photographic approaches. Some animals are lazy, so you'll have to encourage them to look alert. Other animals are high-strung, and you'll have to devise ways and means of restraining them.

It's been my experience that animals cannot be forced to pose. They must assume the pose you want of their own volition. Here's a chance for you to make good use of ingenuity, planning, patience, and understanding.

Most animals will look alert and prick up their ears if they hear a strange noise. This is great for pictures. I've found that a rattle, a whistle, a toy that squeaks, the rustle of paper, a loud metallic ring—are all effective means of attracting the attention of an animal and producing an alert look.

If your pet won't stay put, why not use a prop that will help keep him in one place long enough for you to shoot your pictures? Puppies and kittens like to explore small confined areas. Baskets, drawers, bags, narrow boards, or stairways are props that will limit a pet's travel. If animals seem reluctant to stay at the picture-taking spot, a little food can be a powerful persuader. A bit of ground meat for a dog or some fish oil for a

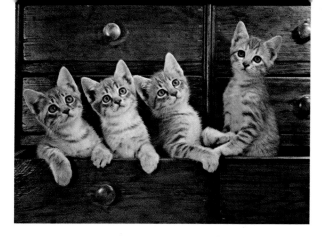

Use props to limit the travel of non-cooperative pets.

cat usually keeps the animal where you want him.

It sometimes helps to have another person working with the animal when you're shooting pictures. This lets you devote full time to the camera and the picture. Ideally, this person should be one who has a "way" with animals.

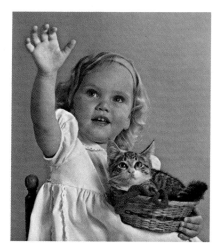

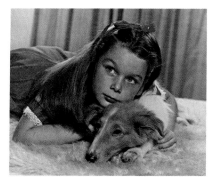

Picture them together. Children and pets are a natural combination. The person in your picture can help keep your pet where you want him.

You can also control your pet by including a person in the picture. Pictures of pets and children are naturals. The child can act as a built-in handler and help control the pet. The combination of a child and a pet in one picture can make a real prizewinner—both in photographic salons and in family circles.

When I take pictures of animals by myself, I like to use what I call the "pre-set method." Here's how it works. Set up all of the photographic equipment in advance, with the camera and lights focused on a given spot. Then, to make the exposure, all you need to do is trip the shutter. If you use a long cable release to trip the shutter, you'll have more freedom to move about. With the camera all ready for action, you can concentrate on the subject.

The next step is to lure or coax the animal to the proper spot. Encourage the pet to assume a good pose and to look alert by using some of the techniques previously mentioned. Be ready to press the cable release at the peak of action.

LIGHTING

Lighting can make the difference between an average picture and a prizewinning photograph. Sometimes, a particular combination of sunshine and shadows provides a pleasing effect. However, I prefer to use artificial light because it's more reliable and more controllable. Your light source can be either tungsten or electronic flash. I usually use electronic flash because of its ability to stop action. This feature is particularly important in photographing active animals.

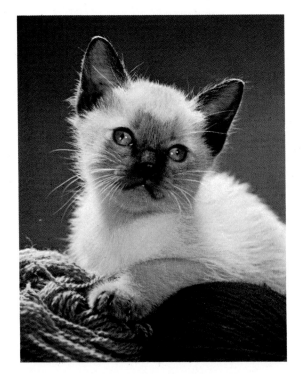

Good lighting often makes the difference between an ordinary snapshot and a prizewinning photograph.

262

The number of lights you use depends on your personal preference and, of course, on the number of lights available. You can take fine pictures with just one light. Some photographers use as many as seven lights. There are also a great many ways you can arrange the lights. However, I prefer to use the five lights and the reflector as shown in the following illustrations. The lighting diagrams illustrate the positioning of each light in the setup in order of its importance. The photograph next to each diagram was made by using the lights shown in the diagram. (I used a toy squirrel to illustrate the lighting because I was pretty sure my feline or canine friends wouldn't remain patient while I shot the complete series.) Although you can use as many of the lights as is possible or convenient, I think you'll be most pleased with your results when you use all five of the lights, because each light serves a definite purpose.

Begin with a main light (M) 45 degrees above and 45 degrees to the side of the lens-to-subject axis.

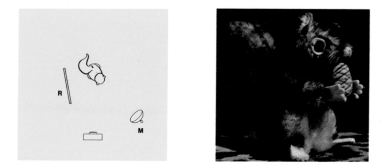

Add a reflector (R). The reflector should be white, such as a projection screen, or a large sheet of white paper or cloth.

 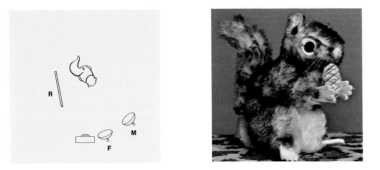

Add a fill light (F). Both the fill light and the reflector fill in the shadows and reduce the lighting contrast. The fill light should be as close to the camera as possible, and on the same side of the camera as the main light.

Add a right backlight (RB) to highlight the right side of the subject. This light should be about 45 degrees above and 30 degrees behind the subject. Use a sunshade to shield the camera lens from the backlights.

Add a left backlight (LB) to highlight the left side of the subject. This light should be about 45 degrees above and 30 degrees behind the subject.

In this shot, the reflector and all of the lights except the background light were used.

Add a background light (B) to brighten the background and to help separate the subject from the background. Place this light low and behind the subject so that it shines up at the background.

All of the lights plus the reflector produce a high-quality animal photograph with good modeling, good detail, and good background separation.

I used one of my dog baskets to keep these four active puppies where I wanted them. Good lighting produced nice modeling and highlights on the dogs, and it brought out the texture of the basket as well.

When I photographed the month-old miniature dachshunds, I used the lighting setup illustrated at the bottom of page 265. The ring of lights provided good lighting on each puppy regardless of his position.

Remember—move in close, groom the animal, watch the background, exercise subject control, and use good lighting. The result: good pictures!

Barbara Kuzniar, a Publications Editor in Kodak's Consumer Markets Division, writes and edits Kodak books and pamphlets for amateur photographers. Barbara is an avid photographer in both black-and-white and color, and her pictures have been accepted in numerous photographic salons. She also serves as a photographic judge, lecturer, and teacher. Barbara and her husband, Paul, who has an article in "The Eighth Here's How," are Kodak's only husband and wife photography team. They travel around the nation teaching photography and giving slide presentations on a variety of photographic techniques.

Creative Close-Ups of Garden Flowers

by Barbara Kuzniar

As summer fades into autumn, you may regretfully watch the last of the beautiful flowers of the season fade and die. Flowers contain a rare combination of vibrant color and delicate beauty. They are a never-ending source of enchantment as the petals unfold, revealing the intricate formation of each blossom. And perhaps, when winter comes, spring *can* seem far behind.

But fortunately for flower fanciers and photographers, photography can preserve the beauty of flowers. By taking pictures, you can "deep freeze" the beauty of a summer garden. The flowers in pictures never wilt. They are always fresh and ready to be enjoyed at the touch of the button on a projector or the turn of a page in your picture album.

267

Pictures of your garden can serve as a handy reference through the years, too. You can compare yearly pictures of flowers from the same plant, or you can compare pictures of last year's garden with those you took the year before. It's fun to see how your garden changes from year to year.

For the creative color photographer, flowers offer an exciting challenge. By mastering the techniques of flower close-ups, you can create dramatic pictures that you'd be proud to enter in any photographic salon.

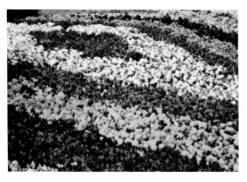

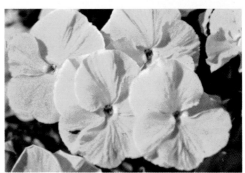

You'll probably want to make an overall shot of colorful and interesting flower beds, but the dramatic close-ups you shoot will be the most breathtaking. I made the first shot at a distance of 25 feet, the second at 2½ feet, and the third at 8⅞ inches with a 3+ close-up lens.

Flower photography can be a year-round project. During the winter months, flowers from the florist offer many picture possibilities. And after you've shot your pictures, you can use the bouquet or plant to brighten up your living room. Then after April showers and May sunshine turn the outdoor buds to blossoms, you can take your camera on an adventure in your favorite garden and focus on close-ups.

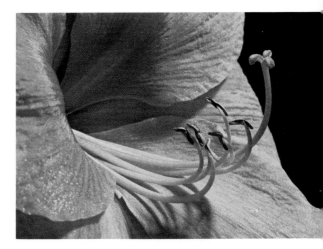

Close-ups reveal all the intricate beauty of flowers, because you can fill your picture area with just one blossom.

FOCUS ON A CLOSE-UP

Taking close-ups is the best way of showing the intricate beauty of small blossoms. You can take extreme close-ups by using close-up lenses, or, if your camera is designed to accept them, extension bellows or tubes. Any of these aids will allow you to move in close enough to fill your picture area with one tiny blossom or just part of a blossom.

Using Close-up Lenses

One advantage of using close-up lenses rather than a lens-extension device is that you use normal exposures. (Most extension devices require more figuring.) Your photo dealer will help you select what you need to fit a close-up lens on your camera.

The strength of a close-up lens is indicated by its number, such as 2+ or 3+. The bigger the number, the closer you can get to your subject. You can use two close-up lenses together to get even closer to your subject. Be sure to follow the instructions packaged with the close-up lens.

You'll get better results if you shoot your close-up pictures with your camera set at a small lens opening, such as $f/16$ or smaller. A small lens opening will increase the depth of field. This increase will help to compensate for the slight depth of field at extreme close-up distances. You should also measure the distance to your subject quite accurately.

At the close shooting distances you use with close-up lenses, the camera viewfinder doesn't show exactly what will be in the picture unless you're using a single-lens reflex camera. This phenomenon is called "parallax." Parallax occurs because the viewfinder is located above and often to one

269

side of the lens. You can correct for parallax by tipping the camera slightly in the direction of the viewfinder after you have composed the picture. The closer you get to the subject, the more you need to tip the camera in order to get the picture you first saw in the viewfinder.

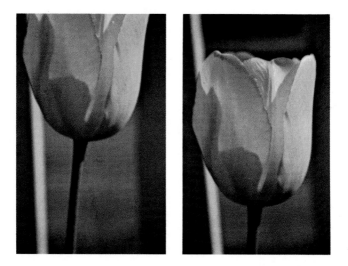

When you shoot close-ups with a camera that doesn't have through-the-lens viewfinding, be sure to correct for parallax. When I made the first shot, the tulip appeared centered in the viewfinder, but the top of the flower was "cut" in my picture. For the second shot, I used a cardboard measuring device like the one illustrated on page 271.

You won't have to worry about parallax or subject distance if you'll take a few minutes to make a cardboard measuring device such as the one illustrated on page 271. You can make this device from the cardboard that laundries put in shirts. Get the subject distance (Distance A in the illustration) and the width of the field size (Distance B) from tables in the instruction sheet for your close-up lens. Measure these distances on the cardboard. Then draw a line down the center as indicated in our example.

With the close-up lens on your camera, hold the center line of the cardboard at the center of the close-up lens. You won't need to use the viewfinder, but make sure that you hold the cardboard straight out from the camera lens. Then move toward your subject until the cardboard touches your subject, drop the cardboard, and shoot.

Parallax is not a problem if you have a single-lens reflex camera, such as a KODAK INSTAMATIC® Reflex Camera. When you peer through the view-

270

A Subject distance.

B Width of area that will be in your picture (field size) when subject is at Distance A.

finder of this camera, you are actually looking through the lens that takes the pictures, and you can see whether the picture will be sharp and properly framed.

Using Lens-Extension Devices

If your camera will accept extension bellows or tubes, you can make close-up pictures without accessory lenses. However, when you use the bellows or tubes, you may need to increase the exposure to compensate for the "light loss" that results from the lens extension. To determine what exposure compensation is necessary, see the instructions packaged with the equipment or use the Effective *f*-Number Computer in the *KODAK Master Photoguide,* available from photo dealers.

Some lens-extension devices, such as the KODAK INSTAMATIC Reflex Lens Spacer, automatically compensate for the "light loss" that results from lens extension. These extension devices are as easy to use as close-up lenses because no exposure compensation is necessary.

PHOTOGRAPHING FLOWERS OUTDOORS

You can take creative flower photographs either outdoors in sunlight or in the controlled atmosphere of a studio. Indoors, you can move the lights to get dramatic effects; outdoors, you can move your camera and select the best viewpoint to achieve dramatic lighting. Sidelighting emphasizes the shape of the flower and brings out the texture of the petals. Backlighting accentuates the translucent, delicate quality of flowers and creates really striking pictures.

Both sidelighting and backlighting produce shadows. Since shadows help show shape and dimension, you shouldn't try to eliminate them. However, you'll probably want to lighten the shadows to reveal more detail in your close-ups. It's a good idea to have a reflector that will bounce

Backlighting brings out the translucence and texture of the blossom. This iris was next to a white house, which served as a natural reflector to lighten the shadow areas.

light into the shadow areas. You can make an inexpensive reflector from crumpled aluminum foil stretched over a piece of cardboard. If this is not available, use a newspaper or a white shirt to reflect the light.

What about those days when the sun doesn't shine? Some people like the soft, hazy quality of flower pictures made on overcast days, and I have seen some beautiful pictures made under these conditions. However, I prefer the texture and shadows produced by strong lighting. So, on overcast days I use flash. Flash can be a real help in photographing flowers. When you use flash close to your subject, the subject is so brightly illuminated that you can use a small lens opening to get the depth of field you need for close-ups. Also, if your flash unit can be used off the camera, you can use flash to create sidelighting or backlighting. Since the background goes quite dark when you use flash, the flower stands out in striking contrast.

If your flash is built into your camera, you can use one layer of white handkerchief over the flash to diffuse the light and to reduce the intensity of the light on the flower. This helps you get proper exposure at close shooting distances. It also helps light the subject evenly. If your flash unit can be used off the camera, you can hold the flash some distance from the flower, rather than covering the flash with a handkerchief.

You can use the tables on pages 273 and 274 as a guide in determining exposure for close-ups with on-camera flash.

When you use flash, the background appears black.
This makes the flowers stand out in sharp contrast.

Flash Exposure Information for Close-ups

Use a shutter speed of 1/25 or 1/30 second and put one layer of white hand-kerchief over the flash. This table applies directly to KODAK EKTACHROME-X, KODACHROME-X, and KODACOLOR-X Films. If you use KODACHROME II Film, use a lens opening 1 stop larger than the table indicates.

Flashbulb and Reflector	Lens Opening*	
	Subject Distance: 10-20 inches	Subject Distance: 30 inches
Flashcube	f/16	f/11
Hi-Power cube	f/22	f/16
AG-1B, shallow cylindrical reflector	f/16	f/11
AG-1B, polished-bowl reflector	f/22	f/16
M2B, polished-bowl reflector	f/22	f/16
M3B, 5B, or 25B, polished-bowl reflector	f/22 (with two layers of handkerchief)	f/22

*For very light subjects, use 1 stop less exposure or add another layer of handkerchief over the flash reflector.

Electronic Flash Exposure Information for Close-ups

Use any shutter speed (with leaf-type shutters) and put one layer of white handkerchief over the flash. The information in this table applies directly to KODAK EKTACHROME-X, KODACHROME-X, and KODACOLOR-X Films. If you use KODACHROME II Film, use a lens opening 1 stop larger than the table indicates.

Output of Unit BCPS	Lens Opening*	
	Subject Distance: 10-20 inches	Subject Distance: 30 inches
700-1000	f/16	f/8
1000-2000	f/16	f/11
2800-4000	f/22	f/16
5600-8000	f/22 (with two layers of handkerchief)	f/22

*For very light subjects, use 1 stop less exposure or add another layer of handkerchief over the flash reflector.

Controlling the Background

Every photographer knows that a distracting background can ruin a picture. However, this is usually not a problem when you shoot close-ups. In a close-up, the background is usually so out of focus that it becomes a soft blur of color. As a result, the subject stands out in sharp contrast. On the other hand, bright reflections or spots of bright color can be distracting even though they're out of focus. Look at the background carefully before you snap the picture, and select the camera angle that will give you the most pleasing results.

Sometimes the camera angle which gives you the best background doesn't show off your subject to its best advantage. This is the time to modify the background. You can ask someone to stand so that his shadow falls on the background. This will cause the background to turn out underexposed and will eliminate any distracting elements. Take your meter reading before you shade the background so that the reading won't be affected by the shadow.

You can also make your own background. I like to use a large sheet of art paper. With art paper, the background can be black or any one of a rainbow of colors. Using these paper backgrounds gives you complete control over the color and mood of your shot. The mood of your picture changes completely when you change the background from dark green to vibrant orange. Hold the background paper away from the flower so

274

that you keep distracting shadows from falling on the background. You can also use a piece of colored cloth for the background, but be sure to keep it far enough away from the subject so that wrinkles in the fabric will be out of focus.

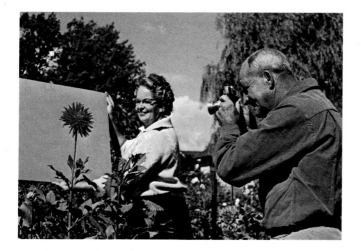

Large sheets of colored art paper make good backgrounds for your flower pictures. Hold the paper away from the flower, so you can't see the shadow of the flower on the background.

You can control the mood of your shots by using art paper of different colors for backgrounds.

Getting That Fresh, Dewy Look

You don't have to get up at the crack of dawn to capture the dew on your flowers. You can have "instant dew" at any time of the day with one spray of a window spray bottle (or a plastic squeeze bottle) filled with water.

Another way to make sure your flowers look fresh is to carefully remove any wilted or damaged petals and leaves. Try to avoid touching the blossom when you position the flower for your pictures, since the petals of some flowers turn brown when they're handled.

Spraying water on the flowers will help give them a fresh, dewy look.

Keeping the Flowers from Bobbing

Flowers will sway and bob in the spring and summer breezes. Since a moving subject requires a fast shutter speed, and a fast shutter speed means a larger lens opening, you'll lose your valuable depth of field. Also, since

276

depth of field is so shallow, it's necessary to focus carefully, and it's hard to focus when your subject keeps moving. To help eliminate this movement, you can easily improvise a wind screen to shield the flower from the wind. I like to use a screen made from clear plastic sheeting stapled to wooden dowels. This type of screen is self-supporting: Just drive the dowels into the ground, and the screen will stand alone. Although you can use cardboard or heavy paper for a screen, the clear plastic offers several advantages. It doesn't cast shadows. Also, you can place it behind your subject, and since it is transparent and will be out of focus, it won't show in your picture.

Select Part of a Blossom

With a strong close-up lens, or several close-up lenses used together, you can focus on the center of a flower and discover a whole new world of beauty. Tulips offer many colorful possibilities. In extreme close-ups, the petals become colorful backgrounds for unusual compositions in which the pistil and stamens are the center of interest. Since focusing is extremely critical at this ultra-close distance, focus on the closest stamen and let the petals go into an out-of-focus blur of color.

The center of some blossoms looks like a unique and unusual flower in itself—quite different from the entire flower. For example, magnolia blossoms have a center that looks like an unusual spiny cactus. You can create all sorts of interesting designs and abstract photographs by moving in close and photographing only part of a flower.

To create abstract pictures, take extreme close-ups of a flower. This is the center of a tulip.

277

The petals of a magnolia blossom surround a delicately colored, cactus-like center.

SHOOTING FLOWER PICTURES INDOORS

There are several reasons why you might want to bring your favorite blooms indoors to photograph them. The main advantage of working indoors is the control you have over the lighting. Also, you don't have to worry about the flowers swaying in the wind. Of course, most of the techniques I discussed in the section on outdoor picture-taking, such as spraying water on the flowers and using art-paper backgrounds, are just as useful indoors as outdoors.

You can use flash for your indoor shots. If you do, you can use the same techniques and exposures discussed in the section on taking flower pictures outdoors. However, I prefer to use several reflector photoflood lamps to illuminate my subjects. Not only are photofloods less expensive than flashbulbs, but they also have the distinct advantage of letting you see the lighting before you take the picture.

I like to work with three reflector photofloods. I use one for the main light, one for the fill light, and a third for the background light or for adding extra highlights. I usually begin by placing the main light to one side of the flower to create strong sidelighting. Then I add a fill light at the camera position to lighten the shadow areas. I use the third light either to illuminate the background or to add highlights by aiming it from behind the flower. If you like very soft lighting, you can bounce the light by aim-

ing a photolamp (or flash, for that matter) at the ceiling. Some people enjoy experimenting to see how many different effects they can create just by changing the lighting arrangement.

You can tie several flowers together with string or florists' wire to hold them in a pleasing arrangement.

This hanging fuchsia was photographed indoors and illuminated with three photolamps. One lamp was placed to the right behind the flowers to create backlighting. A second light was placed at the camera position to fill in the shadows. The third light was aimed at the blue paper background.

Main light only.

Main light and fill light.

Main light and fill light, with third light used as background light.

Main light and fill light, with third light used to add highlights.

"Painting" Photographs of Flowers

You can make your flower pictures look like unusual paintings by placing flowers behind a sheet of textured glass or plastic before photographing them. In "A Galaxy of Glassware" (page 310 of this book), Frank Pallo discusses a method of creating "etched" effects by using textured glass. You can produce many kinds of unusual pictures by combining colorful flowers with glass or plastic of different textures. If you try this technique, be prepared to explain it to your photographer friends. They'll all want to know how you "painted" a photograph of flowers.

These flowers were illuminated by the light of the late afternoon sun shining in a window. A sheet of clear textured plastic held in front of the arrangement created the painting effect.

281

The late Charles A. Kinsley, Hon. PSA, FPSA, FACI, taught more than 75 photographic courses in his lifetime. As a widely known photographic lecturer, Chuck photographed all 50 states to illustrate his slide and movie programs. While Director of Kodak's Photo Information department, he managed the staff of specialists who prepare and present photographic programs, develop services for youth groups, and answer thousands of letters every week from people requesting photographic information.

Pictorial Lighting Outdoors

by Charles A. Kinsley

Long before the days of color photography, pictorial artists had a descriptive word for the arrangement of light and shadow in pictures. They called it "chiaroscuro," from the Italian *chiaro,* light, and *oscuro,* dark. The artist knew that if he arranged the light and dark areas of his artistic efforts effectively, he was heading in the right direction. If he chose to ignore chiaroscuro, the quality of his work would probably suffer.

"Quality" is often a difficult thing to describe or define. Someone may look at a picture and say, "Boy, that has quality!" Most listeners would know what he meant. But ask him to *define* what he means and there may be a long pause in the conversation. We all seem to understand what quality is, but sometimes we have difficulty putting our feelings into words.

So it is with chiaroscuro. If a picture has good chiaroscuro, we promptly describe it as having good quality even though we might not immediately be able to say why. We simply recognize the pleasing arrangement of the

tones as quality, without necessarily trying to understand the mechanics of the arrangement.

This is true whether the picture is a painting, an etching, or a photograph, as long as some realism is involved. If the object in the picture is identifiable, the effect of the angle of the lighting is important to the quality —perhaps more important than any other single element. Being constantly aware of the impact of lighting is often the only bridge over the gulf separating the average photographer and the excellent one. This is particularly true in outdoor photography.

THE DIVIDENDS OF ANGULAR LIGHTING

The easiest and most foolproof way to take outdoor color pictures is to be sure that the sun shines over your shoulder and falls flatly on the subject. Unfortunately, this approach often results in mediocrity—your pictures seem to have less quality than you anticipated. Sometimes it is difficult to put your finger on the trouble. The exposure is fine, the color is good, the subject matter is what you wanted—but the general appearance of the total picture is disappointing.

The cause could be a common photographic malady known as "lighting laziness." L.L. affects most photographers at some time. With some, it lasts a lifetime. With others, the cure may come in a few months or a few years.

Sand dunes, snow drifts, or rolling hills are good subjects for very early or very late shooting. Sidelighting emphasizes the contours.

The spotty crosslighting that precedes or follows a storm can be quite dramatic. The effect seldom lasts for more than a few minutes.

The cure for L.L. is simple: Begin looking for the exciting picture possibilities created by crosslighting and backlighting. Unlike most cures, this one costs nothing, can be taken anywhere, and the results are only a few processing days away. Better yet, your pictures will take on a new life and dimension. Angular light adds roundness, accentuates texture, and produces naturalness. In addition, many colors are enhanced, people stop squinting, and the edge lighting that results adds pictorial quality.

Look for unusual color quality in angular light, such as backlighting filtered through smoke or dust. Try crosslighting very early or late in the day when the shadows are long. Watch for spotty crosslighting when there are billowing clouds. Notice the dramatic effect of crosslighting just before or just after a storm.

Some rare subjects—perhaps a wrecked schooner partially buried in the sands of a lonely beach—can be photographed in almost any type of light and still be interesting because the subject forms are strong. Subjects like this look well in silhouette, by warm sunlight early or late in the day, under hazy lighting conditions, at high noon, or in snow or rain. No matter what the light, the subject interest makes the picture successful. But this type of subject doesn't come along very often. Life simply isn't full of compelling dramatic situations everywhere you go.

To many people, most of what they see every day has an "everyday"

appearance. But to the observant photographer, life can be quite different. He makes it different. The discerning pictorial photographer learns to improve his pictures by selecting the best camera angle in order to eliminate distractions in the background, add foreground interest, or show the best shape or side of the main subject. As his level of experience increases, there comes a day when either by accident or design, he discovers that camera angle also controls lighting. This is one of his most important discoveries, because now the emphasis in his work shifts from a mere recording of details to an artistic interpretation of mood, atmosphere, or depth. Suddenly he becomes stimulated by his surroundings. No longer are they prosaic. Patterns become more pronounced, architectural forms more interesting, and landscapes more photoscenic. Snow, rain, fog, and dust aren't quite the nuisances they once were. Now they have a different look—a sort of beauty that wasn't there before. The elements haven't changed, but the photographer has. He has become perceptive.

It is precisely this perceptiveness that identifies the true pictorialist. Because he is aware of the effect of light on his surroundings, he becomes a visualizer. He will often say: "Imagine how that would look with afternoon light." Or, he will mentally walk around a subject and examine it from every angle. He's simply forming a mental image of the best possible angle and lighting for his subject.

My own experience with this area of photography has been a rewarding one. I've shortened many a long ride and made a repetitive walk more interesting by playing the visualizing game. A row of telephone poles, a used-car lot, a narrow street—any subject can be dressed up with the right kind of lighting.

The nature photographer often prefers strong backlighting for showing textures and for separating his subject from the background. Here, backlighting emphasizes the pubescence on the stalks of the freshly emerged fiddleheads.

The distinct value of this visualizing game is that it prepares you to recognize picture possibilities. Most photographers are looking for new picture-taking ideas, particularly on long trips. Mountains, animals, waterfalls, and the family on a bridge are no problem—but what after that? I believe that the continual practice of seeking variety in lighting will make almost any subject more stimulating. (Just for fun, spend one picture-taking session shooting nothing *but* backlighted or sidelighted subjects. It will open your eyes!)

The nature photographer also recognizes the importance of lighting. For example, in photographing many specimens where texture is important, he will use strong backlighting or sidelighting. Backlighting gives a strong separation from the background and adds a halo effect, both of which would be lost with frontlighting. Sidelighting exaggerates pores, roughness, hair-like surfaces, or any other texture. It helps to identify the true characteristics of the subject.

SOME EXAMPLES

Let's examine what happens to the appearance of some familiar types of subjects when they're photographed with crosslighting or backlighting.

People

People often look more natural with angular lighting. In real life we seldom see people illuminated with frontlight. Outdoors with the sun shining, or in a brightly lit room, people engaged in conversation or other activities will unconsciously shift position to avoid bright lights catching them full face. No one wants to stare directly into the sun or a lamp. As soon as the face is turned partly away from the light source, modeling appears in the features and squints disappear.

Artists through the ages have recognized the value of crosslighting in portraiture. The so-called "Rembrandt lighting" creates a triangular patch of light on one cheek because the light source is high and usually at least 45 degrees from the plane bisecting the subject's face. This type of lighting adds depth to the features, and creates an interesting play of light and shadows on the subject's face.

Birds and Animals

Fur and feathers look richer, particularly with backlighting. The light playing through the tips of fur or feathers produces a halo or rim effect which adds a third-dimensional quality and separates the subject from the background.

Backlighting helps to retain delicate pastel colors. The highlighted feathers appear almost white, but in the middle-tone and shadow areas the color is quite strong.

Flowers

The petals of most flowers are translucent, and therefore they become richer in color with backlighting. Frontlighted flowers appear less colorful because some white light is reflected from their surface. This white light tends to dilute the color of the petal, causing it to look less saturated. The colors of the flowers appear richest when light is transmitted by the petals rather than reflected from them.

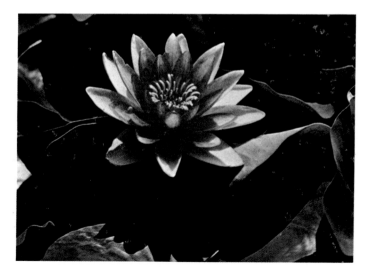

The translucent petals of flowers appear richer when they're photographed with backlighting.

When flowers are photographed by backlighting, the background is often in shadow. This results in good separation of the flower from the background. Also, a shadowed background compliments the subject because distracting elements are subdued or hidden.

Foliage

Leaves and grass often appear greener with crosslighting than with front-lighting. However, sometimes foliage appears bluish with certain angles of backlighting. Because of the multiplicity of angles in leaves and grass, any degree of crosslighting will tend to reduce some of the surface-reflected white light. However, when the prime angle of the lighting begins to approach backlighting, there is a considerable increase in specularly reflected skylight. This bluish-white skylight reflected from the foliage surface tends to obscure the deeper green, causing the foliage to look bluish. This is an effect sometimes overlooked by landscape photographers. For the best greens, look for sidelighting. Be careful of backlighting unless the light is actually being transmitted through the leaves.

Landscapes

Interesting shadows and edge lighting result from backlighted or side-lighted scenes. However, sometimes backlighting results in a loss of quality in scenic shots. Sometimes the photographer is mystified because for no apparent reason the sky seems a little milky, the colors appear less saturated, the foliage is almost gray rather than green, and there might even appear to be an overall bluish cast. Such results are most apparent in medium-to-

Strong crosslighting in scenic photography often helps to separate the foreground from the background. Notice how the aspens stand out against the distant mountains.

Rim lighting of trees is an effective way to emphasize the foreground without putting up a "visual barrier." Full sun on the tree trunks would tend to create a barrier between you and the background.

288

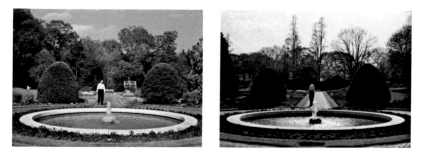

The difference in the overall color quality of these two pictures is due to the angle of the lighting. These pictures were made less than 1 minute apart, but at an angle of 180 degrees to each other. Backlighting is generally better for close-ups or medium shots than for more distant scenes that include sky areas.

distant views, and are due primarily to the prevalence of shadow areas and to the skylight reflected from foliage and other objects.

Strong backlighting is usually better for close-ups, for subjects where highlight detail is relatively unimportant, or for shots including a minimum of sky. Even on a very clear day, the sky area next to the sun will appear "weaker" than the sky at 180 degrees from the sun.

Pastel Colors

The use of sidelighting or backlighting to create shadow areas will deepen pastel colors. Many rock formations lose their delicate coloring if they are photographed with frontlighting. Rock formations in places such as Zion and Bryce National Parks are very colorful when backlighted but often drab with flat light. Again, this drabness is usually caused by the surface reflection of white light.

There are probably 48 measurable hues in Cedar Breaks National Monument. Most of them would be lost if they were photographed with frontlighting. Backlighting produces mostly middle tones and shadows, and retains the pastel hues.

Subdued with sidelighting or backlighting, foreground objects such as tree trunks make unobtrusive frames for your main subject. These types of lighting also produce specular highlights that add sparkle to scenic shots.

Water, Ice, and Snow

To make any of these really glisten, strong backlighting is really mandatory. With strong backlighting, a river becomes a silver ribbon, icicles develop brilliant highlights, and a field of snow appears to be sprinkled with a million diamonds.

EXPOSURE

Crosslighted and backlighted subjects usually require more exposure than frontlighted subjects. As a general rule, you should increase exposure ½ stop for sidelighted scenes and 1 stop for backlighted subjects in cases where you haven't added any extra light to the shadow areas. This rule applies when you want to preserve shadow detail. If you want to produce a silhouette effect, don't increase the exposure.

The best way to hold shadow detail in close-ups is to add light by using flash or reflectors rather than by increasing exposure. Increasing exposure tends to wash out the highlight areas. To preserve the highlight detail, maintain the same exposure level required for a frontlighted scene and simply add sufficient light to fill in the shadows. With crosslighting or backlighting on the beach, in snow-covered areas, adjacent to a white

Rim lighting, or edge lighting, makes the subject stand out against the background. Here, the desert sand served as a natural reflector to lighten the shadows.

290

house, or wherever a natural reflector exists, the subject can usually be exposed at the same level used for frontlighting and there will be plenty of detail in the shadows. You can also use artificial reflectors or flash to add light to the shadows, and the quality is usually superior to the effect obtained by increasing exposure.

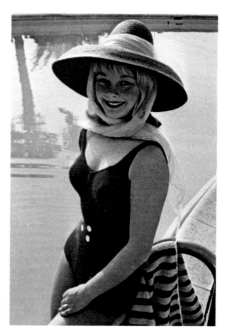

For best expressions, turn faces away from the sun and then use flash or reflectors to make the shadows luminous. Flash added desirable catchlights in the eyes of this pretty miss.

GUARD AGAINST FLARE AND REFLECTIONS

A word of caution: Angular lighting increases the risk of lens flare and reflections. Keep your camera lens as clean as possible. Dust, fingerprints, or grease on the lens will cause more trouble with angular lighting than with frontlighting. Also, it's important to shield the lens from the direct rays of the sun. A lens shade can be used for this purpose. Or, hold a hat or hand in such a manner as to cast a shadow on the lens. This may mean a marked improvement in picture contrast and quality.

Photography is a personal matter. As in any of the arts, no one can say a particular photograph is all good or all bad, and be certain that the next observer will agree. But, there does seem to be a general agreement among most photographers that sidelighted and backlighted pictures are very often more interesting than frontlighted shots. And for most of us, that's the prime motivation—to take interesting pictures.

Neil Montanus is a photographer for Kodak's Photographic Illustrations Division. He has traveled throughout the world making advertising photographs for the Company (including the Kodak Coloramas discussed in *The Third Here's How*). He has been awarded the degree of Master of Photography by the Professional Photographers of America and is a member of the American Society of Photographers. Neil has exhibited a number of one-man photo shows and is a well-known judge of photographic salons. He has a degree in photography from Rochester Institute of Technology.

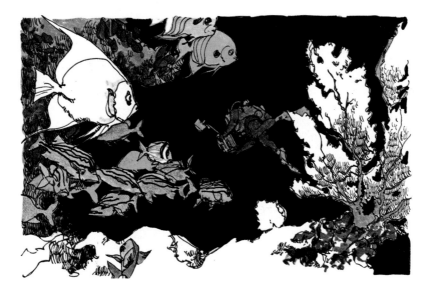

Underwater Photography

by Neil C. Montanus

The underwater world is a dreamlike place—full of delicately beautiful formations; lazy undulating shapes; muted colors; and curious, darting creatures dotted with bright splashes of color. Only you who have visited this mysterious, exotic world know how exciting it is and what an apparently endless number of photographic possibilities it presents.

Underwater photography is not only exciting and bursting with stimulating pictorial possibilities, it's also a very challenging field, often difficult to "pin down" technically. Personally, I feel it's one of the most rewarding photographic challenges I've ever faced. In the next few pages, I'm going to pass along to you some tips and techniques that will help you get your feet wet (oops, sorry about that) in underwater photography.

292

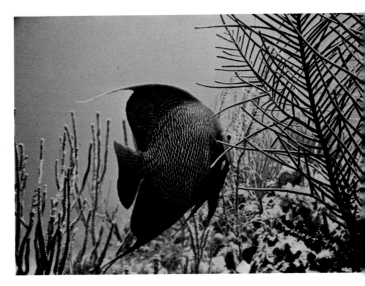

French angel fish

LIGHT MISBEHAVES UNDERWATER

As you know, light is a basic ingredient for taking pictures. We all know how we expect light to behave in our everyday, above-water world. But underwater, light does some apparently strange things that have a strong bearing on underwater picture-taking. First let's look at the behavior of light underwater. Then we'll see just what effect this behavior has on picture-taking techniques and on the selection of equipment for underwater photography.

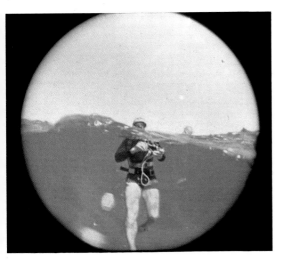

Due to refraction, underwater subjects look closer than they actually are. Here the body looks closer than the head. This photograph of the author was made with a 180-degree fish-eye lens by Paul Brundza of Upsi, Inc., Marathon, Florida.

293

Refraction

When rays of light pass from water to air, or vice versa, they are refracted, or bent. As a result, when you look at subjects underwater, they look closer, and therefore larger, than they actually are. Subjects will appear to be about one-fourth closer than their actual distance. For example, a subject that is actually 8 feet away will appear to be only 6 feet away.

Falloff of Light Intensity

When sunlight strikes the surface of water, some of the sunlight is reflected. When the rays of the sun strike the surface of the water at an angle, as when the sun is low in the sky or when the surface of the water is choppy, the water reflects more light than it does when the sun's rays are perpendicular to the water surface.

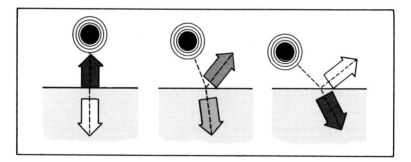

Not all of the light that penetrates the surface of the water will get to your underwater subject. Some of the light will be scattered and absorbed by air bubbles near the surface and by dissolved material suspended in the water. The amount of light that gets to your subject depends on both the depth of the subject and the clarity of the water.

Change in Color Balance

As light penetrates deeper below the surface of the water, the colors of the spectrum are selectively absorbed. The blue-green color of the water acts as a filter, absorbing colors at the red end of the spectrum. Since progressively less red and orange light reaches underwater subjects as depth increases, these colors become progressively less evident the deeper you go. As you might suspect, the first color to disappear is red. At only 10 feet below the surface, red is considerably reduced in intensity. At about 25 feet, red is almost completely absorbed, and pure red subjects appear brownish-black. The next color to go, at about 30 feet, is orange; then yellow disappears. Greens are not completely eliminated till depths of below 100 feet. At these depths, all colors begin to appear as blue monochrome.

Above water | 30 feet—no flash | 30 feet—with clear flash

At a depth of 30 feet, the red patch on the color chart is almost black, and the orange patch no longer looks orange. Flash helps restore a natural appearance to the colors.

There is one interesting exception to the manner in which warm colors disappear as depth increases. Materials that have been treated with fluorescent dyes retain their normal hues, regardless of depths. In the photograph below, the red, orange, and yellow patches of the color chart have "lost" their colors, but the fluorescent orange glove still looks quite orange.

Interestingly enough, as you go deeper underwater, you tend to remember colors as you saw them at or near the surface and may not be aware that the warm colors are becoming less evident. However, color film doesn't make this adaptation, so the photographer may often be somewhat surprised when he sees the bluishness of his underwater pictures. (This recalls the early days of color film when photographers "discovered" that shadows on snow are blue.)

At a depth of 65 feet the fluorescent orange glove still looks orange. The fingers of the glove are on the orange patch on the color chart. The red patch is in the lower right corner of the chart.

295

Visibility

Even in the clearest water, taking your camera "below" is somewhat like going picture-taking on a very hazy or foggy day. This turbidity effect, or cloudiness, is caused by plankton and other tiny particles that are dissolved or suspended in the water. These particles form a rather dense light-scattering or light-absorbing barrier between your camera and your subject.

Visibility underwater varies considerably from day to day and from place to place. Wind conditions play an important part in the turbidity of the water. Wind causes waves on the surface which stir up sediment in the water. This reduces underwater visibility.

Divers usually discuss underwater visibility in terms of the number of feet at which the human eye can see underwater. However, for taking pictures, divide this number by 4. If visibility for large objects is 80 to 100 feet, you will get best photographic results by taking pictures of subjects no farther away than 20 to 25 feet. Obviously, when the water is cloudy, picture-taking possibilities are very limited.

This statue of Christ is in approximately 35 feet of water in Pennekamp Coral Reef State Park off Key Largo, Florida. The statue is 22 feet high.

PHOTOGRAPHIC EQUIPMENT

Now that you are familiar with some of the peculiarities of the underwater world, let's talk about the photographic equipment you'll need when you visit the briny deep to shoot pictures.

Underwater photographic equipment is available through some photo dealers. It is also available from firms which specialize in such equipment. Some of these firms are:

Upsi
10935 Overseas Highway
Marathon, Florida 33050

Giddings Underwater Enterprises
584 Fourth Street
San Francisco, California 94107

Ehrenreich Photo-Optical
Industries, Inc.
623 Stewart Avenue
Garden City, New York 11530

Sea Research & Development, Inc.
P. O. Box 589
Bartow, Florida 33830

Ikelite Underwater Systems
3301 North Illinois Street
Indianapolis, Indiana 46208

American Hydrophoto
Industries, Inc.
7251 Overseas Highway
Marathon, Florida 33050

Cameras and Lenses

You can shoot underwater pictures with almost any camera—as long as you use the camera in a watertight housing. Most simple cameras have a fixed shutter speed for daylight picture-taking (usually somewhere from 1/60 to 1/125 second) and a maximum lens opening of approximately $f/8$ or $f/11$. On a sunny day, such cameras will allow you to take pictures without flash at depths of 15 to 20 feet using a film with a speed of ASA 64, and at 30 to 40 feet using a film with a speed of ASA 160. At greater depths, you'll need to use flash (more about flash later).

Here are some good points to keep in mind when thinking about a camera for underwater work.

1. It should be simple to operate. A one- or two-stroke film advance (or automatic film advance), and a one-step operation for tripping the shutter (without the need of manually cocking the shutter) is ideal.

2. The focus and lens-opening controls on adjustable cameras should be easily accessible and visible. Generally, you'll set the shutter speed before you go below, and leave it at that setting. (I usually prefocus the lens, too—more on this later.)

3. Ideally, the camera should have a means of attaching a flash unit. You'll need flash to fill in shadows and as a primary light source at greater depths.

4. In most instances it's necessary to resurface to load film in the camera. To avoid frequent resurfacing, I like to use a camera that accepts film in at least 20-exposure cartridges or rolls (such as 126 or 135 film).

5. Because the light intensity falls off very rapidly as depth increases, a camera with a fast lens ($f/2.8$ or faster) is very desirable for picture-taking at any appreciable depths.

6. A wide-angle lens is preferable to a normal lens or a telephoto lens for underwater photography. Because of the refractive index of water,

subjects appear larger underwater than they would at an equal distance above water. A wide-angle lens will allow you to work closer to your subject and still get it "all in." This cuts down on the thickness of the "wall" of water between you and your subject, and as a result you'll get clearer pictures.

There's still another advantage of using a wide-angle lens. Since you'll usually be using large lens openings (thus less depth of field), you'll appreciate the greater depth of field of a wide-angle lens.

You can attract fish with fish "delicacies." Here I used chopped-up sea urchin. I also discovered that fish like hot dogs or ham left over from a photographer's sandwich.

Underwater Housings

Forgive me for mentioning the obvious, but the prime prerequisite for a housing for encasing a camera underwater is that it must be watertight. Watertight housings are usually made from metal (most frequently, cast aluminum), Plexiglas, or Lucite. In choosing a housing, consider size, weight, and shape. A large, bulky box is awkward to handle both in and out of water. The camera and housing should have a neutral or slightly negative buoyancy, so it will be easy to control and manipulate under-

water. The table below points out the advantages and disadvantages of the two popular types of housings.

Comparison of Metal Housings, and Plexiglas or Lucite Housings

	ADVANTAGES	DISADVANTAGES
METAL:	Greater strength Greater resistance to bumps Conforms to contours of camera Less possibility of internal reflection	Corrosion High cost Poorer visibility of camera parts
PLEXIGLAS OR LUCITE:	Reasonable cost Corrosion-proof All parts of camera visible	Scratches easily Possibility of internal reflection Less rugged than metal

If you plan to do some deep diving, it's a good idea to test your housing (when it's empty of course), to make sure it will withstand the pressures at the maximum depth of which you will be working. You can do this by attaching the weighted housing to a line and lowering it to the desired depth (or even to a greater depth for added safety). This will assure you that you won't encounter a leakage problem when you take your camera below. Also, an implosion of the housing would result if it wasn't built to withstand the pressures at great depths. An implosion would not only damage your photographic equipment but, if you are holding the camera when it happens, you may be shaken up or stunned.

Incidentally, there are some cameras designed specifically for under-water photography—they don't require an underwater housing. The ex-posed metal parts are corrosion resistant, so after a dive a good rinsing in fresh water is all the cleaning such a camera normally requires.

FILM

You can shoot underwater pictures on black-and-white or color film, but, of course, underwater subjects are much more interesting and exciting when reproduced in color.

For shooting color slides at moderate depths, I like to use KODAK EKTACHROME-X Film (ASA 64). I use this film because of its excellent contrast and because I like the saturated rendering of colors it produces. These features help compensate for the lower contrast and color saturation of underwater subjects.

KODACHROME II Film (ASA 25) is good for shooting at shallow depths where the light is good, or for shooting with flash. This film is noted for its extreme sharpness and accurate color rendition.

The great sensitivity of KODAK High Speed EKTACHROME Film (Daylight)—ASA 160—makes it an excellent choice for shooting color slides under poor lighting conditions and at great depths. You can gain additional speed through modified processing. Kodak will push-process your High Speed EKTACHROME Film (Daylight), sizes 135 and 120 only, to 2½ times the normal film speed—from ASA 160 to ASA 400. To get this service, purchase a KODAK Special Processing Envelope, ESP-1, from your photo dealer. The price of the envelope is in addition to the regular charge for KODAK EKTACHROME Processing. After exposing the film at the increased speed, put it in the envelope and have your dealer send it to Kodak for processing, or send it directly to Kodak in the proper KODAK Prepaid Processing Mailer. If you process your own High Speed EKTACHROME Film, you can increase the film speed either to 320 by multiplying the time in the first developer by 1.35, or to 640 by multiplying by 1.75. All other steps in the process remain the same. When you modify processing in this way, there is almost no color-balance shift. However, there is a slight increase in graininess and contrast. For low-contrast underwater subjects, the increased contrast is actually desirable.

Because of the great sensitivity of KODAK High Speed EKTACHROME Film, I was able to stop down to f/11 for this shot. This gave me good depth of field.

High Speed EKTACHROME Film is also a good film for all-around underwater work. Its high speed allows you to shoot at smaller lens openings to get more depth of field, or at higher shutter speeds to stop action.

Shoot KODACOLOR-X Film (ASA 80) when you want color negatives for color prints. The exceptionally good exposure latitude of this film means that you can get good-looking prints even if you slightly misjudge the exposure.

Your photo dealer can have slides made from your color negatives, or prints from your color slides.

If you want to shoot some black-and-white underwater pictures, KODAK VERICHROME Pan Film (ASA 125) and KODAK PLUS-X Pan Film (ASA 125) are excellent at moderate depths. The fine grain of these films will allow you to make very high-quality enlargements. For greater depths or when lighting conditions are poor, use KODAK TRI-X Pan Film (ASA 400) for your black-and-white shots.

FILTERS

You can use filters over the camera lens to help remove some of the bluishness in some underwater color pictures. However, since some of the light from the red end of the spectrum doesn't reach underwater subjects, you can't completely restore the reds, oranges, and yellows to underwater pictures. Neither would you want to do this if it were possible. The "cool" appearance of underwater pictures denotes "underwater."

These shots of a diver examining a red sponge were made on KODAK High Speed EKTACHROME Film (Daylight) at a depth of 65 feet. I made the first shot without a filter. For the second shot I used a CC30R filter over the camera lens, which had no effect on the color rendition. I used flash for the third shot.

301

Since red practically disappears in the first 30 feet of water, filters are useless below that depth. You can partially compensate for the lack of warm colors above that depth by using a red filter, such as a KODAK Color Compensating Filter CC30R, over the camera lens. (CC means Color Compensating, 30 refers to the density of the filter, and R means it's red.) The red filter allows light from the red end of the spectrum to pass through but holds back the blue-green light. When you use a CC30R filter, open the lens two-thirds of a stop. KODAK Color Compensating Filters are available from photo dealers. If your dealer does not have them in stock, he can order them for you.

EXPOSURE

At the beginning of this article, I mentioned that underwater photography is often difficult to "pin down" technically. This is particularly true in the area of exposure recommendations. The type of day, time of day, depth of the subject, wind velocity, amount of material and bubbles suspended in the water, and the color of the bottom all have some effect on exposure. That's why a camera with automatic exposure control is so handy in underwater work. The large number of variables also means that any data given in an exposure table, such as the one below, is only a starting point from which you should bracket your exposures. The suggestions in this table are based on a bright, sunny day, between 10:00 a.m. and 2:00 p.m., with winds blowing lightly, and with an underwater visibility of about 50 feet.

Exposure Compensation for Underwater Photography

DEPTH OF SUBJECT	NUMBER OF *f*-STOPS TO INCREASE LENS OPENING OVER NORMAL, ABOVE-WATER EXPOSURE
Just under surface	1½ *f*-stops
6 feet	2 *f*-stops
20 feet	2½ *f*-stops
30 feet	3 *f*-stops
50 feet	4 *f*-stops

If conditions are discernibly different from those on which this table is based and you are using a manually adjustable camera, I strongly urge you to use an exposure meter. You can use a meter designed especially for underwater work. Or if you have a direct-reading meter (no adjust-

ments required), you can seal it in a watertight jar if you're not going too deep. (At great depths, water pressure may break the jar.)

When you use an exposure meter, follow the same precautions you would follow above water. Don't tilt the meter upward, because the light from the sky will give you a falsely high meter reading and the result will be underexposed pictures. Even when you use a meter to determine exposure, bracket your exposures at least 1 stop on either side of the exposure indicated by the meter. If the lighting conditions are particularly unusual, bracket 2 stops on either side. At this point, film is usually your least expensive investment.

The most common shutter speeds for underwater picture-taking are from 1/60 to 1/250 second. If lighting conditions are bright enough, use 1/250 second. This speed helps eliminate the effects of camera movement due primarily to underwater currents. Faster shutter speeds would, of course, stop more action. However, a startled fish usually turns tail and swims away so fast that even at higher shutter speeds you'd probably only get a sharp picture of the northern end of a southbound fish. Your best pictures of live subjects will be made when the subject is virtually motionless—which means you'll need to practice your stalking techniques.

I think the queen angel, pictured here, is among the most beautiful of fish. The technique of approaching these fish without frightening them takes some practice. I found that if I follow them very slowly until they become accustomed to my presence, I can increase my swimming speed until I'm swimming parallel to them to make the shot. 303

FOCUSING AND AIMING

Once you have your camera in its underwater housing and have ventured below, you may find that the rangefinder and the viewfinder on your camera are useless. This is because the housing won't let you get your eye close enough to the viewfinder opening. That's why I usually prefocus my camera before I go below. When I'm going to photograph small fish, I set the focusing scale for 2 or 3 feet. For shooting larger subjects, such as people and large coral, I focus on about 6 feet. Then I shoot pictures only at the distance for which I've prefocused. Since the refractive index of water affects your eyes just as it affects the camera, judging distance doesn't present a major problem.

To help you aim the camera, most underwater housings have a sports-type viewfinder. If you don't have such a finder, just aim the camera as accurately as possible.

FLASH

You can take underwater flash pictures with flashbulbs or electronic flash. While electronic flash offers the advantages of action-stopping ability and no bulb changing, flashbulbs generally produce more light. Incidentally, flashbulbs are waterproof in themselves, and they can withstand pressures at depths well below 100 feet. Underwater flash equipment is available from those firms specializing in underwater photographic equipment.

Basket sponge illuminated solely by a blue flashbulb.

Flash has several important uses in underwater photography. You can use flash as a primary light source when there isn't enough daylight to take pictures, and as a secondary source with daylight when you want to fill in shadow areas. Flash also allows you to record the natural colors of subjects at depths where red and orange light don't reach.

Flash As the Principal Light Source

When you take underwater flash pictures, the degree of turbidity or cloudiness of the water affects the amount of light that reaches your subject and is reflected back to the film. In an average situation when visibility is good, a rule of thumb for determining flash exposure is to divide the normal above-water guide number for your film-and-flashbulb combination by 3. For example, if the normal guide number is 120, you would use a guide number of 40 underwater. Remember, while you will be focusing at the apparent subject distance, you must divide the *actual* subject distance into the guide number. The actual distance will be about 1.3 times the apparent distance. As with available-light pictures, it's very wise to bracket your flash exposures.

You may want to run a series of flash exposure tests with your equipment under various visibility conditions (you can run some basic flash exposure tests in a swimming pool). As a starting point, divide the normal above-water guide number by 3. Under good visibility conditions, bracket 1 stop on either side of the lens opening that is indicated by the guide number. Under poorer visibility conditions, bracket several stops on the larger lens opening side of the *f*-number indicated by the guide number. For your tests, make sure you maintain a constant subject distance and record the lens openings at which the tests were shot.* When you see the results, select the best exposure. Multiply the *f*-number used for that shot by the subject distance in feet to get your guide number for those visibility conditions. If, for example, you make the tests at a subject distance of 8 feet and the best picture is the one shot at $f/4$, your guide number for those visibility conditions with that combination of film and flashbulb would be 32.

Flash Used As Fill-In

Sometimes your underwater subject may include predominant shadow areas. You can use flash to lighten these areas. The light from the flash

*A good underwater note pad is the base side of a sheet of photographic paper. Just attach the paper to a clipboard and write on it with a grease pencil or a thick lead pencil with very soft lead. KODAPAK Sheet (matte), available from photo dealers, is also good for writing on under the water. Use a grease pencil to write on KODAPAK Sheet.

These shots were made at a depth of 35 feet off Grand Bahama Island. The first shot was made with available light, the second with a blue flashbulb, and the third with a clear flashbulb. The choice between blue and clear flash for underwater photography is often a matter of personal taste.

should not overpower the daylight. If it does, the background will be much darker than the subject. Obtaining good balance between the flash and the daylight could become very involved. However, since I'm not an engineer, I take the easy way out. First I determine what the lens opening should be for the available daylight, just as if I didn't plan on using flash. Then I adjust my flash-to-subject distance so that the lens opening for flash is equal to that required for the daylight: To find what the flash distance should be, I simply divide the lens opening for the daylight exposure into my flash guide number. The answer is the flash distance. For example, suppose the daylight exposure is 1/60 second at f/5.6. If my guide number is 32, I divide 5.6 into 32, and the answer is approximately 6. So, I shoot with flash at a distance of 6 feet. As a result, the shadows are filled in, and the background will approximately retain its normal brightness relationship to the subject.

Incidentally, the thought processes seem slower and more difficult underwater than above. For this reason, if at all possible, make calculations such as those mentioned above *before* you dive.

Clear or Blue Flashbulbs?

When you use flash with Kodak color films above water, you should use blue flashbulbs or electronic flash (except with those films designed for use with studio or photolamps). However, in underwater photography, personal taste may dictate an exception to this rule. If you're using flashbulbs to shoot pictures of subjects beyond 5 feet, you may want to use clear bulbs. The filtering effect of the water will absorb the additional warm light of the clear bulbs, and your pictures will be less bluish than they would be with blue flashbulbs. At distances of less than 5 feet, when there is less water between you and the subject, use blue flashbulbs. The examples on page 306 show the results obtained with available light, clear flash, and blue flash.

You can make convenient flashbulb holders like these by sewing pockets in elastic bands. I carry blue bulbs on the left and clear bulbs on the right.

Since the light from electronic flash is about the same color as blue bulbs, distant shots made with electronic flash will tend to be slightly bluer than those made with clear flash.

Position of the Flash Unit

The position of the flash unit on the camera will have an effect on the quality of your underwater flash pictures. If the flash is used close to the camera lens, you will probably encounter a situation known as "backscatter." Backscatter occurs when light from the flash strikes particles of suspended material in the water and reflects back into the camera lens. The illuminated particles close to the camera appear as white, out-of-focus spots in the finished picture.

You can help avoid backscatter by mounting the flash unit on a 12-to 18-inch arm positioned at about a 45-degree angle forward from the camera (see the camera I'm holding in the picture on the first page of this article).

This is an example of backscatter, which can occur when the flash is close to the camera lens or when the water is full of suspended material.

SNORKELING, TOO

If you're a "snorkeler" and not a scuba diver, please don't feel left out. You can have lots of fun and shoot good underwater pictures, too. Your picture-taking will just be confined to a more limited territory.

ABOVE ALL, SAFETY FIRST!

If you're an experienced diver, you know that it's impossible to overemphasize the importance of playing it ultra-safe when you dive. You're out of your natural element when you're underwater, so you must know and practice the safety rules of diving. If you're not an experienced diver, the surest and safest way to learn these rules is to take an accredited scuba-diving course from a certified instructor, such as those sponsored by the YMCA.

MORE INFORMATION

For the photographer who is interested in the scientific and technical aspects of underwater photography and photogrammetry, Kodak has prepared a bibliography containing nearly 300 references. You can get a copy by writing to Eastman Kodak Company, Department 412-L, 343 State Street, Rochester, New York 14650. Ask for *Bibliography on Underwater Photography and Photogrammetry,* KODAK Pamphlet No. P-124.

For more information on underwater movie-making, read *Home Movies Made Easy,* AW-2, available from your photo dealer.

A special word of thanks must go to my diving buddy, Earl Clark of Kodak's Film Testing Division, for his contributions to this article. Earl did a large share of the testing related to underwater exposure and the "loss" of color.

As a correspondent-photographer during World War II, Frank Pallo, FPSA, photographed such historic events as the rocket bombings in London and the Nuremburg War Crime Trials. Before joining Kodak in 1947, Frank operated a portrait and commercial photo studio. Today Frank is a well-known lecturer and teacher, and is the Coordinator of Special Events in Kodak's Consumer Markets Division. He has presented his idea-inspiring slide shows throughout the United States and Canada. Frank also served as host of the TV series "Let's Take Pictures."

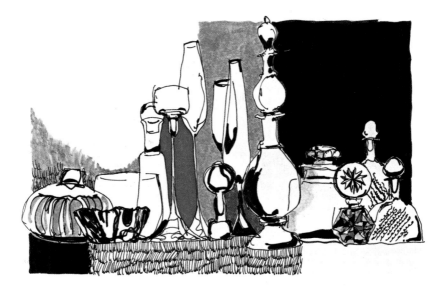

A Galaxy of Glassware

by Frank S. Pallo

If a "Here's How" article on photographing glassware authored by Frank Pallo sounds a bit familiar to you, you're not dreaming. I've been here before. Which just goes to show you, we all keep on learning. Since I wrote "Colorful Glassware" on page 25, I've continued to experiment and have learned a lot more about glassware photography. Armed with my new glassware setup, new ideas, and new pictures, I knocked on the door of our Publications group, and they let me in!

Many photo enthusiasts consider photographing glassware to be one of the most challenging and exciting areas of photography. Because you can photograph glassware in daylight as well as with indoor lighting arrangements, the opportunities are virtually unlimited. Just remember that the prime key to success is the lighting.

310

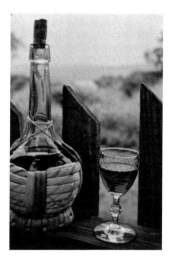

The top portion of a picket fence served as the support for this simple arrangement.

A slow shutter speed of 1/10 second with the camera on a tripod produced this "frozen" water setting. In this instance I shot on a sunny day to obtain sparkling highlights.

Pick a cloudy day and place the glassware on the roof of an automobile.

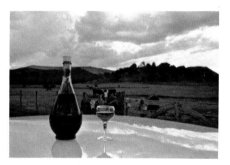

OUTDOORS

When I photograph glassware outdoors, I like to shoot on hazy or overcast days. On these days the lighting is soft and diffuse. Consequently it isn't necessary to use reflectors to fill in dark shadows, and you aren't troubled by bright reflections of the sun. But regardless of the type of lighting, always be especially aware of the way the lighting affects the subjects you photograph.

Begin by placing your glassware on supports such as fence posts or roofs of automobiles, or in shallow streams of water. Before you snap the shutter, examine the objects from every possible angle and choose the best point of view. Make sure that the highlights and shadows separate the glassware from the background.

311

AN INDOOR SETUP

Indoors, using a tabletop setup similar to the one illustrated below is a very versatile way to achieve variety of lighting and subject arrangements. The opal glass is necessary for all of the pictures made with this setup; the use of textured glass is optional, depending on the effect you desire.

For lighting, I prefer spotlights rather than floodlights. The concentration of light that you get with a spotlight is essential for creating good highlight and shadow effects, and for producing halo effects with all types of glassware. The illustrations on page 313 show the dramatic difference between floodlight and spotlight illumination. When you are arranging your lights, as well as when you shoot the picture, turn off all the other lights in the room.

TABLE TOP SETUP FOR PHOTOGRAPHING GLASSWARE

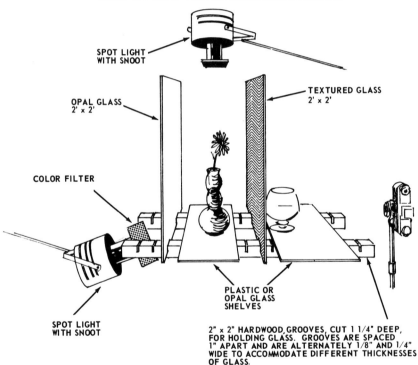

SPOT LIGHT WITH SNOOT

OPAL GLASS 2' x 2'

TEXTURED GLASS 2' x 2'

COLOR FILTER

PLASTIC OR OPAL GLASS SHELVES

SPOT LIGHT WITH SNOOT

2" x 2" HARDWOOD, GROOVES, CUT 1 1/4" DEEP, FOR HOLDING GLASS. GROOVES ARE SPACED 1" APART AND ARE ALTERNATELY 1/8" AND 1/4" WIDE TO ACCOMMODATE DIFFERENT THICKNESSES OF GLASS.

Arrange your setup so that the front side is near the edge of a table. This will allow you to place your camera in the best position for attaining good composition and lighting effects. For most of my glassware pictures, I use a low camera angle, with the lens almost level with the opal-glass shelf. The low angle de-emphasizes the separation between the shelf and the back-

For the top shot I used photo-lamp illumination. For the shot below I used two spotlights for more dramatic results.

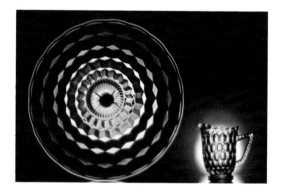

ground, and helps emphasize the size and shape of the objects being photographed.

A big advantage of this setup is that it gives you the opportunity of lighting solid objects that are placed behind the textured glass. Although the sketch shows a spotlight above the subject being photographed (as well as another spotlight behind the opal glass), it's often necessary to aim the light from the side of the setup instead of above it. For example, because the stem of the day lily in a dark vase was curved, I had to light the flower

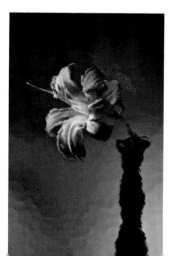

You can create "etched" effects by photographing subjects behind textured glass.

313

from the side. When you photograph subjects like this, make sure that the beam of light doesn't "spill" onto the textured or opal glass. If it does, you'll get a flare effect similar to the effect you'd obtain if you aimed your camera into the sun.

The textured glass is available in a wide variety of designs and can be cut to practically any size you need. I've found that a sheet of glass 2 feet square is ideal for most of the objects I photograph. The square format is especially desirable for glass that is fluted or ribbed, because you can place it vertically or horizontally and still cover the same area.

Some of the textures are quite coarse, and therefore more suitable for backgrounds. Others are fine enough to place in front of objects for an "etched" effect. The first picture in the series below shows the result of placing wine glasses and a wine bottle in front of the opal-glass background. The remaining pictures in the series were made by positioning glass of various textures between the wine glasses and the wine bottle.

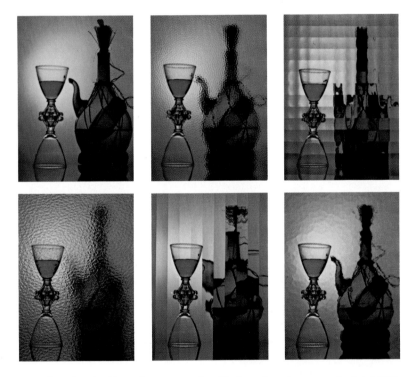

The first shot in this series was made with the wine glasses and wine bottle in front of the opal-glass background. The other shots were made with various types of textured glass placed between the wine glasses and the wine bottle.

314

A decorative "grid" with various colored filters taped to the openings.

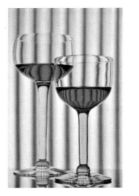
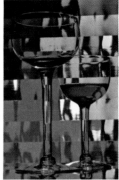

Two versions of the same arrangement. The one on the right was made with the multi-colored grid in back of the opal glass.

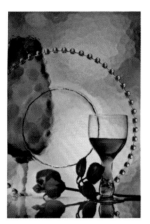

For a gradual blending of the colors in the grid, move the grid closer to the light source.

Most of the time you'll probably photograph the objects in their natural color against a plain or textured background. This is especially true if the glassware or liquid in the glassware provides all the color you need. If you want more color, you can place colored plastic or glass filters over the light source. If you prefer a multicolored background, purchase a decorative grid from a local building supplier, hardware store, or upholstery shop. Then tape various colored filters over the openings. These grids are usually made of plywood ⅛ inch thick and are used to decorate room dividers, hi-fi speaker cabinets, etc.

You can tape the filters to the grid at random, or you may want to select a combination of colors which would be particularly effective for a specific subject. In either case, position the grid between the background light and the opal glass. For a brilliantly colorful abstract effect, place the grid close to the opal glass. For a more gradual blending of colors, move the grid closer to the light source.

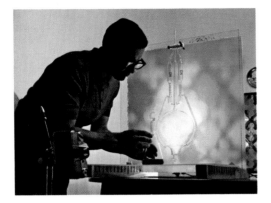

Here the author uses his setup to take creative photographs of glassware borrowed from a chemistry lab.

SHOOTING THE PICTURE

For my indoor shooting, I use KODAK High Speed EKTACHROME Film (Tungsten) or KODACHROME II Professional Film (Type A). Since extremely accurate color rendition is rarely a factor in photographing glassware I use either of these films with 3200 K or 3400 K tungsten lamps.

My camera is a single-lens reflex with a built-in exposure meter. I make the meter reading from the shooting position. Because I work close to my subject, the meter isn't affected by the dark area surrounding my setup. Since it's often desirable to render the scene somewhat lighter or darker than normal, it's a good idea to bracket your exposures. A great deal of time and effort often goes into a setup, and bracketing the exposures will help insure successful results.

"Wine" was made by diluting red food coloring with water. Notice how the tight cropping kept all the necessary elements in a pleasing arrangement.

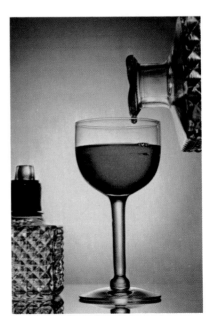

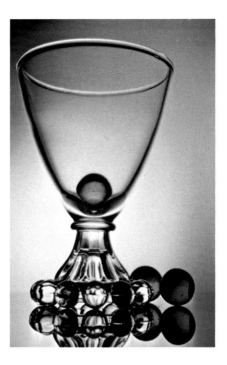

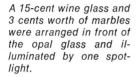

A 15-cent wine glass and 3 cents worth of marbles were arranged in front of the opal glass and illuminated by one spotlight.

Most of your glassware pictures will be made at relatively close subject distances. The closer you get to your subject, the smaller your depth of field becomes. Consequently, I always use a lens opening of $f/16$ or smaller to capitalize on the additional depth of field obtained with small lens openings. When you're using close-up lenses, extension tubes, or extension bellows, pay close attention to the instructions the manufacturer provides with the equipment. These instructions usually include depth-of-field tables. Be sure you have enough depth of field with your setup to include your entire subject.

MONTAGES

Because most glassware is transparent, slides of glassware lend themselves beautifully to producing montages. This simply involves combining two pictures to make one composite. Making a composite, or montage, with color slides is amazingly easy and effective. The transparencies should be slightly overexposed, which is another good reason for shooting an exposure series. When you select the slides you want to combine, remember that the composite should look like one slide, so judge the brightness accordingly. Since the glassware will be the dominant center of interest in the montage, the glassware shot should be a bit more dense than the background slide.

A New York City street scene and a glassware display in Corning, New York, were combined to produce a montage that appears to be a single photograph taken through a store window.

For this montage I used a close-up of a cut-glass leaf pattern to provide the background for the shot of the wine glass.

After you've selected the two slides you want to combine, remove them from their cardboard mounts so that you can remount them together in one mount. You can glass-mount your slides easily and quickly by using KODAK Slide Cover Glass 2 x 2-inches, KODAK Masks for Glass Slides, and KODAK Metal Binders (all available from photo dealers). If you prefer cardboard mounts, KODAK READY-MOUNTS let you do the job in seconds. Presto—you've created your first montage masterpiece!

I hope these words and illustrations will inspire you to make the most of the unlimited photographic opportunities that glassware offers. Your inventive curiosity and the suggestions in this article can serve as a foundation for building new ideas. I think you'll be amazed at how quickly your artistic ability will take charge.

Jack Streb, APSA, is Director of Still Photography Product Planning for Kodak's Consumer Markets Division. He has written articles on scores of photographic subjects and has taught photography to such diverse groups as airline hostesses, National Park Rangers, magazine writers, and adult camera clubs. He has presented his slide and movie programs to over 100,000 people in personal appearances in the U.S. and Canada.

Photography from the Air—
Then and Now

by Jack M. Streb

"Here's How" aerial photography got started, how it's used today, and how you can get better pictures next time you climb aboard a commercial airliner.

It was a December morning in 1858. On the outskirts of Paris, a discouraged French photographer named Nadar eyed the sagging envelope of an aerial balloon. For months, Nadar had tried without success to make pictures of the earth from his swinging basket under the balloon. Now, almost out of funds and with barely enough hydrogen sulfide in the envelope to lift him off the ground, he decided to try once more. He climbed into the wicker basket and shed his overcoat, his vest, even his shoes, to lighten the load. Slowly the swaying rig ascended to a height of 80 meters, and Nadar tried again.

319

"Trying again" was roughly like trying to thread a needle while riding a surfboard. To begin with, a photographer in those days had to make his own "film" by coating a glass plate with collodion and potassium iodide. In darkness he had to plunge the tacky plate into a solution of silver nitrate. Then he had to expose his plate immediately, before the chemicals dried. In fact, the whole sequence of sensitizing, exposing, and developing in iron sulfate had to be done within 20 minutes. Wherever the photographer worked, he had to have a darkroom with him. So Nadar built his darkroom into the gondola of a balloon!

"From the balloon's hoop," he wrote, "is hung the tent, proof against the least ray of light, with its double orange and black envelope and its little skylight of non-actinic yellow glass which gives me just enough light. It is hot inside it, for the operator and the operations, but our collodion and other chemicals are unaware of that, because they are plunged in baths of ice."

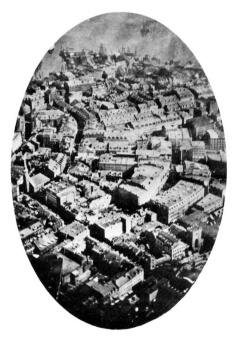

The world's oldest existing aerial photograph—made over Boston, Massachusetts, on October 13, 1860, by James Wallace Black. (Courtesy Library of Congress)

After Nadar made his exposure, ropes tugged him and his balloon out of the sky, and he rushed to a nearby inn to develop his picture. "I urge, I force," the Frenchman wrote, "the image appears little by little, very weak, very pale. But sharp, definite." Man had just made the world's first aerial photograph.

320

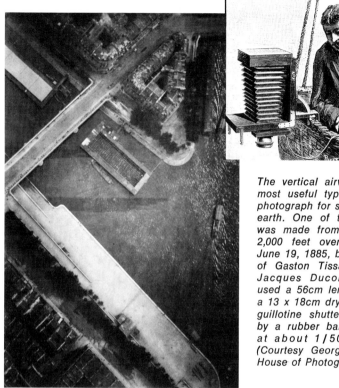

The vertical airview is the most useful type of aerial photograph for studying the earth. One of the earliest was made from a balloon 2,000 feet over Paris on June 19, 1885, by the team of Gaston Tissandier and Jacques Ducom. Ducom used a 56cm lens to cover a 13 x 18cm dry plate. The guillotine shutter, powered by a rubber band, worked at about 1 / 50 second. (Courtesy George Eastman House of Photography, Inc.)

But the world wasn't very impressed. For years aerial pictures were little more than a novelty. Pictures were made from balloons, kites, rockets, even from small cameras strapped to pigeons. But the whole business was risky and cumbersome; its results, uncertain.

Even so, practical uses for aerial pictures began to evolve. It became apparent that aerial pictures provided data of incomparable precision for mapmaking. By dividing the height of a camera above the earth by the focal length of its lens, cartographers got a scale of reduction that let them determine, within inches, the size of objects on the ground.

In 1906, George R. Lawrence made some aerial "news" pictures of San Francisco stricken by earthquake and fire. Using a giant camera suspended from 17 kites, Lawrence exposed negatives measuring 18¾ x 48 inches—among the largest ever to be taken from an airborne vehicle.

But before aerial photography could enjoy any real stature and usefulness, three factors had to be brought together: the airplane, improved films, and a real need for aerial pictures. As we'll see, World War I combined all three.

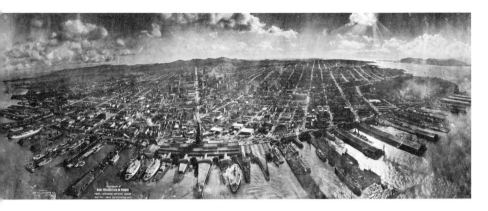

San Francisco lies in ruins after the earthquake and fire of 1906. George R. Lawrence made a series of aerial pictures by suspending a large camera from a battery of 17 kites he called a "captive airship." Detail in this picture is remarkable. (Courtesy Library of Congress)

PICTURES FROM AIRPLANES

The first pictures taken from an airplane were probably made by a Frenchman whose name is now lost to history. We do know that this unheralded pioneer made his pictures over Camp d'Avours, an artillery range 7 miles east of Le Mans, France. At the controls of his flimsy craft was the renowned Wilbur Wright himself, trying to sell the French on his crazy idea that machines heavier than air could stay aloft.

The first aerial movies were also taken from Wilbur Wright's plane by a Pathé cameraman named Bonvillain. Early aerial movies provided breathless footage for audiences of the time. By 1910, airplanes could fly 67 miles an hour. At the low altitudes attained in those days, the ground slipping by in a blur gave a greater impression of headlong speed than that experienced by today's jet passengers.

AERIAL PHOTOGRAPHY GOES TO WAR

By 1914, most of the pieces were in place. The airplane had developed remarkably in a very short time. In Rochester, New York, a young bank clerk named George Eastman had formed a company called Kodak, which found a way to make flexible film. (This made possible film in rolls, which meant that many pictures could be made on a single flight. Flexible film also made modern motion pictures possible.) Finally, the war was to prove a tremendous stimulus to aerial photography.

At first, few people recognized the value of aerial reconnaissance to a nation at war. Today we accept rather casually the existence of aerial pho-

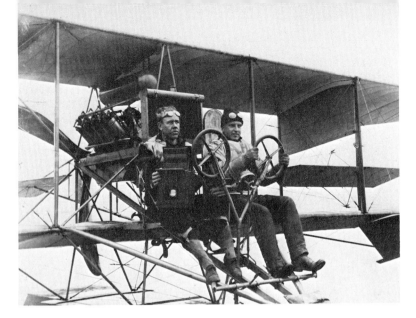

Aerial photography was simple and direct during the early days of World War I. The photographer, holding a Graflex camera, and the pilot are in a Type AH-14 plane at Pensacola, Florida. It's December, 1915, and America has not yet entered the war.

tographic systems that can resolve objects the size of a basketball from miles in the sky. Aerial surveillance is so much a part of modern defense systems that it's hard to believe that military men rejected the idea at the start of World War I. (By the way, it's often been said that aerial pictures were made during the Civil War, but there is no evidence that this ever happened.)

Early in World War I, enthusiastic British fliers carried their own cameras aloft and made maps of the trenches from the resulting photographs. The official view was that "... trench maps are not within the sphere of the Royal Flying Corps." This attitude changed very quickly as the value of cameras with wings became apparent. When the United States joined the conflict, Kodak established a school of aerial photography in Rochester for the Army. During 1918, a total of 1,995 men graduated from the school. (One of them, a young lieutenant named Albert Chapman, was later to become chairman of Kodak's board of directors.)

Kodak contributed not only knowledge but improved technology to help end the war. When vital chemicals from Germany became unavailable, for example, Kodak synthesized new ones so that panchromatic films (which "see" all colors) could be made. Millions of aerial photos were made during the Great War, and the usefulness of the science was firmly established.

BETWEEN THE WARS

During the two decades between world wars, the new skills of aerial photographers were put to more peaceful uses. Lumber companies measured the amount of timber in a given area by means of aerial pictures. Mining companies "prospected" with pictures, and cartographers surveyed unmapped areas through the camera's airborne eye.

And all the while, the tools kept improving. Newer and better cameras were built. By 1930, Kodak scientists, using new sensitizing dyes, had increased the sensitivity of films to light by a factor of 2½ times; by 1938, the sensitivity was quadrupled. Also, by 1938 color came on the scene when some of the first professional color pictures were made from the air over Alaska.

WAR AGAIN

As war clouds gathered again in the late 1930's, there was another spurt of interest in aerial photography as an intelligence-gathering tool. Again, Kodak scientists put their skills to work and created all sorts of new films: fast emulsions for low-light levels, film for detecting camouflage—whatever the need, men worked to fill it. The many uses of aerial cameras in World War II are well-known and far too extensive to be retold in these pages.

In Korea, as in World War II, aerial cameras provided an eye in the sky. By the 1950's, aerial films had reached a sensitivity about 4 *million* times as great as the early films.

A TOOL OF PEACE

Today, aerial photography is a tool of peace. It is used in helping to locate mineral resources, determining soil fertility, finding water, and helping to locate roads and cities.

The parched little country of Kuwait, for instance, used aerial pictures to help find water. For years, water had been hauled in small boats called dhows. A dhow would sail 50 miles up the Persian Gulf to the Tigris or Euphrates River, and then take on water by pulling a plug in the bottom to flood the hold. Back in the city, water was sold by the goatskinful.

Eventually an aerial mosaic photograph helped ground water experts pinpoint locations for new wells. A vast supply of new water was found, and is now being pumped at one-seventh the cost of distilling sea water.

Ground surveys are impossible in some parts of the world because of jungles, mountains, and rain forests. Aerial mapping provides the information needed.

The location of Brazil's new capital city of Brasília was selected after an exhaustive survey of five potential sites to evaluate such things as soil con-

*Top: An area south of Syracuse, New York, photographed on a Kodak aerial color film.
Bottom: The same area exposed on a Kodak aerial infrared film. Plants containing chlorophyll appear red or magenta on this film, which is used for making forest inventories, detecting plant diseases, and identifying water pollution.*

ditions, water supplies, and transportation facilities.

The uses of aerial pictures are steadily increasing. State and local governments plan highway construction, utility companies survey right-of-ways for transmission lines, and factories take inventory of their stockpiles of coal, sulfur, and iron ore—all with the help of aerial photography.

HOW ABOUT YOU?

Whatever you do, wherever you are, you benefit from the results of aerial pictures. If you're like most people who use commercial planes, you probably enjoy shooting some of your own aerial pictures when you get the chance on a vacation or business trip.

You can take pictures of sights even the birds haven't seen: a dazzling sea of billowing white clouds *beneath* you; the vivid blue-black of the sky 6 miles up, set off by the gleaming silver wing of your jet; the sun setting

You get your best chance at shooting familiar scenes just after takeoff and just before landing, when your airliner is at lower altitudes than during the flight. Don't let the camera touch the window, and make sure your lens isn't obstructed by the window frame.

into a bank of purple clouds, radiating orange and red streaks through the tiny scratches on the plane's window.

Next time you fly, remember that your pilot may have used photos from an orbiting weather satellite to help plan the smoothest flight route. And when you get ready to make your own pictures, here are some tips to help you get good results.

1. Select the right seat—if you can. The "right" seat is near a window, preferably on the shady side of the plane. You'll have a better view of the ground if you're in front of or behind a wing, not right over one.

2. Set the camera before you take off. If your camera is automatic, or has no settings, you have nothing to do. Just shoot when the time comes. If your camera has adjustable focus and lens openings, set the focus at 50 feet. (That will keep the wing fairly sharp but will throw any dirt on the window out of focus.) Set still-camera shutters at 1/250 second (or whatever shutter speed your camera has that's close to it). Then pick the lens opening to go with that speed from the instruction sheet packaged with your film. For shooting movies during takeoff, use 24 or 32 frames per second, if you have that speed—with the right lens opening for your film. If your movie camera has only one speed, fine. Use it.

3. When the plane leaves the ground, start shooting anything that looks interesting: runways, skyscrapers, farms—almost anything looks unique from this viewpoint. *Two important cautions:* Don't brace your camera against the window. Vibration might blur your pictures. And, make sure

The earth photographed from Apollo 8 during its first lunar orbit. The moon was only 70 miles below; the earth was about 240,000 miles away. On the earth, north is at right, with the line that separates day and night bisecting Africa. (Courtesy National Aeronautics and Space Administration)

327

From 19th century balloons to 20th century rockets: the Near East as seen from the Gemini XI spacecraft. The United Arab Republic (Egypt) is in the foreground. The triangular-shaped area is the Sinai Peninsula. It is separated from the Arabian Peninsula by the Gulf of Aqaba (right center). (Courtesy National Aeronautics and Space Administration)

the *lens* is not obscured by part of the window frame. (Sometimes the *viewfinder* is looking out the window, but the lens isn't!)

4. When you're up high—more than a mile—things look brighter. Use a lens opening 1 stop smaller than you'd use on the ground (*f*/11 instead of *f*/8, for example). Try to include the wing in the foreground to add depth and interest to your pictures. Lots of pictures of the ground from around 30,000 feet will be, frankly, rather dull. When you shoot pictures of the ground from great heights, you may run into a haze problem—color slides and movies look bluish from ultraviolet radiation. A skylight filter over your lens helps a little, if you have one.

5. Pilots often make a special effort to identify and fly close to famous places like Niagara Falls and the Grand Canyon. Shoot them! Other good subjects to look for: farms and woods early or late in the day when shadows are long and the light is a warm orange; snowcapped mountains; city skylines at takeoff and landing; and ships, rivers, and harbors.

Follow these tips, and chances are you'll get some very enjoyable pictures. And, as you sit back in the soft cushions of your seat, enjoying a meal at several hundred miles an hour, think of that crazy, barefoot Frenchman dangling under a balloon over Paris. He'd be surprised at what he started.

We're indebted to Mr. Beaumont Newhall, past Director of the International Museum of Photography at George Eastman House, for his help with the historical sections of this article. Mr. Newhall has written a fascinating book on the history of aerial photography, *Airborne Camera: The World from the Air and Outer Space,* published by Hastings House.

John Brandow is a Supervising Photo Specialist in Kodak's Photo Information department. His vast photographic background includes work in film testing and analytical sensitometry, as well as in salon photography. He has had hundreds of his photographs accepted in domestic and international photographic exhibitions. He is a well-known photographic judge and has taught many classes in photography. John's first love is nature photography, and he has presented his intriguing shows on this and other photographic subjects throughout the United States.

Photography of Insects

by John F. Brandow

The world of insect photography is small only in terms of the size of the subjects. This fascinating area of photography presents a virtually endless variety of subject material. The insect kingdom comprises about one million *identified* species, and one authority has said that this number represents only about 10 percent of the total number of species in existence. So you see, when you and your camera begin exploring the insect world, you aren't likely to run out of subjects!

KNOW YOUR SUBJECT

Let's begin with a few conversation stoppers. Did you know that insects don't grow after they acquire wings? Alas, a little fly doesn't grow up to be a big fly! Did you know that an insect never has more than three pairs of true legs? Did you know that some dragonflies have 28,000 or more "single

329

eyes" in a compound arrangement? I'm sure you could go through life without knowing these little bits of trivia, but this kind of knowledge may be useful when you're planning to photograph insects. Many moons ago, when I was just getting started in insect photography, my photograph for a camera club "insect competition" was disqualified because my subject had four pairs of legs. Turned out it wasn't an insect!

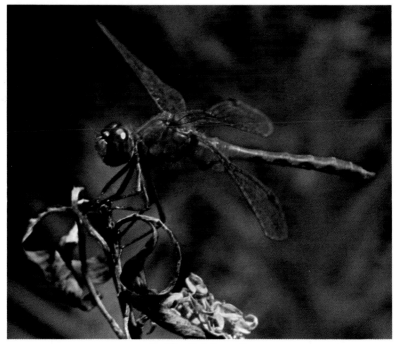

Red-bodied dragonfly.

This is only one rather minor reason for knowing something about the subject. More importantly, knowledge of the basic functions and habitats of insects will help you to locate and photograph them. For example, it's much easier to get a picture of an emerging annual cicada if you know the approximate time of year this event occurs in your area. (Local entomologists or botanists, or your State Conservation Office, can usually give you this and other information about insects in your area.) Also, if you know that dragonflies usually live along the edges of ponds, you won't spend time looking for them above the timberline. Almost any public or school library will have some books on entomology, and many bookstores have a selection of good books on the subject. Here are several books I've found useful:

Lutz, Frank E., *Field Book of Insects,* 3rd ed. New York, G. P. Putnam's Sons, 1948.

Mitchell, Robert T., and Zim, Herbert S., *Butterflies and Moths.* New York, Golden Press, 1962.

Zim, Herbert S., and Cottam, Clarence, *Insects.* New York, Golden Press, 1951.

THE EQUIPMENT YOU'LL NEED

You can use almost any camera for photographing insects. However, a single-lens reflex camera makes the project easier and more precise. With an SLR you view the subject through the camera lens; consequently, parallax is eliminated. Also, if the subject appears in sharp focus in the viewfinder of this camera, it will be in sharp focus in your picture. With a non-reflex camera, you can use a focal frame or another kind of measuring and framing tool, but these devices may sometimes disturb your subject. With either type of camera you'll also need a close-up device (like a close-up lens or a lens-extension device) so that you can take pictures at the very close subject distances necessary in insect photography.

For lighting, I prefer using electronic flash, even for my daylight shots. I use two small portable units, each of about 1,000 BCPS. Of course, two regular flash units will do the job, too, and many fine shots have been made with only one flash unit or with the sun serving as the only light source. However, the extremely brief burst of light from electronic flash offers the advantage of "stopping" action. At the close flash-to-subject distances used in insect photography, the light on the subject is so bright that you can use a small lens opening. With an X sync leaf shutter, you can also set your camera at its fastest shutter speed. For example, with KODAK EKTACHROME-X Film and with my main light about 2½ feet from my subject, I shoot at 1/500 second at $f/22$ (more on lighting and exposure calculation later). In this situation, almost all of the light for the exposure comes from the flash, and almost none from the daylight. Consequently, the short duration of the flash helps "stop" the action. In addition, the background goes quite dark, and the insect stands out in contrast. (In other situations you may want to use a black cloth or paper backdrop to assure a dark background.)

I also carry a small reflector that I made by gluing crumpled aluminum foil to a piece of cardboard about 1 foot square. The only other equipment you need is a tripod, a cable release, and film. While insects make excellent subjects for either black-and-white or color film, the colorful nature of many of the subjects will "scream" for color film.

THE SETUP

I try to work with the same basic setup whether I'm shooting outdoors or indoors. Except in a "shoot now or never" situation, I always use my camera on a tripod and trip the shutter with a cable release. Because of the limited depth of field in extreme close-ups, it's best to position the camera with the lens parallel to the plane of the insect. Also, the limited depth of field makes accurate focusing a must.

Author photographing a cecropia moth.

My basic lighting setup is illustrated in the diagram below. Of course, the diagram represents only a starting place. Individual situations almost invariably require some shifting of the lights. I base my exposure on the distance from the *main* light to the subject.

I usually use a reflector, even with the two electronic flash units. A reflector is indispensable for filling in the shadows when you use only one flash or when you're shooting with the sun as your only light source.

The distance from the fill light to the subject should be about 1.7 times the distance from the main light to the subject. I usually have the fill light at about camera height, and the main light about a foot above camera height.

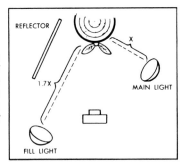

SHOOTING IN THE FIELD

There are two major approaches to insect photography: "grab shooting," which is sometimes necessary in the uncontrollable situations of the field; and controlled setups, which are often more feasible around home. Top-notch pictures are possible in both situations. However, the percentage of good pictures is usually higher when you have control over the subject, the

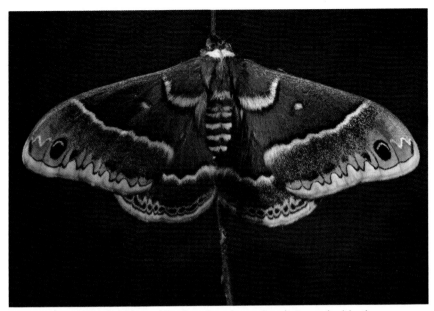

Subjects such as this gloveri moth can be photographed in the field or home.

lighting, and the background. Some picture subjects, such as mating damselflies, can be photographed only in the natural surroundings of the field. Other subjects, like moths or butterflies, can be photographed just as easily in your basement or kitchen as in the field.

But now, let's pack our gear and go into the field. When possible, try to photograph insects in the field on warm, sunny, and preferably windless days. That's when insects are most active and when you're likely to find more of them.

Do you know what helps attract insects such as butterflies and bees? Bright, colorful clothing and sweet aromas, such as colognes and perfumes. In the field, pleasant aromas are a definite lure to insects. Of course, bees can sometimes be a nuisance. If a bee starts flying around you, try to ignore it (don't swing at it), and chances are it will go away.

Bees and butterflies on colorful flowers are excellent picture subjects. Perhaps you'll even be fortunate enough to discover a hummingbird moth. Although moths are nocturnal by nature, the hummingbird moth is one exception. A nectar feeder, he has a fast wingbeat and hovers very briefly at the flowers he visits. If you are fortunate enough to find this fellow at the same location on several occasions, you've probably discovered his daily flower-visiting pattern. In situations like this, you might want to set up a remote release for your camera, such as the one described on page 8.

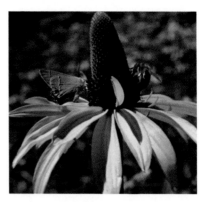

Bees and butterflies on colorful flowers make good picture subjects.

EMERGENCE OF AN ANNUAL CICADA

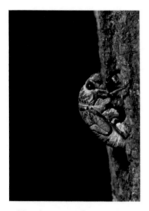

Cicada nymph on tree. Nymph has just emerged from ground.

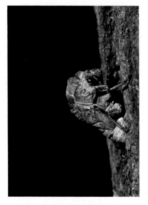

Nymph case begins to split.

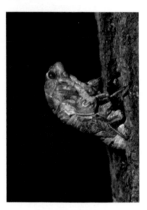

Immature wings still held by nymph case.

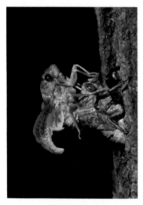

Halfway out.

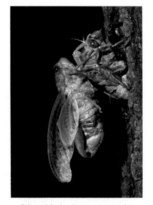

Blood is being pumped into wings to fully form them.

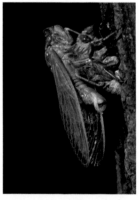

Wings are full and dry. Cicada is ready to ascend tree.

In the early mornings of the hot summer months, watch for the nymph stage of the annual cicada. During these months the full-grown nymph emerges from the ground and crawls up on rough-barked trees. Then the skin splits, and the winged adult insect emerges. This is a fine opportunity for you to shoot a sequential picture series. Fortunately, the insect will be easy to approach in this stage of metamorphosis. A side view will give you the best angle for covering the action. It's important to remain calm and patient, since total emergence of the insect may take from 20 minutes to more than an hour.

Insects are also rather easy to approach when they are mating. This usually occurs in spring and early summer. An interesting phenomenon to photograph is the mating of damselflies. These insects pair to mate and lay their eggs. In pairing, the male fastens the pincers located on his posterior around the neck of the female. Mating often occurs on reed stalks near the edge of a pond or similar bodies of water. Be cautious as you set up to take your pictures—one bump, and your subjects may make a quick exit. Since the eggs are laid almost immediately after fertilization, you may also be able to photograph the eggs as they appear. Using flash will produce beautiful lighting on the luminous wings of the insects. The result should be some great nature shots.

So as you walk through the fields and the forest, and along the water's edge, keep a keen eye peeled for insects. Take a close look under stones, tree bark, and logs. Also, as you do your research on insects you'll find that many specific plants attract insects. One of these is the milkweed. You may well find the eggs of a monarch butterfly deposited on the underside of a milkweed leaf. The life cycle of the monarch is enacted on this plant.

An insect picture-taking field trip can be an interesting, thrilling, and photographically profitable experience.

335

Paired damselflies. *Mating damselflies.*

*Even common insects, such
as ladybugs, make interesting
and colorful picture subjects.*

SHOOTING AT HOME

Insect photography in the home requires patience, too. However, since you can completely control the lighting and background and since breezes are eliminated, shooting indoors is a little easier.

Moths and butterflies are good indoor subjects. You may find a cocoon, or chrysalis, in the field and bring it home to be photographed. You can also purchase cocoons and insect eggs commercially. Here are several sources:

Butterfly Company
291 East 98th Street
Brooklyn, New York 11212

John Staples
275 Colwick Road
Rochester, New York 14624

Bruce Pulsifer
Cherry Tree Hill
Benson, Vermont 05731

If you have insect eggs, you must feed the larvae after they hatch. Acquaint yourself with the particular food eaten by the larvae through the various molts. Cecropia moth larvae, for example, favor leaves of wild cherry trees (they'll also eat willow leaves). These moths have ravenous appetites. You can actually hear them crunch away as they enjoy their almost continuous "lunch."

To take the picture, you can glue or otherwise fasten the cocoon, or chrysalis, to a branch. Be sure you don't use glue that contains solvents or other chemicals that may kill or malform the pupa in the cocoon. I usually use white liquid glue or a bit of very fine thread. Position the cocoon against an appropriate background. As a background, I use the branches of a tree or shrub, or a backdrop that I paint myself. (You don't have to be an artist to paint a satisfactory background because it will usually be dark and out of focus in your picture.)

I sometimes store the cocoons in the refrigerator until I want to photograph them. Emergence won't occur until after they're taken out of cold storage. The time between removal from the refrigerator and emergence will vary from one week to several, depending on the species. Emerging insects frequently put on their "escaping" act between about 8 and 10 a.m. One way to forecast an approaching emergence is to shake the cocoon gently. If you can't hear any movement of the pupa, emergence is probably imminent.

Cecropia larvae.

Female cecropia.

Emergence *may* be preceded by a moist condition on the end of the cocoon. However, the precise moment of emergence is impossible to predict, and unless you are able to keep a rather constant watch over the cocoon, the next phase of this cycle that you see may be the complete butterfly hanging from your cable release. I think it's wise to have several cocoons of the same species on hand. When one butterfly emerges, you'll know that the others won't be far behind. In the words of my wife (and someone else before her), "patience is a virtue." Anyway, the results are certainly worth waiting for.

After the insect has emerged and dried, he is ready to fly—and he probably will. I've found that I can retrieve runaway moths and butterflies by

Always be on the lookout for those "once in a lifetime" shots. Here a male (center) and a female (bottom) damselfly are paired. A second male (top) mistook the male in the center for a female.

holding a stick lightly against their forelegs. They'll often climb onto the stick. You may have to do this several times before they'll stay put. Remember, you outweigh them, and you can outthink them. Eventually you'll wear them down, and they'll pose for the photograph.

Some insect photographers chill their subjects in a refrigerator to render temporary immobility. I avoid this because the insects just don't have a warm, natural appearance when they're chilled. Furthermore, when they return to room temperature, they seem doubly uncontrollable. I also never photograph a dead insect because the results are seldom convincing. I've found that at certain times, like after a heavy rain or in the early fall, insects are relatively inactive, but alive enough for a natural-looking picture. This is an excellent time to photograph them.

As in all photography, keep an eye open for unusual situations, like the one in the picture above. These are bluet damselflies. (They pair to mate as I mentioned previously.) The thin-bodied insect in the center is a male. He had corralled the female, at the bottom, just before being mistaken for a female himself by the searching male at the top. The nearsighted male quickly realized his error and was soon on his merry way—but not before I made this picture.

Although I've talked about photographing only a few of the millions of species of insects in existence, I hope this article will help you get started in insect photography, and will stimulate your curiosity and enthusiasm. As you become more involved, your own experiences will undoubtedly become your greatest source of knowledge in this enjoyable and intensely interesting area of photography.

338

George Butt, APSA, is the Coordinator of Program Services in Kodak's Photo Information department, where he supervises the production and presentation of programs on a variety of photographic subjects throughout the world. With more than 25 years of experience as an international photographic judge, teacher, lecturer, and professional photographer, George brings a wealth of practical experience to his audiences. His inspirational photographic presentations have been enjoyed throughout the United States and Canada.

The Art of Seeing

by George S. Butt

It's been said that "twice happy is a man with a hobby, for he lives in two worlds." How true this is. Everyone should have some means of expressing himself, of creatively releasing thoughts and feelings, and of projecting and extending his personality. I believe there is no better way to achieve these goals than through the medium of photography.

Never before has it been so easy to express ourselves through photography. We have modern cameras with fast lenses and features such as built-in exposure meters and automatic exposure controls, plus a wide selection of fine color films. These give us great versatility and at the same time relieve us of concern for many of the technical aspects of picture-making so that we can concentrate on its creative aspects. We are free both to expand our enjoyment of photography and to benefit from its value as an art.

THE ARTIST PHOTOGRAPHER

Whether or not photography is an art is an academic question that doubtless will never be answered to everyone's satisfaction. The answer probably lies somewhere in definitions that don't matter. What does matter is that a photographer *can* be an artist in the truest sense. I don't believe anyone can deny that a camera can capture beauty. What may often be overlooked, however, is that a photographer can actually create beauty, feeling, and mood. He is free to interpret, not just reproduce, the world as he perceives it. He can strive for the deep personal involvement characteristic in every art form.

When he creates, the experienced artist is almost totally unaware of his "tools." The brush becomes an extension of the painter, the pen an extension of the poet, and the baton an extension of the conductor. So, too, a creative photographer will become so engrossed in creating a photograph that manipulating his equipment becomes an unconscious gesture. As an extension of the photographer, the camera mirrors his whole personality—his thoughts, feelings, mood, and temperament.

The artist photographer can create beauty. This 10-second exposure captured detail and subtleties of color that were not visible to the human eye.

THE SECOND LOOK

The artist photographer possesses the "art of seeing." His alert, probing eyes penetrate the significance of places, objects, and events that is lost in the fleeting glance of the less alert, untrained eye. He sees beauty in the commonplace, unusual in the usual, meaning in the apparently meaningless. And so for him the world holds more of many things—beauty, interest, excitement, meaning. Through that intensive second look and the articulate use of his camera, he strives to share these things with those who don't possess his art of seeing.

An untrained eye would pass over a scene like this with a fleeting glance, but a keen-eyed photographer will study it to see how he can create the best photograph within the boundaries of his camera's viewfinder.

A simple example is the way a creative photographer may see a common plant. While a casual observer may admire it for its basic beauty, the photographer will go a step further. His second look at the plant will become a careful study of its potential as a subject for his camera. For example, in studying a teasel like the one on page 342, he'll be aware of the many delicate shades of gold and brown in its delicately sharp spines; of the texture of the

341

spines and bracts as the light skips over and shines through them; of the intermingling of colors, or virtual lack of color, in the background or foreground. He may see the complete story of the plant's existence cradled within its protective barbs. As he sees these things, he'll almost unthinkingly use his knowledge of photography to capture them on film. He'll move in close to eliminate all that's not essential to the story or mood of his picture. Perhaps he'll use selective focus to concentrate attention on a certain part of the plant in order to tell his story clearly and artistically.

This is one very basic example. The photographer would just as intensely see and enjoy the grinning face of a happy child or the massive steel skeleton of a growing skyscraper.

The viewpoint you choose will often be a very personal one, and your knowledge of photographic technique can help you tell the story or create the mood you want.

VIEWPOINT

When we give any subject more than a mere glance, the act of observing becomes a very personal thing. What we see in the subject largely reflects our own feelings for it. If we like it very much, we may want to take a very close look. If the texture looks pleasant, we may want to run our fingers over it. Perhaps we think it looks best from a low angle, or in profile. All these things determine how we frame the subject in the viewfinder before we snap the shutter. At the same time, these personal feelings are tempered by our knowledge of composition and balance, as well as by the conscious effort to create the mood and feeling we want in the final photograph.

In doing a thorough photo-graphic interpretation of a single subject, you'll probably discover the strongest and most exciting views after you've spent some time pho-tographing and getting to know the subject.

It's often an enjoyable and refreshing experience to make a probing photographic study of the viewpoints you find most intriguing in a single subject. Choose a subject that interests and excites you, and study it from every point of view. Use your camera as a tool in interpreting the subject. As you become more deeply involved with the subject, you may discover some intriguing viewpoints that you overlooked in your first go-round. I've

343

found that the more closely I become involved with a subject, such as the Toronto City Hall in Ontario, the more stimulating viewpoints and interpretative possibilities I discover. Very often I find the most exciting shot only after I've become almost completely enthralled by the subject. It takes time to see—time to study lines, shapes, composition and balance, and to perceive patterns and textures, light and shadow.

AWARENESS OF LIGHT

Perhaps the one thing to which the creative photographer is most sensitive is *light*. An untrained eye sees light only in terms of quantity, for example, there's a lot or a little on a certain subject. But quantity is only one aspect of light. The artist also looks at the quality, direction, color, and mood of

The soft quality of the light on the Gateway Arch in St. Louis creates a peaceful mood. This unusual viewpoint includes silhouetted steelwork in the foreground, which not only gives depth to the scene, but balances and strengthens the composition.

The direction of light greatly affects the appearance of textures and shapes in your photographs. You can often use the play of light on your subject as a strong factor in the composition.

344

The color of light changes with the time of day. Early or late in the day the change is very rapid. You can use the changing color of light to enhance your subject.

light. Is it soft and soothing, or is it contrasty and harsh? Does it fall flatly on the front of the subject; does it skim across the surface, emphasizing the texture; or does it strike from an angle where it brings out the shape of the subject? Is it the cool light of the shade, the warm light of a setting sun, or the brilliance of high noon? Is it the muted and mysterious light along the foggy seashore, or simply the glare of a hot day at the beach? The creative photographer sees these aspects of light and uses them as some of his strongest creative tools. He knows that light is affected by time, place, and weather. He makes the most of this knowledge in interpreting his subjects. He also knows that he can use the shadows cast by light as strong forms in the composition of his photographs.

The creative photographer sees, enjoys, and uses this thing called light that so many take for granted. A subject with a great deal of pictorial potential may be rather ordinary and unimpressive if the photographer doesn't capitalize on light. Yet the most common subject, such as two children chatting on some stairs, can become a compelling photograph when the photographer studies and uses the light and shadows in composing and creating his photographs.

It takes time to cultivate appreciation and feeling for light, and it takes a keen eye sharpened by exercise in seeing. Become aware of the effect that the quality, direction, color, and mood of light have on the world around you. Watch for the textures, shapes, colors, patterns, and moods created by light as you walk through towns, cities, countrysides, and backyards.

Lighting and weather conditions can create vastly different moods even though the subjects are similar.

Be alert for the manner in which light and shadows can transform a commonplace situation or object into a striking photographic subject.

PRACTICE SEEING

Practice in almost anything we do helps us achieve success. So practice looking into your everyday world. Give it that second look for all those elements we've discussed in this article. Concentrate on the tiniest details, and think how you would treat them if you were looking through your camera's viewfinder.

347

Practice taking an intense second look at the simple things you see each day. Study them. Look for ways of interpreting them photographically which will reveal their beauty most powerfully.

The art of seeing can play an exciting and important role in your life and in the lives of those who enjoy your photographic work. I honestly believe that your life will become fuller and more meaningful as you become increasingly aware of the beauty of the common, the small, the often overlooked. This art of seeing will be reflected in your photographs, and so you'll pass along to those who don't possess your visual talents some of the benefits of your keen observations. Through your eyes, their world, too, will become fuller, more beautiful, and more complete.

The rewards of seeing—the rewards of creativity—are many, and are well worth our efforts.

When you acquire the art of seeing, your world becomes an unusually beautiful and interesting place both for you and for others.

Bob Clemens is a photographer for Kodak's Photographic Illustrations Division, where he has been a specialist in small-camera illustrative photography for more than seven years. Beginning his photographic career as a studio assistant and darkroom technician for various commercial studios in Chicago, he went on to become staff photographer and editor of a camera column for an award-winning Midwest newspaper. His illustrated article, "Hometown Newspaper Photography," appears in the *Encyclopedia of Photography*. Bob's camera work for Kodak covers a wide range of subject matter, appearing in the company's national advertisements, publications, news releases, and audio-visual presentations.

Tell It Like It Is—
With Candid Photography

by Robert L. Clemens

"Tell it like it is" is one of the "in" philosophies of the day. It's a call for honesty, candor, and directness. And that's what candid photography—and this article—is all about.

Of all the various capabilities of photography, I find none more basic or fascinating than its potential for recording reality in clear, concise, visual terms. This capability, creatively applied in taking pictures of people being themselves, provides the basic formula for one of the most dynamic and challenging kinds of picture-taking: candid photography.

Although the term "human interest" has become a cliché, it holds more than a kernel of truth. People are interested in other people. For this reason, good candid photographs of people will never lack for an audience.

349

WHAT IS A CANDID* PHOTOGRAPH?

A candid photograph is a moment in time, an image of a person or persons made from life as it was really happening, an honest instant caught on film by a photographer who did not directly intrude on or interfere with the situation he was witnessing. The subjects of candid photographs are not posing or acting. They are simply being themselves and behaving as they would if the photographer were not there. These subjects might be anyone: grade-school children in their classrooms, a group of men shooting a game of billiards in a basement recreation room, a one-year-old getting his first haircut, or a bride waiting nervously at the rear of a church just before her wedding.

An ordinary college seminar was given pictorial interest by framing the intent coed with a chin-in-hand pose of the student in the foreground. Shallow depth of field, often unavoidable in low-light situations, was used to create emphasis on the girl's face by having it the only area of sharpness amid a large area of soft focus. I used KODAK TRI-X Pan Film for this shot.

It is the genuineness, the warmth, and the truth of such photographs that gives them their great appeal. Created by such master photojournalists as Henri Cartier-Bresson, W. Eugene Smith, and Alfred Eisenstadt, the candid documentary photograph can indeed take on monumental status.

*Editor's Note: We feel that Mr. Clemens' concept of candid photography is important to the advanced photographer. To some, the word "candid" may connote sneaky photographers or embarrassing pictures. Nothing could be further from the mind of the sophisticated photographer.

The candid camera has the unique ability to pick interesting bits of human interest from a scene of apparent confusion, such as this teen-age party. Careful timing caught this young bongo player's hand at the top of a beat. Without this detail, much of the storytelling impact would be lost.

CANDID SUBJECTS

While most of us will never have the imposing subjects that these men's lenses have photographed, potential candid subjects are all around us. Indeed, the ability to select meaningful images from the constant stream of people and events in our everyday lives is what really counts in getting good candid photographs. To probe for and to extract evocative pictures from a seemingly ordinary scene, a candid photographer must have a real ability to see, to interpret, and most important, to feel.

Certainly, familiarity with, and empathy toward, the subject is a basic requirement for getting good candids. For most of us interested in doing slice-of-life picture-taking, our family and friends will provide a wealth of subject matter. A wife or husband at work around the house; children at play, alone or together; an animated conversation at a dinner party; teen-agers during an informal get-together; weddings; christenings; picnics. The list goes on and on. People being themselves, remember? Tell it like it is.

Children at play are an unending source of spontaneous picture material. Be ready for impish expressions that give such pictures an added touch of excitement.

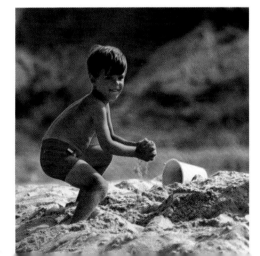

351

EQUIPMENT

Any camera, simple or sophisticated, is capable of becoming a candid camera. While limited in the range of picture situations they can handle when compared with their more advanced relatives, even simple cameras can make candid photographs of happenings around the home which can provide rewarding results for the family photo album. Again, it's the ability to take a really discerning and selective look at what's going on around you that counts.

More advanced cameras, with their fast, interchangeable lenses, are admirably suited to candid photography in a much wider range of locations and lighting conditions. I use a miniature single-lens reflex camera (35mm, or the KODAK INSTAMATIC® Reflex Camera) for my candid shooting. The small size makes for ease of handling, and the large number of exposures per roll of film lets me keep on shooting when other cameras might have to stop for reloading. Because of the fast lenses, I can shoot pictures indoors easily without having to use flash, which may destroy the mood and call unwanted attention to me. By making use of wide-angle and telephoto lenses, I can control my viewpoint and perspective at the camera, without interfering with the subject or imposing on the situation.

Whatever camera and accessories are used, handling must be practiced and smooth. A fast-moving human-interest situation does not allow time for fumbling with camera controls, flash equipment, exposure meters, or loading techniques.

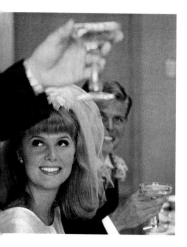

Anticipation is the key to success in pictures such as this. The photographer was ready when the best man offered the traditional toast to the newlyweds.

Be a "head hunter" at parties such as this teen-age get-together. The exuberant expression on the girl's face gives this picture extra appeal. To catch such fleeting expressions, focus on your subject and wait for just the right moment to press the shutter release. Take lots of pictures to make sure you get exactly what you want.

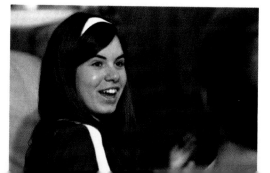

Pictorial candids, such as this nighttime street scene in New Orleans, have great appeal because of the mood they capture. For this photograph, I had the camera on a tripod and prefocused on the shop window. Then I waited as passersby stopped to window-shop. Since these tourists weren't moving, I was able to shoot at ¼ second at f/2.8 on KODAK High Speed EKTACHROME Film (Tungsten), rated at ASA 320 and processed with EKTACHROME Special Processing.

This tender moment between a mother and her young son was just that—only a moment. A quick picture on KODAK TRI-X Pan Film at 1/30 at f/2.8 was all that the situation allowed. Technical "flaws" such as slight subject movement and lack of overall sharpness (caused by shallow depth of field) can be overlooked in return for the warmth and spontaneity of the situation.

SHOOTING BY EXISTING LIGHT

Existing-light photography is taking pictures indoors, or outdoors at night, using only the light found at the scene. This light might be light from fixtures in a room, daylight from windows, light from a streetlamp, or candlelight. There's nothing new about this technique. It's been used successfully for years by photojournalists and other photographers to give their pictures believability and realism, which would be virtually impossible by any other method. *Life, Look,* and other picture magazines are filled with pictures made by existing light. These pictures appear so natural that when you look at them the mode of lighting that was used will probably never enter your mind. This is as it should be.

353

Situations for creative candid photo-graphs are all around, waiting for the alert eye of the photographer to find them. This dance-band drummer, photographed on KODAK High Speed EKTACHROME Film (Tung-sten), was illuminated by colored lights in a discotheque. ESP-1 Pro-cessing, which increases the speed of High Speed EKTACHROME Film by 2½ times, let me take this picture at 1/30 second at f/2.8.

Today's high-speed films, such as KODAK TRI-X Pan Film for black-and-white prints and KODAK High Speed EKTACHROME Film for color slides, make existing-light photography possible with any camera that has an $f/2.8$ or faster lens. By using the KODAK Special Processing Envelope, ESP-1, you can obtain special processing that increases the speed of KODAK High Speed EKTACHROME Film, in 135 and 120 sizes, two and one-half times. This means that hand-held existing-light color pictures are possible under all but the dimmest lighting conditions. (The Special Processing Envelope is discussed in Neil Montanus' article on page 357.) For existing-light pic-tures with color films, use Tungsten film with tungsten light, and Daylight film with existing daylight.

When existing light and candid photography get together, beautiful, compelling, and natural-looking pictures can result. But if you're not using a camera with automatic exposure control, you must be able to determine the correct exposure quickly and accurately. There is no *one* right way to do this. My only suggestion is that you use an exposure meter you feel comfortable with and which gives you consistent results, follow the manu-facturer's recommendations for its use, and *practice* with it until using it, like using your camera, becomes second nature.

Inclusion of action and reaction can make a candid photograph a concise, clear statement. The action of the girl in the foreground says "Charades," and explains the reaction of the couple in the background.

At the slow shutter speeds and large lens openings used in existing-light photography, accurate focusing and a very steady camera are a must. Practice holding the camera steady, and squeeze—don't jab—the shutter release.

THE UNOBTRUSIVE PHOTOGRAPHER

No matter what camera or lighting techniques you use, the real secret to getting good candid photographs comes from being able to use your equipment in a situation without calling undue attention to yourself. How can this be done? It all depends on the situation. In some cases, the people you are photographing may be so engrossed in what they are doing that they are virtually oblivious to your presence. This might include people concentrating on a hobby project, playing a game, or absorbed in an interesting conversation. On the other hand, the situation could be so relaxed that you can't help being noticed. In such an instance, get in there and start shooting. Many times, after the first dozen or so shots, the people will be used to your shooting and, hopefully, will begin to ignore you.

I have had many assignments in grade-school classrooms. What could be more of a curiosity to a group of second-graders than a strange man wandering about the room, bristling with cameras, lenses, and other mysterious objects? My solution in these situations has been remarkably simple and has almost always worked. I simply tell the children to pretend that I'm not there, and not to look at me or my cameras. Both the cooperation and the results have been amazing. The same approach could be used with a group of adults, say at a small gathering in your home. Just ask them to ignore you. It usually works!

Better candid subjects than children would be hard to imagine. I used a telephoto lens to photograph this pensive young ballet student so that I wouldn't disturb the situation. Since the girl was illuminated by daylight coming through windows, I used KODAK High Speed EKTACHROME Film (Daylight).

355

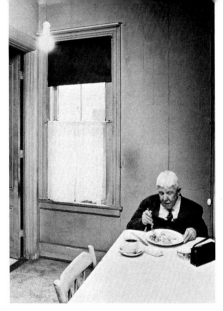

This picture was made for the Community Chest drive to illustrate a hot-lunch program administered by the Visiting Nurse Service in Rochester, New York. The man is blind and lives alone in a sparsely furnished apartment. His hot lunch, brought in to him five days a week, is a bright spot in his world. Careful choice of camera position helped make this a strong storytelling photograph. I used bounce flash to augment the existing light in the room.

Relationships between people, when shown believably like this, play a primary role in good candid photography. An alert, sensitive eye—not fancy equipment—is the chief prerequisite for pictures like this one.

Then keep shooting. Keep looking. Be ready for the significant facial expression or interesting gesture. Move around. Look for interesting camera angles. Watch for the relationship of one person to another. Frame the principal subject with someone or something in the foreground that will help tell what's going on. If your equipment permits, use selective focus to isolate the prime subject from its background or foreground. Existing light too dim? Try bounce flash to simulate or augment the existing light.

Look at the professionals' candid work in the magazines and newspapers. See how they have used existing light or other lighting to the best advantage. Be your own harshest critic; keep shooting and don't spare the film. In the long run, it's the least expensive item you're using. You're going to miss some shots by the very nature of the fleeting subjects you're photographing, and being stingy with film won't increase your percentage of good pictures one bit. Since this advice comes from a Kodak man, you may think I have selfish reasons for saying this. But if you don't believe me, ask *any* photographer.

So start looking, seeing, and selecting. Then shoot. Your pictures, mirrors of the people and events around you, will have a compelling authenticity that posed pictures never equal.

Neil Montanus is a photographer for Kodak's Photographic Illustrations Division. He has traveled throughout the world creating advertising photographs for the company. He has been awarded the degree of Master of Photography by the Professional Photographers of America and is a member of the American Society of Photographers. Neil has exhibited a number of one-man photo shows, and is a well-known judge of photographic salons. He has a degree in photography from Rochester Institute of Technology. Neil's article "Underwater Photography" appeared in *The Fifth Here's How.*

Photographing the Dance

by Neil C. Montanus

My interest in dance photography began when my daughter started taking dancing lessons. She was my model for lots of experimental picture ideas. I photographed her at the dance studio, practicing at home, on stage during performances, and out of doors. Of course, I brought her into our studio for some posed shots, too.

Making photographs of the dance is an interesting phase of photography with a lot of creative potential. This is true whether you photograph a graceful ballerina, a go-go girl, or a child taking her first lessons. In this article I'll pass along to you some of the things I've learned that I think will help you make some intriguing and exciting dance photographs.

357

EQUIPMENT

Before we get into techniques of photographing the dance, let's talk briefly about equipment.

For available-light shooting at rehearsals, on stage, and at home, a single-lens reflex camera with a fast 50mm lens ($f/1.4$ to $f/2$, if possible) is ideal. Sometimes I also use a wide-angle or a telephoto lens. These lenses should also be fast enough to permit some available-light shooting. A camera with a motorized film advance is handy for action-sequence shots.

When light is more plentiful and I don't need a very fast lens, such as in the studio and outdoors, I usually use a 2¼-inch square format camera. The size of film for this camera is good for big enlargements, and the camera's large ground glass permits ease in composing.

FILMS

I do all my dance photography on color film. For shooting under low-light conditions, a fast film, such as KODAK High Speed EKTACHROME Film, is a must. It was a real boon to available-light photography when Kodak introduced a special push-processing service for KODAK High Speed EKTACHROME Film (135 and 120 sizes *only*). This service bumps the speed of High Speed EKTACHROME Film (Daylight) from ASA 160 to ASA 400, and (Tungsten) from ASA 125 to ASA 320.*

When I want prints and don't need an extremely high-speed film, I use KODACOLOR-X Film. I like to use this film when my goal is enlargements to enter in salons, or to frame and hang in my home.

Now, let's take pictures.

PICTURES OUTDOORS

The easiest place to photograph a dancer is outdoors. Outdoors you're not limited by such things as walls and the number of lights you have to work with. You won't be concerned with complex lighting setups, and you'll determine exposure as you would for a normal subject in daylight. Therefore, you're free to concentrate your creative efforts on selecting a beautiful pose in a beautiful setting. Choose a point of view that gives you a pleasing background, such as foliage or a blue sky, and ask your dancer to perform. You can practice snapping the shutter at the peak of the movements when the dancer is in the most graceful and artistic positions. You may want to ask your dancer to express herself by running or leaping. If you have a camera with a motorized film advance, such as a KODAK INSTAMATIC X-90 Camera,

*To get this service, buy a KODAK Special Processing Envelope, ESP-1, from your photo retailer. The cost of the envelope is in addition to the normal cost of processing by Kodak. After you've exposed the film at the higher speed, put it in the ESP-1 Envelope and return it to your photo retailer for processing by Kodak, or send it directly in a KODAK Prepaid Processing Mailer.

you can shoot a rapid sequence of pictures. This gives you the opportunity of having a good picture series, and also helps insure catching the best position.

IN THE DANCE STUDIO

One of the best times to capture candid moments is during a rehearsal at the dance studio. Be sure to get permission to take pictures from the dance instructor, and assure her that you'll remain as inconspicuous as possible so that you don't disturb the class (and *keep* your promise). You'll probably use your normal lens and perhaps a medium telephoto lens. If there's enough light, shoot without flash. If there isn't, use flash (I prefer a small electronic unit) and bounce the light off the ceiling. Fortunately, most dance studios I've worked in have white (or nearly white) ceilings, so the color of the ceiling isn't reflected onto the subject. If the ceiling is colored or is too high for bounce flash, put your flash unit on a stand, and place it high and to one side. This helps simulate natural overhead lighting.

A telephoto lens is great for capturing unguarded moments. Depth of field will be shallow at the large lens openings used for available-light photography, so focus very accurately.

PICTURES AT HOME

Having the model in your own home gives you the opportunity to take your time posing and working with her. This is a good time, too, to have her wear her "dress-up" dance costume such as she might wear for a recital. Again, I think that taking pictures by natural light produces the most natural and pleasing results. During the day I like to pose my subject near a window, but not in direct sunlight. At night, if the available light in the room is too dim or too contrasty, I use bounce flash. Watch the background; keep it simple and uncluttered.

Use an exposure meter to determine exposure for available-light pictures, both in the dance studio and at home.

IN THE THEATER

It's the night of the big performance, the event everyone has eagerly
awaited. This is a must for picture-taking. Ask permission in advance to go
backstage and make shots before and during the performance. (If you can't
get permission to shoot during the performance, dress rehearsal is second
best.) The wings are the best places to be for taking angle shots which cap-
ture the stage lighting that gives an intimate and dramatic quality to your
pictures.

Before the performance, get permission to go into the dressing room, and record the excitement and preparation for the big show.

Another "must" shot is one of the performance from the audience viewpoint. For the best view, shoot from the balcony. You'll usually need a telephoto lens to get a good image size from this distance.

Determining the exposure for stage productions is a bit tricky because of the ever-changing lighting. This is especially true for full-scale stage productions, such as Tchaikovsky's popular ballet, *The Nutcracker,* shown above.

Here are some situations you might encounter in photographing stage productions and the solutions I've found most useful.

Situation: To get the best exposure, you should make a meter reading of the dancer's face. When you're shooting from the wings and making an overall meter reading with a reflected-light meter, the meter may be unduly influenced by direct light from the stage lights and will indicate too little

362

exposure. When you're shooting from the audience viewpoint and have no direct lights to contend with, large expanses of dark background may cause the meter to indicate too much exposure for the dancers.

What to do: If you have a spot meter (either separate from the camera or incorporated behind the camera lens), you're all set because you can read small areas from some distance away. Otherwise, attend the dress rehearsal and get permission to make some close-up meter readings. With the cooperation of the lighting man you can make readings either before or after the rehearsal.

Situation: Your subjects will be moving around on the stage, so focusing won't be easy. You'll be taking pictures with large lens openings, and consequently depth of field will be shallow. Of course, depth of field will be even less with a telephoto lens.

What to do: Attend a rehearsal or two to become familiar with the action. This will make it easier for you to anticipate where the action will be on stage and to prefocus on that area. Then when the action moves into the area, snap the shutter.

Situation: When arc spotlights are used, you'll get the best color with daylight-type color film. When only the stage lights are on, you'll get the best color with a film intended for use with artificial light.

What to do: If possible, try to use two cameras. Load one with each type of film. Otherwise, when you use artificial-light film with the arc lights, you'll get cold-looking pictures, and when you use daylight film with the stage lights, you'll get warm pictures. If you must make a choice, I'd suggest artificial-light film. Most of your pictures will probably be made under the stage lights, and most people are willing to accept some coldness in spotlighted pictures. Conversion filters aren't a practical solution because they absorb too much light.

STUDIO-TYPE SITUATION

There will be times when you'll want to be complete master of the situation. In a studio-type setup you'll have complete control over all conditions. You'll be able to pose your model in an area, maybe in your home, where you can put her in front of a plain background—perhaps a seamless paper background (available from large photo-supply stores). You can take your time to carefully choose the pose and lighting to create the mood you want. Talk with your model, and plan what poses and costumes both of you feel will make the most successful pictures.

The background is an important element in setting the overall tone or mood of your pictures. A white or light-colored background might lend a feeling of gaiety, purity, happiness, or exuberance. A black one might say just the opposite. You can use a type of vignette in front of the camera lens

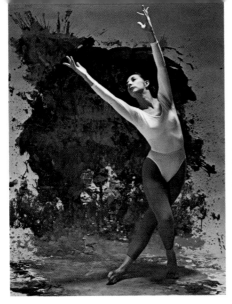

If the artist in you yearns to be freed, choose several colors of paint and splatter it in interesting patterns on a white background. A word of advice: You'd better have excellent aim or a very understanding lady of the house!

to add color to the area surrounding your subject. For the picture below, left, I used an 8 x 10-inch piece of clear glass a few inches in front of the lens. I glued small, irregularly shaped pieces of colored gels on one side of the glass. I used colored gels sold by theatrical-supply houses because I often use them over my lights, too. (Two sources of colored gels are Paramount Theatrical Supplies, Alcone Company, 32 West 20th Street, New York, New York 10011, and F & B/CECO, 315 West 43rd Street, New York, New York 10036.) On the other side of the glass I rubbed a thin coating of petroleum jelly around the edges of the picture area to further soften the spots of color, and to give a soft-focus effect to the edges of the picture.

You can vary the color of a background by using colored gelatin filters over a background light illuminating a white background. This makes it easy to change background colors.

Now, let's get on to the business of making pictures. I'm going to discuss four different techniques for photographing the dance in a studio-type setup.

1. At rest.
2. Action—single image.
3. Action—multiple sharp images.
4. Action—multiple sharp and blurred images combined.

At Rest

This is about the simplest way to photograph a dancer in the studio. If you use a little imagination in your choice of lighting and background, and perhaps add a prop or two, you can produce some fine shots. A talented and graceful model who can suggest various poses and hold them without moving is a great help.

I usually light my subject with incandescent lights rather than with flash. Since my subject isn't moving, I don't need the action-stopping ability of electronic flash, and with incandescent lighting I can see the effect on my subject before I shoot. If you have them available, such lighting aids as barn doors and snoots help you keep the light from striking areas where you don't want it, such as on the background or foreground when you want these areas to go dark in your picture. You can also use pieces of cardboard taped to light stands or some other tall objects that are handy in order to block the light from areas where you don't want it.

There are no special lighting techniques for photographing dancers at rest. Light the subject to create the mood you want. Here I used a single photoflood covered with a blue gel to backlight my subject. The rest of the light came from the candle.

365

Action—Single Image

When you take action shots of dancers, you'll want the action-stopping ability of electronic flash. To help you catch the action at the precise moment that will produce the best and most graceful photographs, ask your subject to go through the dance several times while you simply watch. When you're familiar with the dance, you can anticipate the dancer's movements and snap the shutter at just the right times. This takes some practice and a fast reaction time. No matter how talented your dancer, if you catch her at the wrong moment you can make her look quite awkward.

This shot was made by using three electronic flash units. One accent light was covered with a blue gel and the other with a magenta gel. I based my exposure on the unfiltered main light that was very high and to the left of the camera.

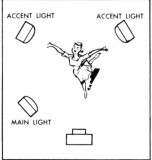

Action—Multiple Sharp Images

This is where you can take some pictures that are really exciting and different. People often look at pictures like the one below and say, "I wish I could make shots like that." A bonus of this type of picture is that, while they look hard to make, they're really not difficult at all. All you need is a dark room, a black (or very dark) background, and an electronic flash unit that you can trigger independently from the camera shutter.

First decide on the action that's to take place and the number of images you want to show that action best. Next, turn off all the room lights. When your subject is in the first position, open the camera shutter and fire the first flash. When the flash unit has recycled and the model has taken the position for the second image, fire the flash again. Simply repeat this until you've photographed all the positions that you want. Then close the shutter.

Your lens opening will be the same as for a normal electronic flash shot. If necessary, use a cardboard baffle to keep the light from the flash from striking the background or foreground. If there is *any* existing light in the room, hold something, such as a dark cardboard, in front of the lens between flashes. Incidentally, if you don't have an electronic flash, you can use a normal flash unit that's separate from the camera. Simply have an assistant fire the flash on your signal by shorting it with something such as a paper clip.

You can use a paper clip to fire an off-camera flash unit.

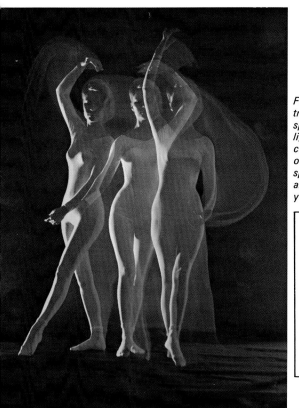

For this shot I used two elec-tronic flash units and two spotlights to get the edge-lighting effect. However, you can also get good results with one electronic flash and one spotlight. Vary the lighting arrangement to get the effect you like best.

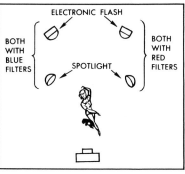

Action—Multiple Sharp and Blurred Images Combined

I believe this technique is one of the finest for showing motion in a still photograph. Basically, you use the same technique described in the preceding section, but add a spotlight or two. (I use colored gels over the spotlights, and often over the electronic flash, too.) Your electronic flash freezes the action, and the spotlights provide the exposure for the blurred images.

Here's how it works:

1. Turn on the spots.
2. As your dancer begins to perform, open the camera shutter.
3. Fire the flash for as many positions as you choose.
4. Close the shutter and turn off the spots.

I'd be less than honest if I didn't tell you that getting just the right balance between the flash and the spotlights is a little tricky and requires some exposure tests. First, determine the lens opening for the electronic flash by using the normal guide number. Then your goal is to adjust the spotlight-to-subject

distance to get the right lighting balance. Here's a way to determine a good spotlight-to-subject distance as a basis for your first test. Adjust your spotlight distance so that an exposure meter reading of the subject indicates a shutter time of 1 second at the lens opening required for the electronic flash. For example, using the normal guide number for your electronic flash, assume you determine that your lens opening should be $f/5.6$. Then adjust the spotlight distance so that a meter reading of the subject indicates a lens opening of $f/5.6$ at 1 second. After you see your test exposures, you'll know if you must move the spots closer or farther away, or if they're satisfactory where they are. Be sure to keep careful records of your tests so that you'll be able to repeat the results when you want to.

When your model performs for this type of photograph, she must move *very slowly* so that her movements appear as you'd expect to see them in a very-slow-motion movie. Her movements should also be *continuous*. Otherwise, the blurred effect will be jumpy and uneven. If your electronic flash takes a relatively long time to recycle, you may want to ask an assistant to hold an extra electronic flash unit or two that can be recycling while one is in use.

MAKING IT BIG

In winding up this article, I'd like to tell you how some experimentation with a miniature camera led to my making a dance photograph that was reproduced as the world's largest color transparency—the 18 x 60-foot Kodak Colorama in Grand Central Terminal in New York City.

I became intrigued by the new dance craze of this generation, and especially with the clever way it was being presented in discothèques. I wanted to experiment with some ideas in the studio, so I put up a black paper background and cut a number of holes in it. I put colored gels over the holes, and behind each hole I put a floodlight aimed directly at my camera lens. I did this purposely to create what I hoped might give a "psychedelic lens-flare" effect.

I put one electronic flash unit near the ceiling, brought in the girls and some music, and started shooting. I based the lens opening on the electronic flash, and varied the shutter speeds from 1/15 to 1/2 second. Of course, the

exposure for the electronic flash remained constant because of its short duration. Changing the shutter speed only affected the exposure from the incandescent lamps. I used a diffusion filter over the lens, and had friends blow cigarette smoke in front of the lights.

When it was over, we'd all had a ball, and I had quite an interesting collection of pictures like the one on page 369. (You could make similar pictures in your "studio.") I put the slides in a sequence, added music on a tape recorder, and ran the show through a KODAK CAROUSEL Dissolve Control coupled with two KODAK CAROUSEL Projectors. The result was a pretty exciting show.

Our manager saw the show and liked the idea. He assigned me the pleasurable task of doing something similar for the Colorama. I made the Colorama shot (below) with a view camera which uses 8 x 20-inch film—a far cry from the small transparencies I started out with.

Dance photography has offered me a wide scope of picture possibilities, and chances are it can do much the same for you.

Keith Pfohl, FACI, is a former Program Production Specialist in Kodak's Photo Information department, where he produced and presented slide and movie programs. Keith was a photographer in the Navy, and has since taught many photographic courses. He is an officer in the American Chapter of the Institute of Amateur Cinematographers. Keith has won numerous awards with his motion pictures, and has published many articles on cinematography. He has also served as editor of the *Techniques Division Bulletin* for the Photographic Society of America.

Creative Movie Editing

by Keith A. Pfohl

Proper editing of a movie can mean the difference between a movie that is quite ordinary and one that is exciting and interesting to see. For this reason, I think that editing is the core of movie-making.

In this article I'm not going to cover the use of editing equipment, such as splicers, viewers, and "T" bars. Rather, I'm going to tell you how to create better movies through planning, and through careful selection and arrangement of movie shots and sequences. I'll also tell you how awareness of such things as motion and timing can help you control the message your movie conveys. You can use many of my suggestions with movies you've already made as well as with your new movies, and they'll hold true for any film size—super 8, 8mm, or 16mm.

THE FIRST PHASES OF EDITING

Let's begin by defining movie editing. Basically, it's *selecting* the scenes and *arranging* them within the body of the film. It may come as a surprise to you to learn that the first stages of movie editing begin even before you put film in the camera. You're actually doing a form of editing when you *plan* your movie.

Let's assume you're going to make a documentary film based on a volunteer fire department. You begin by deciding what sequences to include to tell the story the way you want to tell it. Possible sequences might include fire-fighting equipment, training sessions, men on duty, actual fires, and social activities. When you select the different aspects of the volunteer fire department story that you want to photograph, and arrange these ideas in some sort of logical order, you're editing. So even when you *think* about making a movie, you're starting to edit.

If you write a shooting script, you may rearrange some of the sequences and tentatively decide what shots will make up each sequence. You'll decide what the shots should include, and whether a shot will be an extreme long shot, a long shot, a medium shot, a close-up, or an extreme close-up. This arranging and selecting is another form of editing.

Another phase of editing occurs in shooting the movie. Through the camera's viewfinder, you exercise your creative eye and select the strongest pictorial viewpoint for your scenes. When it's convenient, you'll want to do as much editing as possible in the camera. Carefully plan the action of your sequences, and when possible, photograph them in their final order. This saves time at the final editing stages when you're splicing your movie together. Also, when you edit in the camera, chances are you'll become more acutely aware of the continuity of the movie and the formation of the story line. Once in the habit, you'll begin to "think sequences" and to form the story several shots ahead rather than to place emphasis on only one shot at a time.

After you've exposed the film, had it processed, and projected it (just to see how it looks), you're ready to begin working with your action editor and splicer. This is the viewing, cutting, and splicing stage when you take the processed movie to a secluded room and put a "Do Not Disturb" sign on the door. You're ready for the final stages of editing your movie!

As you're handling your movie film during these final stages of editing, remember to handle it with extreme care. Wear soft cotton gloves (many photo retailers stock inexpensive gloves for this purpose) and handle the film carefully. A scratch could mean a ruined scene.

Here are what I consider the three most important elements of this final stage of movie editing:

1. Screen movement.
2. Meaning.
3. Pacing.

SCREEN MOVEMENT

This is *all* movement on the screen—people walking, stretching, swinging; leaves tossing gently in the breeze; panning the camera slowly to take in all of a vast scenic vista. It's possible to make an already good sequence even better if during this stage of editing you are critically aware of the effects of subject and camera movement.

A major element of screen movement is the direction of the subjects' travel. Direction of travel is important to the audience—they should feel that both the story and characters are logically moving through time and space. Keep direction of travel in mind while you're shooting, and remember to keep your audience clearly aware of the direction in which your subject is moving. If you want the audience to think the subject is getting closer to his destination, all of his movement should be in one direction on the screen.

If he's moving left to right in one shot, and right to left in the next, your audience will think he changed his mind and reversed his direction. This could happen when, for example, you begin photographing a man walking down a path from one side of the path, and move to the other side of the path to complete the sequence. When the movie is projected, it will look as if the man changed the direction in which he was walking. If you inadvertently create a situation such as this, you can help cover the error by editing in a "cutaway" shot. This filler-type scene is one related to the action in preceding and following shots, but is not directly a part of that action. When placed between unintentional direction changes, cutaways help divert the audience's attention from the original direction of travel, so they'll tend to overlook the fact that the subject is moving in another direction in the shot following the cutaway.

In the sequence on page 374, when the shot of the boy "spying" from the tree is spliced between the shots where the man and child's direction changes, their change of direction becomes less obvious. We've been sidetracked momentarily, and when we pick up the trail of the man and child once again, they're still taking their casual stroll. By clever editing we've covered a blunder.

Another element in screen movement is matched action. To keep the action moving smoothly on the screen, always keep in mind the continuity of movement from one shot to the next. For example, consider the movement in a shot of a youngster settling down to play a record on his phonograph. He extends his hand, lifts the tone arm, and moves it over to place it on the record.

When you move in for a closer view of the action, simply ask the boy to repeat it for the close-up shot. Once this is accomplished, you have two shots, both of the same action.

In splicing these shots together, you must be sure to cut to the close-up shot at precisely the same spot in the action as you left off in the medium shot. If the action overlaps on the screen, the boy's hand may reach out and pick up the tone arm twice. If there's a gap in the action, the boy's hand will appear to jump from one position to another. Either situation will jar the audience. You can avoid the problem by viewing the two scenes very carefully in your action editor, and then cutting and matching the action correctly.

Here's a tip that makes it easier to cut on the action. Make the cut from one shot to the next at the beginning or end of the movement, rather than in the middle. It's easier to select and cut on the frame where, for example, the boy puts the tone arm on the record than it is to match action in the middle of his reach for the tone arm.

A type of cut that can easily creep into your movies, if you don't keep a sharp lookout for it, is a "jump cut." A jump cut is a gap in the action from one shot to the next when neither the viewpoint nor the subject distance has been changed. Like mismatched action, this can be jarring because the audience sees a person or object suddenly jump from one position to another. For example, let's assume you're watching a movie sequence of a small boy coloring in a color book. The cameraman didn't change his viewpoint or subject distance—he kept the camera in the same position during the entire 2-minute sequence. However, he started and stopped the camera several times throughout the lad's activity. What does this look like on the screen? The child starts to color; suddenly, he "jumps" to the other side of the frame for a few moments; then his position is shifted again and he's coloring a different part of the picture. Of course, we realize that during each interval the camera was stopped and the child shifted his position. But on the screen this appears as a glaring jump cut.

If you inadvertently make a jump cut, once again you can help smooth the visual jolt with a cutaway shot. Insert the cutaway between the two shots that make up the jump cut. This fills the apparent time gap and produces a smoother sequence.

It's always a good idea to shoot extra footage when you make your movie. A few cutaways in the bank may save the day by helping to cover an occasional blooper.

MEANING

The second consideration in final editing is screen meaning. After you've edited all the movement to the best of your ability, you want to make sure that the meaning you convey to your audience is the one you intended. When you've spliced all the shots together, does your movie tell the story in the best possible way? A good way to answer this question is to show the movie to an impartial panel. Your family will do nicely, provided they view the film with an unbiased eye. From the opinions of this preview audience, you'll learn

whether you've pieced your film together in a manner that tells the story you want to tell. Your editing is not complete at this point. There are still final polishing and tightening up to do, but you can proceed with the knowledge that you're getting your message across. Previewing the film will also help you do the final polishing by giving you a feel for the pacing and story continuity of the film.

Changing the Meaning

Can you alter the meaning of your movie by altering the order of the shots or sequences? The answer to this question is, of course, a resounding *Yes!* For example, it's possible to take three very basic shots and connect them in as many as six different ways. This gives you the chance to create as many as six possibly different meanings. Let's take a look.

With the shots in this order, the audience gets the message that the "goodies" have immensely pleased our movie's character. Now, try reversing the order of the three shots.

The fellow must have been on a diet, and the plateful of doughnuts reminded him of his caloriecounting.

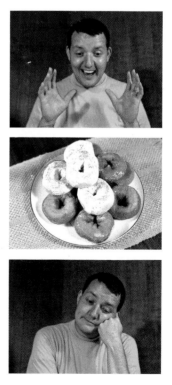

Editing a shot in or out of the sequence can also drastically change the meaning of the movie. Here's a sequence I shot recently.

But I made one more shot that I didn't include when I first edited this movie. When I did include the shot, the meaning of the sequence changed considerably!

PACING

Pacing is the timing, or rhythm, of your movie. Each shot in the film should stay on the screen just long enough to support the action. If the shot is cut too quickly, the audience may become confused. If it stays on the screen too long, the audience may become restless or bored. So, correct film pacing is important.

I've chosen these six shots to help illustrate pacing.

Now, imagine that the photographer made each of these six shots 10 seconds long, and kept them that length when he edited his movie. Of course, the pace would drag in spite of the fact that the shots tell a story, are well photographed, and are in logical order. What went wrong? The answer is the scene length. The subject matter indicates the need for a rapid pace, but with all the shots the same long length the audience will have a feeling of dragging time. If the sequence is edited so that the first shot is 10 seconds long, the second one 4 seconds, the third 3 seconds, and so on, the entire sequence may last 35 seconds rather than the original 60. More important, the pace

of the sequence will help to indicate the subject's "panic" to the audience.

Some film editors prefer to tighten up their films by cutting the action immediately after the subject has either left the frame or completed a phase of his action. I sometimes like to cut the action a few frames *before* it's been completed. This really accelerates the tempo of the film. You may want to try this technique in one of your movies.

Our old standby, the cutaway shot, plays an important role in the pace of a movie, too. You can edit cutaways into your movies to add variety, and variety almost invariably quickens the pace. In addition, you can include a cutaway shot to indicate the passage of time—either rapidly or very slowly. Let's look at some examples.

When you shoot public activities such as sports events or parades, shoot footage of the spectators, too. Later you can edit these shots into your movie to help control the pace. A rapid series of shots showing spectators jumping to their feet at a football game creates a feeling of fast action and excitement. You might also indicate passage of time by showing an excited child in one cutaway, and later splicing another cutaway shot of the child leaning against his father, sound asleep.

You can control pace by cutting away to the dial of a clock. If you insert this shot every so often in the sequence, it can indicate rapid or slow passage of time, depending on the time that has elapsed on the clock between cutaways.

Close-ups often make superb cutaways, and they add variety to increase the pace of your movie. When you're shooting a movie, make some extreme close-ups of subjects related to the action. Chances are these shots will come in handy as cutaways.

Someone once said, "For every action, there's a reaction." No doubt this is true, and cutaway shots showing reactions to the main activity of your movie can be interesting and pace-controlling additions to your sequence. Once these priceless pieces of film are inserted into a movie, they may even become the highlights of a sequence. You can increase suspense by splicing the reaction shot *before* you show the action.

Screen pacing also includes the use of parallel action—switching back and forth between two bits of action that are taking place at the same time. The way you edit the pieces of parallel action determines the pace. Switching from one short segment to another quickens the pace. If you splice in long segments of the parallel action, you'll slow the pace of your movie. Editing parallel action into your movie is also a good way to establish suspense. For example, switching between shots of a man climbing stairs and a secret agent trying to open a safe containing espionage plans can build up a lot of excitement and suspense.

When you shoot a movie, take footage of related action so that you'll have it on hand to splice into the movie when you need it. Pacing is important, and discreet use of cutaways can have a strong bearing on the pace of your movie.

I'd like to mention one more factor that leads to skill and creativity in editing. This factor is experience—one of the best of all teachers. I believe that if you practice the suggestions I've covered in this article, and carefully choose, arrange, and cut your movies, you will find movie editing more fun and the results more rewarding.

Dick Werner is the Coordinator of Customer Services in Kodak's Photo Information department, where he supervises a staff that answers inquiries from Kodak customers on all phases of amateur photography. He has taught Color Theory and Color Printing courses at the Rochester Institute of Technology and at Kodak Camera Club, and has lectured on the principles of photographic optics to photo retailers from the U.S. and Canada. Dick is an avid photographer who has combined his mechanical and photographic hobbies to design several pieces of photographic equipment for picture-making and program work. His photographs have been accepted in numerous national and international photographic salons.

Creating New Pictures from Old Negatives

by Richard E. Werner

The next time you're looking through your file of color negatives, use your imagination and look at the negatives with your most creative eye. Chances are there are new and exciting prints lurking among your favorite negatives, and there may well be a prizewinner or two among the negatives you've never printed because they were, well, mediocre.

Frankly, I get quite a kick out of dreaming up new treatments for old negatives. In this article I'm going to tell you about some methods I've used to create drastically different pictures from "straight" negatives. You don't need a bulging negative file to find some negatives that you can use with these techniques. Once you get started, you'll probably dream up some brand-new techniques of your own.

CREATING NEW PICTURES WITH HIGH-CONTRAST FILMS

Let's begin by exploring the possibilities of a special film that I've found extremely useful for making "new" pictures from old negatives. The film is KODAK Professional Line Copy Film 6573.* This film completely ignores all those fine middle tones that other films work so hard to register. The subjects on a Professional Line Copy negative (or positive) are recorded as black or clear—all middle tones are missing.

Let's look at this shot I made one drab, overcast morning. The feeling of loneliness and isolation that I hoped to capture somehow just didn't come through. However, I decided a good picture was hidden there, and thought I might find it by eliminating all the light tones from the print and saving only the dark ones. To do this, I needed to make a high-contrast mask for my original negative, which would be black in the light areas of the print.

First, I made a contact print from the original KODACOLOR-X negative on a sheet of 4 x 5 Professional Line Copy Film (exposing and processing instructions are packaged with the film). The result was a black-and-white positive that was clear in the areas that were light on the original print and black in the dark areas. Since this was just the opposite of what I needed, I contact-printed the positive on a second sheet of Professional Line Copy Film. On the resulting negative, the light areas of the original print were black.

*This film is sold by suppliers of professional photographic equipment and some photo retailers.

Professional Line Copy negative which was "sandwiched" with my KODACOLOR-X negative to make the print with the white background.

The next step was to sandwich the Professional Line Copy negative in perfect register with the KODACOLOR-X negative and make a print on KODAK EKTACOLOR Professional Paper, just as you would make a normal color print. The black areas on the Professional Line Copy negative prevented light from reaching the paper in areas that were light in the original print, producing the unexposed, white background. The clear parts of the Professional Line Copy negative let light through the images of the boats and other darker areas, so these areas printed normally. The result was the picture below.

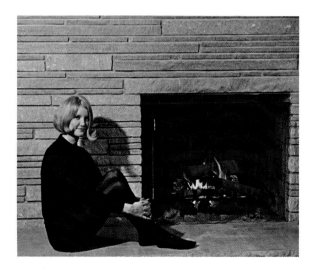

You can also use high-contrast film as a tool for creating special effects in only certain areas of a print. I made the picture above from a normal KODACOLOR-X negative. Then I made a Professional Line Copy positive and negative from the KODACOLOR-X negative, just as I did for the boat scene, and made the high-contrast black-and-white print from the Professional Line Copy negative. The black-and-white print had to be *exactly* the same size as the color print, so when I made the black-and-white print, I used the color print as a guide on the enlarger easel.

Then I used black opaque (sold by photo retailers) on the black-and-white print to completely blacken everything that was to be in color on the final print. On the color print, I used the opaque to blacken everything that was to be in black and white on the final print.

The next step was to copy the two prints on the same frame or sheet of color-negative film by double-exposing. The "trick" in doing this is to have the two prints in *perfect* register when you make the double exposure. One way to do this is to lay a piece of clear plastic, larger than the prints, on the floor and tape the plastic along one edge. Then put one of the prints under the plastic and carefully mark several reference points on the plastic. Fold the plastic back and shoot the first picture. Place the second print under the plastic, line it up with the reference marks, fold the plastic back, and make the second exposure on the same piece of film. The print below was made from the double-exposed color negative of the two opaqued prints.

I used Professional Line Copy Film in two different ways to create the stylized photograph of the figure study on page 388 (the original is a slide). I began with a negative of a figure study against a dark background. I enlarged the negative on Professional Line Copy Film so that everything was completely black except the highlight areas. (In this instance it was a KODACOLOR-X negative, but a black-and-white negative would have worked,

too.) I put the Professional Line Copy positive on a slide illuminator and photographed it with KODACOLOR-X Film through a cyan filter. In areas where light could come through the Professional Line Copy positive, the image registered on the color-negative film as a deep red (the color on the negative will be the complement of the filter used). Areas that were black on the Professional Line Copy positive received no exposure on the color-negative film, so these areas remained the yellow-orange color of the color negative itself.

To get the lace-overlay effect, I put a piece of lace on an illuminator, photographed it on black-and-white film, and made a positive on Professional Line Copy Film. I sandwiched the Professional Line Copy positive with the KODACOLOR-X negative, and the result was a rather interesting slide of what had been an ordinary figure study.

A ZOOM LENS FOR THE ENLARGER

The straight print of the ballerina and the cherry tree is one I found interesting, but not many people agreed with me. O.K., so the ballerina *is* static, and the cherry tree probably *isn't* the best background for a ballerina. But there must be a good print here somewhere!

The modified print has enjoyed a good record of salon acceptances. To create it, I built a zoom lens for my enlarger out of a zoom lens from a KODAK CAROUSEL Projector. My zoom lens is actually a little "fancier" than would be necessary, because I added the crank and gear arrangement to help assure a smoother zoom.

Homemade zoom enlarger lens made from the zoom lens of a KODAK CAROUSEL Projector.

A simple zoom lens for an enlarger without the crank and gear isn't really too difficult to make. All you need to do is cut a hole in a material such as Masonite and fasten the lens to it with screws. To avoid splitting the lens mount, I drilled holes, slightly smaller than the screws, into the mount. After you attach the lens to the Masonite, fasten the Masonite to a lens board that fits your enlarger. You may even be able to make the lens board from Masonite and paint it black.

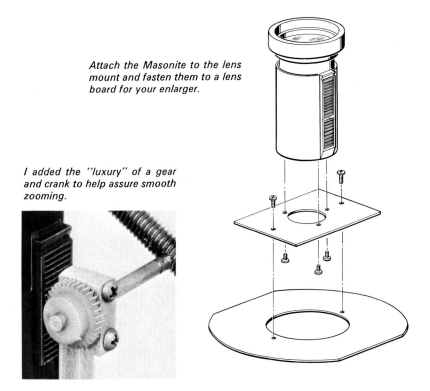

Attach the Masonite to the lens mount and fasten them to a lens board for your enlarger.

I added the "luxury" of a gear and crank to help assure smooth zooming.

To add the crank and gear, I cut the focusing rack off the outer barrel of the zoom lens and glued it to the inner barrel. The gear is the same one that's used in the projector to focus the lens. You can usually buy these gears from the parts department of the projector manufacturer. The projector lenses are sold by photo retailers.

With the zoom lens on the enlarger, all that's left to do is zoom the lens during part or all of the print exposure, depending on the effect you want. Since prints made in this manner are seldom literal interpretations, you're free to experiment with different color renditions. I chose a blue rendition of the ballerina because it created the mood I wanted in the picture.

NEW BACKGROUNDS FOR SLIDES OR PRINTS

If you've done much photographic printing, you may already have used texture screens. Perhaps you've bought some from a photo store, or maybe you've made some yourself either by taking a close-up picture of a textured subject illuminated by strong crosslighting or by using a translucent textured material such as silk, lace, or glass. (If you'd like to read more about printing with texture screens, the subject is discussed in KODAK Photo Information Book AG-16, *Enlarging in Black-and-White and Color.*) On page 388 I mentioned using a high-contrast film to make a type of texture screen from a piece of lace and sandwiching it with a slide.

But now I'd like to tell you one way of making a really different background for an impressionistic slide or print. I made the colorful piece of background below by placing a 4 x 5 sheet of KODAK EKTACHROME Film 6115, Daylight Type (Process E-3), on the enlarger easel in total darkness and covering it with a piece of textured glass. With no negative in the enlarger, I made an exposure through a No. 25 red filter. Then I rotated the glass 90 degrees, and made a second exposure through a No. 44 blue filter. I rotated the glass 90 degrees again, and made an exposure through a No. 57 green filter.

Background material made on a sheet of KODAK EKTACHROME Film 6115, Daylight Type (Process E-3).

You can use an incident-light exposure meter set for the speed of your film to determine the time to expose the film through each filter. With the filter over the enlarger lens and the lens set at the opening you're going to use to make the exposure, turn on the enlarger and take the incident-light reading with the meter on the easel. If you want one color to predominate, expose for a slightly *shorter* time through that color filter. On your first try, it's a good idea to cut up the sheet of film into several pieces and make some test exposures.

After you've had the film processed, or processed it yourself with KODAK EKTACHROME Film Chemicals, Process E-3, you can either sandwich it with the slide of your choice or sandwich it with a color negative for printing. The effect in the finished picture is about the same whether you sandwich the background with a slide for projection or with a negative for printing.

USING THE LEFTOVERS

The picture below is basically a combination of a few leftovers from some of the other pictures I discussed in this article. I began by making a Professional Line Copy negative from the Professional Line Copy positive of the figure study. All the highlight areas are now black, and the background is clear. I sandwiched this with a Professional Line Copy positive of the lace like that which I used in the figure study. Then I added a piece of the textured background discussed in the last section. I put all the components together on a slide illuminator and shot them with KODAK EKTACHROME-X Film.

Why not take a look through your negatives and slides for old pictures with new possibilities? Techniques such as those discussed in this article give you an excellent opportunity to exercise your artistic talent. Try anything that comes to mind—no matter how wild it may seem at first. It's fun, and I'll bet you come up with some prizewinners.

SUBJECT-TITLE INDEX

Consumer Markets Division **Rochester, New York 14650**

The *Here's How* Book of Photography
Kodak Publication No. AE-100

Minor Revision-11-73-EX
Printed in U.S.A.